Intimate Worlds

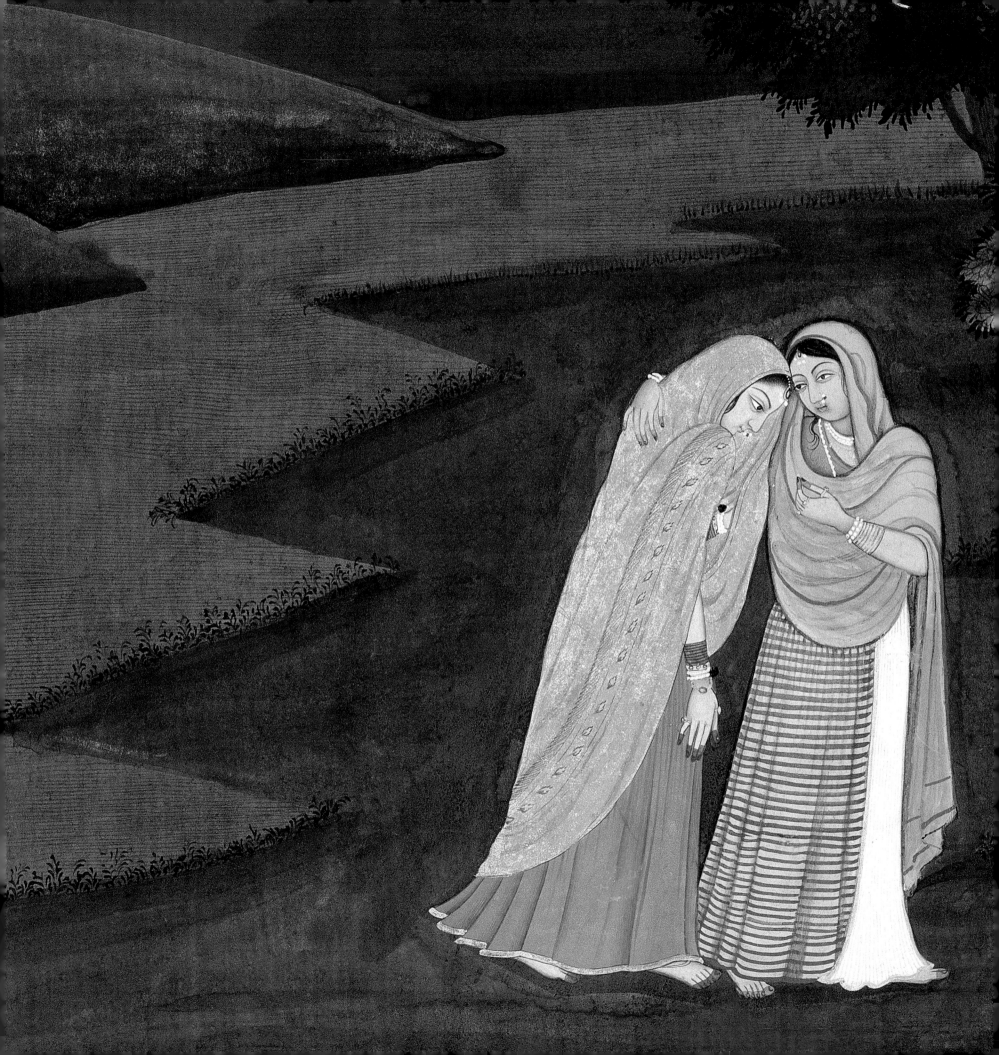

Intimate Worlds

INDIAN PAINTINGS FROM THE ALVIN O. BELLAK COLLECTION

Darielle Mason

with contributions by

B. N. Goswamy
Terence McInerney
John Seyller
Ellen Smart

PHILADELPHIA MUSEUM OF ART

Published on the occasion of the exhibition
*Intimate Worlds: Masterpieces of Indian Painting
from the Alvin O. Bellak Collection,* Philadelphia
Museum of Art, March 2–April 29, 2001

The exhibition and publication are supported by a
generous grant from The Pew Charitable Trusts.

Produced by the Publishing Department
Philadelphia Museum of Art
2525 Pennsylvania Avenue
Philadelphia, Pennsylvania 19130
USA
www.philamuseum.org

Library of Congress Cataloging-in-Publication Data

Mason, Darielle.
 Intimate worlds: Indian paintings from the Alvin O. Bellak
 collection / Darielle Mason; with contributions by B. N.
 Goswamy . . . [et al.].
 p. cm.
 Published on the occasion of an exhibition held at the Phila-
 delphia Museum of Art, Philadelphia, Pa., Mar. 2–Apr. 29,
 2001.
 Includes bibliographical references.
 ISBN 0-87633-147-9 (cloth: alk. paper)—
 ISBN 0-87633-146-0 (pbk.: alk. paper)
 1. Miniature painting, Indic—Exhibitions. 2. Illuminations
 of books and manuscripts, Indic—Exhibitions. 3. Bellak,
 Alvin O.—Art collections—Exhibitions. 4. Art—Private collec-
 tions—Pennsylvania—Philadelphia—Exhibitions. I. Goswamy,
 B. N., 1933– II. Philadelphia Museum of Art. III. Title.

ND1337.I5 M368 2001
751.7'7'09540902—dc21
 00-069292

Edited by Sherry Babbitt, with the assistance of
 Jessica Murphy
Designed by Mariana Canelo
Production by Richard Bonk
Photography by Lynn Rosenthal
Map by Noble & Israel Design, Brooklyn, New York
Color separations by Professional Graphics, Inc.,
 Rockford, Illinois
Printed and bound by CS Graphics, PTE, Ltd.,
 Singapore

COVER: *The Poet Bihari Offers Homage to Radha
and Krishna* (detail; cat. 79)

PAGES ii–iii: *Radha, Enter Madhava's Intimate
World* (detail; cat. 82); PAGE v: *The Awakening of
Trust (Vishrabdhanavodha Nayika)* (detail; cat. 26);
PAGE viii: *The Rainy Season* (detail; cat. 19); PAGE
xviii: *Maharana Jagat Singh II of Mewar Holds a
Feast for Yogis* (detail; cat. 61); PAGE 31: *Maharao
Ram Singh II of Kota Riding His Horse on the
Palace Roof* (detail; cat. 75)

ABBREVIATIONS OF CONTRIBUTORS
Darielle Mason (DM), Terence McInerney (TM),
John Seyller (JS), Ellen Smart (ES)

NOTES TO THE READER
Height precedes width in all dimensions; measure-
ments are for the full folio.
 All dates have been converted to the Gregorian
calendar.
 Diacritical marks have been omitted in the
transliteration of all names and terms, except in
bibliographic citations and quotations from other
published sources. Certain variations in translitera-
tions may appear in order to comply with popular
spelling.

Contents

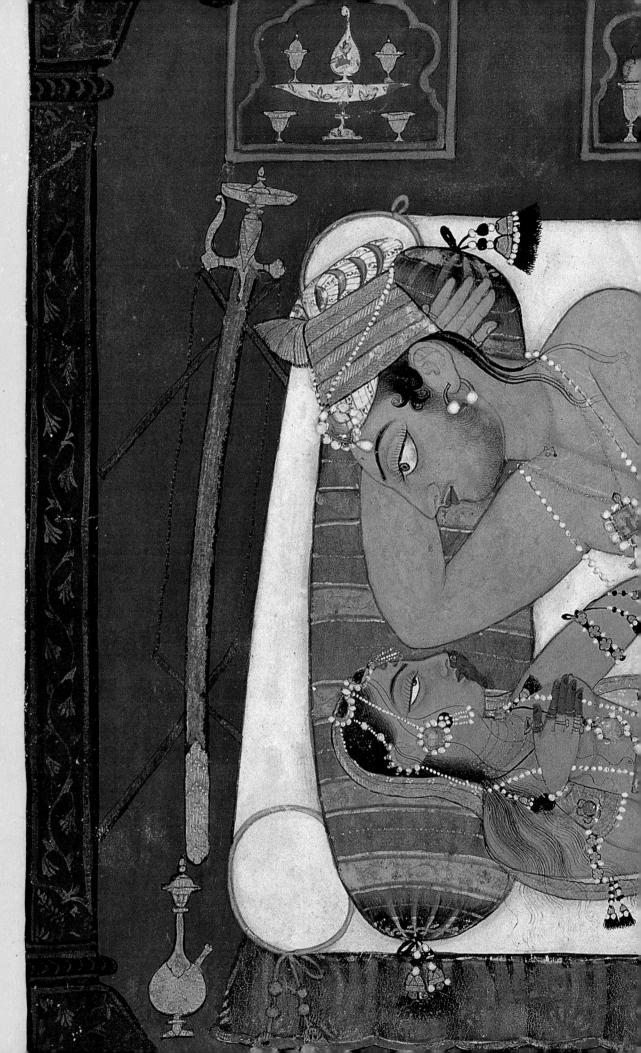

Foreword

When asked for a descriptive title for her 1986 exhibition of Indian paintings from Philadelphia collections, the distinguished scholar and emeritus curator at the Philadelphia Museum of Art, Dr. Stella Kramrisch, replied instantly and resoundingly, "Painted delight!" She would be sublimely happy (perhaps not surprised) to know that some of the most beautiful works in that exhibition, lent by her friend and protégé Dr. Alvin O. Bellak, are now part of his splendid gift of eighty-eight paintings to the Museum, which will delight its public for generations to come.

This Museum is world-famous for its collection of the life work of many great collectors—whether of arms and armor, Pennsylvania German furniture, Chinese ceramics, or modern art. As our galleries demonstrate, collecting is itself an eloquent art form. Marcel Duchamp once described the true collector as an artist "squared" (*au carre*), in a vivid phrase evoking that passion for filling a room with beloved works of art—painting, as it were, in three dimensions. The walls of Dr. Bellak's Philadelphia apartment often vibrate with the thunder of elephants in battle, or echo, more seductively, with the plangent notes of an evening *raga*. His decision to share his own vivid pleasure in these painted worlds with the public makes the Philadelphia Museum of Art in one stroke home to one of the finest collections of Indian painting in the United States.

As the Museum's first Stella Kramrisch Curator of Indian and Himalayan Art, holding a position endowed by her extraordinary predecessor, Darielle Mason has risen enthusiastically to this auspicious occasion, organizing the public debut of the Alvin O. Bellak Collection as the first major exhibition project of her tenure. Her thoughtful scholarship and elegant eye, already evident in the installation of the Museum's galleries devoted to Indian and Himalayan art, are here brought to bear on the most significant addition to the department's collections since Dr. Kramrisch's own bequest in 1994. She and I are deeply grateful to the quartet of scholars whose contributions to this book give it such authoritative depth: B. N. Goswamy, Terence McInerney, John Seyller, and Ellen Smart. And we owe warm thanks to Jennifer Bellak Barlow, who has generously lent two paintings formerly in her father's collection. Finally, we express our profound appreciation to the Pew Charitable Trusts, whose generous support of exhibitions at the Museum over twenty years continues to make possible not only major projects in Philadelphia but the sharing of Philadelphia's treasures with the rest of the world.

This catalogue owes its handsome design to Mariana Canelo and its skillful and careful editing to the Museum's inimitable Assistant Director of Publishing, Sherry Babbitt, to whose high standards so many books published by the Philadelphia Museum of Art are indebted.

Dr. Bellak's desire to share his passion for Indian painting with a wide audience has coincided miraculously with the Museum's celebration of its 125th Anniversary in 2001. The Museum has been hugely fortunate over the past twelve decades to receive an astonishing proportion of its distinguished holdings of works of art as gifts from individual collectors, and no collector has been more devoted to his chosen field, nor more eager to introduce others to its delights, than Alvin Bellak. Together with his fellow Trustees, the Committee for Collections 2001, and its Chairman, Harvey S. Shipley Miller, I salute his extraordinary generosity as these paintings, so long cherished in private, are presented to the public for the first time, in honor of the Museum's anniversary.

ANNE D'HARNONCOURT
THE GEORGE D. WIDENER DIRECTOR AND CHIEF EXECUTIVE OFFICER

Acknowledgments

Numerous individuals both inside and outside of the Philadelphia Museum of Art have helped in a wide variety of ways to make this publication possible. Lynn Rosenthal photographed the entire collection to reveal the paintings in their full glory of gleaming gold, lustrous colors, and sharp details. Sherry Babbitt shouldered the monumental job of editing the volume, as well as acting the role of atlas for the entire project. She was ably assisted in verifying often esoteric, not to say obscure, references by the amazing biblio-detective work of Jessica Murphy. Josephine Chen of the Library staff tracked down the untrackable. Nicole Amoroso held down the editorial fort and Lynne Shaner provided much-needed editorial skills at critical moments. Richard Bonk managed the production of the book, juggling color verification and tight deadlines with aplomb. Conservator Julie Ream worked for over a year treating all the paintings in the collection to make them as healthy and as free of visual distraction as humanly possible. Nancy Ash and Faith Zieske, the Museum's paper conservators, oversaw the entire conservation project. Mariana Canelo created the exquisite design for this volume.

The staff of the Department of Indian and Himalayan Art contributed in spate: Nancy Baxter established invaluable early organization; Laura Silvasi saw the project through as organizer extraordinaire, coordinating with Trine Vanderwall of the Registrar's Office the complex dance of the paintings among four locations. Sharon Littlefield arrived toward the end of the process as *deus ex machina* to chase down comparative photographs and clean up in a host of ways; Pia Brancaccio cheerily took over other projects to allow us to focus on this one. Suzanne F. Wells, Coordinator of Special Exhibitions, and Assistant Director Alice Beamesderfer dealt with essentials and emergencies.

B. N. Goswamy, consultant to the project, generously provided his vast expertise, linguistic acumen, and magical vision, particularly on the Pahari paintings. Shridhar Andhare graciously advised on the Jain paintings and others. In addition I am grateful to the following individuals who helped in translations of inscriptions on paintings in the Bellak Collection, both during the work for this catalogue and previously: Jerome Bauer, Joachim Bautze, Richard Cohen, Signe Cohen, Vidya Dehejia, Debra Diamond, Peter Gaeffke, and Andrew Topsfield. Thanks to Catherine Glynn Benkaim, Sheila Canby, Naval Krishna, and Andrew Topsfield for their assistance in our search for comparative photographs; and to David Nelson and the staff of the University of Pennsylvania libraries. My great appreciation goes also to Jennifer Bellak Barlow, whose exquisite paintings complete the story this collection tells.

The authors who wrote essays and catalogue entries—B. N. Goswamy, Terence McInerney, John Seyller, and Ellen Smart—were asked to undertake often gargantuan amounts of work. They have triumphed, individually and collectively producing a body of exemplary scholarship that not only informs the individual works of art, but, I believe, gives broader insights that will be of value to students, scholars, and collectors into the future.

I am ever grateful to Anne d'Harnoncourt, The George D. Widener Director and Chief Executive Officer of the Philadelphia Museum of Art, whose eye recognized the significance of this collection, and whose support, manifested in so many ways, made its publication and exhibition possible. Of course, without Alvin O. Bellak there would have been no collection and thus no catalogue, no exhibition, and no anticipation of a glorious, transformed future for the Museum's Indian painting collection. But it was Al's unstinting enthusiasm, help, and friendship throughout the work on this project that, for me, made roadblocks surmountable and everything worthwhile.

DARIELLE MASON

THE STELLA KRAMRISCH CURATOR OF INDIAN AND HIMALAYAN ART

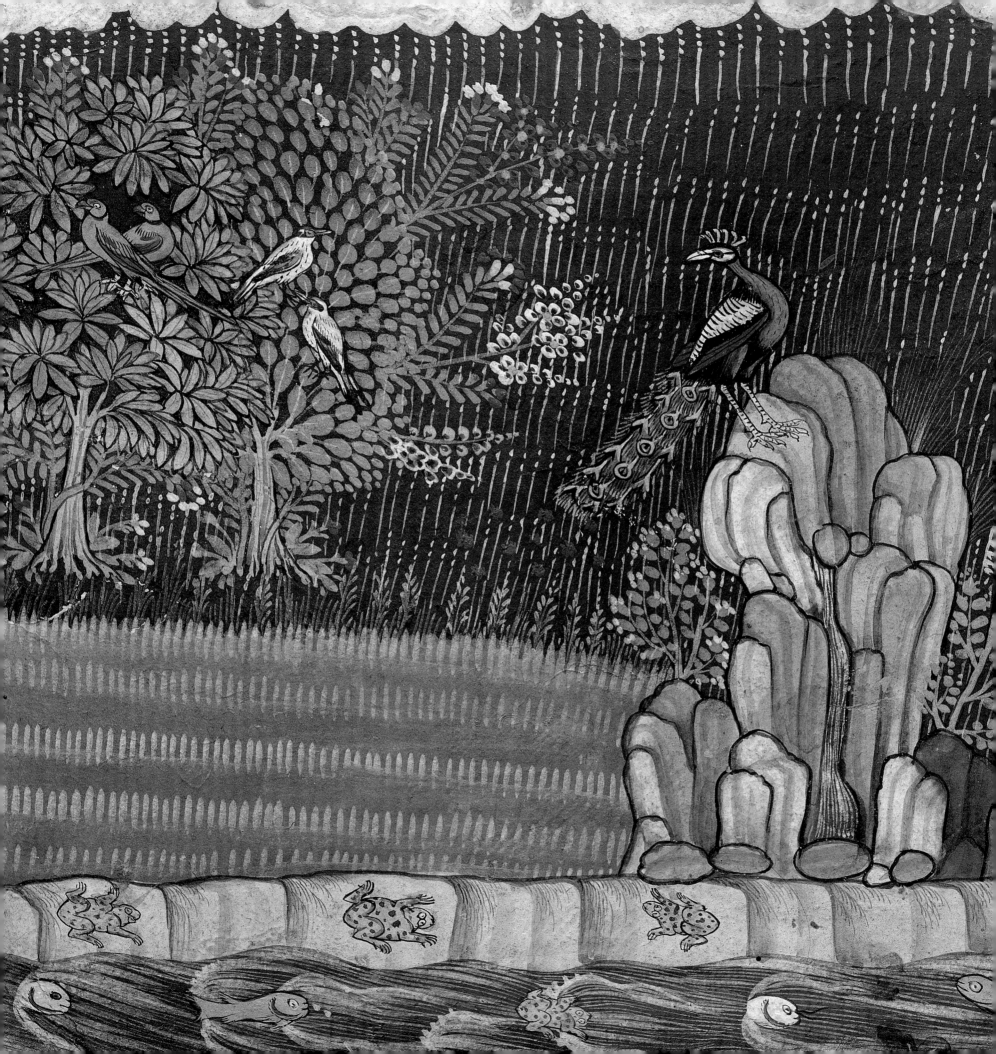

Intimate Worlds

DARIELLE MASON

O Krishna, you wander in our village,
make love with all manner of girls.
Only in this way, so you tell us, can a man
learn the difference between good, better, best.[1]

"Enter Madhava's intimate world," Radha is urged as she hesitates to join Madhava (Krishna), her radiant paramour, who awaits her in a glowing forest bower. The words of this invitation are part of a verse written on a painting in the Alvin O. Bellak Collection (see cat. 82), and in the context of this collection these words are multivalent. On the one hand, paintings on paper made in India between the fourteenth century and the nineteenth are for the most part tiny works of art originally intended to be held in the hands of a single person and examined closely. Even when the pages were passed among a group, it was alone that the viewer entered into the intimate world created on each folio. On the other hand, just as the leaves, branches, and boughs intertwine to form Krishna's bower, so too each thoughtfully and lovingly chosen work of art in the Bellak Collection interacts with the others to form an environment of aesthetic delight and rich historical narrative. This collection, then, is its own intimate world, one created by Dr. Bellak, and one he invites us to enter.

In many ways the illuminated books (whether bound or loosely grouped) and the individual paintings and drawings that originated in the court workshops of the Indian subcontinent are like jewels. As portable luxury goods, both types of objects are treasured for their artistry, their fine colors and polished finishes, their status as courtly accouterments. Over the years, both have been given as gifts to commemorate political alliance, included as parts of dowry settlements, seized as booty in conquest, amassed into royal treasuries, sought after by collectors, preserved and exhibited throughout the world. Yet where paintings differ from jewels is in the level of intentionality of their creation. A painting is not a found natural object enhanced by the craftsman; it is entirely a work of artistry—pulp to paper, mineral to paint. And, unlike a jewel, the primary original aim of these works, whether a religious epic or a portrait,

was to tell a story. Yet to focus solely on the point of creation of paintings—on the painter, patron, and original meaning—is to ignore a great and intriguing part of their history.

At each stage in their lives these pages take on new and distinct significance. With each owner, indeed with each viewer, the individual work of art comes to be perceived in distinct ways—social, economic, and aesthetic. Each generation of owners brings to its appreciation a culturally and personally determined set of values that may overlap in whole, part, or not at all with the value set of the painters and of previous owners. Each is equally legitimate, for it is an honest evaluation that tells us something about not only the individual and his or her society, but also the intrinsic properties of the objects themselves. The very act of forming a collection may also be an act of artistic creation, one that expresses both a particular set of critical values and a vision of the entire known body of related works. This is particularly true of the Bellak Collection.

Collectors of Indian painting proceed in a variety of ways. Their focus may be broad or narrow. Their criteria for selecting objects may be based solely on their own taste in subject matter or type, size or color; on their own aesthetic sense; or on their own desire to gather a group of works that tells a story—religious, historical, cultural, or formal. As his own words in this catalogue make clear, Bellak's approach combined several intentions. With a Ph.D. in clinical psychology, Bellak worked throughout his professional life as a consultant with the Hay Group, initially advising corporate executives on ways to improve their effectiveness, and later, as the general partner, heading the worldwide management compensation business of the firm. A kind and insightful man as well as a highly rational and disciplined scientist, he possesses an unusual ability to examine his own thoughts and actions calmly and objectively, as he did those of the executives he counseled. His career as a collector and the collection he has built reflect these traits. After a stage of discovery and learning (what he terms "wandering in the wilderness while driven by passion"), he mapped out a two-fold plan of collecting that he adhered to with singular tenacity: to express his conception of quality

through the acquisition of superb works of art, and to illustrate his understanding of the history of Indian "miniature" painting.

The idea for the three essays in this catalogue emerged from Bellak's qualitative and historical approach to collecting. Rather than reiterating the history of style as it has often been written, these short studies seek to explore through a historical perspective the question of the meaning of "quality" to the various individuals who have made, used, and owned these works of art. What aspects of these paintings were most valued at any point in time? How did notions of value change? What made one work more desirable than another? How was—and is—a hierarchy of taste established, and what might these hierarchies imply?

The essays work their way backward according to the progress of an individual painting's creation and ownership, from tertiary (international collecting) to secondary (ownership in the treasuries of the Indian royal courts) to primary (patron and painter). In "On Collecting Indian Miniature Paintings: Twentieth-Century Issues and Personalities," Terence McInerney examines the most recent era. This is a history of personalities, of the collectors and scholars whose interconnected conceptions of this art underlie Bellak's (and our own) judgment of "quality," in ways both overt and subtle. The essays by John Seyller and B. N. Goswamy seek to assess such judgments within the context of the Indian courtly milieu, although the evidence before the twentieth century is much scarcer and very difficult to evaluate. In "For Love or Money: The Shaping of Historical Painting Collections in India," Seyller ingeniously utilizes the monetary valuations written on paintings while they were held in treasuries of the imperial Mughals and various Rajasthani courts to glean a sense of the hierarchy of taste among northern India's courtly cultures. It is these courts that owned the paintings (whether painted in their own ateliers or in those of other courts) in the generations after production, but while workshops were still active. Goswamy, in "Painters and Patrons: Notes on Some Relationships Within the Pahari Tradition," explores the written and visual records from the time when these paintings were produced for insights into the various relationships

that existed between patrons and painters in the region of the Panjab Hills. Together the three essays aim, as they wend their way backward in the life cycle of paintings, to probe a crucial but often ignored facet of India's artistic history: the history of taste.

The catalogue of the individual paintings and drawings in the Bellak Collection that follows is not subdivided. Works are arranged in roughly chronological order, rather than strictly by the regional-dynastic divisions more traditional for this art form (Mughal, Rajasthani-Rajput, Pahari-Rajput, and so on). While regional-dynastic divisions have not been ignored, eliminating the conventional separations prompts an understanding of broader formal trends and highlights the rich visual interrelationships among individual works of art that characterize this collection.

The sequence of images and accompanying commentary seek to provide a coherent history. This history is a vision of origins and culminations. Bellak demonstrates his interest in what he terms the "foundation of Indian miniature painting" through the strength and coherence of the pre-seventeenth-century works (cats. 1–4, 6, 10, 13–16) as well as the sixteenth-century *Bhagavata Purana* pages (cats. 7–9, 11–12). The deliberateness of his collecting is also visible in this group. Each cultural strand that came to be woven into the tradition—Indian, Persian, European, and Central Asian—is represented in the Bellak Collection by a paradigmatic and exquisite work of art. Most of the collection, however, comprises works created by the various groups of painters under the patronage of the Hindu Rajput rulers of northern India, active in the seventeenth through nineteenth centuries. The range is broad, and the collection offers extraordinarily fine examples from all regions as well as breathtaking groups of paintings from selected centers, such as late seventeenth-century Basohli-Nurpur, including two superlative pages from the justly renowned "Tantric Devi" series (cats. 23–24), and the only folio from Devidasa's *Rasamanjari* still in private hands (cat. 26).

Bellak has never denied his own likes—and dislikes. His visual preferences are for rich color; strong, satisfying compositions; unusual, playful, even absurd subjects; and paintings that, to use his own words, in some way reveal "the creative genius of the artist." This acceptance of personal taste, combined with his carefully considered vision of history, means that each image resonates with others in expected and, frequently, unexpected ways to break through boundaries of time, region, and workshop and provide not only a sweeping historical lesson in the cross-fertilizing painting traditions of India, but also a visually opulent, yet always intimate, world.

1. *Not Far from the River: Poems from the Gāthā Saptaśati*, trans. David Ray (Port Townsend, Wash.: Copper Canyon Press, 1990), p. 72, verse 295.

Reflections of a Collector

ALVIN O. BELLAK

On a pleasant January day in 1975, my ex-wife called to tell me that a Pakistani rug dealer in her neighborhood had some wonderful pictures. She encouraged me to go to see them. Why she felt compelled to do this is a story for another day, since she knew that the only piece of original art I had ever bought was a whimsical woodcarving of a giraffe done by a local artist—for which I had paid an extravagant seventy-five dollars! However, my curiosity was piqued, and I took her advice. I went, I saw, and I bought, and bought, and bought. Up to this fateful point I had never seen an Indian "miniature." I knew absolutely nothing about them and the rug dealer knew little more—only that they were from India and that they were old. Yet the pictures reached me in ways that I still can't begin to understand. My conscious thoughts at the time were prosaic: these paintings are highly colorful, they look exotic, I like them—a lot.

I brought home a large stack of pages. Over succeeding months I went back again and again until I had pretty much bought him out. All together I had accumulated eighty-five pictures—most of them, as I only much later discovered, rather crudely executed pages of several *Bhagavata Purana* manuscripts made in Kashmir in the second half of the nineteenth century (plus a few fake Mughal pictures). Yet they continued to intrigue and excite me. I stared at them for hours, noticing a lively detail here, a glowing color there. I framed many of them and hung them all over my house. I was really hooked. Over the next four years, I searched out a number of dealers. I discovered the auction houses. I met collectors, curators, and art historians. And I continued as I had begun, buying hundreds of pictures, indiscriminately. It was trial and error on a very grand scale. I had learned the outlines of a history of style, but the closest thing I had to a plan was compulsively to acquire pictures from every school and period. The result was a very large collection of "folk" pictures, and an array of court pictures of truly mediocre quality.

A great mystery to me is why it took me four years to both recognize *and* buy a good picture. I had been to many exhibitions and owned dozens of books. It was as if there existed a great secret in there, some-where, that eluded me. Yet the good news was that, slowly, I was developing a sense of what the art form was all about. It was on a visit with the wonderful collectors of Himalayan and Indian art, John and Berthe Ford, that John offered two suggestions that were to change everything for me. He said that I should go to see Stuart Cary Welch, the distinguished scholar-collector then at Harvard, and that I should visit a dealer by the name of Terence McInerney.

The moment of truth occurred on my visit to Harvard. Over a period of several hours Cary showed me one fantastic picture after another; the more I responded the faster he pulled them from his cabinet. There were incredible Kota drawings of elephants and snarling lions, rare and beautiful pictures from the Deccan. And it hit me. I could see what collecting was all about. It was about quality, not quantity. It was not about prices; it was not about having pictures from every school and period. It was about recognizing the hand of a master, seeing the difference between good, better, and best. It was about recognizing a great work of art even when it was unlike anything previously known to you. The emotional experience I had with Cary's pictures was so overwhelming that I had to escape. I told Cary I needed to leave immediately to catch my plane home. The plane wasn't scheduled to depart for four hours.

This new-found sensibility finally crystallized in May of 1979. As per John's advice, I went to visit Terry McInerney. He showed me a number of things. I bought the one I liked best: *Men with Fireworks* (cat. 62). It was my first really good picture. Terry and I got along very well, and he quickly became my principal supplier, my mentor, and my good friend. He learned that when I appeared at ten in the morning it was best to not schedule any more appointments for that day. We looked at pictures and talked and talked. He would pull books from his vast library to show works related to his offerings. He wrote me lengthy treatises on the pictures and advised me on purchases at auction. Thanks to his work and openness, when the moment came to make a decision, I felt prepared.

It was not long after this first purchase that my master plan began to emerge:

- Buy primarily pictures that I judged to be great on an absolute scale.
- Seek a comprehensive collection, but never by sacrificing quality.
- Accept my own prejudices and tastes (my preferences for certain schools, periods, and subjects).
- Emphasize early pictures, those that marked the beginning of a distinctive school, where I could see how the art began and from where it evolved and spread.

With all these wonderful intentions, however, the reality of collecting art from an established body of works available is not a neat process. You can't just go into the market and find what you want when you want it. Some of the types of paintings I desperately desired I was never able to find, for example, a Jain painting on palm leaf. And the unexpected was the norm. At times hitherto unknown paintings would just appear, sometimes in smaller or larger groups, as if from a buried treasure. There were, of course, frustrations along the way—once I discovered what a good painting looked like, I found that, as opposed to my early experiences with the Pakistani rug dealer, here I would face stiff competition.

But I really don't have any complaints. The process of collecting has been as glorious as my enjoyment of the paintings themselves. Over the years I pretty well realized the goals I had set for the collection. Of course, despite the title of this exhibition, not every painting *is* a masterpiece. Some I consider to be among the best of their kind—perhaps not in and of themselves great, but still worth having to make a historical or formal point, or to show the wondrous variety of the art form. Some others are excellent, yet I acquired them more for their historical than their aesthetic value. Others are attractively quirky, and they delight me. Where I acquired a picture from a venerated manuscript or portfolio, the standard was very strict: buy one of the best or none at all. No matter what the dealers said, I was the sole judge of quality.

As I acquired paintings, the words of W. G. Archer, the pioneer scholar-collector of Pahari painting, became ever more true, at least for me: "You have to

Alvin O. Bellak in his Philadelphia
apartment, 2000

own the pictures in order to know them." Yogi Berra also got it right: "You can observe a lot just by looking." I stared—and stare—at my pictures for hours and hours at a time. How I have enjoyed them! I sit there in my living room, the principal gallery space in my home, with a bottle of wine and a pack of cigarettes, and I watch them. I have hung them in different combinations so that I can see how they talk to each other, and how the art varied from one school or time to another. At one point I hung them only according to date so that, as my eye traveled around the room, I could see the centuries roll by. More recently those walls have been filled with the glory of the Panjab Hills. The early pictures in particular are so strong, so brightly colored, that their amazing impact on me and on my visitors never seems to pale.

When I brought a work home on approval, I would hang it with related pictures. Sometimes it would take minutes, sometimes hours, sometimes days, but inevitably the "truth" of the painting, for me, would finally, and suddenly, emerge. This was a good way to detect the occasional fake, but I really did it to establish quality. Either the painting would hold up to those around it, or it would come down in a flash. Sometimes I thought that the pictures themselves were alive. A friend once said that my pictures must hang there in fear of their lives. He was right. Like living entities, they never remained static. Sometimes years would pass as a painting hung on my wall, or sat in my hands, before I would see it in a new light, for better or worse. All this looking was learning. Through it, photographs in books also became alive, even when they were in black and white—my closeness to the real thing allowed my imagination to add the color, detail, and texture.

My story would not be complete without recounting my relationship with the remarkable Dr. Stella Kramrisch, long-term Curator of Indian Art at the Philadelphia Museum of Art and an art historian of enormous importance. I met Dr. Kramrisch in late 1977 or early 1978, when I went to the Museum, a pile of pictures in hand. Ushered solicitously into her office, I was greeted by a tiny woman in her eighties with a pleasant little smile. As she worked her way through the pile, I waited for confirmation. It soon became clear that she was not impressed.

In 1980, I heard about an exhibition she was preparing, *Manifestations of Shiva*. By then I had acquired one page from the "Tantric Devi" series (cat. 23). I wanted her to know that I had a really good picture, so I sent her a transparency. She included it in the exhibition. I met her two years later in London, by chance. She told me about a wonderful picture she had seen at a gallery, but that it had been sold. She asked if I knew the buyer. Miraculously, I was the buyer (cat. 9). Upon our return home, she finally came to visit.

From that point on, we saw a lot of each other—back and forth from our apartments on opposite sides of Rittenhouse Square in Philadelphia. We had wonderful discussions. Occasionally, I would show her a piece I had on approval. What an eye she had! As we talked, she would help me see the strengths or weaknesses of the picture. Sometimes I was a bit startled by her comments. For example, I showed her *A Nobleman Returns to the Hunt* (cat. 43) just after I bought it. To me it is strange but beautiful—the hunting dogs resemble raging lions, instead of the usual sleek salukis; the hawk, far from showing the standard regal stillness, swirls its head around to find its prey; the horse is fierce, as if aroused by the hunt. She looked at it for a moment, told me it was the work of a madman, and directed me to books on paintings by mental patients!

For her 1986 exhibition *Painted Delight,* Dr. Kramrisch came over and selected twenty-eight pictures. When she was finished she said, with a sly smile, "This will make your collection famous." Yet as my collection grew, I sometimes felt like a miser who locked the doors, closed the drapes, and gleefully contemplated his hoard. What was I doing? Why was I accumulating all this stuff? To what end?

Fortunately for my psyche, I recalled the words of an earlier visitor, the art historian Pramod Chandra. I asked him, "What role do collectors play in the world of art?" He quickly responded that the collectors are the preservers of the art. Sounded good to me. Now I could look in the mirror and say, "There stands a preserver of the art." That was a lot better than saying, as Freud would have it, "There stands an anal retentive personality!"

But preserve them for whom? Was I supposed to take care of them and then pass them on? Should I haul them off to the auction house and disperse them? Yet I felt that the collection, as a whole, was a creation that said more than its individual parts. I had assembled much that I believe to be among the best of Indian painting, and a group of works that together teach about history and about beauty. I finally concluded that the pictures belonged to everybody. They belonged in a museum where they would be protected and be available for the enjoyment and education of all people, forever. The only question was, "When?" What would I do without these pictures that have become such an essential part of my existence, that provide me with such ongoing pleasure? The perfect solution has been reached—they have been bequeathed to the Philadelphia Museum of Art. Lest this sound too totally altruistic, I must confess that "The Bellak Collection of Indian Paintings at the Philadelphia Museum of Art" does have a nice ring.

Over the years, I have been told by several people who should know that I have a "personal" collection. I take that as a compliment. I would really like to articulate what I believe makes for a great picture, but I can't. Sometimes it is the perfection of the drawing, sometimes it's a complex composition that just "works" well. Sometimes it's the brilliant or, conversely, subtle use of color. Of course, it isn't a single feature but rather some harmonious combination that adds up to quality. I hope that the paintings themselves, exhibited and published together here for the first time, will demonstrate what I cannot say.

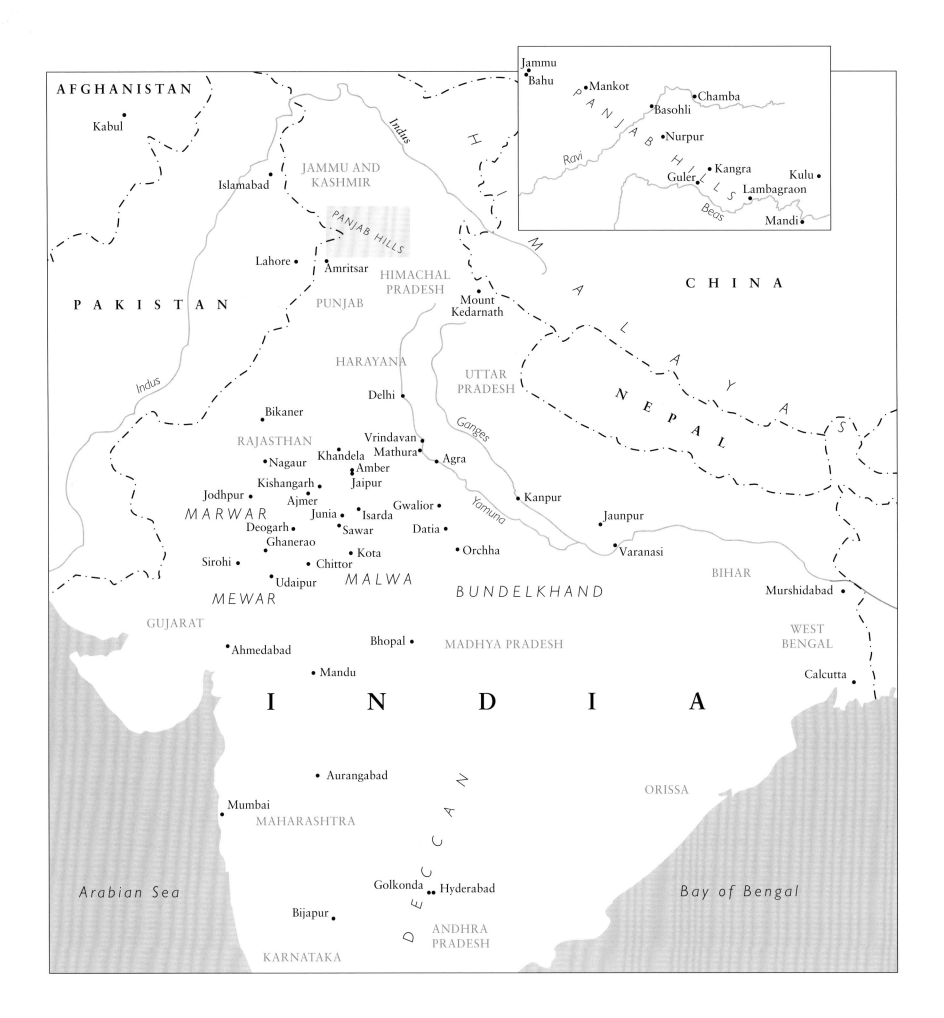

Inset map (top right):

Jammu
Bahu
Mankot
Chamba
Basohli
Nurpur
Ravi
Kangra
Guler
Kulu
Lambagraon
Beas
Mandi
PANJAB HILLS

Main map:

AFGHANISTAN

Kabul

JAMMU AND KASHMIR

Indus

Islamabad

PANJAB HILLS

CHINA

PAKISTAN

Lahore

Amritsar

HIMACHAL PRADESH

PUNJAB

Indus

HARAYANA

Mount Kedarnath

H I M A L A Y A S

NEPAL

Delhi

UTTAR PRADESH

Bikaner

Ganges

RAJASTHAN

Vrindavan
Mathura
Khandela
Agra
Nagaur
Amber
Kishangarh
Jaipur
Jodhpur
Ajmer
Junia
Gwalior
Yamuna
Kanpur
Jaunpur
MARWAR
Isarda
Deogarh
Sawar
Datia
Ghanerao
Orchha
Varanasi
BIHAR
Sirohi
Kota
Chittor
Murshidabad
Udaipur
MALWA
BUNDELKHAND
MEWAR

WEST BENGAL

GUJARAT

Ahmedabad
Bhopal
MADHYA PRADESH
Calcutta

Mandu

I N D I A

Aurangabad

ORISSA

Mumbai

MAHARASHTRA

D E C C A N

Golkonda
Hyderabad

Arabian Sea

Bijapur

Bay of Bengal

ANDHRA PRADESH

KARNATAKA

The Courtly Painting of the Indian Subcontinent

Darielle Mason

In the literature on Indian courtly painting written over the last century, from the time of the great scholar-collector Ananda Coomaraswamy's "discovery" of Rajput painting in 1916 to the present, a history of style has been laboriously constructed and refined both to identify and explicate these works of art. The categories that developed as a result of this process are based on the relationship of form to place and time of production, which has more recently been refined by a better understanding of the practices of workshops and the movements of ideas and individuals. Yet the very attempt to create such categories to give meaning to the otherwise uninterrupted and ungraspable continuity of artistic creation may at times take on its own importance that overshadows the complexity and richness of the works themselves. However, this caveat having been voiced, a "thumbnail" stylistic history of Indian courtly ("miniature") painting is presented here to offer the reader a basic glossary of terminology found in the literature in general and in this catalogue in particular.

The history begins with painting of the so-called pre-Mughal period, before and during the early years of the Muslim Mughals' conquest of northern India in the sixteenth century. Works produced at this time in indigenous styles for Jain (cats. 1–4) and Hindu (cats. 9–11) patrons are characterized by the use of bold, primary colors, unmodulated by shading. Flat, monochrome backgrounds subdivide compositions; figures are relatively simplified but lively, well rounded and in profile; and the page is composed by the arrangement of figures and landscape, rather than by the illusion of depth. At the same time the Muslim Sultans who ruled parts of northern India before the Mughals were developing their own modes of painting, hiring painters trained in local workshops catering to Jain and Hindu patrons (cat. 6). However, they also had a predilection for adopting the more extensive and often pastel color palette, smooth three-quarter-profile face, swaying figures, and small repeat patterns found in paintings in the contemporaneous style of the Persian Timurid court (cat. 10).

In the mid-sixteenth century the Mughal rulers brought with them from Central Asia a passion for illustrated books. They also hired painters trained in the sophisticated Safavid court of Persia (cat. 13). In the workshop of the Mughal emperor Akbar, these painters worked together with local artists to create a new style (cat. 14) that combined the bold colors, full figures, and lively movement of indigenous Indian painting with the love of pattern, blended colors, and exquisite finish of Safavid Persian works. During the same period, contact between India and Europe increased. Characteristics of imported European prints and paintings, such as the use of shading and the evocation of distant space through atmospheric perspective, were added to the Mughal artist's repertoire (cat. 15). Some painters trained in or in the manner of the royal Mughal workshop also worked for nonimperial Mughal patrons, for example, wealthy governors or other court officials, many of whom were Hindu. The paintings thus produced outside of the imperial atelier tend to be labeled "subimperial Mughal" (cat. 16).

Islamic rulers had conquered portions of the Deccan region of central-southern India as early as the fourteenth century, and in the sixteenth established Sultanates with capitals including Bijapur, Hyderabad, and Golkonda. Retaining close ties with Persia, homeland of their ancestors, the works of the Deccani painters of the sixteenth and seventeenth centuries are at times indistinguishable from Persian production. However, at the same time a distinctive Deccani sensibility did evolve, one that emphasizes lush fantasy colors, the use of outrageously oversize plants, and elegantly stylized Persianate figures (cats. 40, 43).

Somewhat in imitation of the Mughal atelier, regional Hindu courts across northern India (some coming under Mughal overlordship, some remaining independent) augmented existing painting workshops and established new ones, each cultivating its own identifiable style between the sixteenth and the nineteenth centuries. The region of Malwa in western Madhya Pradesh, for example, long retained the sensibility of pre-Mughal indigenous painters (cat. 21). Conversely, the various court workshops of Rajasthan and other parts of western India developed a plethora of new and distinctive practices. Some, such as Bikaner, at times produced a style closely based on the Mughal model (cat. 52), while others, such as the staunchly independent state of Mewar (Udaipur and its surrounding area), took note of Mughal developments but created their own individualized format (cat. 58). The northerly region of the Panjab Hills (called Pahari, literally "mountainous"), while aware of painting production in the plains of northern India, was even more of a self-contained regional entity that very much proceeded along an independent trajectory that by the mid-eighteenth century had formulated a characteristic, exquisitely idealized style (cat. 81).

Although these courtly painting traditions continued in both the hills and plains of northern India and in the Deccan, by the latter years of the nineteenth century they were losing ground to a new medium—photography—and painters attempted to compete with the camera in both form and format (cats. 89, 90) . This production is indeed the final chapter in the history of courtly "miniature" painting in the Indian subcontinent, but it is by no means the final chapter in the history of painting in the region, an art that remains vital in many forms and on many levels into the present.

Texts and Themes

Created primarily for private delectation or devotion, and sometimes for pious donation, the paintings in the Alvin O. Bellak Collection presented here display a range of subject matter, but it is a range circumscribed by various traditions. Many of the paintings were created to illustrate religious narratives. The *Kalpasutra* (cat. 4) and *Kalakacharyakatha* (cats. 1, 3), for example, are devotional texts that tell the life stories of figures important to Jain belief. In these manuscripts, the text is written out continuously on the front and back of each folio. Standardized illustrations, often iconic in flavor, punctuate it at relevant points, but the text remains primary. Hindu narrative texts include tales of the incarnations of the great god Vishnu—especially the *Ramayana* (cats. 16, 27–31, 81), the epic of the hero Rama, and the *Bhagavata Purana* (cats. 7–9, 11, 12, 18, 19, 32–34, 57, 80, 88), focusing on stories of the life and adventures of Krishna. The *Gita Govinda* (cats.

82, 83, 87), which also narrates a coherent episode in the life of Krishna, is a mystical-devotional love lyric, while the *Kedara Kalpa* (cat. 86) is a series of didactic tales narrated by the god Shiva. As opposed to the Jain practice, in illustrated series of these Hindu texts the painting is paramount, with only the relevant sections of the text written on the page (if they are even present at all), often on the reverse of the painted image.

This is also the case with illustrated series of the *Rasikapriya* (cats. 20–22), *Rasamanjari* (cat. 26), and *Satasai* (cats. 71, 79), which are poems with devotional Hindu overtones that classify and explore the many states of love. Likewise, the *Ragamala* (cat. 56) and *Barahmasa* (cat. 84) are classificatory poems dealing in large part with the nuances of love, giving literary (and visual) form to the modes of music (*ragas*) and to the months of the year, respectively. The so-called Tantric Devi series is similarly a non-narrative devotional text that honors the multifarious forms of the Great Goddess.

In contrast to the Hindu examples, most of the illustrated narrative texts originating in the Islamic milieu differ in that they are essentially secular or non-devotional. The well-known chronicles of the reigns of the Mughal emperors, such as the *Akbarnama*, are both historical documentation and royal glorification, their illustrations giving detailed visual accounts of actual events. Although such paintings are not represented in the Bellak Collection, in many of the paintings that are included, the line between secular and religious—and between Muslim, Hindu, and Jain—is less distinct. *Bizhan in the Dungeon* (cat. 6), for example, is a page from the mytho-historical narrative of the kings of Persia, the *Shahnama*. However, its simplified and generic image, as opposed to its text, was probably painted for its Muslim patron by an Indian artist trained in the Jain tradition and so relates more to semi-iconic Jain illustrations than to the historical specificity of works produced for the later Mughal rulers. Further, the Hindu epic the *Mahabharata* appears here in a page from the *Razmnama* (cat. 17), the Persian retelling created for the ecumenically curious Mughal emperor Akbar. In the Bellak image, painted by an artist trained in the Mughal atelier, probably for a wealthy Hindu court

official, the mythological scene is imbued with all the specificity of the battle scenes in the historical court chronicles. Likewise, a page from a *Ramayana* (cat. 16) transforms the ancient Hindu story into a Mughal audience scene that, although imaginary, is particularized by individualized faces and a wealth of concrete detail.

Portraits are the second largest subject category in the Bellak Collection. The artist may represent the particular individual in the form of an imagined type (cats. 13, 42); or he may depict an actual, idiosyncratic physiognomy (cats. 59, 60, 74). Portraits of this latter type, those depicting a specific likeness, entered the vocabulary of painters in India via the Mughal court atelier.

Other categories of subject seen in the Bellak Collection include adaptations of European models introduced into the Mughal and Rajput courts, such as the evangelist (cat. 15) or the Madonna and Child (cat. 64), derived from imported prints or paintings, and the flower (cat. 41), adapted from European botanical images. Finally, there is a single example of a sacred text with no images (cat. 5), where the beauty of the writing itself forms the substance; and of a Jain painting on cloth (cat. 2) that, in a single work, tells a complete sacred story and itself fulfills an iconic function.

Materials and Techniques

Painting is an art form with roots reaching far back into the history of the Indian subcontinent. Unlike its more durable kin, sculpture and architecture, evidence for India's painting traditions prior to the fourteenth century is sparse, but surviving wall paintings and written descriptions demonstrate extensive use of the medium. Scholars believe that in ancient northern India texts were written on many different materials, including bark, cloth, and especially indigenous palm leaves. The long leaves of the talipot palm (*Corypha umbraculifera Linn*), imported from southern India, were used for the earliest illustrated manuscripts, which date to about A.D. 1000. The pages of Buddhist and Jain religious texts on palm leaf are written horizontally, with the text at times punctuated by small illustrations. The pages were bound between

wooden covers in a rudimentary fashion, with string threaded through holes in the leaves in a manner that allowed them to be turned horizontally. However, as palm leaves tended to become brittle with age and the paint to flake from their surface, they were not an ideal material for book pages.

In the thirteenth century, Islamic traders and invaders from West and Central Asia brought paper-making into northern India, and paper gradually replaced palm leaves in book production, although the horizontal format of palm-leaf books was retained in the earliest Indian manuscripts on paper (cats. 1, 3, 4). The first Islamic courts established in northern India, the Sultanates, not only imported vertically formatted paper manuscripts from West and Central Asia (such as cat. 5) that were sewn together and bound in leather, but began to produce their own. Soon paper was introduced into artists' workshops catering to Hindu patrons in northern India as well (cats. 7, 8), which gave them the flexibility to break away from the palm-leaf configuration and gradually create pages that were larger in size and in either horizontal or vertical format. But rather than turn to the sewn bindings of West and Central Asia, painters for the Hindu courts stacked unattached pages, keeping them together in cloth wrappers or between stiff cardboard covers.

Opaque watercolor paints were used for both text illustrations and individual paintings. The paints were composed of ground pigments mixed with a binder, usually a plant gum such as gum arabic from the acacia tree. The pigments could be derived either from organic sources, such as plants and insects, or from mineral or metallic substances. Pigments commonly encountered in Indian paintings include brilliant Indian yellow, which is extracted from the urine of cows fed exclusively on mango leaves; white lead and lampblack, both of which have been made since antiquity; copper-green pigments, such as verdigris, which result from the corrosion of copper; and greens that are produced by mixtures of yellow and blue. Common blues include indigo dye, obtained from the plant of that name, and ultramarine, derived from the semiprecious stone lapis lazuli. Red pigments used traditionally by Indian painters were vermilion (mercuric sulfide) and red lead, both manufactured

since early times, and lac dye, derived from a resin secreted by the lac insect (*Laccifer lacca*) onto host trees indigenous to India.

The artist, as often represented in Indian paintings, worked sitting on the floor, holding his painting against a board on his lap, surrounded by clamshells containing colored paints, fine squirrel-hair brushes, and pens fashioned from hollow reeds. Artists functioned within workshops adhering to regional traditions but following the same basic steps in the process of making a painting.

The artist first may have made a sketch that served as a model for a more complete drawing; at times this sketch would then be kept as part of a reference collection for use by all the artists in a given workshop. The sketch may have been transferred onto the paper to be used for the final painting by pouncing—pricking pinholes along the outlines and patting charcoal dust over the surface—or it may have merely served as a guideline for the freehand underdrawing done on the painting paper in charcoal or ink, on which the artist sometimes noted the names of the colors to be applied to each area as instructions to co-workers or apprentices. A thin veil of white or tinted color was then applied to serve as a priming layer and allow the drawing to show through faintly. Finally, the artist made a more developed line drawing on top of this ground in red or black ink, incorporating any corrections and changes. At this point the paper was often burnished by being placed face down on a smooth stone slab and rubbed on the back with a polished stone, such as an agate.

Once the drawing was complete, color was applied following the tradition of the particular workshop. The artist might start with the background, first laying down broad planes of color and then modeling finer elements. When the background was fully realized, he would complete the picture by delicately detailing the human figures. To bind the many layers of paint together and create the smooth surface that is characteristic of Indian paintings, the artist again rubbed the back of the sheet with a polished stone.

Toward the end of the process, metallic pigments or leaf were applied and also burnished to a high luster. As a final step, to accentuate the smooth surface of the paint and metal, the artist applied such textured details as the tiny raised daubs of white paint that often make up the beaded necklaces; pinpoint punched or incised line ornamentation in metallic surfaces (see cat. 85); and jewel-like beetle-wing cases (see cats. 23–25).

Knowledge about painters' materials and techniques comes not only from surviving works—including copious preparatory sketches and unfinished paintings—but also from the tradition as it survives and has been revived in northern India and Pakistan today. Finally, however, understanding the nature of materials and techniques, as of style and story, only aids the viewer in appreciating these visually delicious works of art. As will become clear in the following pages, it is only with keen and sensitive eyes that one can come to know their delicacy, power, and passion.

On Collecting Indian Miniature Paintings: Twentieth-Century Issues and Personalities

Terence McInerney

When Ernest Binfield Havell (1861–1934) began to assemble a collection of Indian miniature paintings for the Calcutta Art Gallery in 1896, he did not realize that he was laying the foundation for a new branch of art history. Nor did he realize that he was initiating a modern tradition of collecting that would take root in India, spread to London, Paris, and New York, and bear fruit in Philadelphia in the year 2001. Havell, a dogged contrarian and the first great champion of Indian art, formed a collection only to "show that in some branches of fine Art the Moghul artists reached a much higher degree of perfection than is generally supposed."[1] These words refer to three paintings by Mansur (active 1590–1625), the greatest of Mughal natural history painters, which Havell acquired in 1897.[2] In concentrating on selected masterpieces like these, Havell hoped to build a collection of unquestionable importance, an inspiring repository of craft and style, that would challenge the deep-rooted prejudice of his day.

In the half-century before 1896, Indian miniature paintings were collected for their antiquarian or ethnographic interest. They were thought to have very little artistic or material value, and almost nothing was known of their history or provenance. Sir George Birdwood, the doyen of Indian art studies, spoke for Victorian taste when he declared, in 1879, that "painting and sculpture as fine arts did not exist in India."[3] Needless to say, this limited and condescending point of view inhibited collecting and scholarship during Birdwood's time. Havell's focus, in his own words, on strictly "artistic principles," represented a significant turning point, marking a shift in taste and attitude.[4] His insistence that Indian painting was worthy of study provoked widespread skepticism in official circles but found immediate acceptance in the small group of Havell's like-minded friends.

Havell's most important protégé was Abanindranath Tagore (1871–1951), the father of the first nationalistic art movement in India, known as the Bengal School, and the scion of an aristocratic and influential Calcutta family. (Abanindranath's uncle was the famous poet and the 1913 Nobel Laureate of Literature, Rabindranath Tagore.) Under Havell's guidance Abanindranath began to form a collection in 1897.[5] Through Tagore, Ananda Kentish Coomara–swamy (1877–1947; see fig. 1), the renowned historian of Indian art, gained an awareness of Indian miniatures. On a trip to India in 1909, he stayed at Jorasanko, the Tagore family mansion in northern Calcutta. After studying the collections of Havell, Abanindranath, and his brother Gaganendranath Tagore, Coomaraswamy acquired a new understanding of the subject and decided to assemble an even larger collection of his own. With this idea in mind, and with "the prophet's mantle resting securely on his shoulders,"[6] he embarked on a number of ambitious buying trips in the years 1910–12. Scouring the bazaars and curio shops of northern India, Coomaraswamy collected, in the words of the scholar Ordhendra C. Gangoly, "an enormous quantity of the finest specimens of Indian Paintings and Drawings, and other masterpieces which presented Indian Art in hitherto unknown phases and expressions."[7] This great collection yielded the source material and ideas that launched Coomaraswamy's later career as an art historian. It also provided most of the illustrations for his book *Rajput Painting* (1916), which became a landmark in Indian painting scholarship.[8] But it is doubtful whether Coomaraswamy could have written this book if Havell had not prepared the ground for a new appreciation, twenty years before.

Havell arrived in Calcutta, the largest and wealthiest city in India, and capital of the British Raj, to take charge of the Government School of Art, where he served as principal until 1906. Founded in 1854, the Government School embodied a British establishment ideal of art. It also propagated a system of instruction that Havell loathed. He quite rightly believed that the official encouragement of oil painting, life drawing, linear perspective, and the other devices of Western-style academic instruction had created a taste in India for the type of anecdotal naturalism that was admired, by 1896, only in the most hidebound circles in Europe. From the 1850s, the Indian elite had been taught to worship at the altar of Victorian naturalism. In the process, they had lost all appreciation and understanding of the radically different aesthetics and methods of instruction of their own tradition. Raja Ravi Varma (1848–1906), the leading practitioner of the naturalistic, Euro-Indian school of oil painting, and the darling of the maharajas and magnates of his day, reached the peak of his

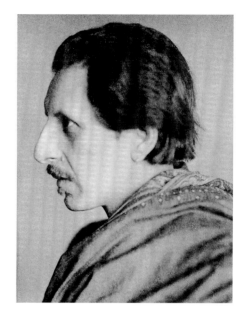

FIGURE 1
Ananda Kentish Coomaraswamy: The approximately 900 Indian paintings and drawings acquired by this venerable historian of Indian art in 1910–12 form the cornerstone of the notable collection at the Museum of Fine Arts, Boston.

influence during Havell's ten-year stay in Calcutta (1896–1906).

Immediately after arriving, Havell embarked on the campaign of artistic reform and polemical agitation that was to make him famous. As a first step in a planned overhaul of the Government School of Art curriculum, he abolished the practice of drawing from Greco-Roman plaster casts so that Indian art would be the basis of teaching. He also set his sights on the "very mediocre and miscellaneous collection of European pictures" in the Calcutta Art Gallery, the teaching museum that was attached to the Government School of Art.[9] As director of the Art Gallery and principal of the School of Art, Havell saw that his joint institutions suffered from a common, Westernizing defect. He would sell the collection of European paintings to finance a collection of Indian paintings, and make Indian art the teaching focus of his museum. From 1896, this policy of sale and purchase fueled the growth of Havell's great collection.

The collection was never published in its entirety; nor has it survived intact. Prior to 1905, on the insistence of Lord Curzon, viceroy of India, a number of the finest paintings were sent to the Victoria Memorial Hall, a neo-Baroque museum and monument to the queen-empress in Calcutta, where they exist today, buried in the museum's rarely displayed collection of historical material. Sometime between 1909 and 1924, the remaining works were sent to the Indian Museum, the leading art museum in Calcutta, where they were added to an already existing, yet spotty, collection of Indian paintings. Prior to this move, however, Havell published some twenty examples from this second group in his book *Indian Sculpture and Painting* (1908). And from these one can form an impression of the range and quality of the original collection.[10]

It should come as no surprise that Havell's collection was strong in Mughal painting. The Mughal dynasty (1525–1858) was in control of most of India when the British first arrived as traders in 1608. And the heartland of the old Mughal empire—the Panjab, Doab, Bengal, and the Gangetic Plains—was the region of India the British knew best. Between the Battle of Plassey in 1757, and the Indian Mutiny (or War of Independence) of 1857–58, the various Mughal dynasties had toppled, one after the next: Murshidabad

in 1765, Lucknow in 1856, and Delhi in 1858. Their ancestral territories were absorbed into the expanding British Empire; and the great painting collections their former ruling families had either inherited or assembled were looted, burned, or sold.

A fair amount of the material that was not destroyed made its way to Britain, explaining the present wealth of Mughal and Mughal-style painting (sixteenth–nineteenth century) in British collections. It arrived in two great waves. In the pre-Birdwood period, it followed in the lee of bibliophilic collectors such as Richard Johnson, a cultivated *amateur* of Indian literature, history, and language, who lived in India between 1770 and 1790. Johnson's important collection of Mughal albums and illustrated manuscripts forms the cornerstone of the India Office Library's impressive holdings in this field.[11] A substantial portion of the Indian material in other British public and private collections has a similar late eighteenth-century, bibliophilic provenance.

With the hardening of British cultural attitudes in the 1830s and 1840s, the movement of Mughal paintings from India to Britain diminished. Sir Caspar Purdon Clarke, Keeper of the Indian collection at the South Kensington Museum in London (later the Victoria and Albert Museum), acquired important items on a buying trip to India in 1881–82.[12] But the second great wave really begins with Havell, and the dramatic change in appreciation that he set into motion in 1896–1906.

Havell's knowledge of Mughal painting was extremely limited. From the inscriptions that appeared on a number of his pictures, and from the histories of the Mughal emperors that were available to him in English, Havell was able to label the elegantly refined, early seventeenth-century Mughal album paintings that he admired above all. (His interest in this material anticipates the taste of his aesthetic descendant, Sir Alfred Chester Beatty, whom we shall discuss in due course.) But Havell had no comparable knowledge of the non-Mughal painting that he also collected. He thought one of his most inspired purchases—the ethereal *Villagers Around a Fire* (c. 1765–75) by Nainsukh, the brilliant painter of the Panjab Hills[13]—was a modern work. It was painted, according to Havell, by an anonymous, contemporary craftsman of northern India, who "but

for the prevailing ignorance of art and the generally vitiated taste of the 'educated' classes in [British] India, would be honoured as artists of distinction were under [earlier] Hindu and Mogul rule."[14] But Havell's sensitive eye and focus on "purely artistic principles" allowed him to select works of uncommon distinction, regardless of type. Though handicapped by the rudimentary or nonexistent knowledge of his day, he triumphed as a collector in the final result, and built an extremely important collection of Indian paintings.

Havell's principal disciple as a collector, Abanindranath Tagore, was India's leading contemporary artist in the years 1900–1940. Just as Raja Ravi Varma had represented an earlier period of optimistic Westernization in the arts (1850–1900), so Abanindranath Tagore represented its counterpoint, a succeeding period of cultural nationalism that was epitomized by the *swadeshi* (indigenous) style of the Bengal School artists.[15]

By the year 1906, when Havell suffered a nervous breakdown and returned to England, the tiny initiative in collecting that he had started was catching fire, fueled by the volatile cultural politics of the period. The British government's unwise 1905 partition of Bengal, the birthplace of an emerging national identity, had resulted in the first widespread political unrest in India. Among the *bhadralok* (gentlefolk) of Calcutta, *swaraj* (self-rule) and *swadeshi*, or cultural autonomy, became the rallying cries of the day. In the elite circles to which the Tagores and Coomaraswamy (in the years 1909–12) belonged, collecting Indian paintings was not only an aesthetic diversion, it was also "politically correct." Sympathetic British visitors of liberal persuasion were not immune to the attractive atmosphere and scintillating ideas that were filling the drawing rooms of their like-minded Calcutta friends. After meeting Havell and Coomaraswamy in London in 1909, and Abanindranath Tagore and Coomaraswamy in Calcutta in 1910, Sir William Rothenstein, a leading painter in England at the time and later principal of the Royal College of Art, began to form an important Indian collection of his own.[16]

Abanindranath described the transforming moment when Havell urged him to examine one of the great paintings by Mansur that Havell had

acquired in 1897: "My word! As if a live crane was in front of me. What incredible detail . . . in the wrinkled skin of the legs and the tiny feathers sticking to its sharp claws I then noticed Havell standing silently behind me with a pleased expression, as if he had anticipated my reaction. I felt dizzy."[17]

Abanindranath admired the rigorously severe, early seventeenth-century Mughal miniatures that Havell valued. But he acquired a different kind of Indian painting, preferring the pretty, late eighteenth- and early nineteenth-century Kangra miniatures that have always been the first love of the public at large (for examples, see cats. 81–87). These paintings employ, in the words of one of their great champions, W. G. Archer, "a flowing, rhythmical line to convey the nobility of love."[18] This same line, soft color, and mood of romantic or melancholic indolence also define the essence of Abanindranath's personal style as an artist. In fact one of his greatest watercolors, and the unofficial emblem of the *swadeshi* movement—*Bharat Mata (Mother India)* of c. 1906—is for all intents and purposes a latter-day Kangra miniature.[19]

Abanindranath's large collection had more variety than a description of its strength in Kangra pictures suggests. He also acquired a small number of superb Mughal paintings dating from the reign of Muhammad Shah (1719–48), and a group of equally dazzling, pre-Kangra miniatures from the Panjab Hills.[20] These Basohli-style, or pre-Kangra, miniatures represented the type of streamlined, brilliantly colored, and abstractly simplified painting that Coomaraswamy had discovered on his buying trips in northern India, and was popularizing in Calcutta after 1910 (see cats. 23–26).

With Coomaraswamy, Indian painting scholarship came of age, shedding its previous, Havell-period innocence. His great achievement, in *Rajput Painting* of 1916, was to recognize and bring to light the so-called Rajput tradition of Indian painting: the painting of the Hindu courts of Rajasthan and the Panjab Hills. (Rajput painting comprises the greater part of the present exhibition; see cats. 18–39, 44–77, 79–90). The Rajput and Mughal traditions were the nourishing streams, and polar stars, of Indian painting history. It seems unbelievable now that Rajput paintings could ever have been unknown in the West, or for-

gotten in India, particularly at a time when its final, late nineteenth-century production was still being made (see cats. 88–90). It shows the degree to which appreciation and knowledge of Indian high culture had fallen that it required a Coomaraswamy, in the years 1910–16, to rediscover this centuries-old tradition for the modern world.

To characterize the nature of the material that he had "discovered," Coomaraswamy exaggerated the differences between Rajput and Mughal painting. According to Coomaraswamy, Rajput painting was religious (Hindu), anonymous, iconic, and poetic. Mughal painting was secular (Muslim), worldly, naturalistic, and factual. Rajput painting represented a continuation of the most ancient traditions of Indian art. Mughal painting represented an interlude, "an admittedly brilliant departure from the norm that lasted little more than a century, from the reign of Akbar (1556–1605) through the reign of Shāh Jahān (1628–57)."[21] This sharp distinction has been modified by later scholars, and we now see Rajput and Mughal painting not as two opposing states on a map, but as two historical tendencies that separated, interacted, and blended over distance and time. "Working as a pioneer in this field, Coomaraswamy to some degree shaped his description of Rajput painting according to his own [Neoplatonic] ideals, but his accomplishment in establishing a field of study, laying out its main lines, and gathering many of its masterpieces, far outweighs his errors."[22]

One can follow the development of Coomaraswamy's expanding knowledge and the trajectory of his rising ambition in comparing the title and content of two of his early studies: *Indian Drawings* of 1910, and *Indian Drawings: Second Series, Chiefly Rājput*, of 1912.[23] Both of these publications were prepared for the India Society, a support group for Indian art that Havell, Rothenstein, and Coomaraswamy had established in London in 1910. In the introduction to his 1912 study, Coomaraswamy writes:

When preparing the book on Indian Drawings, issued to members of the India Society in 1910, I remarked that the subject was not at all exhausted The majority of drawings reproduced were Mughal, and Mughal and Rajput works were not sharply differentiated.

Since then I have had further opportunity of study in India, and many thousands of Indian drawings and pictures . . . have been in my hands. The result has been to show how large is the mass of material still existing in India, and to establish the relative importance of the indigenous schools in Rājputāna and the Panjāb Himālayas.[24]

Of the 41 items that Coomaraswamy published in his 1910 study, 13 belonged to the author. Of the 37 items that Coomaraswamy published in his 1912 study, all but one belonged to the author. Of the 105 items that Coomaraswamy published in *Rajput Painting* (1916), 81 belonged to the author.

Coomaraswamy used part of the considerable fortune he had inherited in 1905 or 1906 to finance the art purchases that he made in India.[25] For the kind of painting or drawing he was collecting, he would have paid very small prices in the primitive market that existed at that time. By 1912, when he left India to return to his house in the English countryside, Coomaraswamy had amassed a collection totaling well over one thousand items. In a 1913 letter to one of his principal suppliers, Radha Kishan Bharany (c. 1877–1942), a painting and curio dealer in Amritsar, Coomaraswamy states that he spent 4,000–5,000 rupees at Bharany's establishment in the previous years.[26] If, at a reasonable guess, this sum represented 10 percent of Coomaraswamy's total Indian purchases, then the cost of his collection can be estimated at 40,000–50,000 rupees, which is roughly equivalent to $150,000–$200,000 today.

This was a significant sum for a youngish, though wealthy, art historian to invest at the beginning of his career. On a 1916 tour of the United States, Coomaraswamy let his acquaintances know that his great collection—part of which had been only recently published in *Rajput Painting*—was now available for sale.[27] Denman W. Ross, a teacher of art and design at Harvard, and an early patron of Asian art at the Museum of Fine Arts, Boston, rose to the bait. A deal was struck in 1917, and Coomaraswamy and his collection (albeit only a part of it) were acquired for the museum. This bold transaction created the first important collection and curatorship of Indian art at an American museum.

The museum's part of Coomaraswamy's collection, financed by Ross, totaled about nine hundred items.[28] It consisted mostly of Rajput painting and drawings, but also included a fair number of Mughal and early Jain works.[29] (Coomaraswamy retained several hundred items for himself. In the 1920s and 1930s he dipped into this private reserve to supply a small circle of private collectors and a larger circle of American museums, including those in New York, Brooklyn, Washington, Chicago, and Cleveland.)[30] Coomaraswamy remained at the Museum of Fine Arts, Boston, from 1917 until his death in 1947. And with his arrival, Indian painting began its eventful career in the United States.

Coomaraswamy's departure from India left a void other collectors and scholars soon filled. Rai Krishnadasa (1892–1980; see fig. 2), a brilliant Indian painting connoisseur, had the career in India that Coomaraswamy might have had, but chose not to pursue. Krishnadasa wanted to create an important collection of his own after seeing the pioneering exhibition that Coomaraswamy had organized in Allahabad in the winter of 1910–11. After 1920, Krishnadasa did not acquire paintings for himself, but for the Bharatiya Lalit Kala Parishad (later the Bharat Kala Bhavan), the museum of Indian art that he founded in Banaras (Varanasi). After 1950, the Bharat Kala Bhavan became an integral part of Banaras Hindu University, where it was installed in a specially designed museum. Together with the National Museum in New Delhi and the Prince of Wales Museum in Bombay (Mumbai), it possesses one of the largest and most comprehensive collections of Indian paintings in the world. Building this great collection was Krishnadasa's life achievement. Having exhausted his own resources to establish its foundations, Krishnadasa depended on the support of others to complete its walls and roof. The repertoire of inspired tricks and devious strategies that "Rai Sahib" invented, to soften his enthusiastic yet often tight-fisted benefactors, and his untutored yet often crafty suppliers, is a source of art-collecting legend in India even today.

Rai Krishnadasa's collection has an item-by-item distinction that Coomaraswamy's collection lacks. Coomaraswamy was not really interested in works of art in themselves, but in the ideas they represented.

His buying trips of 1910–12 yielded an enormous archive of images. But his exposure to the rough-and-tumble of the market was limited to a two- or three-year period in his life.[31] Of the nine hundred items in the Ross-Coomaraswamy Collection now in Boston, perhaps 10–20 percent would be rated exceptional when judged by the slowly acquired, yet unforgiving, standards of today. Rai Krishnadasa allowed his instinct for quality to develop over a much longer stretch of time. During the fifty- or sixty-year period that he was active in the market, Krishnadasa did not always get what he wanted, but what he got was usually very, very good.

From 1917, Krishnadasa influenced a small, ever-widening circle of Indian-born collectors. P. C. Manuk, a high court judge in Patna, Nanalal Chamanlal Mehta, an officer in the Indian Civil Service, and Gopi Krishna Kanoria, a wealthy businessman in Patna and Calcutta, were three important members of Krishnadasa's early circle.[32] Mehta, like many early collectors, became a part-time expert in Indian painting. His *Studies in Indian Painting* (1926) explores, among other topics, several that Coomaraswamy had pioneered in *Rajput Painting* (1916).[33]

As collectors, these early enthusiasts shared a period taste for amplitude and number. Manuk's collection was typical: it included almost four hundred items by 1913, and fourteen hundred items by 1946, the year of his death.[34] These men were buying mostly Rajput paintings at a time when price was not a serious obstacle. In the 1920s and 1930s, a good example might be had for 50 rupees, which is roughly equivalent to $150 or $200 today. When confronted by the trunkful of miniatures that Radha Kishan Bharany was offering on his increasingly frequent selling trips, price was no impediment. In a period when knowledge and standards were still vague, other factors came into play. According to Rai Krishnadasa's explanation of traditional *rasa,* or aesthetic, theory, if a painting did not access or unleash a durable emotion in his heart, the collector should leave it alone. As a standard of selection, this advice was rudimentary and unchallenging. But it established the foundation for an increasingly sophisticated understanding in the post-independence (1947) years.

The small circle of collectors in Bombay stood apart. They were almost exclusively Parsis, that is, they

belonged to the small community of Zoroastrians that dominated Bombay's industrial, commercial, and cultural elite. As the Parsis had thrived under British rule, they were less susceptible to the outpouring of nationalistic fervor that Mohandas Gandhi and the India National Congress were unleashing from 1921. Perhaps for this reason their collections had more variety and avoided the obligatory focus on Rajput painting—with its emotional appeal to Hindu nationalism—that was typical of the Rai Krishnadasa circle (but not of Rai Krishnadasa himself).

Karl Khandalavala (1904–1995; see fig. 3), a leading barrister (and the later *éminence grise* of Indian art); Ardeshir C. Ardeshir, the chairman of the Royal Western India Turf Club; and F. D. Wadia, Khandalavala's brother-in-law, were distinguished collectors and very close friends.[35] In the years 1935–60 they would meet every week to exchange gossip and discuss purchases, prices, and trends. Ardeshir insisted that the extremely refined, sixteenth- and seventeenth-century Mughal miniatures that he collected were the only things to have. Khandalavala and Wadia made similar claims for the Rajput paintings they were buying.[36] Sir Cowasji Jehangir, a common acquaintance, straddled the divide. In assembling a large and very important collection of his own, he gave equal attention to the Rajputs and Mughals.[37] For these cosmopolitan yet studious Bombay connoisseurs, art collecting was a serious endeavor. At a time when art historical information was limited, they taught one another.

Indian Painting Collectors in the West

Studious is not the first adjective that leaps to mind when thinking of early Indian painting collectors in the West. From 1900 to 1950, they were interested mostly in an elite class of Mughal and Deccani painting. (Deccani painting is the art of the Muslim courts of South India; see cats. 40–43.) At the time these paintings were loosely referred to as "Indo-Persian," a label invented by dealers to enhance their value. The label implied that these "pictures were Indianised Persian paintings, desirable for their approximation to the art of Persian miniature painting," which sold for several times the price.[38] Rajput paintings did not appear in the Western market until the 1920s

and 1930s. To the average Western collector of the day, they were incomprehensibly strange, and discouragingly cheap. In 1924–27 the great Parsi dealer from Bombay, Nasli Heeramaneck (1902–1971), had tried to sell Rajput paintings in Paris, with a notable lack of result. In 1928 he resettled in New York, where local attitudes were marginally more receptive. In the 1930s he had some success in selling Rajput paintings to the American museums: Coomaraswamy had already planted the seed. But real interest developed only much later, in the late 1950s and 1960s.

In the early decades of the twentieth century the market for Mughal painting in London and Paris occupied one small corner of a glittering bazaar. Centered near Bond Street and the rue du Faubourg–St. Honoré, respectively, it was dealer-driven, competitive, expensive, and snobbish. The only link between it and the curio shop reality of the Indian art market at this time was Imre Schwaiger (1869–1940), a dealer of Hungarian origin, who kept one foot in both worlds. Schwaiger had settled in India to sell race horses for an English firm, but turned to art dealing in the 1890s.[39] He specialized in great works of Mughal art. In his introduction to *Indian Sculpture and Painting* (1908), Havell thanks Schwaiger for providing a number of the greatest Mughal paintings that were acquired by the Calcutta Art Gallery.[40] Schwaiger was obviously a very smooth operator. When the 1911 *darbar*, or imperial assembly, was held in Delhi, the king-emperor and Queen Mary paid him a visit. (Passing the king-emperor's vetting committee was in itself an accomplishment.) Schwaiger asked them to sign one of his Mughal paintings, which they did: clearly, India was too small a world to hold a man like this![41] From about 1910, Schwaiger established premises in London (in Bond Street), dividing his time between India and England. In the years 1910–30, when Schwaiger was shuttling between Delhi and London, the second great wave of Mughal painting began to reach British shores.

The Mughal paintings that were arriving in Paris from about 1900 had a different source. They came from Persia, or from Russia via Persia. Following the 1739 sack of Delhi by the Persian king Nadir Shah, an enormous quantity of Mughal paintings and illustrated manuscripts had been removed from the Mughal imperial library and carried to Persia. This

material remained in Persian royal or noble collections until the late nineteenth century, when the disintegration of the Qajar dynasty (1779–1924) and a new taste for Islamic art in Europe pried it loose. Persian and Mughal album paintings and manuscripts were acquired from the crumbling palaces of the East and transported to Paris, which was then the center of the international art market. In Paris this material was quickly redistributed by a network of closely allied, but squabbling dealers: Georges Demotte, Charles Vignier, Léonce Rosenberg, Georges Tabbagh, and Reza Khan Monif. Of these, Demotte was clearly the most important, and the most skilled in the backroom, manuscript- and album-splitting science of the day. If an illustrated manuscript could not be sold intact, it would be scavenged for its illustrations, to supply the free-floating "miniatures" that collectors preferred. Seymour de Ricci, who catalogued Rosenberg's collection, summarized the attitude of his friends "succinctly if not crudely": "In the first place one cannot properly look at a miniature unless it is detached For almost all collectors the text is unimportant, only the miniatures count. Are there not enough calligraphied examples of the *Shahnama* and al-Hariri's *Séances [Maqamat]* in the world?"[42]

Those encouraging or abetting this practice included a small, yet dedicated circle of early collectors: Henri Vever, Victor Goloubew, Georges Marteau, Jean Pozzi, and Baron Maurice de Rothschild.[43] All of these men were attracted to the posh, late sixteenth- and seventeenth-century Mughal miniatures that Havell had admired. In 1910 Vever paid approximately 4,000 francs each for the seven illustrated folios from the so-called Late Shah Jahan Album (c. 1650) that he bought from Demotte.[44] This sum, which equals roughly $15,000 per page today, is modest by present-day standards. But it dwarfs by a factor of one hundred the prices that Coomaraswamy was paying for his Rajput miniatures at the same time.

Sir Alfred Chester Beatty (1875–1968; see fig. 4), possibly the most important of the early twentieth-century Western collectors of Indian painting, lived not in Paris, but in London, where he resettled in 1913. An American of Irish descent, Beatty became known as the World Copper King, following the success of his company, Selection Trust Limited, in

Northern Rhodesia (Zambia).[45] From 1914 he began to assemble a large and very important collection of European, Islamic, and Indian manuscripts and miniatures. His collection of seventeenth-century Mughal album paintings equaled in quality, and exceeded in number, those acquired by Maurice de Rothschild, his only real rival at the time. Beatty also acquired the complete (or notionally complete) illustrated Mughal manuscripts that Rothschild was less keen to collect. Beatty remained active as a buyer until the Great Crash of 1929 unsettled his fortune, and initiated a severe depression in the art market that lasted for thirty years. (The price trend that Beatty had helped to provoke culminated in a 1929 Sotheby's auction in London, when the great Kevorkian Album of fifty Mughal folios, dated to c. 1658—now mostly in the Metropolitan Museum of Art—was sold for £10,500, or roughly $400,000 today. The purchaser was Hagop Kevorkian, a dealer and collector from New York; Beatty was the underbidder).[46] After 1950, Beatty's spirits and finances improved, and he began to acquire the collection of Rajput painting, mostly of mediocre quality, but including several masterpieces, that signaled a surprising new shift in his taste. (This development probably had nothing to do with his move to Ireland the same year.) Beatty's great library, a gift to the Irish nation, is now installed in specially designed galleries in Dublin Castle.[47]

While Beatty was assembling his world-class library, the British attitude toward Indian painting, as represented by the exhibition and acquisition policies of the great London museums, underwent a profound change. Battered by the polemical attacks of Havell, Coomaraswamy, Rothenstein, and the critic Roger Fry, the old Birdwood wall of contempt had collapsed. Men like Laurence Binyon, an expert in Asian painting and the first Keeper of Oriental Antiquities at the British Museum, began to treat Indian painting with the respect that it had not previously received. In 1913 Ganeshi Lall, an enterprising early dealer from Agra, sold the British Museum one of its greatest Mughal treasures—the *Princes of the House of Timur*—a rare painting on cloth dating from c. 1550–55.[48] The museum and library continued to make notable Mughal acquisitions in the following years.

The old India Museum in South Kensington (later the Indian Department of the Victoria and Albert Museum)—previously a museum of curiosities with the "busts of British conquerors and the spoils of the Indian wars . . . proudly displayed alongside art manufactures and natural products"—was also reorganized.[49] From 1918, the Museum's growing collection of Indian paintings was prominently and intelligently displayed. This was also an age of serious Mughal painting scholarship, producing a number of landmark, and still readable, studies: *The Court Painters of the Grand Moguls* (1921) by Laurence Binyon, *Indian Painting Under the Mughals* (1924) by Percy Brown (Havell's successor as principal at the Calcutta Art School), and *La Peinture indienne à l'époque des Grands Moghols* (1929) by Ivan Stchoukine, the leading Mughal painting scholar of the day.[50]

The advance in British museological understanding culminated in the giant Burlington House exhibition *The Art of India and Pakistan*, of 1947–48.[51] This greatest-ever exhibition of Indian art commemorated the birth of India and Pakistan as independent nations. The painting section, including an astonishing 615 exhibits, was selected by Basil Gray, a Keeper at the British Museum and the son-in-law of Laurence Binyon. In range, quality, and historical interest, Gray's selection set a standard that would be difficult to top even today.

The Post-Independence Years: India

On the eve of Indian independence (August 15, 1947), "two-fifths of the land area of the subcontinent, and 100 million of its 400 million inhabitants, were ruled by the princes—Maharajas, Nawabs, Rajas and so on In all, there were 562 princely states in India, ranging in size from Hyderabad and Kashmir, each of which was almost as big as mainland Britain, to mere dots on the map."[52]

Of the seventy most important princely states, half were located in Rajput India: Rajasthan, Central India, and the Panjab Hills. Their ancestral painting collections had survived the disintegration of the Mughal Empire as well as the change in taste that Raja Ravi Varma and the Euro-Indian school of oil painting had set into play. These nineteenth-century developments

were the death of Indian court painting as a living tradition. But the legacy that had accumulated from previous generations was not sold or destroyed: it survived in the moldering storerooms of royal palaces. As personal property of the royal families, this material had little or no value until the increasing interest in Rajput painting and the declining fortunes of the ruling families resulted in a new appraisal of its importance in the post-independence years.

A number of the smaller princely states had sold surplus or unwanted paintings in the years 1900–1950. This material supplied the market, and source material, for Rajput painting that existed at that time. By the 1950s and 1960s, what had been an earlier stream became a river in spate, as paintings numbering in the tens of thousands entered the market, to the bewilderment of all. "Public and private collections both in India and abroad were remarkably successful in acquiring important examples, and these became the basis of scholarly researches of considerable importance. Slowly, painfully, and step by step, the great individual schools of Rājasthān [and the Panjab Hills] began to be isolated."[53] The great sell-off yielded not only amazing numbers of seventeenth- and eighteenth-century Rajput miniatures, but also rare examples of earlier periods (see cats. 7–9, 11, 12, 18–20). With the appearances of this material, and the surviving corpus of entire later Rajput schools, "our knowledge of Indian painting has improved so greatly over the years as to be almost unrecognizable from what it was in the opening years of this century."[54]

The years 1950–75 witnessed the dramatic enlargement and improvement of the painting collections at the great Indian museums. The National Museum in New Delhi was founded only in 1949. But with the advice of Karl Khandalavala and Rai Krishnadasa, it quickly made up for lost time, assembling an Indian painting collection of matchless size and distinction. During the 1950s and 1960s, the museum purchased whatever it wanted from the great supply of Rajput miniatures that was flooding the market. At the same time it acquired a number of the finest private collections in India, including those assembled by B. N. Treasuryvala, an early collector and dealer in Bombay; Samarendra Nath Gupta, a former student of Abanindranath Tagore; Jagmohandas Modi, the

owner of twenty-seven folios from the great Kangra-Guler *Bhagavata Purana* series of c. 1780–85; Eric Dickinson, an expert on Kishangarh painting; and Motichand Khajanchi, a collector of Rajasthani painting.[55] During the same period the Prince of Wales Museum in Bombay, under the directorship of Moti Chandra, a distinguished scholar of Indian painting, experienced a similar growth in acquisitions.

The greatest private collectors of the period were Marwari, that is, they belonged to the Calcutta-based Hindu community of industrialists who had come originally from Shekhawati in Rajasthan. It is estimated that the great Marwari families control 50 percent of India's industrial wealth even today. Of these collectors, Jagdish P. Goenka and Basant Kumar Birla assembled the largest and most important collections. Goenka's collection, begun in the 1930s under Rai Krishnadasa's direction, multiplied and remultiplied in the post-independence years. By the time he stopped collecting in the mid-1980s it numbered several thousand examples.[56]

Basant Kumar Birla, a scion of India's most famous industrial house, shared Goenka's catholicity of taste. Unlike the Hindu nationalists in Rai Krishna-dasa's early circle, these men collected Mughal and Deccani paintings, as well as Rajput and early Jain art. After 1950, Nanalal Chamanlal Mehta, one of the pioneering collectors mentioned earlier, joined the board of one of Birla's companies. He would visit Calcutta six or seven times a year, and stay in the Birlas' house:

During his visits, Ramkumar Kejriwal—a family friend of the Birlas and a noted collector of Indian art—would come over to meet his friend and fellow collector. These meetings invariably turned into spirited discussions on Indian art where ideas were exchanged. Frequently, noted dealers such as [Chunni Lal] Naulakha and the Bharany brothers [sons of Radha Kishan] were also present at these sessions. Though at first only observers at these gatherings, Basant Kumar and Saraladevi [Birla] became more and more interested in what was a passion with N. C. Mehta and Ramkumar Kejriwal. The advice of these connoisseurs began to have an

impact . . . [and gradually the Birlas] found their love for Indian art growing like a creeper that entwines a tree in its embrace.[57]

Part of the enormous collection this love entwined is now housed in the Birla Academy of Art and Culture, the public institution the Birlas established in Calcutta in 1962.[58]

The great Marwari collectors assembled collections with the same flair and market-dominating vision that inspired their industrial activities. But India also continued to produce collectors who represented an older, pre-independence, scholar-collector tradition. Kumar Sangram Singh of Nawalgarh, a Rajput and one-time curator at the City Palace Art Museum in Jaipur, assembled a comprehensive private collection of Rajasthani paintings in the years 1955–75. And in the same period, Jagdish Mittal, an artist and scholar of Indian painting in Hyderabad, assembled an equally comprehensive, pan-Indian collection focusing on works of the highest caliber.[59] But the days of art collecting in India were numbered. With the passing of the Antiquities and Art Treasures Registration Act of 1973, the history of twentieth-century painting collecting in India comes to an end. In a culture that is suspicious of the government's desire to tax, register, and control, the impulse that had inspired Abanindra-nath Tagore, seventy-six years before, was effectively destroyed.

One of the act's ancillary intentions was to discourage the flow of antiquities and art treasures, including historical Indian paintings, to the West. But by the time the act was promulgated in 1973, most of the paintings were already gone. What India was not able to absorb from the great sell-off of the 1950s and 1960s had already made its way to the West, where it has been traded and recycled from 1973 until the present day.

The Post-Independence Years: Europe and the United States

William George Archer (1907–1979; see fig. 5) represents the type of scholarly, encyclopedic approach to collecting that flourished in the West in the years 1950–75. Archer had earlier lived in India, where

FIGURE 4
Sir Alfred Chester Beatty: This Anglo-American mining magnate assembled the world-class library of Indian and Islamic manuscripts and paintings that is now installed in Dublin Castle.

FIGURE 5
William George Archer: A scholar and later Keeper of Indian art at the Victoria and Albert Museum, London, Archer found the inspiration for his life's main study in India, where he lived from 1931 to 1948.

he served as a district magistrate in the Indian Civil Service. On a posting to Patna in 1941, he met P. C. Manuk and Gopi Krishna Kanoria, two pioneering collectors from Rai Krishnadasa's early circle.[60] This experience changed his life, as he explained: "A new world had opened and guided by Manuk himself in my first fumbling efforts, I began to collect, and through collecting, to embark on my life's main study—the appreciation and history of Indian painting."[61] After returning to England in 1948, Archer took charge of the Indian department at the Victoria and Albert Museum. During his eighteen-year tenure (as Keeper in 1949–59 and Keeper Emeritus in 1959–67), the museum's collection of Rajput painting was dramatically enlarged. During the years 1941–79, Archer also formed a large and extremely important private collection of his own. He wanted to assemble a textbook array of Rajput paintings from the Panjab Hills, the branch of Indian painting he understood better than anyone.[62] Archer's tireless research and collecting resulted in the insights that are catalogued in his magnum opus: *Indian Paintings from the Punjab Hills* (1973).[63] Following an earlier study by Karl Khandalavala, *Pahārī Miniature Painting* (1958), Archer's great book helped launch the craze for Pahari, or Panjab Hills, painting that flourishes today.[64]

From about 1960, Archer exerted a direct influence on Edwin Binney, 3rd (1925–1986; see fig. 6), the flamboyant, yet scholarly, collector of private means whom he advised for many years. Binney represents the Americanization of a new, postwar generation of Indian painting collectors. From the late 1950s, as the market caught fire in the West, the action shifted from Europe to the United States. London remained an important entrepôt for Indian art, but the buyers, even in London, were increasingly American.

Binney eventually assembled a collection totaling more than fourteen hundred items.[65] On one occasion in the late 1970s, he showed the present writer a large chart. It was divided into small squares to represent the various schools of Indian painting, which were listed along one margin, and their divisions in time, which were listed along another. If the box labeled "Bundi, c. 1700–25," was marked with an X, then Binney had an example. If the box was

empty (and very few were), then a hole needed to be filled. As Binney always wanted the best examples possible, his collection grew to include many masterpieces. But his obsession with style and mania for completeness were the real driving forces. As a collector, Binney embodied the omnium-gatherum tendencies of his day.[66]

Unlike Binney, certain collectors of the period focused on subject matter, not style. Others wanted only the finest paintings from a list of critically approved series. (Rajput paintings were usually painted in large series that comprised dozens, or even hundreds, of folios. As in days gone by, these series were generally broken up to create the free-floating "miniatures" that collectors preferred.) In a period when Indian paintings existed in overabundance, and new styles were appearing every year, these various strategies all made sense: collectors were trying to chart a steady course through a challenging and fast-changing sea. Among the collectors who formed important Indian painting collections in the years 1950–75 were John Kenneth Galbraith, the American ambassador to India in 1961–63; James Ivory, the celebrated film director; Cynthia Hazen Polsky, a trustee at the Metropolitan Museum of Art in New York; Paul F. Walter, a trustee at the Museum of Modern Art in New York; George P. Bickford, a trustee at the Cleveland Museum of Art; John Gilmore Ford, a trustee at the Walters Art Museum in Baltimore; Ralph Benkaim, a lawyer and theatrical agent in Los Angeles; Prince Sadruddin Aga Khan, a collector of important Mughal and Deccani painting; and Jacqueline Kennedy Onassis, a collector of the Kangra miniatures that Abanindranath Tagore had also loved.[67]

A number of American museums also recognized the rich opportunities that existed at this time. In 1969 the great private collection formed by Nasli Heeramaneck, the leading Indian painting dealer of the period, was acquired by the Los Angeles County Museum of Art. Containing about one hundred paintings, the collection is notable for its spectacular Mughal and Rajput examples.[68] In 1971 the Cleveland Museum of Art also acquired the small, yet distinguished, collection of Mughal paintings that had been assembled by John Dolliver MacDonald.[69] These are only two examples of the type of impor-

tant acquisitions that were being made at this time.

The most influential American collector of the period, Stuart Cary Welch (born 1928), a former teacher and curator at Harvard, stands apart. "Through force of example as well as his numerous writings, Welch has done more than anyone in the last thirty years to inform taste and to open eyes to those few Indian paintings, of whatever school or period, whose exceptional (or occasionally bizarre) quality sets them above the common run."[70] A student of Eric Schroeder, Curator of Islamic art at the Fogg Art Museum at Harvard, Welch first gained recognition as a scholar and connoisseur of Persian and Mughal painting. In the 1960s and 1970s, he consolidated his reputation as an expert in all branches of Indian painting by organizing a series of five remarkable exhibitions at the Asia Society Gallery in New York.[71] When not writing catalogues or making exhibitions, Welch was training students who later became specialists in Indian painting: Milo Cleveland Beach, a leading expert on Mughal and Rajasthani painting, and the current Director of the Freer Gallery of Art and Arthur M. Sackler Gallery, Smithsonian Institution, in Washington; Mark Zebrowski, the late author of a pioneering book on Deccani painting; Glenn D. Lowry, an expert in Mughal painting and the current Director of the Museum of Modern Art; Michael Brand, another expert in Mughal painting and the current Director of the Virginia Museum of Fine Arts in Richmond; John Seyller, a contributor to the present catalogue; and myself.

But all of these endeavors pale in comparison to Welch's greatest achievement: the creation of what is arguably the finest private collection of Indian painting and drawing ever made. Containing many hundred examples, Welch's collection is particularly strong in Mughal and Deccani painting, Rajasthani painting, Company School painting (Indian painting made for the British), and Indian drawings and painted sketches of all periods and schools.[72]

Welch's 1973 exhibition at the Asia Society Gallery, *A Flower from Every Meadow,* was subtitled *Indian Paintings from American Collections.* As an overview of Indian painting history and collecting, the exhibition was remarkably original for its day. The Rajput material eschewed the conventional

manuscript illustrations that formed the bulk of most collections. Illustrations from the kind of *ragamala* (musical modes) and *nayaka-nayika* (phases of love, or literally "hero-heroine") series that were beloved by Rai Krishnadasa and other devotees of Hindi poetry were included. But they were shown in examples that had a visual personality that transcended the specific requirements of the text. The exhibition also included a sprinkling of the bazaar, or folk-style, paintings that most collectors shunned. To some disaffected collectors of the day, the exhibition constituted self-promotion (25 percent of the exhibits belonged to Welch) and was unsuccessful. But the public, rightfully, was enchanted.

During the years 1950–75, Howard Hodgkin (born 1932), the celebrated British contemporary painter, was one of Welch's few spiritual confreres as a collector of Indian painting. Their joint interest in material that expressed an individual, or even idiosyncratic, vision, rather than a corporate, or workshop, style, was regarded as highly unconventional at the time: Indian painting had been sentimentalized to the extent that it was thought to represent a timeless or "anonymous" art. But this focus on individual artists, whether named or unknown, has become part of the accepted orthodoxy that shapes Indian painting appreciation and collecting today.

Hodgkin bought his first Indian painting as a schoolboy in the late 1940s. According to his own testimony, his real turning point as a collector came only in "early 1958, over lunch at a popular Polish restaurant in South Kensington."[73] On that occasion, Robert Skelton, the rising authority on Indian painting at the Victoria and Albert Museum, introduced Hodgkin to Welch, whom Hodgkin described as "the Bernard Berenson of Indian art." As Hodgkin further recalled, "I remember going home . . . realizing I had found the kind of new friend that one makes very rarely in a lifetime, and I was filled with a renewed lust to buy pictures."[74] Their long, mutually influential, and sometimes rivalrous friendship has continued to the present day.

Hodgkin and Welch are collectors who have focused, famously, on "quality." But quality, as a rule of thumb, is a very slippery and subjective standard: one man's chalk is another man's cheese. What

they really share is an understanding and appreciation of drawing—the secret and ultimate test of distinction in an Indian picture. As Andrew Topsfield has written, "not many Indian artists ever had a faulty colour sense, at least until they discovered European pigments in the 19th century. But only a few masters at any period could draw at a level above the conventional. Drawing is the most immediate of the graphic arts; its marks expose the artist's integrity, without the dissimulation of paint."[75] One can have a great collection of Indian paintings without owning a single drawing. In an art form that is essentially graphic, line and color are creatures of the same brush.

When Alvin O. Bellak (born 1928), a senior partner at Hay Associates, a leading firm of management consultants in Philadelphia, bought his first Indian painting in 1975, an enormous accumulation of material—that is, a corpus comprising tens and even hundreds of thousands of Indian paintings—was beginning to make sense in a way that it had not before. Thanks to the tireless efforts of the collectors and scholars described in the preceding pages (not to mention others too numerous to list), the historical corpus had been inspected, labeled, and appraised. As interest began to focus on the one significant painting in a hundred, a connected understanding of the principal features on the map began to emerge.

In the years since 1975 those features have been subjected to a further test, as their peaks were measured and compared. The commanding heights of Indian painting have been isolated according to the understanding and taste of our day, and a canon, or agreed standard of importance, has now emerged. The winners have belonged to neither one tradition nor another: a Rajput masterpiece now enjoys the acclaim (and near price) that only a Mughal or Deccani masterpiece would have received twenty-five years ago. The real winners have been not regional traditions but individual painters, the one artist in a hundred who towers above the rest. The act of historical retrieval that Stuart Cary Welch and Robert Skelton initiated in the 1950s has continued to the present day, as new generations of scholars labor to isolate the style and career of the great Indian masters of form.

FIGURE 6
Edwin Binney, 3rd: A balletomane, authority on French literature, and art-collecting maven, Binney assembled one of the most comprehensive private holdings of Indian painting ever formed.

FIGURE 7
Stella Kramrisch: This curator, scholar, and high priestess of Indian art bequeathed her distinguished private collection to the Philadelphia Museum of Art in 1993.

Bellak represents the type of focused, quality-oriented collector that has flourished in the West since 1975. As prices rise and museums acquire ever larger holdings, the taste and need for the type of enormous collections that Manuk, Kanoria, Goenka, and Binney formed have probably become a thing of the past. Bellak's focus on Rajput painting is not atypical. A number of other great Rajput collections have been assembled in the last twenty-five years. (At the risk of forgetting someone, I won't attempt to mention even one.) If Bellak's collection—in range, quality, and variety—is not the greatest, there is probably not another to top it.

Bellak had Indian painting and collecting antecedents in Philadelphia. In the opening decades of the twentieth century, John Frederick Lewis (1860–1932), a bibliophile and philanthropist, assembled a large collection of Indian paintings in the Chester Beatty style and range. Now housed in the Free Library of Philadelphia, the collection is not strong in masterpieces, but it contains at least three Mughal paintings of peerless quality.[76] Stella Kramrisch (1896–1993; see fig. 7), Curator of Indian Art at the Philadelphia Museum of Art from 1954 until 1993, also formed an Indian painting collection totaling about one hundred examples.[77] Strong in study material, the collection also contains about twenty Rajput paintings of uncommon distinction. Her paintings form part of the great collection of Indian art that was bequeathed to the Philadelphia Museum at the time of Kramrisch's death.

It is doubtful, however, whether Lewis or Kramrisch, despite their obvious accomplishments, ever suffered from the high anxiety that troubled collectors like Bellak and Hodgkin. As Hodgkin once said: "At home there was a mantelpiece opposite my bed on which I would put Indian pictures side by side. I would lie in bed, propped up on pillows at a comfortable angle, looking from side to side, left to right and back again, for hours and hours. During the time when most people read books, I would just lie there thinking, 'Is this one better than that one? No it's not better than that one, take it away.'"[78] This high anxiety is the inescapable curse, and redeeming grace, of the ultimate collector.

1. Mitter 1994, p. 283.
2. Ibid. For the paintings, which are in the Indian Museum, Calcutta, see Havell 1908, plates LXI, LXII; and Asok Kumar Das, "Mansur," in *Master Artists of the Imperial Mughal Court,* ed. Pratapaditya Pal (Mumbai: Marg Publications, 1991), p. 49, fig. 13.
3. Mitter 1994, p. 32.
4. Havell 1908, p. 22.
5. Mitter 1994, p. 313.
6. Ibid., p. 260.
7. Quoted in Lipsey 1977, p. 87.
8. Ananda K. Coomaraswamy, *Rajput Painting,* 2 vols. (London: Humphrey Milford/Oxford University Press, 1916).
9. Havell 1908, p. 17.
10. See ibid., frontispiece, plates LII, LIV–LXXII.
11. See Falk and Archer 1981. For discussion of Richard Johnson, see ibid., pp. 14–29.
12. Among the miscellaneous items that Clarke purchased were twenty-four illustrations from the great *Hamzanama* manuscript of c. 1570. They "were purchased at Srinagar, Kashmir, in 1881, where they were . . . rescued from the lattice-windows of the humble curiosity-shop, over which they had been plastered by the vendor during the previous frosty season" (C. Stanley Clarke, *Indian Drawings: Twelve Mogul Paintings of the School of Humāyūn [Sixteenth Century] Illustrating the Romance of Amīr Hamzah,* Victoria and Albert Museum Portfolios [London: His Majesty's Stationery Office, 1921], p. 3).
13. Now in the Indian Museum, Calcutta, 250/628; see Havell 1908, plate LXVI; and Goswamy 1997, pp. 232–33, no. 91.
14. Havell 1908, p. 226.
15. Quoted in Mitter 1994, p. 9.
16. Rothenstein (1871–1945) would select from paintings that were sent to him by post from India. Strong in paintings from the Panjab Hills, his collection was acquired by the Victoria and Albert Museum in 1951.
17. Quoted in Mitter 1994, p. 284.
18. Archer 1976, p. x.
19. Now in the Rabindra Bharati Society, Calcutta; see Mitter 1994, pp. 295–96, plate XXI.
20. Abanindranath's collection was actually the joint collection that he formed with his brother and fellow artist, Gaganendranath Tagore. Sometime after Abanindranath's death in 1951, the Abanindranath-Gaganendranath Tagore Collection was acquired by Kasthurbai Lalbhai, a wealthy industrialist in Ahmedabad. For a book devoted to twenty-six highlights from the collection, see Karl Khandalavala, *Paintings of Bygone Years* (Mumbai: Vakils, Feffer & Simons Limited, 1991).
21. Lipsey 1977, p. 99.
22. Ibid., p. 101.
23. Ananda K. Coomaraswamy, *Indian Drawings* (London: India Society, 1910); and *Indian Drawings: Second Series, Chiefly Rājput* (London: India Society, 1912).
24. Coomaraswamy, *Drawings, Second Series,* p. 7.
25. Lipsey 1977, p. 42.
26. I am grateful to Mr. C. L. Bharany, the son of Radha Kishan Bharany, for providing me with a photocopy of this letter. Coomaraswamy states, "I have purchased Indian pictures and other curios from Radha Kishan Bharany on many occasions—to the total amount of four or five thousand rupees—during the last 7 years and have obtained many good things from him at reasonable prices." The letter is dated February 14, 1913.
27. Lipsey 1977, pp. 125–26.
28. Ibid., p. 96. The purchase price has never been revealed.
29. See Ananda K. Coomaraswamy, *Catalogue of the Indian Collections in the Museum of Fine Arts, Boston,* Pt. 4, *Jaina Paintings and Manuscripts* (Boston: Museum of Fine Arts, 1924); Pt. 5, *Rajput Painting* (Boston: Museum of Fine Arts, 1926); and Pt. 6, *Mughal Painting* (Boston: Museum of Fine Arts, 1930).
30. By the standard of the day, Coomaraswamy was charging high but not excessive prices.
31. In 1920–21 and 1924–25 Coomaraswamy made two additional buying trips to India, on behalf of the Museum of Fine Arts, Boston. But on these later trips he was searching mainly for sculpture, not painting.
32. After Manuk's death in 1946, his collection was divided between the British Museum, the Victoria and Albert Museum, and the Fitzwilliam Museum in Cambridge, where he had been an undergraduate. For the N. C. Mehta Collection, see Karl Khandalavala, *Pahari Miniature Painting in the N. C. Mehta Collection* (Ahmedabad: Gujarat Museum Society, n.d.); and Leela Shiveshwarkar, *The Pictures of the Chaurapañchāśikā: A Sanskrit Love Lyric* (New Delhi: National Museum, 1967).
33. Nanalal Chamanlal Mehta, *Studies in Indian Painting* (Mumbai: D. B. Taraporevala Sons & Co., 1926).
34. Goswamy 1997, p. 293 n. 8.
35. Karl Khandalavala was active as a collector only between the years 1937 and 1948. After 1948, he stopped buying for himself and became the principal art purchase advisor to the National Museum, New Delhi. After his death in 1995, Khandalavala's personal collection was bequeathed to the Prince of Wales Museum, Mumbai, where he was a longtime trustee. See Anuja Mahindra Sharma, "Karl Khandalavala Collection," *India Magazine,* vol. 9, no. 1 (December 1988), pp. 98–104; and Pratapaditya Pal, "The Khandalavala Collection: A Munificent Birthday Gift," *India Magazine,* vol. 12, no. 8 (July 1992), pp. 30–37. Most of the Ardeshir Collection was sold at auction in the early 1970s. See Sotheby's, London, July 11, 1972, lots 42–56; Sotheby's, London, July 10, 1973, lots 1–41.
36. I am grateful to Mrs. Ernie Dubash for information about her uncle, A. C. Ardeshir (c. 1885–1960), and his collector-friends.
37. Karl Khandalavala and Moti Chandra, *Miniatures and Sculptures from the Collection of the Late Sir Cowasji Jehangir, Bart.* (Mumbai: Prince of Wales Museum, 1965).
38. Falk 1976, p. 167.

39. I am grateful to Mr. Sultan Singh Backliwal for information about Schwaiger, the art-dealing partner of Backliwal's grandfather and father, Suraj Lal Backliwal (c. 1859–1934) and Manick Chand Backliwal (1894–1954), respectively, the former proprietors of Indian Arts Palace, New Delhi.

40. Havell 1908, p. viii.

41. For the Mughal painting signed by the king-emperor and Queen Mary, now in a private collection, see B. N. Goswamy and Eberhard Fischer, *Wonders of a Golden Age: Painting at the Court of the Great Mughals* (Zurich: Museum Rietberg, 1987), pp. 174–75, no. 85.

42. Quoted in Lowry 1988, p. 34.

43. The Vever Collection was acquired by the Arthur M. Sackler Gallery, Washington, D.C., in 1986. The Goloubew Collection was acquired by the Museum of Fine Arts, Boston, in 1914. The Marteau Collection was bequeathed to the Musée du Louvre, Paris, in 1916. The Pozzi Collection was sold at auction in Paris in 1970. The Rothschild Collection was dispersed in London in 1976. See Lowry 1988; Ananda K. Coomaraswamy, *Les Miniatures orientales de la collection Goloubew au Museum of Fine Arts de Boston*, Ars Asiatica, vol. 13 (Paris: G. van Oest, 1929); Ivan Stchoukine, *Les Miniatures indiennes: De L'Époque des Grands Moghols au Musée du Louvre* (Paris: Librairie Ernest Leroux, 1929); M. Rheims & Laurin, Paris, *Miniatures Moghules Indiennes—Turques et Arméniennes: Succession de M. Jean Pozzi* (December 5, 1970); and Falk 1976, pp. 167–200.

44. Lowry 1988, p. 230.

45. Brian P. Kennedy, *Alfred Chester Beatty and Ireland, 1950–1968* (Dublin: The Glendale Press, 1988), p. 32.

46. Stuart Cary Welch et al., *The Emperors' Album: Images of Mughal India* (New York: The Metropolitan Museum of Art, 1987), pp. 11–12.

47. For the Indian painting collection, see Leach 1995.

48. The British Museum paid 350 pounds for this painting (1913.2-8.01), which is roughly equivalent to $20,000 today. See Gerald Reitlinger, *The Economics of Taste: The Rise and Fall of the Objets d'Art Prices Since 1750* (New York: Holt, Rinehart and Winston, 1965), vol. 2, p. 535. For the painting itself, see Canby 1994, frontispiece.

49. Malcolm Baker and Brenda Richardson, eds., *A Grand Design: The Art of the Victoria and Albert Museum* (New York: Harry Abrams with the Baltimore Museum of Art, 1997), p. 223.

50. Laurence Binyon, *The Court Painters of the Grand Moguls* (London: Humphrey Milford/Oxford University Press, 1921); Percy Brown, *Indian Painting Under the Mughals, A.D. 1550 to A.D. 1750* (Oxford: Clarendon Press, 1924); Ivan Stchoukine, *La Peinture indienne à l'époque des Grand Moghols* (Paris: Librairie Ernest Leroux, 1929).

51. Leigh Ashton, ed., *The Art of India and Pakistan* (New York: Coward-McCann Inc., 1949).

52. Anthony Read and David Fisher, *The Proudest Day: India's Long Road to Independence* (New York: W. W. Norton & Company, 1998), p. 476.

53. Pramod Chandra, *On the Study of Indian Art* (Cambridge: Harvard University Press, 1983), p. 101.

54. Ibid., p. 85.

55. The National Museum acquired the twenty-seven Modi paintings in 1958 for 1,500 rupees per folio, which is roughly equivalent to $2,000 per folio today. See M. S. Randhawa, *Indian Paintings: Exploration, Research, and Publications* (Chandigarh: Government Museum and Art Gallery, 1986), p. 121. In the late 1990s several folios from the same series were offered on the London market for about fifty times this price. For the Khajanchi Collection, see Karl Khandalavala et al., *Miniature Painting: A Catalogue of the Exhibition of the Sri Motichand Khajanchi Collection* (New Delhi: Lalit Kala Akademi, 1960).

56. For a volume of highlights from the Goenka Collection, see Goswamy with Bhatia 1999.

57. Karl Khandalavala and Saryu Doshi, *A Collector's Dream: Indian Art in the Collections of Basant Kumar and Saraladevi Birla and the Birla Academy of Art and Culture* (Mumbai: Marg Publications, 1987), p. 7.

58. For a volume of highlights from the Birla Collection, see ibid.

59. The Jagdish and Kamala Mittal Museum of Indian Art, Hyderabad, was established as a public trust in the late 1970s. It is not yet housed in a building of its own.

60. William Archer and Mildred Archer, *India Served and Observed* (London: Putney, 1994), pp. 93, 95. Archer was married to Mildred Archer (born 1911), the leading expert on Company School painting. For their charming memoirs, see ibid.

61. Archer 1976, p. x.

62. For the Archer Collection, see ibid.; and Smithsonian Institution Traveling Exhibition Service, *Indian Miniatures from the Collection of Mildred and W. G. Archer, London* (Washington, D.C.: Smithsonian Institution, 1963–64).

63. See Archer 1973.

64. See Khandalavala 1958.

65. Over the twenty-eight-year period in which he was active as a buyer, Binney assembled a collection totaling 1,459 items, for a cost of $2,357,753. (I am grateful to Ellen Smart for this information.) The Binney Collection is now in the San Diego Museum of Art.

66. For part of the Binney Collection, see Portland 1968; and Edwin Binney, 3rd, *Indian Miniature Painting from the Collection of Edwin Binney, 3rd: The Mughal and Deccani Schools* (Portland, Ore.: Portland Art Museum, 1973). For a discussion of Binney, see Thomas W. Lentz, Jr., "Edwin Binney, 3rd," in *American Collectors of Asian Art*, ed. Pratapaditya Pal (Mumbai: Marg Publications, 1986), pp. 93–116.

67. The Galbraith Collection was given to the Harvard University Art Museums. For the Polsky, Walter, Bickford, Ford, and Sadruddin Aga Khan collections, see, respectively, Cynthia Hazen Polsky and Terence McInerney, *Indian Paintings from the Polsky Collections* (Princeton: The Art Museum, 1982); Pal 1978; Vidya Dehejia, "Paul F. Walter," in *American Collectors of Asian Art,* ed. Pratapaditya Pal (Mumbai: Marg Publications, 1986), pp. 205–23; Czuma 1975; Pratapaditya Pal, *Indo-Asian Art from the John Gilmore Ford Collection* (Baltimore: Walters Art Gallery, 1971); Anthony Welch and Stuart Cary Welch, *Arts of the Islamic Book: The Collection of Prince Sadruddin Aga Khan* (Ithaca: Cornell University Press, 1982); and Sheila R. Canby, *Princes, Poets, and Paladins: Islamic and Indian Paintings from the Collection of Prince and Princess Sadruddin Aga Khan* (London: British Museum Press, 1998).

68. Museum of Fine Arts, Boston, *The Arts of India and Nepal: The Nasli and Alice Heeramaneck Collection* (November 21, 1966–January 9, 1967), pp. 120–60. For Heeramaneck's stock in trade as a dealer in Indian painting, see Alice N. Heeramaneck, *Masterpieces of Indian Painting from the Former Collections of Nasli M. Heeramaneck* (Verona: A. Mondadori Editore, 1984).

69. See Leach 1986.

70. Topsfield and Beach 1991, p. 13.

71. Stuart Cary Welch, *The Art of Mughal India* (New York: Asia Society, 1963); Welch and Beach 1965; Welch 1973; Stuart Cary Welch, *Indian Drawings and Painted Sketches: Sixteenth Through Nineteenth Centuries* (New York: Asia Society, 1976); and Stuart Cary Welch, *A Room for Wonder: Indian Painting During the British Period, 1760–1880* (New York: American Federation of Arts, 1978).

72. A portion of the Welch Collection has been given to the Harvard University Art Museums. For the Rajasthani paintings, see The Drawing Center, New York, *Rajasthani Miniatures: The Welch Collection from the Arthur M. Sackler Museum, Harvard University* (April 16–June 7, 1997).

73. Topsfield and Beach 1991, p. 13. For the Hodgkin Collection, see ibid.; and Filippi 1997.

74. Hodgkin 1991, p. 11.

75. In Topsfield and Beach 1991, p. 18.

76. For the Lewis Collection, see The Pennsylvania Academy of the Fine Arts, Philadelphia, *Paintings and Drawing of Persia and India . . . from the Collection of John Frederick Lewis* (December 17, 1923–January 10, 1924), esp. nos. 77 and 81; and Milo Cleveland Beach, *The Grand Mogul: Imperial Painting in India, 1600–1660* (Williamstown: Sterling and Francine Clark Art Institute, 1978), pp. 148–49, no. 50.

77. A number of Kramrisch's finest Indian paintings, as well as twenty-eight items from the Bellak Collection and fifteen from the Lewis Collection, are in Kramrisch 1986.

78. Hodgkin 1991, p. 14.

For Love or Money: The Shaping of Historical Painting Collections in India

John Seyller

Like nearly all Indian paintings, the works in the Alvin O. Bellak Collection have traveled a long road from their original owners and contexts. Some are but fragments of larger entities, such as complete manuscripts or extensive sets of paintings, and were never intended to be seen as separate works of art. Nearly all were made to be viewed under very different conditions, normally by only one or two individuals at a time, held close in one's hands or lap rather than framed and mounted on a wall. This change of circumstance is unavoidable for the most part, and should not detract from the intellectual and aesthetic pleasure that these paintings can bring modern audiences. We can, however, enrich our understanding of these works by recalling something of the different ways in which they were acquired, valued, and viewed in an Indian environment.

While most of the types of paintings represented in this exhibition were produced and used in a courtly milieu, Jain illustrated manuscripts (cats. 1, 3, 4) were commissioned by both monastic and lay patrons, and were donated immediately upon completion to a Jain temple as a gesture of devotion. Because these manuscripts were used in recitations to the faithful and constantly ran the risk of loss or damage, it behooved the temple to have multiple copies of the same text on hand, a need met happily by individual donors. The colophons of these manuscripts make it clear that these donors and their families believed that they would earn religious merit when they sponsored the copying of a sacred text. That merit was apparently augmented by the addition of illustrations, which had the attraction of simultaneously inculcating piety and providing a tangible measure of fiscal generosity. Indeed, with the illustrations to these manuscripts showing little variety in subject, their expansiveness and sheer costliness seem to have become goals in their own right. Paintings covered more and more of the folio's surface, and expensive materials—notably gold and ultramarine blue—gradually superseded fineness of execution as a priority.

At the Mughal court in the late sixteenth and seventeenth centuries, the painting studio operated on an unprecedented scale, but was still only a small part of the imperial workshops that produced a wide array of fine goods for use at court. Thousands of manuscripts were commissioned for the imperial library, and several hundred of these were embellished with dozens of illustrations and lavish illuminations. The text itself was normally a key element in the commission, sometimes for the new information it contained, but more often for the esteem in which a particular literary classic was held. Multiple copies of many literary and historical texts were made, either to ensure that they would be available to different members of the royal family, including queens and princesses, or to distribute to favored nobles or distant dignitaries. No matter what the subject, manuscripts written by the most accomplished calligraphers of the period were the most cherished books, a status established by the content of the notes written on them by the emperors themselves and by the qualitative rankings (for example, first class, first grade) and monetary valuations inscribed on them by imperial librarians.[1] Because these select manuscripts were such desirable objects, they changed hands more frequently than other books, but usually found a permanent home in the imperial library. Some older Persian manuscripts were purchased from hard-strapped courts or individuals from Persia or Central Asia, and were selectively refurbished in up-to-date Mughal styles; others came as gifts to the emperor from individual Mughal nobles. A number of manuscripts also passed into the imperial collection upon the death of a Mughal queen, prince, or high-ranking noble. Indeed, at the highest social level, manuscripts and paintings, like the titles and ranks bestowed by the emperor, reverted to the crown, and the distinction between private and corporate ownership became quite amorphous.

Some Mughal manuscripts bear inscriptions that indicate that in addition to their regular wages, calligraphers were presented with substantial bonuses upon completion of a special project.[2] Few individual specimens of calligraphy are marked with valuations, but those that are have considerably higher values than paintings of comparable size and quality.[3] Both these kinds of documentation corroborate the privileged status traditionally accorded to calligraphy in both Mughal India and the larger Islamic world.

Paintings, by contrast, seem to have been objects that required a less valuable type of labor. We can deduce this from notes on the flyleaves of several illustrated manuscripts that provide a detailed inventory of the various expenses involved in their production.[4] We can also calculate the cost of individual illustrations in those particular manuscripts, and estimate that of others of lesser size and density.[5] This kind of pricing system points to raw materials and the amount of labor being the principal determinants of value in Mughal manuscript illustrations; indeed, as will be demonstrated below, there is meager evidence that the renown of individual artists or the perception of skillfulness ever entered into the calculation of the expense of paintings in these collaborative undertakings. This conclusion is particularly surprising in light of the systematic recording of the name of the artist responsible for each aspect of these Mughal illustrations, a practice apparently developed to ensure that artists received their proper due. However, if the degree of success met by these labors did not affect payment on a regular basis, it could occasion special remuneration in the form of cash bonuses or gifts.[6]

What made a Mughal painting exceptional or even meritorious in its day is still largely a matter of conjecture. Contemporary literary discussion of painting by the Mughals consists primarily of a defense of painting against the traditional Islamic charges of idolatry and a highly conventionalized praise of the incomparable talents in imperial employ. Even the Mughal emperor Jahangir (reigned 1605–27), who prided himself on his ability as a connoisseur, comments on very few actual paintings in his memoirs. He does remark that Bishndasa had painted the Safavid ruler Shah 'Abbas and his chief statesmen "very, very well."[7] This assessment was apparently based upon the principle of verisimilitude, for though Jahangir had never met Shah 'Abbas, he was reassured by the secondhand testimony of the latter's servants that the portrait was well drawn.[8]

Another set of criteria emerges earlier in Jahangir's description of an early fifteenth-century painting by Khalil Mirza Shahrukhi of a battle between his illustrious ancestor, Timur, and Iletmish Khan. Remarking upon its similarity to the style of Bihzad (active c. 1470–1525), a Persian painter whose renown in

Mughal India was unsurpassed, Jahangir declares Khalil Mirza Shahrukhi's work to be so masterful that Bihzad must have been his student.[9] He also commends the painting for its 240 identified portraits. Hence, Jahangir voices an appreciation of the painting for three reasons: its subject, its art historical connection to Bihzad, and its wealth of individual likenesses. These stated concerns, which dwell on the eminence of the subject and the presence of individualized likenesses, were complemented by some more purely aesthetic considerations. For many years, the exercise of these other considerations could only be assumed, but new physical evidence has come to light that indicates that, for a time at least, individual Mughal paintings were also rated according to artistic quality, a judgment in which fine line and expressiveness seem to have been major factors.[10]

Many Mughal paintings (such as cat. 14) have survived as discrete objects and probably were always kept as such in bundles organized by size and subject. Other paintings (such as cat. 13) clearly belonged to albums, a more deliberate compilation of disparate materials. Paintings, calligraphic specimens, and even actual European prints were selected for inclusion in these albums for their inherent visual interest; once this decision was made, however, they were subordinated to the physical requirements of the album, and were regularly expanded, surrounded by additional examples of writing, and given standardized borders so that the book would have a harmonious appearance. Individual paintings and calligraphies are never singled out for description in the albums' flyleaf inscriptions. Instead, they are simply tallied in these two basic categories, which are sometimes subdivided by subject and type of script. In short, individual paintings were always subordinated to the manuscripts and albums to which they belonged.

Not every Mughal-style painting was made originally for the imperial collection. A number of high-ranking nobles at the Mughal court availed themselves of former imperial artists to commission paintings and illustrated manuscripts, a custom known in other parts of the Islamic world and promoted by the Mughals. In a few examples of illustrated manuscripts, the identity of these subimperial

patrons is established by information supplied in the colophons or flyleaf inscriptions; in others (such as cats. 16, 17), we depend upon formal comparison to ascribed or otherwise documented works to posit a plausible patron. Individual subimperial Mughal paintings are very rarely inscribed with the names of their owners; in fact, the only exceptions to this rule are paintings that later entered the imperial library, where librarians exercised their usual meticulousness in recording the source of the acquisition.[11] Although many of the details of subimperial Mughal collecting remain sketchy at best, the outlines are clear. With the exception of 'Abd al-Rahim (see cat. 17), it was not until the mid-eighteenth century that the Mughal nobles who had illustrated manuscripts and paintings produced at their behest began to fashion truly distinctive collections. Before this time, the paintings and manuscripts they commissioned were for the most part pale reflections of interests established at the imperial level, and lacked the variety and flashes of brilliance so prominent there.

Books and paintings were regularly included among the gifts exchanged between the Mughal court and the Deccani states. In some cases, the numbers were staggering. For example, a Bijapuri chronicle records that two thousand manuscripts—some of which are specifically noted as being illustrated—from the royal library were presented to the Mughal ambassador as part of the dowry settlement of the marriage between the daughter of the Bijapuri ruler Ibrahim 'Adil Shah II (reigned 1580–1627) and the Mughal prince Daniyal.[12] Mughal emperors traded paintings with the rulers of the Deccan on other occasions as well. Some exchanges were instigated by a desire to assess the character of their adversary and a determination to press a political advantage. Jahangir describes one such exchange in 1618, when he acquiesced to Ibrahim 'Adil Shah II's repeated request for his portrait; Jahangir obliged with a gift of a ruby and a portrait, personally inscribing the latter with these verses: "Our merciful glance is always in your direction./ Rest assured in the shadow of our felicity./ We have sent you our likeness/ So that you may see our inner self through our external appearance."[13] At the same time, Jahangir issued a decree authorizing Ibrahim to take whatever territory

he could from a rival Deccani ruler, Nizam al-Mulk, the implication being, of course, that Ibrahim could not do so without Jahangir's permission. Ibrahim reciprocated by sending Jahangir a portrait of himself, but that painting, like so many other Deccani works that had reached the Mughal court by this time, is known only in a Mughal copy rather than in the original. The emperor Shah Jahan wielded this same brand of painting diplomacy in 1635, when he compelled the ruler of Golkonda to sign a treaty greatly compromising the independence of that Deccani state, and then sealed the deal with a gift of a gem-incrusted portrait of himself.[14]

Manuscripts and paintings also changed hands as the spoils of war. Chand Bibi, the valiant queen of the Deccani kingdom of Ahmadnagar, offered a Sultanate manuscript to Akbar in 1600, when her beleaguered citadel was on the verge of capitulating to Mughal forces.[15] Other manuscripts bear Mughal inscriptions recording their accession into the imperial library after Mughal armies captured Bijapur and Golkonda in 1686 and 1687, respectively.[16] Some Deccani paintings show secondary signs of having been part of the loot the Mughals took from Golkonda, such as Mughal-style borders or other features that were added when they were compiled in albums.[17]

Not all paintings plundered from the Deccan found their way into Mughal collections. Many fell into the possession of Rajput rulers and nobles serving in the Mughal armies, and soon entered various royal collections in Rajasthan. At the Rajasthani state of Bikaner, which once had a particularly strong concentration of Deccani works, a Bijapuri portrait of Ibrahim 'Adil Shah II bears an inscription that indicates that it was obtained in 1689 at the fort of Adoni in Bijapur territory and dates its subsequent accession into the Bikaner library to 1691;[18] other Deccani paintings formerly in that royal collection are inscribed with the phrase "concerning the collection of Adoni," which may have been used to refer discreetly to their acquisition by force rather than by gift or purchase.[19]

Many of the conditions described above also shaped the development of painting collections at the Rajasthani courts. Obliged by treaty to remain in at-

FIGURE 8
John the Baptist. Ascribed to Sadiq Cela.
Northern India, Mughal court; c. 1619.
Opaque watercolor on paper; 8 15/16 x
6 5/16 inches (22.7 x 16 cm). Valuation:
Rs. 2. Courtesy of Sotheby's, London

FIGURE 9
Seals and inscriptions on the reverse of
John the Baptist (see fig. 8). Ink on paper.
Courtesy of Sotheby's, London

tendance at the Mughal court, most Rajput princes had ample opportunity to become familiar with Mughal mural and miniature painting. They collected a number of examples of Mughal works, and encouraged their own court painters to assimilate Mughal subjects into their local traditions. With Mughal subjects came Rajput adaptations of the Mughal style, fostered in many cases by artists who had some experience at the Mughal court. Over time, these genres shed much of their overt indebtedness to Mughal models and became part of local custom. Portraits, the paintings tied most tightly to sovereignty, were often exchanged among ruling clans as a means of underscoring political and marital alliances, and elaborate gift-giving codes were developed to ensure that proper distinctions in social status were maintained.[20]

Nonetheless, the smaller size of the Rajasthani courts appears to have made the commissioning and presentation of paintings somewhat more personal processes than they were at the Mughal court. Rajput rulers themselves would order painters, who could enjoy the privilege of being kept on exclusive retainer by the court or suffer the indignity of being relegated to freelance or itinerant work, to depict certain performances or festivals, or traditional literary subjects such as *ragamala* series (see cat. 56). When the artists completed these commissions, they would wait for an appropriate occasion—normally one of the major holidays of the year or the maharaja's birthday—to present their work in person to the patron and await a sign of his approval. After briefly perusing the work, the patron would respond with an ordinary sum of money if the work were merely competent, and a more conspicuously generous gift if it were exceptional. Other paintings were not commissioned explicitly, but were produced routinely and were submitted in the same manner.

Monetary Value and Aesthetic Worth

Thus far we have concentrated on the processes by which various historical collectors in India procured their manuscripts and paintings. But a more fundamental question remains to be addressed: What did Indian patrons actually look for in the paintings they

commissioned and collected? Did they regard paintings much differently than we do now?

We might speculate freely about this matter if we were so inclined, for contemporary historical sources are practically silent on this topic. There is, however, some overlooked evidence that can add substance to a discussion of historical collecting, and that may cause us to rethink some modern historical and aesthetic assumptions. The first kind of evidence is provided by the painting inventories that are part of the historical archives maintained at a number of Rajasthani courts, most notably those of Bikaner, Amber (Jaipur), and Mewar (Udaipur).[21] Although the analysis of these registers is still at a preliminary stage, the range of information contained therein is simply astounding: rosters of artists, sometimes with their monthly salaries; records of the acquisition and exchange of manuscripts, albums, and individual paintings; lists of categories into which paintings were grouped; and periodic enumerations of the stock of paintings in each category.

The nature of the categories and the relative proportion of each are instructive. At Bikaner, for example, paintings were categorized in one late seventeenth-century register in the following manner: portraits, group compositions, hunting scenes, *Barahmasa* sets, *ragamala* sets, illustrations of epics, and miscellaneous works.[22] At Jaipur, an inventory of 1745 recorded 2,498 loose paintings; among these were 195 paintings of deities, 163 court portraits, 147 images of holy men (subdivided into three groups), 256 depictions of foreigners in various combinations of male and female figures, 545 paintings of women, 48 of men, 178 works featuring birds and animals, 81 erotic scenes, and 20 hunting scenes.[23] Some categories, such as paintings of women (22 percent of the total), are much more prominent than we might expect from the subjects represented in surviving paintings; others, such as hunts (less than 1 percent), are far less. A broader point is the nature of the categories themselves, which identify paintings almost exclusively by general *subject* rather than by date, region of origin, artist, size, or quality—in other words, the very categories established and emphasized by twentieth-century collectors. This classification by subject is no mere matter of clerical

expediency, but a clue to the way in which Indian patrons and artists initially conceived and later regarded paintings.

The second kind of evidence is monetary in nature, and takes the form of valuations written on individual paintings. There was a profound correspondence of monetary value and contemporary qualitative assessment in the manuscripts collected by the Mughals, so that the most expensive manuscripts were always rated as first-class in quality, and ones of more modest prices were usually ranked as second- or third-class.[24] Might similar patterns emerge from the valuations written on paintings? The data are more sporadic and in some cases more problematic.[25] Nonetheless, the concrete evidence I have gathered of more than 350 historical valuations recorded on individual paintings—primarily Mughal and Mewari works of the seventeenth and eighteenth centuries—allows us to draw the outlines of a hierarchy of genres in each of these schools, and to posit the rationale for the pricing system for paintings within these categories.[26]

Surprisingly few Mughal paintings bear valuations written by the Mughals themselves. A simple Mughal image of John the Baptist of c. 1619 introduces us to this kind of evidence (fig. 8). An inscription in the lower center of the reverse records that the painting was made and presented by a minor artist named Sadiq Cela in year 14 of Jahangir's reign (1619), and concludes with a Mughal valuation of Rs. (rupees) 2 (fig. 9).[27] Another European-derived Mughal image of approximately the same date depicts Daniel in the Lions' Den; it features a greater number of better-drawn figures and is even a third larger in size, but its assessed value is still a very modest Rs. 3.[28] A page of sketches of mountain goats, probably done by Mansur about 1610, merits this same amount despite its preparatory nature.[29] Another category of Mughal paintings is represented by a hunting scene by Sura-dasa of about 1600 (fig. 10). This work is easily the most accomplished of the individual paintings considered thus far, and even features a figure probably intended to be Prince Daniyal, but it still commands a valuation no higher than Rs. 5. Hence, despite considerable variation in subject and quality, we see a relatively modest and constricted range of values with gradations marked in one-rupee increments.

The reason that this group of paintings had such a compressed range of values becomes clear when we turn to a group of Mughal images of two different genres, portraits of holy men and rulers. Consider, for example, a mid-seventeenth-century painting attributed to Muhammad Nadir al-Samarqandi that shows Sufis engaged in ecstatic dance (fig. 11). In the margins are some inspection notes and a later seal along with a valuation of Rs. 40.[30] A similar painting of c. 1715 depicts Prince Dara Shikuh visiting a renowned holy man, La'l Sahib Faqir; although approximately seventy-five years later than the other work, it enjoys the same valuation of Rs. 40.[31] Both works are denser visually than the previous examples that had been valued between Rs. 2 and Rs. 5, but a more important difference lies in their *subject,* which is a band of holy men in one case, and an identifiable prince and holy man in the other. It seems that these particular paintings have been elevated to a much higher level of monetary value primarily by virtue of their respective genres.

This hypothesis is bolstered by two portraits, one depicting 'Alamgir (reigned 1658–1707) and his young son, and the other recording the image of Safavid ruler Shah 'Abbas (fig. 12); the value of the first work, a lightly colored image of the reigning Mughal emperor, is set at Rs. 30, that of the second, a superb work by Bishndasa, at an astronomical 22 *muhrs,* or Rs. 220.[32] This latter amount is not only the greatest value assigned to any individual Mughal portrait, it is also the highest recorded by the Mughals for any painting of any subject. The reason that this particular painting soared to such a lofty level is uncertain, but it seems likely that it was a combination of the eminence of 'Abbas and the acutely observed rendering by Bishndasa. A more general implication, of course, is that portraits ranked highest in the Mughal hierarchy of genres. This conclusion is corroborated by the range of all known valuations on Mughal portraits, which have a minimum value of Rs. 15 and an average range of Rs. 50–80. Within this genre, however, the valuations are a bit erratic, correlating directly with neither the prestige of the subject nor the complexity of the image.[33] A late seventeenth-century equestrian portrait of Nawab 'Izzat al-Dawla, for example, has a valuation of

FIGURE 10
Prince Daniyal Spears a Lioness. Attributed to Suradasa. Northern India, Mughal court; c. 1600. Opaque watercolor on paper; 6 5/16 x 7 9/16 inches (16 x 19.2 cm). Valuation: Rs. 5. Victoria and Albert Museum, London, I.S. 97-1965

FIGURE 11
Sufis in Ecstatic Dance. Attributed to Muhammad Nadir al-Samarqandi. Northern India, Mughal court; c. 1650. Opaque watercolor on paper; 16 5/8 x 11 5/8 inches (42.2 x 29.5 cm). Valuation: Rs. 40. The British Library, Oriental and India Office Collections, London, Johnson Album 7, 3

FIGURE 12
Shah ʿAbbas. Attributed to Bishndasa.
Northern India, Mughal court; c. 1618.
Opaque watercolor and gold on paper;
7 1/16 x 3 9/16 inches (18 x 9 cm). Valua-
tion: 22 *muhrs* (Rs. 220). The British
Museum, London, 1920.9-17.013(2)

FIGURE 13
A Woman at Prayer. Ascribed to Madhava.
Northern India, Mughal court; c. 1600.
Opaque watercolor and gold on paper.
Valuations: Rs. 1, Rs. 3. Location unknown

Rs. 103, but a qualitative rating of second-class *(duvum).*[34]

An analogous system of valuation appears to have been used in Rajasthan for both Mughal and Rajasthani paintings. Some twenty Mughal paintings have ample Mughal inspection notes and seals, but valuations written in Devanagari, a script not used in imperial records. Many of the valuations can now be identified as part of a systematic inspection carried out at the court of Amber in Rajasthan in 1700. The date is supplied by the Hijra year 1111 that appears at the end of a formulaic inscription written in the unusual combination of Persian language and Devanagari script.[35] A provenance in Amber, which had close cultural relations with the Mughals, is suggested by the exceptional use of the Islamic calendar in these inspection notes, and by the appearance of similar inscriptions on one painting known to have come from the so-called Amber Album.[36] In addition, from the presence of Mewari inventory numbers and valuations on this same group of Mughal paintings, we may conclude that these works then passed into the Mewari royal collection, perhaps being presented to Maharana Amar Singh II of Mewar by Jai Singh, the ruler of Amber, upon the latter's accession in 1700.[37] In any case, these Amber valuations both establish a secure date for many of the valuations written in Devanagari, and broaden the courtly base that assigned them to this group of Mughal paintings.

Eight Mughal paintings have both a Mughal valuation and a Rajasthani one, and thus allow a comparison of the two systems of valuation. A fine European-inspired painting of a woman at prayer, done by Madhava about 1600, bears a Mughal valuation of Rs. 1; after belonging to both the imperial collection and the painting collection maintained by Asaf Khan, the work ended up in Mewar, where its value was recorded as Rs. 3 (fig. 13). Likewise, a Mughal painting of a group of intoxicated *bhang*-drinkers, dating to c. 1630, is given a Mughal valuation of Rs. 10 and a Mewari one of Rs. 12.[38] In one case, however, the later Mewari valuation is actually significantly less than the Mughal one, perhaps because the renown of the Mughal artist ʿAbd al-Samad had grown dim over the intervening century.[39]

Such exceptions notwithstanding, the overall con-gruence in values in the two systems predicts a parallel Rajasthani hierarchy of genres. For example, a finished Mughal painting of an emaciated ram of c. 1590 has a Mewari valuation of Rs. 2, an amount in keeping with the value of Rs. 3 the Mughals assigned to Mansur's sketches of mountain goats.[40] A Mughal group scene of a horse and its grooms merits Rs. 10 from both Mughal and Mewari librarians.[41] Suradasa's scene of hunters transporting the carcass of a lioness, the companion painting of the hunting scene discussed earlier (fig. 10), is assigned a value of Rs. 20, an amount inexplicably quadruple that of its mate.[42] Representative Mewari valuations of Mughal images of foreigners and holy men fit easily into the scheme outlined earlier. Accordingly, a painting of a European soldier, rated a first-class work in a marginal inscription, is given a monetary value of Rs. 8, about what must have been the upper limit for images of this category.[43] A very accomplished painting of Christ holding an orb would have been placed in the category of holy men, and so rose to the level of Rs. 20.[44] A more typical holy man, the faqir on the right side of a double-sided album page, has a slightly higher valuation, Rs. 25.[45] Holy men elicit much veneration, of course, but they are surpassed by the deities themselves. So it is that a spectacular painting of the goddess Bhairavi, attributed to Payaga, has a Mewari valuation of Rs. 210.[46] This amount is exceeded only by a dense, historical Mughal battle scene by Hunhara—until recently thought to be part of the Royal Library *Padshahnama* —which has a Mewari valuation of Rs. 300.[47]

A series of eighteenth-century Mewari portraits reveals another principle that helped determine the value of a painting. A small painting of three *peris* (fairies) worshiping at a shrine, which would fall under the category of women or miscellaneous subjects, has a Mewari valuation of Rs. 1 1/2.[48] From this benchmark, we rise to Rs. 5 for a modest portrait of Maharana Jagat Singh II hunting and Rs. 10 for a standing portrait of the same figure.[49] The reason for the difference in value among the three paintings appears to be the higher regard not only for portraiture, which presents exemplary or extraordinary figures, but also for a greater level of formality. In the hunting portrait, Jagat Singh is small and relatively

active; in the latter, the maharana is proportionately larger and static, raised above the trifles of mundane human activity. This preference for more stately images is also manifested in the valuation of two equestrian portraits. In the first, Maharana Ari Singh practices his horsemanship, a vigorous activity rendered by two complementary portraits (fig. 14); in the second, Amar Singh II has already achieved complete mastery of his horse, and placidly smokes a *huqqa* from his mount (fig. 15). Whereas specialists would have no trouble discerning the more unusual image or the finer one, we probably would not anticipate the tremendous gap between their values: Rs. 4 for the informal riding display, and Rs. 150 for the ceremonial procession. The frequency with which artists resorted to the hieratic formula of this latter type of image and the consistently high valuation of such images leave no doubt the preferred type of royal portrait was the most formal.

A second pair of Mewari images demonstrates a more quantifiable aspect of the valuation process. In a painting dated 1765, Maharana Ari Singh is depicted at worship in the Amar Vilas (fig. 16). Although the midsize painting has such desirable elements as a conspicuously pious activity and a meticulously described palatial setting, it is the number of courtiers in attendance (forty-three in all, plus the maharana) that appears to figure most prominently in its valuation of a relatively modest Rs. 60. We can surmise this from the valuation placed on a very similar painting made in Udaipur seventy years later, in which the reigning maharana, Jawan Singh, presides over a recitation of the *Bhagavata Purana* in the same location (fig. 17). But in this later work the veritable throngs of courtiers—here pressing close to Jawan Singh, there ringing the central tank, elsewhere studding the porticoes and garden walkways—impart a visual and aural buzz to the painting; more to the point, they drive up its valuation to Rs. 500, more than eightfold that of the earlier scene. Can this part of the valuation process be as elementary as a simple head count? I think so, for the only Mewari paintings of comparable price also have enormous crowds of figures, as in one work with a value of Rs. 500, or another with the unsurpassed value of Rs. 1,000.[50]

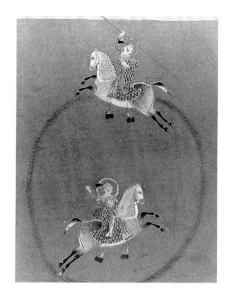

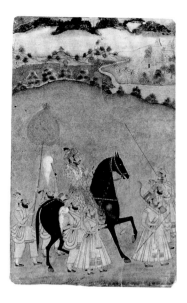

FIGURE 14
Maharana Ari Singh Practices Horsemanship. Ascribed to Shiva, son of Naga. Rajasthan, Mewar; 1761(?). Opaque watercolor and gold on paper; 19 1/2 x 15 1/2 inches (49.5 x 39.4 cm). Valuation: Rs. 4. The City Palace Museum, Udaipur

FIGURE 15
Equestrian Portrait of Maharana Amar Singh II. Rajasthan, Mewar; c. 1705–10. Opaque watercolor and gold on paper; 14 1/2 x 9 1/4 inches (36.9 x 23.5 cm). Valuation: Rs. 150. Catherine and Ralph Benkaim Collection

FIGURE 16
Maharana Ari Singh Performs Puja *in the Amar Vilas.* Rajasthan, Mewar; dated 1765. Opaque watercolor on paper; 26 3/4 x 20 7/8 inches (68 x 53 cm). Valuation: Rs. 60. Freer Gallery of Art, Smithsonian Institution, Washington, D.C., F1986.7

FIGURE 17
Maharana Jawan Singh Presides over a Recitation of the Bhagavata Purana *in the Amar Vilas.* Rajasthan, Mewar; c. 1835. Opaque watercolor and gold on paper; 55 1/2 x 36 inches (141 x 91.4 cm). Valuation: Rs. 500. The City Palace Museum, Udaipur

In these crowd scenes, the nature and arrangement of the figures affect the valuation as well, with tidy, hierarchical rows of high-status individuals counting for more than large numbers of ordinary townspeople milling about randomly. This principle can be demonstrated dramatically in two contemporary Mewari processional scenes featuring Maharana Raj Singh II.[51] In one case, a miniaturized wedding party wends its way through the town of Gogunda, passing by endless clusters of well-wishers, assorted tents, and exploding fireworks; in the other, the maharana is more prominent, occupying the center of a human wave of nobles mounted on elephants and horses. Both paintings have numerous figures, and both bear long inscriptions naming many of the dignitaries depicted. Yet the first painting was given a valuation of Rs. 50, while the second received one of Rs. 350. I believe that the difference in valuation lies in the greater number and larger scale of the ancillary portraits. Because customized likenesses are naturally more labor-intensive than generic images, their inclusion inflates the cost of any painting.

We are able to refine further the criteria that played significant roles in the determination of the monetary value, and presumably the aesthetic worth, of an individual painting by the valuations found on several large Mewari series of literary paintings. Among these series, which have the lowest average valuation of any genre of painting, are two *Rasikapriya* series of c. 1635 and c. 1700, a volume of the Jagat Singh *Ramayana* dated 1651, a *Kalila Daman* set of c. 1710–20, and a *Mulla Do Piyaza* series of the same date. Each member of these series—more than two hundred paintings in all—was inscribed with a specific valuation, apparently all at once, perhaps about 1720.[52] In the *Kalila Daman*, a late Indian recension of a popular collection of didactic animal fables, these valuations begin as low as Rs. 1 and rise as high as Rs. 7. Calibrated to the quarter rupee, they provide the most nuanced monetary assessment of a series of paintings in which size and type of painting have been removed as variables.

In most cases, it is easy to understand the logic of the librarian who determined the value of a given painting. The opening painting of the *Kalila Daman* series has a single figure, arms raised in prayer, before a spare background.[53] Such a work is simple in every respect, and earned the lowest valuation of all, a meager Rs. 1. A second image seems more complicated, but that impression is probably colored by our response to the charming landscape, which apparently had negligible worth (fig. 18). The core of the painting is, in fact, little more than a scene of two men conversing, a fact reflected in its valuation of Rs. 1¼. A courtyard scene presents many more figures (nine in all), but scatters them loosely across the composition, which is organized by an unwieldy courtyard wall and garden; the unimpressed appraiser fixed its value at Rs. 1½.[54] A scene with five figures set in a properly constructed pavilion and garden doubles in value to Rs. 3 (fig. 19). Double in value again to Rs. 6 is a two-tiered painting featuring fifteen figures in all, including two royal figures installed on golden thrones amid assorted golden accouterments.[55] At Rs. 7—the highest value in this series—we have a painting with fourteen figures, including one who is enthroned, and a long golden canopy (fig. 20). Together, these examples suggest that once a painting was placed within a broad tier of value by virtue of its category or subject, more precise calculations were made on the basis of the amount of labor and precious material involved. These latter factors were normally measured by the number of figures and by the work's overall visual density, with special consideration given to the amount of gold employed.

But did subtle aesthetic distinctions also factor in the process? Let us examine two generally similar paintings, one with a value of Rs. 3, the second, Rs. 7 (figs. 21, 22). What might account for the difference in value? The number of figures is comparable (seven and nine, respectively), and both are finely executed, apparently by different, albeit unnamed artists. Most modern scholars and collectors would probably guess that the librarian assigned a lesser value to the first painting (fig. 21) because he noted its abrupt compositional bifurcation, and recognized the gracefully curved inset of the other painting (fig. 22) as a more refined solution; indeed, the latter

device is repeated often enough on paintings with valuations of Rs. 7 for one to make this case. And in the absence of this kind of documentation, we could easily argue this without fear of contradiction. But if we step back and weigh carefully the documentation of these valuations, a simpler and more prosaic explanation presents itself, namely, that considerably less gold is used in the less expensive painting, a difference seen clearly around the figure in the upper left. The refinement of the second example probably did not go altogether unnoticed, especially by the artist's co-workers, but it probably never figured into routine calculations of cost and value, which are so often a part of the official record.

Together this documentation argues for the likelihood that before the twentieth century most patrons in India commissioned and collected paintings primarily for their subject matter, which could extol certain aspects of their own existence or present a sampling of the fruits of the world around them. They and their librarians tacitly acknowledged that prestigious subjects should cost more, probably because they expected that the artists would or did take more care in executing the image. Beyond this, they seem to have determined the value of a painting by its visual density, a quality measured most pragmatically by counting the number of figures, but also by assessing the amount of precious materials used and the degree of workmanship exercised. This way of reckoning the worth of a painting not only has roots at least as ancient as the fifteenth century, when ostentatious Jain manuscripts were made routinely, but also has manifestations as modern as the mid-twentieth century, a period from which many modern dealers still recall commissioning and purchasing paintings using exactly the same criteria.

Such an approach to painting may seem both rote and perplexing to many modern collectors and viewers, who bring to bear very different criteria in the aesthetic and monetary assessment of Indian painting. Unlike Indian patrons, who, by their very engagement in well-defined social hierarchies would naturally subscribe to the hierarchy of genres described above, Western viewers often harbor egalitarian sentiments, sometimes with the result that we are attracted most

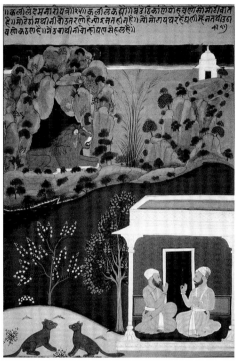

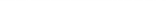

18

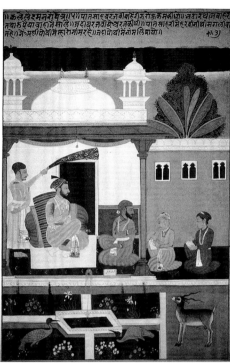

19

20

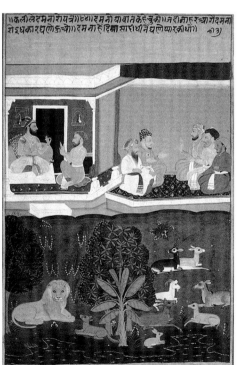

21

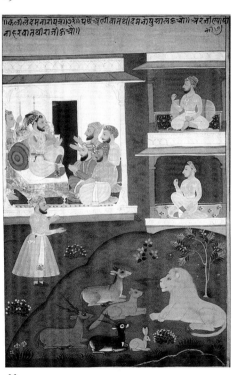

22

FIGURES 18–22
Pages from an illustrated series of the
Kalila Daman. Rajasthan, Mewar;
c. 1710–20. Opaque watercolor and
gold on paper

FIGURE 18
Valuation: Rs. 1 ¼. Government Museum,
Udaipur, 1097 10/25

FIGURE 19
Valuation: Rs. 3. Government Museum,
Udaipur, 1097 10/5

FIGURE 20
11 ½ x 8 ¹³⁄₁₆ inches (29.2 x 22.4 cm)
(painting). Valuation: Rs. 7. Government
Museum, Udaipur, 1097 10/39

FIGURE 21
Valuation: Rs. 3. Government Museum,
Udaipur, 1097 10/84

FIGURE 22
Valuation: Rs. 7. Government Museum,
Udaipur, 1097 10/73

strongly to unusual, even overtly plebeian subjects (see cat. 62). And even when we do collect portraits, widely acknowledged by modern dealers to be the least marketable type of Indian painting, we seek out those images whose immediacy of presentation allows for a sense of individual personality (see cat. 74) rather than those that display the formal demeanor valued most highly by generations of Indian patrons (see cats. 49, 77). Similarly, because Western audiences are well removed from the system of labor involved in these paintings, we tend to lose sight of the value traditionally accorded skillful, time-consuming ornament, and laud as bold works that many an Indian viewer would describe as plain (see cat. 64). Finally, our detached historical vantage point leads us to celebrate images that seem to embody the modern aesthetic ideals of innovation and artistic individuality, traits never at the forefront of the Indian aesthetic tradition.

A telling example of this disparity of vision is a painting that atypically features a landscape devoid of a human presence (cat. 19). In the system of valuation outlined above, this painting would have been the least expensive illustration—almost certainly valued at no more than Rs. 1—in a large and very modestly priced manuscript; nowadays, however, that same work is extolled precisely because it has no figures. Thus, we arbitrarily elevate an aberration in the Indian painting tradition to the status of a willful innovation, and regard it in a most anachronistic way as a harbinger of the familiar Western landscape tradition. In other words, we somehow find ways to make these paintings speak to us even if we resort to an entirely different set of paradigms.

At many times in their history, these Indian paintings were bound to their material limits, and gave pleasure primarily as possessions valued for the prestige of their subjects, their rarity as objects, and the amount of skilled labor they represent. But both the historical and modern valuations assigned to them inevitably stand apart from the revelatory aesthetic experience that each work of art holds as its promise. For that experience, when a scrap of colored paper magically lifts up the soul, a passion for transcendent beauty is still the only coin of the realm.

1. Seyller 1997.
2. In the case of a *Gulistan* of Sa‘di in the Royal Library, Windsor, the calligrapher, Muhammad Husayn, was given an amazingly generous reward of 1,000 *muhrs,* a sum ten times the recorded value of the book itself. See Seyller 1997, pp. 277–78, 312–13, and fig. 15.
3. In addition to an example discussed below (fig. 11), I know of three examples of calligraphy with valuations. Two Persian couplets by Muhammad Zahad Samarqandi on the reverse of a seventeenth-century Persian painting (Freer Gallery of Art, Washington, D.C., F1999.18) are given a valuation of Rs. 190. A specimen of four couplets by an anonymous calligrapher on the reverse of a mid-seventeenth-century Mughal painting by Anup Citara of a woman holding flowers is valued at Rs. 107. A much less formal page of calligraphy in Shikasta script attached to the back of a Bikaner painting of two women is inscribed with a Rajasthani valuation of Rs. 15. The last of these is in the Brooklyn Museum of Art (78.260.4); see Poster et al. 1994, p. 155, no. 116.
4. Seyller 1997, pp. 272–73, and figs. 20–22.
5. John Seyller, *Pearls of the Parrot of India: The Walters Art Museum Khamsa of Amīr Khusraw of Delhi* (forthcoming), Chapter 3.
6. Bishndasa, for example, was rewarded with the gift of an elephant—a very expensive and prestigious possession—upon his return from an ambassadorial mission to the court of Shah ‘Abbas in Persia in 1620 (*Jahangirnama* 1999, p. 319).
7. Ibid. See fig. 12 for a representative example of Bishndasa's portraits of Shah ‘Abbas; for others see Asok Kumar Das, "Bishandas: 'Unequalled in His Age in Taking Likenesses,'" in Das 1998, figs. 6–12.
8. *Jahangirnama* 1999, p. 319.
9. Ibid.
10. John Seyller, "A Mughal Code of Connoisseurship," *Muqarnas,* vol. 17 (2000), pp. 178–203. These aesthetic rankings, which normally take the form of numerals written on the paintings, do not generally appear on paintings with valuations inscribed on them. The two exceptions to this rule are mentioned in nn. 34 and 43 below.
11. A painting of a European woman surrounded by musical instruments, for example, is noted as having belonged to the late Hushmand Banu Begam, the granddaughter of Prince Daniyal; see Spink 1982, no. 88. Three other paintings are recorded as having come from the estate of Asaf Khan Khankhanan. One of these is reproduced as fig. 13; the others are mentioned in nn. 41 and 43 below.
12. Skelton 1958, pp. 98–99.
13. *Jahangirnama* 1999, p. 276.
14. *Qutbshahi of Golcondah, Bharata Itihasa Samshodhaka Mandala Series* (Pune, n.d.), pp. 1–23; cited in Zebrowski 1983, p. 178.
15. The manuscript is a *Bustan* of Sa‘di (National Museum, New Delhi, 48.6/4) written and illustrated at Mandu about 1500. For a translation of its flyleaf note, see Seyller 1997, p. 339; for other details of the manuscript, see Losty 1982, pp. 67–68, no. 42.
16. Seyller 1997, p. 252 n. 37.
17. See Leach 1995, vol. 2, p. 914, for circumstantial evidence that the famous yogini in the Chester Beatty Library was part of this booty.
18. Skelton 1958, p. 102 and fig. 2.
19. Krishna 1995, pp. 255, 277 n. 5.
20. Here I follow Molly Aitken, "Gift-Exchange and the Formalities of Portraiture," a paper delivered at the American Council for Southern Asian Art symposium, Philadelphia, May 12–14, 2000.
21. Krishna 1995; Das 1995, pp. 200–211; and Andrew Topsfield, "The Royal Paintings Inventory at Udaipur," in Guy 1995, pp. 188–99.
22. Krishna 1995, p. 256.
23. Das 1995, pp. 201–2.
24. Seyller 1997, pp. 243–349.
25. The most vexing problem is the date of the valuations. Modern valuations are easy to discern, but older ones can range from exactly contemporary with the painting to more than a century later. Moreover, the exact currency in which the value is recorded is rarely indicated. Because it is impossible to give a modern equivalent for these sums, they should be used only as indications of relative worth. We can, however, make a rudimentary comparison to the monthly salaries of Mughal and Rajasthani artists. My research indicates that the salaries of Mughal artists averaged about Rs. 20 per month in 1600. Records from Jaipur dated 1762 note that one artist (Ramadasa) had his monthly salary raised from Rs. 6 to Rs. 10, and the seniormost artist (Sahibrama) had his raised from Rs. 12, 4 annas, to Rs. 18.
26. The valuations are regularly excluded from sales catalogues, and are rarely recorded in other publications. The notable exceptions to this are Falk and Archer 1981; Vishakha Desai, "Connoisseur's Delights: Early 'Rasikapriya' Paintings in India" (Ph.D. diss., University of Michigan, 1984), pp. 160–61; and many of the pioneering publications by Andrew Topsfield of the Ashmolean Museum, Oxford. I am greatly indebted to Topsfield for his generous assistance with this material.
27. This amount was matched by a valuation written by one Amber librarian in 1700 (in the upper right) and raised to Rs. 3 by a Mewari librarian inspecting it sometime later (along the top left edge).
28. The painting, which dates to c. 1610, measures 8 1/2 x 5 3/8 inches (21.5 x 13.6 cm). It bears a number of Mughal inspection notes and seals as well as the qualitative designation of first-class (*awwal*). It is published in Robinson et al. 1976, p. 254, no. V.55, plate 122.
29. For the painting, which is inscribed in the lower right, "many good mountain goats, three rupees," see Pratapaditya Pal, *Court Paintings of India, Sixteenth–Nineteenth Centuries* (New York: Navin Kumar, 1983), p. 156, M39.
30. On the reverse are still more inspection notes and a valuation of Rs. 8 for the calligraphic specimen.
31. British Library, Oriental and India Office Collections, London (Johnson Album 19, no. 1). For the painting, see Falk and Archer 1981, pp. 107, 420, no. 158; and Jeremiah

P. Losty and Linda York Leach, *Mughal Paintings from the British Library* (London: Indar Pasricha Arts, 1998), no. 16.

32. For the portrait of 'Alamgir, by Khemananda, dated to c. 1660, preserved in the British Library, Oriental and India Office Collections (Johnson Album 2, no. 5), see Falk and Archer 1981, pp. 90, 407, no. 97.

33. This may be due to the later date of the valuations, which are recorded in cardinal numbers written out in longhand in the margin on the reverse of the paintings.

34. British Library, Oriental and India Office Collections (Johnson Album 3, no. 5); see Falk and Archer 1981, pp. 94, 413, no. 115.

35. All of these cursorily written inscriptions read, "'arz tō 26 Zī al-Ḥijja s[ana] 1111 (Inspected on 26 Zī al-Ḥijja in the year [A.H.] 1111 [A.D. June 4, 1700])," with the Devanagari letter *jā* standing in for the Persian letters *ẓ* and *z*. The first part of this reading was deciphered by Robert Skelton in an unpublished entry on a painting in the Fondation Custodia, Paris (1991-T.22); the latter part is my own. These inscriptions employ the same Persian term that the Mughals used for value, *qīmat*, rendered in Devanagari as *kīmat* and abbreviated as *kī*. The numeral of the valuation appears before a larger curving line that wraps around the right side and bottom of the numeral. In some cases, quarter-rupee values are indicated by one to three short vertical marks between the numeral and this line.

36. This album is discussed in a forthcoming article in *Artibus Asiae* by Catherine Glynn, "A Rajasthani Princely Album: Rajput Patronage of Mughal-Style Painting." See n. 45 below for a reference to the inscribed painting in the Amber Album.

37. See Leach 1998, p. 139. I am grateful to Catherine Glynn for sharing her thoughts on the connection of these paintings and inspection notes with Amber.

38. Ashmolean Museum, EA 1999.17. In Spink 1987, no. 3, the painting is erroneously associated with Kesavadasa and dated to c. 1595–1600.

39. The painting of a camel fight, ascribed to 'Abd al-Samad and dated c. 1590, has a Mughal valuation of Rs. 30 and an Amber one (dated 1700) of Rs. 12. It is published in *Treasures of Islam* (London: Sotheby's/Philip Wilson Publishers, 1985), p. 147, no. 121.

40. Leach 1998, pp. 36–39, no. 8.

41. The painting, now in a private collection, is unpublished. Among its Mughal inscriptions is one indicating that the painting once belonged to Asaf Khan.

42. Victoria and Albert Museum, London, I.S. 96-1965. Robert Skelton discusses the inscriptions and reproduces the painting in "Two Mughal Lion Hunts," *Victoria and Albert Museum Yearbook*, no. 1 (1969), p. 47 n. 32, and fig. 2.

43. The unpublished painting, now in a private collection, has several discordant valuations, some of which are crossed out, a cursive marginal inscription ranking it as a first-class work *(awwal),* and a note indicating that the painting was formerly in the possession of Asaf Khan.

44. The painting, which I date to c. 1630, is closely related in theme to a painting by Murar offered for sale at Sotheby's, London, April 23, 1996, lot 7; this image is based more obviously on a European print, a connection most apparent in the modeling of Christ's fingers and palm. Other scholars have placed it to Prince Salim's court at Allahabad, and dated it accordingly to c. 1600–1605. The painting has five Mughal inspection notes and two Mughal seals, as well as a Mewari archival number (20/199, with no. 209 crossed out) and valuation. Now in a private collection, the painting is published in Colnaghi 1978, p. 86, no. 18.

45. The pair of images, which date to c. 1620 and whose valuation of 1700 was rated as Rs. 14, was offered for sale at Sotheby's, London, April 23, 1996, lot 1.

46. The painting dates to c. 1630-35, and is now in a private collection. It has three Mewari inventory numbers on the reverse: 45 (cancelled), 14/45 (written in red), and leaf number 4. See Kossak 1997, p. 52, no. 23.

47. For the painting, which now belongs to The Metropolitan Museum of Art, New York (1986.283), see Milo Cleveland Beach and Ebba Koch, *King of the World: The Padshahnama— An Imperial Mughal Manuscript from the Royal Library, Windsor Castle,* with translations by Wheeler Thackston (London: Azimuth Editions/Sackler Gallery, 1997), p. 222, fig. 153 (Appendix L).

48. The painting of c. 1720 is in the Catherine and Ralph Benkaim Collection.

49. The former, dating to c. 1740–50 and measuring 9 5/8 x 15 3/8 inches (24.5 x 39 cm), was sold at Sotheby's, London, April 23, 1996, lot 33. The latter, dated c. 1735–40, appeared at Sotheby's, London, June 8, 2000, lot 27.

50. The former image measures 34 x 65 inches (86.4 x 165.1 cm); the latter, 28 1/2 x 53 1/2 inches (72.4 x 135.9 cm). For the two paintings, see Topsfield 1990, nos. 23 and 3, respectively. Both Topsfield and Desai had surmised that the number of figures played an important role in the valuations.

51. See Topsfield 1990, nos. 15 and 16, dated 1755 and 1760, respectively.

52. This date has been tentatively proposed by Topsfield, who notes that the valuations on the c. 1635 *Rasikapriya* are written in the same hand as those on the other series. He allows that a date in the nineteenth century is also conceivable, for valuations appear on the *Aranyakanda* of the Jagat Singh *Ramayana* and not on the other volumes of the manuscript, which were given to Colonel Tod about 1820.

53. Government Museum, Udaipur, 1097 10/1.

54. Government Museum, Udaipur, 1097 10/62.

55. Government Museum, Udaipur, 1097 10/79.

Painters and Patrons: Notes on Some Relationships Within the Pahari Tradition

B. N. GOSWAMY

As one enters the seductive world that is Pahari painting, and begins to walk through that magical terrain, one is struck at once—apart, of course, from its sheer brilliance—by certain things: the warm, informal air that one breathes in it; the vast output of the painters active in this relatively isolated region of the so-called Panjab Hills; and the lack of any real connection between the resources of the patrons and the dazzling quality of the work that their retained artists often turned out for them. There is something uncommon in all this, but not everything can be explained.

A well-known, but now untraceable, painting, showing a Pahari ruler—Sansar Chand (reigned 1775–1823; see fig. 23) of Kangra—seated looking at paintings in the company of a small group of companions and courtiers, catches nearly to perfection the ambience of the hill courts and the atmosphere in which paintings were often seen and shared.[1] The elegantly attired chief occupies the center of the painting; this apart, one recognizes his preeminence also through other signs: the yak's-tail *chauri* (fly whisk) being waved over his head by a standing attendant, the *huqqa* that he alone, in this small assembly, is seen smoking. But, like everyone else, he is seated on the carpeted floor, legs carefully tucked under him. No great distance separates him from the princely figure or the group seated opposite. Those seated at right, by his side, are truly close, almost touching his person, or at least the pillow on which he rests his left arm. In Sansar Chand's hand, there is a painting that he seems to be looking at with care, but he is not the only one holding a painting: the occasion is one of sharing, for at least three other persons hold, similarly, paintings in their hands. Everyone else present too seems somehow to be engaged in the act of viewing: comments are being offered, points made. All this while, the painter, who seems to have brought in the sheaf of pictures, also sits in the bottom left corner of the group, occupying the same carpeted space on the terrace: listening, and holding in his hands a cloth bundle, the striped *basta* that almost serves as his cognizance.

There is warmth in the scene, and a sense of intimacy. This is not something, however, that especially marked the court of Kangra, but almost certainly this is the way things were generally in the hills. Most of the Pahari courts were small, certainly much smaller than Kangra when it was at the height of its power under Sansar Chand. Intimacy and closeness belonged therefore somewhat naturally to them. But it was not a matter of scale alone: the social structures were different here. Kingdoms consisted largely of close-knit villages and small towns, with even state capitals being very modest in size compared to those that one associates with Mughal India, for instance, or even the region of Rajasthan. At the courts, there were certainly hierarchies and much insistence upon form—subtle evidence of this can be seen everywhere as one begins to read the paintings with care—but those distances, that formality bordering upon coldness that marked relationships elsewhere, do not seem to have belonged to the situation in the hills.

It is at these informal courts that prodigious quantities of work were turned out. All those extensive sets that one knows so well, some of them produced in successive generations, others in utterly contrasting styles—the *Devi Mahatmya*, the *Ramayana*, the *Mahabharata*, the *Bhagavata Purana*, or, again, the *Rasamanjari*, the *Gita Govinda*, the *Rasikapriya*, the *Satasai*, *ragamalas*, and the like—seem to have been the work of retained artists working for specific rulers or chiefs on whose granted lands they lived, and whose "employees" they were. Casual patronage came sometimes from other quarters—from the head of a religious establishment, for instance; some local *wazir*, or functionary; some visiting dignitary—but there is little doubt that it was for the royal courts of the hills that painters chiefly worked. The region was dotted with courts—more than a score can easily be cited—each headed by some Rajput ruler or the other, often belonging to a dynasty that traced its proud lineage back a thousand years or more. It is difficult to think of a state that did not have a family or group of painters working for its ruler. The truly tiny states—like Arki, near Shimla—might, it is conceivable, only have availed of the services of artists who came in from outside to take up occasional commissions, but

nearly everywhere else, it seems, at least one atelier of artists was active. Without doubt, painting must have been close to the hearts of some of the rulers in the hills. But here we have the uncommon phenomenon of virtually *all* states being centers of some kind of painting or the other. Why this was so one can only guess. It had something to do perhaps with notions of ideal kingship—which clearly included extending meaningful patronage to the arts as one of the obligations of a king—going far into the past of these Hindu, Rajput kingdoms. It could as easily be linked, again, to each ruler seeing himself as the equal of his neighbor or kinsman in all respects, this leading in turn to a kind of competition in the matter of patronage of the arts, which prominently included painting. Whatever the case, painting undoubtedly flourished here, and one can imagine a truly large number of painters at work, attached to courts, quietly turning out series of paintings—on themes taken from the great myths or religious texts, poetry or music, or simply "courtly" scenes and sheaves of portraits—generation after generation, bringing into being in the process the limpid body of work that we collectively designate as Pahari painting. It is not always possible to link individual painters, or even painter-families, with the work they produced, but in many cases—by using the records kept at pilgrimage centers and the land-rights records compiled by the British—it has been done with telling effect, enhancing our very understanding of processes at work and the evolution of styles. Names of literally hundreds of artists have surfaced. From the range of work itself that can be attributed to certain centers—Kangra, Jammu, Chamba, and Nurpur among them—it could have been possible to infer that more than one family of painters, working in different styles, was active in those states. But one now has a substantive body of clear, unequivocal evidence. Seen in this light, the vast number of Pahari paintings—what has survived is surely only a fraction of what must have once been produced—should come as no great surprise perhaps.

But one needs to remind oneself that most of the Pahari courts were small, and their rulers commanded limited means. Maintaining ateliers of

artists, which in this case meant supporting families of artists, was not something that imposed a heavy burden upon the state. It was not a matter of conferment of large land *jagirs*, or of grandiloquent *mansabs* and titles. Generally, a small parcel of land for the family to settle upon, the issuing of daily rations when a painter was working away from his village home at state headquarters, and very modest payments in cash were all that was needed. In a situation such as this, a disjuncture between the means at the disposal of a ruler and the quality of work produced for him can easily be visualized. One is, in fact, constantly surprised by the level of work that was done away from the major centers of power in the hills, at relatively small, unpretentious courts. The little state of Guler, always overshadowed by neighboring Kangra, or Mankot, an insubstantial chieftainship when compared to Jammu, serve as perfect examples. The names that one associates with Guler[2]—Pandit Seu (c. 1680–c. 1740), Manaku (c. 1700–c. 1760), Nainsukh (c. 1710–1778), for instance, all members of the same artist-family—are pivotal not merely to the history of Pahari painting, for the work that one attributes to them is among the most brilliant in the entire range of Indian art. We might not have succeeded in culling the names of individual artists active in Mankot, but the work produced there ranks among the most moving and the most flamboyant known.[3] Obviously, other factors than the resources of a state—including traditional loyalty to a patron's family, an attachment to roots, respect for a discriminating and sensitive patron's taste, sheer inertia—must therefore have been at work. This is not to say that painters never moved from their family homes to take up employment elsewhere, or never went in search of work to other places, but there was not a great deal of that kind of movement. And one thing is certain: the finest work did not always emanate from the largest of states.

With this, one moves into the uncertain but meaningful and complex area of the nature of the relationship between patrons and painters.

Shri Ram ji

Om. To the illustrious Rajadhiraja, Maharaja, Parambhattaraka, Shri Shri Shri Sansar Chand (may peace be upon him!), from his humble servant, the painter Shiba. Every day he [Shiba] salutes you with "Jai Deya"; pray grant acceptance of his touching of your feet. Now be it known that, owing to the righteous rule of the Maharaja, this humble servant is happy. May the Lord of the World keep you, my master, in safety and joy, that your countless subjects may be blessed.

Further, O Maharaja, this is my humble submission: you had said [to me]: "Do not go back to your home; if you do, you will receive punishment. Stay you by my side from now on." I believe, O Maharaja, that it was truth indeed that you spoke (for it is truly punishment that I am going through); first, am I without food; I am, in fact, close to dying. Secondly, truly is your kindness great to this humble servant. So much so that you granted me employment by the side of [the painter] Gaudhu. But the real truth of that "employment" is that the accountant Sardaru does not give me work. He offers me taunts instead, and does never take [enroll?] me, this humble servant of yours.

You had said that I should bring my family over. It is good that I did not do that, for just as your humble servant here has fallen on bad days and is without food, so would my family have suffered. Your servant has been living on loans [of several rupees] that he has taken here. Now, however, no one gives me anything any more.

What matters finally is one's belly. All rights or wrongs that anyone does, he does for his own self, and not without a cause. Do be kind, O Maharaja, and allow this humble servant of yours now to depart. He is desperate, for here he goes without food. And forgive, graciously, all sins and faults of this humble servant.

—LETTER ADDRESSED BY THE PAINTER SHIBA TO
MAHARAJA SANSAR CHAND OF KANGRA, C. 1810[4]

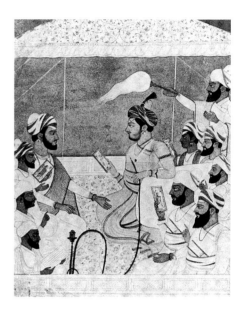

FIGURE 23
Raja Sansar Chand of Kangra Inspecting Pictures. Panjab Hills, Kangra; c. 1788. Location unknown

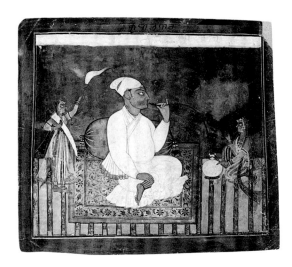

Despite the occasional surfacing of documents such as this, a humble petition addressed by the painter Shiba to his royal patron, the world of Indian painting remains one of haze and layers, especially when it comes to the nature of the relationship between painters and patrons. Much remains obscured from view, and sometimes all that is discernible are faint, elusive outlines. A few things are known with reasonable certainty, of course. One knows, thus, of the distance that separated a royal patron and his retained artist; one is also aware of the routine manner in which painters would often refer to themselves while inscribing paintings or signing petitions: *"chakar," "ghulam," "banda,"* and the like are the terms most commonly employed, all of them denoting a servile status, something akin to a "servant" or "slave." Painters are also known, however, who were close to their sovereigns, offering counsel, sharing with them matters of confidence, even being allowed the privilege of presence at moments of intimacy. There are some hints thus that one can pick up, occasionally even a specific, if brief, statement; but the real texture of the relationship, which must have been complex, one is seldom able to feel. It is just possible that it is revealed in a petition like that of Shiba. For the document has layers of meaning, and the tone of it—even though remaining outwardly humble throughout—keeps subtly changing. In it Shiba flatters, cajoles, petitions, complains, uses sarcasm, boldly reads out a lesson, displays self-assurance, even fleeting flashes of defiance. These all impart the sense that one is hearing the true ring of the coin across time.

But then one begins to wonder again. Is this petition, in which one can almost hear the blunt pounding of the hammer of want, truly typical of its kind? Could all painters have been so hapless, or so bold? In it, is it the voice of Shiba one hears or that of some scribe or court functionary whom he might have persuaded to write on his behalf? Considering that the document did not come out of the Kangra royal collection but that of a learned pandit-astrologer family belonging to a different state, did it in fact ever leave humbler hands and reach princely quarters? While issues such as these hover about, other questions—subtler, and of greater moment—seem to be much more difficult to answer. For instance, what

freedom, if any, did the painter enjoy in respect of his person and his work? Once retained, was the painter free to choose, or free to move about or away? How much interest, or discernment, did the average royal patron—not the likes of the Mughal emperor Akbar or his son Jahangir, for whom painting was a matter of the spirit—bring to the art made for him? What exchanges about art took place between a patron and his artist, and how often? Where more than one artist or artist-family worked for a patron, what considerations governed the allocation of assignments to them? Were commissions discussed and agreed to? Were individual works commented upon? Would a patron clearly express his preference for a given type of work or different style, and ask his artist to adapt himself to it? To what extent *was* an artist capable of bringing about a real shift in his style? Did artists instinctively recognize the emotional needs, or level of sensibility, of their patrons and bring about changes in the content or style of their work accordingly? In what circumstances was patronage withdrawn or extended?

Clearly, there are no firm answers: the documentation is too sparse. And, in any case, even in the broad matters of conduct and the tone of the relationship, nothing is likely to have been reduced to rigid rules. Within the framework of some predictable constants in the situation—like the fact that nearly all work was done for given patrons, or that the painter knew he was an employee with no clear rights to permanence of employment—one can envisage a whole range of equations being worked out, defying sharp definition.

Nothing can be said with certainty, for some variables within these equations must have been far too subtle, intangible, for us to be able to read them from this distance. All that one can hope to gain, therefore, is some insights. Here, one might usefully turn one's attention toward three different sets of situations within the relatively informal Pahari tradition: three rajas who are known to have been significant patrons of art, and three artists—represented by distinguished examples in the Bellak Collection—who worked for them.

Kripal Pal (reigned c. 1678–93; see fig. 24)—for whom the wonderful Bellak painting *The Awakening*

of Trust (cat. 26), exuding languid passion, was done—is a name that one comes upon early in the history of Pahari painting.[5] Relatively little is known of the reign of this ruler of the rather small but strategically located state of Basohli that lay within the Jammu group of states. While an ancestor of his, Sangram Pal (reigned 1635–c. 1673), is spoken of at some length in the vernacular histories of the state, and by J. Hutchison and J. Ph. Vogel, on Kripal Pal the latter have the briefest of notes. Stating that he came to the throne in c. 1678, they go on only to say that "Kirpal-Pal [sic] married two ranis, the first being a Princess of Bandralta (Ramnagar) and the second of Mankot (Ramkot). A patta, or title-deed, of his reign still exists in the possession of the descendants of the original grantee, and was given in s. [sic] 63 = A.D. 1687. He ruled for fifteen years and died in A.D. 1693."[6] Apart from the fact that most of the dates in Hutchison and Vogel are a bit shaky, this is remarkably little to go on. All the same, Kripal Pal has a place in history because of his visible association with painting. It is not only that one sees his portrait time and again—more often, one might add, than that of his better known ancestor, Sangram Pal—done in slightly varying styles and at different points of time; his name also figures in what can be seen as one of the most famous of all colophons in Pahari painting. The colophon appears at the end of a justly famous series of paintings of the Rasamanjari, that celebrated rhetorical text on nayakas and nayikas—"heroes" and "heroines"—by Bhanudatta, from which the dazzling if damaged leaf in the Bellak Collection (cat. 26) comes. It is an intimate scene of a young but self-aware nayika sensually stretched out on a bed on which her husband, having perhaps just returned from a campaign, comes and lies next to her, ardor written all over his frame. The four-line colophon, written in verse form in Sanskrit, is filled with vital information, and this is how it reads in translation:

In order to see well the creation of God and to realize the hollowness of this world, this beautiful cluster [chittarasamanjari], containing many pictures [which] are the wealth [i.e., creation] of mind, was caused to be prepared by Raja Kripal [Pal. It was completed] on Thursday, the seventh day of the bright fortnight of Magha [January–February] in the Vikrama year [which is] counted by the eyes (2), the arrows (5), the sages (7), and the moon (1) [v.s. 1752, or A.D 1695], in the town Vishvasthali [present-day Basohli], which lies on the beautiful banks of the Airavati [present-day Ravi], by Devidasa, who is well-versed in the art of painting.[7]

The colophon has been much written about and used, for it contains concrete information: a clear date, the reference to and location of a place, and the names of a patron and a painter. The raja, although mentioned only by his first name, can only be Kripal Pal, considering the mention of the place where the work was done. But Devidasa, apart from the reference to him as being "well-versed in the art of painting," is not clearly identified. The normal assumption would be that he also belonged to Basohli, where this series was completed, but thus far no information about a Basohli painter called Devidasa has surfaced, either in the form of an inscription or in the genealogies of painter-families. However, a painter by the name of Devidasa, from the neighboring state of Nurpur, across the Ravi River, is known from genealogical records relating to a family of painters based in Nurpur. It has been suggested, cogently, that the artist who figures in the colophon is that very Devidasa whose father, Kripal of Nurpur, is likely to have been the painter of a strikingly similar, but earlier, Rasamanjari series, and whose son, the locally celebrated Nurpur artist Golu, was responsible for yet another, but later, Rasamanjari series.[8]

All this gives rise to some thoughts and questions. If Devidasa was not from Basohli but from Nurpur, in what circumstance did he take up and complete this work for Kripal Pal at Basohli? Had he come and settled down at Basohli, or was the painting of the Rasamanjari a casual commission? Considering that Devidasa's son Golu continued to be active at Nurpur, and seems to have worked for the ruler of that state, Dayadhata, whom he inducted in the guise of a lover in one of his Rasamanjari leaves, it is more than likely that Devidasa himself was also essentially Nurpur-based. If this is the case, what might have brought him to Basohli? Had his reputation as a painter, as someone "well-versed in the art of painting," like the colophon says, spread? Was he specially invited by Kripal Pal to come and work for him? Or was he simply traveling and decided, in the course of some extended visit to Basohli, to produce, for the raja and for a consideration, a series he knew well from his own father's work?

Then again, was the choice of the theme Devidasa's or that of the raja, Kripal Pal? The opening lines of the colophon seem to contain some suggestion, even though one would do well to remember that very often the court pandit-poets who composed verses like these were governed as much by literary conventions as by considerations of meter and rhyme. One notices that the verse credits the ruler—he who "caused to be prepared" these paintings—with clear intent. But, interestingly, the reason given in the verses for having this series made—"in order to see well the creation of God and to realize the hollowness of this world"—sits rather oddly on a series of paintings that is essentially erotic in content, or has at least delightfully detailed—and complex—situations in love as its chosen theme. One is aware of the fact that, in many an Indian text, the erotic and the philosophical or the otherworldly manage to coexist, if not coalesce, rather well, but is it this coming together that is being hinted at here? Did the patron, or the writer of the colophon, see the verse of the Rasamanjari, which occurs toward the end of the text but here appears on the verso of the same last folio that bears the colophon, as signifying a turning away from the snares of the flesh? In that verse, the poet writes about, and Devidasa envisions, a situation in which the nayika urges her mind to give up its playfulness, her eyelids not to let her close her eyes, and Kama, the god of love, to allow her to divert her mind elsewhere, for suddenly stands before her "the comely Krishna, wearing a peacock feather on his forehead and blue lotuses in his ears and carrying a flute in his hand," a true vision of beauty and godliness. It is significant perhaps that, in Devidasa's rendering of the Rasamanjari verses, the nayaka, or hero—in a decided and conscious departure from the earlier Rasamanjari series of Kripal (see fig. 25)—

is not routinely cast in the mold of Krishna (blue-complexioned and wearing a lotus-topped crown) but as a mortal, worldly figure, and it is only in a verse like the one just described that Krishna suddenly appears. The painting depicting this verse (not illustrated here) has an air all its own, as, seeing the Lord outside her chamber, the *nayika* springs with alacrity to her feet, and stands at the edge of the carpet with hands folded, gazing at Krishna, who is lover and god at the same time, taking in his blessed sight. There is a feeling of devotion in it that runs counter to much that has gone on before in the paintings of the series. Could it be possible that the whole matter was discussed between patron and painter? In any case, Devidasa could not have been unaware of Kripal Pal's devout personal inclinations, something that even we, from this distance, know about, as much from his portraits in which he appears carrying on his body a long necklace of sacred *tulsi* beads, as from the colophon of another text written for him—a copy of the famed medical treatise, the *Sushruta Samhita*—which speaks of his being learned in the treatises on *dharma,* and being a devotee of Vishnu.[9]

Although other matters concerning Devidasa's *Rasamanjari* series have been discussed before, they also raise questions relevant here. That the series is related to, and draws upon, that brilliant, earlier *Rasamanjari* that can be attributed to Devidasa's father, Kripal of Nurpur, is abundantly clear. The format of the folios, the compositions, the intensity of feeling in the leaves, seem all to spring from the same matrix. But one also sees significant departures. One, for example, mentioned briefly above, is that the hero in Kripal's *Rasamanjari* is—when unspecified in Bhanudatta's text—Krishna, or at least modeled upon Krishna, whereas Devidasa's *nayaka* is a man of the world, often wearing a slight beard, dressed in the fashion of the day, complete with *jama* and *patka* and a tall, sloping turban. This *nayaka* does not always bear the same appearance in every folio, but there is no mistaking the fact that Devidasa introduces a recognizably worldly figure in his series, thus staying closer to Bhanudatta's original verses, which speak of a hero or lover, but not necessarily of Krishna. It would have been of great interest if Devidasa had modeled his *nayaka* upon his Basohli patron, Kripal

Pal, but that clearly is not the case: the appearances are quite different. But one certainly notes the fact. And the suggestion that comes to mind is that the decision might have been influenced either by the advice that some learned pandit at the court rendered to Kripal Pal, or by the raja's own views, if the phrasing of the colophon, and the brief discussion of it above, are any indication.

The other startling departure in Devidasa's *Rasamanjari,* from that of Kripal, involves what was possibly a painter's, not a patron's, decision. Suddenly, the tiny pieces of beetle-wing cases, emulating the shimmer of emeralds, which appeared everywhere in Kripal's folios—in jewelry, on dresses, even borne like fireflies on moisture-laden air—are gone. It is difficult to guess the reason. Given the feeling of respect and devotion for a father, which one associates with a son in those distant times, one might have expected Devidasa to continue using this brilliant device. But, like others—among them Manaku, who apparently used beetle-wing cases only in his 1730 *Gita Govinda* series—Devidasa seems to have decided to discard them. Why, we may never be able to fathom. Interestingly, Golu, Devidasa's son, while producing his own *Rasamanjari* in the next generation, does not return to them. It is as if, in a flash—an appropriate word!—they leave these folios. We thus encounter a painterly decision.

Nearly forty years later, we move close to another painter, another patron. The painter Nainsukh of Guler—in whose hand there is, in the Bellak Collection, that moving painting *The Poet Bihari Offers Homage to Radha and Krishna* (cat. 79)—is someone about whom we have fairly detailed information; but on his principal patron, Balwant Singh (1724–1763) of Jasrota (fig. 26), there is not more than a line that one can pick up from contemporary chronicles or even from later histories.[10] All the same, the connection between the two, as we know from the paintings, was close, almost magical. From Guler, where over him were the protective wings (or shadows?) of two highly gifted painters—his father, Pandit Seu, and Manaku, his elder brother—Nainsukh moved, somewhere between 1735 and 1740, to the tiny state of Jasrota, in the neighborhood of Jammu. There he worked, first, and on a casual basis perhaps, for

some members connected with the ruling house, but attached himself eventually to Balwant Singh, then but a young man of eighteen years. With this began an association that has become a legend in the annals of Pahari painting, because from it sprang one of the most engaging, delicately nuanced, bodies of any known painter's work. The considerations that led Nainsukh to move to Jasrota, or to attach himself to *mians* (minor princely figures) there, are not known. But one motivation can perhaps be ruled out: it was not for significant monetary gain. Balwant Singh is referred to as a "raja" in some of the inscriptions that have survived on paintings, but, almost certainly, he never sat on the throne of Jasrota, and might have been allowed the use of the title as a matter of courtesy or political prudence. This is worth noting, for no great riches can be associated with Balwant Singh; at the most, he enjoyed a modest *jagir,* and there are some indications that he had eventually even to leave Jasrota under unhappy circumstances, moving about in a poor state before settling down in an insignificant village in the Guler territories. And yet, until the very end of his life, Nainsukh remained attached to him, moving along with his prince to wherever his destiny, or his circumstances, took him, even accompanying his ashes to Haridwar in 1763. Theirs was clearly no ordinary bond.

It is possible to see Nainsukh's great work divided into three phases. The early phase, consisting of the work that he did in his growing years, somewhere between 1730 and 1740—among them, portraits of family members, versions of Mughal works through which he was coming to terms with a new kind of naturalism—does not concern us here. But the middle phase, work of the period between 1740 and 1760, does, however, for it is roughly during these years that he worked for Balwant Singh. In this period, Nainsukh did all manner of work: he has left behind portraits, court scenes, elaborate compositions with scenes of hunt and riding picnics, finished paintings, painted sketches, tinted drawings, the barest outlines of the first flush of thought. He worked with brush and reed pen, used thin washes of pigment or richly saturated colors, drew in black or sepia or vermilion, surrounded his paintings with the most exquisitely painted margins, or left them without a trace of

limiting line or border, as if asking them to go out in the world and stand on their own. But most of the work centered upon Balwant Singh, or things that interested him. Nainsukh sketched, drew, and painted his prince countless times, and in an extraordinary range of situations: alone and in company; formally attired or in a state of near undress; attending to purely private matters and to matters of state; in moods that vary from cheerful and buoyant to pensive and nostalgic. We thus see Balwant Singh writing a letter, savoring music, stalking a duck, watching a group of professional mimics and musicians (see fig. 27), examining a painting, riding out on a litter on a hawking expedition, striking a lion down with a bare sword, sitting with his sons, having his beard trimmed, listening to petitioners, supervising a construction, standing on a palace roof watching rain clouds, heading toward a forest for gaining the *darshan* (sacred gaze) of a goddess, seated in front of a fire before retiring, offering prayers, or simply smoking a *huqqa* in a camp bed, wrapped in a quilt and staring into space.[11] Nainsukh creates a nearly unique visual record of a life in this body of work, and brings us, through it, very close to feeling its texture.

It is certain that all this could not have been done without the consent of his prince, Balwant Singh, who not only took interest in these images of himself and of things around him, but also, like a true connoisseur, savored them, including those that made gentle fun of him and his little foibles. One can imagine painter and patron poring over pictures together, making points, delighting in detail, thinking of other themes or occasions. Whether every single painting or portrait that Nainsukh made for Balwant Singh was approved by the prince is not of consequence; the general feeling one has is of the two collaborating on artistic projects, conspiring, as it were, in order to create an intimate but different, precious world. The two must have shared other interests—in music, for example, or in the subtly varying moods of nature—and one can visualize a feeling of great companionability, of mental closeness, growing with time. But the necessary distances, it needs to be remembered, must also have been kept. One has only to see the celebrated work *Balwant Singh Looking at a Painting*

with Nainsukh (see fig. 26) to get a sense of the atmosphere that must have prevailed at Balwant Singh's modest little court. In it, while Balwant Singh sits on a magnificent throne, smoking a *huqqa*, as a group of seated musicians sing and play facing him, Nainsukh himself stands most humbly behind the prince's throne, body bent forward, hands folded, offering, perhaps, his comments on a painting that the prince holds in his hand.

It might be a matter of the accident of survivals, but other than the Balwant Singh pictures, there are few works in this period that one can easily associate with Nainsukh. However, most interestingly, the situation seems to change dramatically when another patron appears on the scene after Balwant Singh's death in 1763. There is evidence that Nainsukh attached himself then to another raja, Amrit Pal (reigned 1757–78) of Basohli—a relation of Balwant Singh—and worked for him till the end of his own life in 1778. But Amrit Pal was no Balwant Singh, and both his personality and his interests seem to have been very different. The late phase of Nainsukh's work consists therefore not of a record of his new patron's life and career, but of things that interested his piously inclined mind. We see Nainsukh involving himself with different projects: a *ragamala*, for instance, a *Gita Govinda*, possibly a Bihari *Satasai* series to which the Bellak picture (cat. 79) belongs. It is easy to envisage that as Nainsukh entered the service of Amrit Pal, there was some discussion, perhaps a clear indication by the patron of his wishes and his expectations of his retained artist. Even if he was not told, Nainsukh must have been quick to sense this. Different things, different realms, beckoned Amrit Pal, and Nainsukh must accordingly have set his art on a different course, adjusting with marvelous ease to the new situation. In this phase there appears an intense interest in texts, both religious and poetic, and a reaching out toward a different world. The new patron seems to have been less involved in issues of connoisseurship—matters of style and quality and the like—than in those concerning themes. But in some ways Nainsukh's great gifts as a painter were so established by this time, his skills so honed, that he could have been relied upon to go well past what was merely visible in any subject, to take a moment

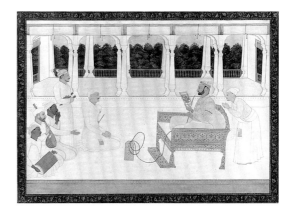

FIGURE 26
Balwant Singh Looking at a Painting with Nainsukh. Panjab Hills, Basohli or Guler; c. 1745–50. Opaque watercolor and gold on paper; 8 1/4 x 11 13/16 inches (21 x 30 cm). Museum Rietberg, Zurich, RVI 1551

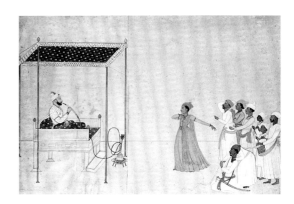

FIGURE 27
Balwant Singh Watching a Group of Mimics and Musicians. Attributed to Nainsukh. Panjab Hills; c. 1750–55. Opaque watercolor on paper; 9 7/8 x 14 3/4 inches (25 x 37.5 cm). Victoria and Albert Museum, London, I.S. 24-197

and throw it clear beyond the reach of time. As for Amrit Pal's preference for the more classical and literary among themes, this might, considering Nainsukh's advancing years, even have agreed with his own inclination. These themes were not alien to him, considering the work done by his elders, Pandit Seu and Manaku, that he must have seen in his own family. But these things surface afresh now, and Nainsukh approaches his task with supreme calm. It is as if his interest in the present—as manifested in portraits and court scenes—all but declines on its own, and his mind centers upon seeing a vision that others before him had seen in their own ways.

A different work in the Bellak Collection—*When He Quickens All Things* (cat. 87)—leads one to the rich and powerful world of Sansar Chand of Kangra, the last of the patrons to be considered here. Here, a different set of issues concerning the relationship between painter and patron comes to the fore. The petition the painter Shiba addressed to him (see above) does not necessarily dispose one in the maharaja's favor, but he certainly was a figure whose fame transcends his times.[12] Reigning from 1775 to 1823 as he did, Sansar Chand controlled substantial power and means for at least thirty of these years, and was the overlord of the hills until he was outmaneuvred and eclipsed by Ranjit Singh, the Sikh maharaja of the Panjab. Unlike Kripal Pal of Basohli and Balwant Singh of Jasrota, he figures with some prominence in the history of these parts; one also knows something about him from other sources, such as the journal of the English traveler William Moorcroft, who spent some time at his court in 1820.[13] The picture that emerges of him from these accounts is of a man interested in the arts—there is even an unpublished gloss on a rhetorical poetic text in Hindi authored by Sansar Chand in his young years. And even if he was not "the Hatim of that age" and "the Rustom of that time," as a Persian chronicler describes him, he seems to have attracted to his court, justly, "crowds of people of skill and talent."[14]

The evidence of paintings in this respect is direct, and almost overwhelming. Sansar Chand figures repeatedly in them: alone; with members of his family, especially his two brothers and his son Aniruddha Chand; holding court and seated in conversation with other ruling chiefs from the hills; celebrating festivals and entertaining guests. His interest in painting seems by no means to have been confined to portraits of himself and scenes glorifying his own power or chronicling his career. There was much else that interested him, according Moorcroft.[15] The Englishman seems to have grown fond of his Rajput host in the course of his stay, and his account of the raja, with whom he came into contact when the raja's fortunes had diminished but the memory of his former grandeur clung to his name, is generally warm and sympathetic. Noting that the ruler "passes more of his time at chess and music than consists either with his age or circumstances," Moorcraft also speaks of his spending long hours at his devotions and of watching, in the evening, "Nachs in which the performers generally sing Brij Bhakha songs generally reciting the adventures of Krishna and those of the Gopees."[16]

"He is fond of drawing," Moorcroft continues, and "keeps several artists who execute the minute parts with great fidelity but are almost wholly ignorant of perspective His collection of drawings is very great but the principal portion consists of representations of the performances and prowess of Arjoon, the Hindoo Hercules [and] the adventures of Krishna so similar to those of the Grecian Apollo, especially in birth and education that no doubt can reasonably be entertained of their relating to the same person." In this account, Moorcroft returns again and again to his own judgment of these works: "Though many of the drawings have great merit independently of want of perspective there is much defectiveness of the principle of the design, there being sometimes three or four representations of the same act in the same picture." But whatever he says about the collection continues to remain of interest. Thus he observes that "the collection of coloured drawings in the possession of the Raja relating principally to Hindoo Mythology is immense," and that "the collection includes many hundred drawings and the Raja has portraits of all the neighbouring families. I found two side portraits of Alexander the Great, one of which Rao Unrood Chand gave me."[17]

If a great many Pahari paintings have been published as being from Kangra—essentially almost any work softly colored and delicately drawn and romantic in theme—leading to a clouding of issues, it is because Kangra was indeed the preeminent among hill states at the time to which these paintings relate, and Sansar Chand, as its most famous ruler, was widely known to have been a major patron of the arts. But through evidence such as that of Moorcroft, and the fact that different families of painters whose genealogies it has been possible to trace in pilgrimage records were settled in towns or villages within the Kangra territories, the importance of Kangra as an artistic center is further underscored. There is also the memory preserved in the region of specific artists who were active in Kangra, and mid-nineteenth-century British surveys of the Panjab speak of some "Kangra" artists whose names were at that time still in the air.

Obviously, then, there is much that was happening in Kangra. The list of painters or painter-families whose names are, or can be, linked with the region, and thus with Sansar Chand, is in itself impressive.[18] The name of Shiba has been encountered already; the family to which he belonged was settled in the tiny village of Ustehar, near Samloti, not far from Kangra. Purkhu, son of Dhummun and a member of a family settled at Samloti, has always been seen as attached to the Kangra court under Sansar Chand (fig. 28). Shiba's petition mentions the painter Gaudhu, a name known to have belonged to one of the sons of Nainsukh. Khushala, whose name J. C. French probably misheard as "Kushan Lal," is again spoken of as being a prominent painter at Sansar Chand's court, and he is not likely to have been anyone else than one of Manaku's two sons, and thus brother of the artist Fattu. Sajnu, son of Moti, belonged to a family that hailed from "Kangra Fort"; other names, such as Uttam, Fauju, Gosaun, and Lalman—all of them belonging to families settled in the Kangra territories—similarly surface either from the genealogies in pilgrimage records or from the Land Settlement Records prepared by the British. Incidentally, the greater the number of artist-families that can be identified as having been active in Kangra, the less likely it is that any single style can be designated as "Kangra," for families had their own styles and their members tended to adhere to it over long periods.[19]

At Kangra, then, one can speak of a great deal of artistic activity, but not of any one given kind or monolithic style. Gaudhu and Khushala—the latter's name figures incidentally in a somewhat problematic inscription at the back of one of the Bellak paintings (see cat. 85)—could only have been working in that seductively fluent style that one associates with the first generation after Nainsukh. And Purkhu, or his two brothers, one can easily envisage as turning out work in the style in which a great many of the paintings of Sansar Chand's family and court are done. Again, Shiba's hand may be seen in the large and extensive *Mahabharata* series, one of the leaves of which bears, possibly, the name of Bassia, his father,[20] and to which Moorcroft perhaps refers when he speaks of so many "coloured drawings" in Sansar Chand's possession that depicted the exploits of "Arjoon, the Hindoo Hercules." The hand of some of the others with a Kangra affiliation—even this list, one needs to say, is only partial, and there may have been many more painters about whom we know nothing at present—is still not securely identified, but Sajnu, whose work *is* known, seems to have been active more at Mandi than at Kangra.

Viewing all this, one can be certain that there was a wealth of talent at Sansar Chand's court at Kangra or, later—when circumstances forced him to abandon the Kangra fort and town—at Sujanpur. The question, however, would be about the allocation of work in such a situation. If one assumes that Sansar Chand's own interests were wide-ranging, and that he was as interested in narrative religious texts (the epics and the *Puranas* among them) and in classic literary works (such as the *Gita Govinda* or the *Rasikapriya)* as he was in portraiture and in painted records of his own family and his court, one also has to imagine his having to decide about asking different painters to undertake various tasks for him. It certainly would have been open to the painters to do some work on their own initiative and present it to the raja, but major projects or tasks, it is fair to assume, would have been embarked upon under royal command, or at least with royal approval.

Unfortunately, there is very little documentation available on what work was actually produced for Sansar Chand. References to his "immense" collec-

tion of paintings (Moorcroft's "coloured drawings") apart, we know virtually nothing about what specific sets or series were produced in Kangra. There are no colophons at hand to provide precise information, and other sources, such as Moorcroft, only give information about Sansar Chand's collection that is, at least for the present purpose, somewhat general: paintings dealing with "the prowess of Arjoon" and "the adventures of Krishna"; "subjects from the Mahabharut . . . , some of which for decency's sake might have been spared"; "portraits of all the neighbouring families"; "two side portraits of Alexander the Great"; many works "relating principally to Hindoo Mythology"; and "representations of his own court."[21] If, however, basing oneself on this and on other grounds that are argued by W. G. Archer,[22] one places some of the great Pahari series produced in the first generation after Nainsukh in Kangra—the *Bhagavata Purana*, the *Gita Govinda*, the *Ramayana*, and the *Satasai*, among them—then one can imagine these having been produced by Khushala and Gaudhu, and whichever other members of this family worked for Sansar Chand. Given the history of the work produced by this family earlier, and the great elegance of line that living members of it commanded, the assigning of these projects to these painters would make perfect sense, even if it remains speculation. On the other hand, there is a truly large number of works that are clearly related to Sansar Chand himself—his family and his court—and nothing needs to be argued about these having been produced for him, at his court. These, one can see, are in the hand of Purkhu.[23]

The decision to ask Purkhu, or closely related members of his family, to record his life and his activities must have been made by the maharaja himself, although his reasons must remain the subject of conjecture. That there were other painters working for Sansar Chand who observed well, who even had a decided flair for portraiture, cannot be doubted: if they had learned anything from Manaku or Nainsukh, the cousins Khushala and Gaudhu must have been very skilled at rendering likenesses and organizing compositions involving large groups. But there is very little that one sees from Sansar Chand's personal court in their hand: only an occasional pro-

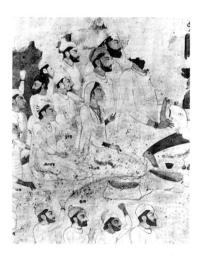

FIGURE 28
The Court of Raja Sansar Chand (detail). Attributed to Purkhu. Panjab Hills, Kangra; c. 1785. Location unknown

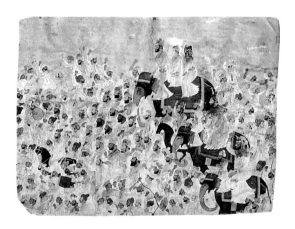

FIGURE 29
The Wedding Procession of Prince Aniruddha Chand of Kangra. Attributed to Purkhu. Panjab Hills, Kangra; c. 1800–1805. Opaque watercolor on paper; 15 1/2 x 20 1/2 inches (39.5 x 52 cm). Government Museum and Art Gallery, Chandigarh, 351

cessional scene, a portrait of the ruler himself, the likeness of a visiting dignitary. However, Purkhu's talent could not have been limited to portraiture or court scenes: mythology and literature were within his reach, too. Was the maharaja's consideration then that painters should be assigned such work as suited their talent best, put to its maximum use? It is also not unlikely that while Khushala and Gaudhu were, strictly speaking, outsiders, Purkhu—and, before him, his father, Dhummun—had been attached to the Kangra court well before Sansar Chand came to power, and had worked for Ghamand Chand and Tegh Chand, the maharaja's grandfather and father, respectively. Earlier portraits in a style close to Purkhu's seem to suggest this. It might therefore have been somewhat natural for them to continue doing this under Sansar Chand, building upon their closeness to the family and on the fact of being part of an inner, intimate circle.

One knows that Purkhu was not the keenest student of appearances, and there is some lack of penetration in his studies of individual character. But he had other strengths: a different kind of subtlety operates in his work. As has been said elsewhere:

> The references to reality in his paintings are clear and repeated, but there is also a certain volitional distancing from it. Men are observed well; moments are understood. But, somehow, everything seems to be part of a flux. Individual paintings seem to be elements of a large design that he had in mind. It is as if Purkhu saw himself as an observer of the majestic flow of time, the natural rhythm of things. Quite possibly this is the reason why he is at his best when rendering crowded, animated processions with figures that fill a page from corner to corner and seem to go on endlessly, spilling out of their edges and into our awareness [see fig. 29].[24]

Could it be possible that the maharaja also saw life in the same manner, and with the same eyes, as his painter did? If so, this would explain his charging Purkhu, almost to the exclusion of anyone else, with the task of recording the flow of life at his own court, and within his own close-knit family.

The three Pahari painters spoken of here, like other painters elsewhere, lived in a world made and ruled by others, but also brought into being parallel worlds of their own. To know these worlds, and what it took to make them, one needs to look hard and wide, and one needs *utsaha*, the energy that classical Indian texts speak of. One needs, in other words, to equip oneself, for, in the final analysis, looking at works of art is a little like embarking on a personal voyage.

1. See Archer 1973, vol. 2, p. 200, Kangra no. 16. This painting is said to have been once in the Lambagraon collection, but is no longer traceable. Interestingly, another painting, with more or less the same setting, shows Sansar Chand's son, the prince Aniruddha Chand (often misidentified as Sansar Chand himself), also looking at paintings in the company of companions and courtiers. See ibid., p. 198, Kangra no. 10.
2. For a reconstruction and an analysis of the work of the members of this gifted family, see Goswamy and Fischer 1992, pp. 211–305.
3. Ibid., pp. 95–125.
4. For the full text of this unusual document and a discussion, see B. N. Goswamy, "A Painter's Letter to His Royal Patron: An Old Tākrī Document," *Journal of the American Oriental Society,* vol. 86, no. 2 (April–June 1966), pp. 209–16. The translation here has been slightly revised.
5. For a brief reconstruction of Kripal Pal's reign and the work done at his court, see Archer 1973, vol. 1, pp. 17–18.
6. Hutchison and Vogel 1933, vol. 2, p. 605.
7. The colophon was first published by Hiranand Sastri in *Indian Pictorial Art as Developed in Book-Illustrations* (Baroda: Baroda State Press, 1936), and his reading of it has, with very minor reservations, been accepted by most scholars.
8. See Goswamy and Fischer 1992, pp. 59–73.
9. Kahan Singh Balauria, in his Urdu history *Tawarikh-i Rajputan-i mulk-i Punjab* (Jammu, 1912), drew attention to this manuscript, while writing on Kripal Pal's reign.
10. The life and times of Nainsukh, touching naturally upon the life and times of his patron, Balwant Singh of Jasrota, are now the subject of a full study: B. N. Goswamy, *Nainsukh of Guler: A Great Indian Painter from a Small Hill State* (1997). The present reconstruction of the relationship between Nainsukh and Balwant Singh draws freely upon that study.
11. All the works known to be by Nainsukh, or reasonably attributable to him, are reproduced in Goswamy 1997. A number of them have been known to scholars for many years, but, obviously, many more by Nainsukh have survived.
12. For a fairly detailed account of Sansar Chand's reign, see Hutchison and Vogel 1933, vol. 1, pp. 176–93; and Archer 1973, vol. 1, pp. 249–56. Also see M. S. Randhawa, "Maharaja Sansar Chand—The Patron of Kangra Painting," *Roopa-Lekhā,* vol. 32, no. 2 (December 1961), pp. 1–30.
13. William Moorcroft, "Manuscript Journal," 1820, India Office Library, London; excerpts from this and other writings by Moorcroft are reprinted in Archer 1973, vol. 1, pp. 261–63.
14. Khandalavala 1958, p. 148.
15. William Moorcroft and George Trebeck, *Travels in the Himalayan Provinces of Hindustan and the Panjab . . . from 1819 to 1825,* ed. Horace Hayman Wilson (1841; reprint, New Delhi: Sagar, 1971), vol. 2, pp. 142–45.
16. Moorcroft, quoted in Archer 1973, vol. 1, p. 262.
17. Ibid., pp. 262–63.
18. The genealogical tables of several families of painters settled in Kangra, or its environs, can be reconstructed from the information available in pilgrimage records. Many of those entries have been photographed, but a part of the information is still pending full publication.
19. This point was first argued at some length in B. N. Goswamy, "Pahari Painting: The Family as the Basis of Style," *Marg,* vol. 21, no. 4 (September 1968), pp. 15–57, 62. The paradigm suggested in that study underlies much later work, including Goswamy and Fischer 1992.
20. The name occurs in an inscription on a leaf of a *Mahabharata* series; the leaf was acquired from the Bharany family for the National Museum, New Delhi.
21. Moorcroft, quoted in Archer 1973, vol. 1, p. 262.
22. Ibid., pp. 290–310.
23. See Goswamy and Fischer 1992, pp. 367–87.
24. Ibid., p. 372.

1. King Vajrasimha and Queen Surasundari in Conversation

Page from a dispersed manuscript of the *Kalakacharyakatha*
Gujarat, c. 1375–1400
Opaque watercolor, ink, and gold on paper
2 9/16 x 9 7/16 inches (6.5 x 24 cm)

This exquisitely illustrated page of a Jain text is among the earliest works on paper from the Indian subcontinent. Its long, horizontal format mimics the narrow dimensions of the palm-leaf pages regularly used for religious manuscripts before Muslim raiders and merchants imported paper and papermaking technology from western Asia in about the fourteenth century. In addition, it bears residual reminders of the palm-leaf binding technique in the form of a prominent red circle *(chandraka)* painted at the center where a string hole would have been, and indeed, although the hole is now filled, this page was once bound with a central string. In addition, the red dots to either side still carry folio numbers, as was also the practice on palm-leaf pages. Although the illustration occurs close to its textual description, the text runs from left to right on the full page, despite the interruption of the illustration and borders, and it is written out continuously on the front and back of the folio. Thus there is only an indirect relationship between the picture and that portion of the text that appears on the page.

The distinctive style of this illustration is often termed "Western Indian" or "Jain," although it is entirely exclusive neither to the region (see cat. 4) nor to Jain patronage (see cat. 6). The palette consists of red, black, white, yellow, green, blue (from lapis lazuli), and gold, the last two used sparingly in the early Jain works. The colors are jewel-like and luminous, painted in flat, saturated areas with only rare touches of tonal modulation. The earliest illustrations, from the second half of the fourteenth century into the fifteenth, often display, as here, the background of solid red that had been typical of earlier palm-leaf paintings. Wiry black lines delineate the figures and setting, seldom overlapping but making up a richly patterned surface. Clarity rather than spatial depth is paramount in the composition. The figures have oversize heads, and their flexed limbs make exaggerated gestures. Lower bodies are depicted in profile; upper bodies, with wide shoulders tapering to tiny waists, are twisted into an almost frontal view.

While the faces are shown in sharp profile, both eyes are drawn frontally, so that the eye on the hidden side of the face projects outward into space. Although this feature has an earlier history, it becomes a distinguishing characteristic of Jain painting from the fourteenth century onward. These Jain images also display a fascination with sumptuously patterned garments and furnishings, which is not surprising since the Jain community was in large part mercantile and closely involved with western India's extensive international textile trade.

Jain illustrated texts were produced for donation to monastic libraries, the donor gaining religious merit in the giving. They were primarily patronized by members of the Shvetambara tradition, one of the two main branches of Jainism. This painting formed part of a dispersed manuscript of the *Kalakacharyakatha* (Legend of the Teacher-Monk Kalaka), read and venerated by the Shvetambaras especially during the annual rainy-season festival of Paryushana. A compilation of legends about a number of individuals, the text is primarily based on the life of Kalaka, a leader of the Shvetambara hierarchy in the fifth century A.D. The story begins with the conversion and initiation of Kalaka as a Jain monk. It then narrates the battle in which Kalaka, aided by the Sahis (local rulers from Central Asia), overthrew the wicked king Gardabhilla of Ujjayini, and concludes with the remainder of Kalaka's life and teachings.[1]

This first page of the manuscript shows Kalaka's parents, King Vajrasimha and Queen Surasundari. They rest beneath a canopy *(chandarvo)* on an elaborate golden throne, upholstered in a swirling red and pink fabric. The king holds a sword in one hand and a dagger in the other, with one finger raised to indicate that he is conversing with the queen. She, too, displays a gesture indicating discourse, her palm turned inward with thumb and index finger touching. Both are elaborately bejeweled in gold and pearl ornaments.

Stylistic comparison with many related works that bear colophons can yield a fairly accurate dating for this page. The narrow page proportions, fine outlines, red ground, and delicate physiognomy, among other features, link it both to late works on palm leaf, such as a *Kalpasutra* of A.D. 1382,[2] and to other early works on paper, such as a *Kalpasutra* and *Kalakacharyakatha* of A.D. 1381.[3] It also closely resembles other manuscripts that are without dated colophons but attributable to about 1375–1400. The images, for example, are particularly close to those in a manuscript in the Prince of Wales Museum, Mumbai,[4] showing such strikingly similar details as the peculiarly shaded beard, long-nailed fingers, and preference for half-tone textile patterns.

Four other pages from the same manuscript as the Bellak page have recently been published as part of the Goenka Collection.[5] The five precisely match in size, format, and calligraphy. The Goenka pages do show more vibrant colors, as is understandable given that they come from the unfaded middle pages of the manuscript, and also retain the string holes in their central *chandrakas* (that on the Bellak page was filled at some point in its history). In discussing the Goenka pages, B. N. Goswamy and Usha Bhatia hypothesize that several painters contributed illustrations to this manuscript, filling in the work of a single pagemaker and calligrapher. This likely accounts for the slight differences in drawing found among the five illustrations. DM

1. See W. Norman Brown, *The Story of Kālaka: The Kālakācāryakathā* (Washington, D.C.: Freer Gallery of Art, Smithsonian Institution, 1933).
2. In the collection of Nemi Darshana Jnanshala, Palitana, Gujarat (Umakant P. Shah, ed., *Treasures of Jaina Bhaṇḍāras* [Ahmedabad: L. D. Institute of Indology, 1978], figs. 23–28).
3. National Museum, New Delhi (Chandra and Shah 1975, figs. 8–8a).
4. Saryu Doshi, *Masterpieces of Jain Painting* (Mumbai: Marg Publications, 1985), fig. 4 (color).
5. Goswamy with Bhatia 1999, pp. 9–11, nos. 8, 9. They identify the manuscript as a combined *Kalpasutra-Kalakacharyakatha*, but there is actual evidence only of the latter. I thank Shridhar Andhare (personal communication, 2000) for confirming the connection between the Goenka pages and the one in the Bellak Collection.

2. *Scenes from the Life of the* Jina *Parshvanatha*

Gujarat, c. 1450–75
Opaque watercolor on cloth
20 x 20 inches (50.8 x 50.8 cm)

This early and extraordinarily fine narrative *pata* (cloth painting) depicts the central image of Parshvanatha, one of the Jain savior-saints (*jinas*), surrounded by attendants and scenes from his life. It is rather like a condensation of illustrations from a manuscript, with each clearly bounded panel fitted together like a collage, and it was obviously painted by an artist trained in the manuscript tradition. Such large-scale paintings, intended for devotion and meditation, are done on a ground of cotton cloth coated with a flour paste and burnished to provide a smooth, canvas-like surface.[1] The paint then applied uses the same range of pigments common for contemporaneous manuscript illustrations.

Jinas are human beings who have perfected themselves over many lifetimes by practicing self-denial, helping others, and inflicting no harm on any living creature (see cat. 4). They have reached a state where they are omniscient, blissfully enlightened, and free from the cycles of rebirth. There have been twenty-four *jinas* so far in this world cycle—Parshvanatha, depicted in this painting, is the twenty-third and may have been an actual person who lived in about the eighth century B.C.

Iconographically, Parshvanatha is one of the few readily identifiable *jinas,* thanks to the cobra that invariably shelters him. This cobra refers to the incident in his life when the serpent-king, Dharanendra, used his hoods to shelter the future *jina* from a terrible rainstorm sent to break his concentration. At the center of this composition, Parshvanatha meditates while standing in a lotus pool. Above him, a mass of serpent heads rises like a great halo, topped by the umbrellas of royalty. Small male attendants surround the *jina.* Larger female attendants, some of whom are cobra-topped to indicate that they are the wives of the snake-king, fill the panels to either side. The panel below Parshvanatha's feet shows, on one side, an elephant-headed *yaksha* (male protective divinity), and, on the other, a Shvetambara monk who pays homage to the footprints of the *jina.*

The remaining panels illustrate the major events of Parshvanatha's life, which follow the basic pattern seen with all *jinas.* They begin at the upper left with his birth and celestial postpartum bath (the baby rests in the lap of the seated deity) and proceed to the upper right, where he is carried in a chariot to the ceremony where he renounces the material world, in part by plucking out his hair to become a monk (see also cat. 4). The next scene in the narrative sequence is found at the lower center, where Parshvanatha stands in meditation.[2] Finally, he attains ultimate omniscience and liberation in the panel at the lower left, where he appears on a cres-cent moon, representing the pinnacle of the universe, and teaches within a mandala-like heavenly hall. The remaining panel at the far right shows two identical images under temple towers, surrounded by monks and devotees who continue to worship the now-absent *jina* at various important temple pilgrimage sites.

By the mid-fifteenth century, when this *pata* was produced, the elements of Jain painting in western India had become extremely standardized, as the same foliage, furniture, ornament, and figures were combined and recombined. Figural compositions used in narratives, particularly in the lives of the *jinas,* constituted a narrowly circumscribed repertoire with each episode readily identifiable in generic if not specific meaning. Painters working in this style, while predominantly producing works for Jain patrons, also illustrated texts for Hindu patrons using the same conventions.[3] DM

1. For a discussion of Jain *pata* paintings see Shridhar Andhare, "Jain Monumental Painting," in Pal et al. 1994, pp. 76–87.
2. The figure on the far right, according to Andhare (ibid., p. 226), is the Shvetambara monk Kalaka (see cat. 1) and represents his pilgrimage to sites holy to Parshvanatha.
3. Such as the *Visantavilasa* or the *Balagopalastuti.* For the possibility that these painters also worked for Muslim patrons, see cat. 6.

3. *Page from a dispersed manuscript of the* Kalakacharyakatha

Gujarat or Rajasthan, c. 1475–1500
Opaque watercolor, ink, gold, and silver-colored paint on paper
4 3/8 x 11 13/16 inches (11.1 x 30 cm)

While this page from a *Kalakacharyakatha* (see cat. 1) bears no narrative illustration, its sumptuous red ground, silver writing, and rich borders heavy in precious lapis lazuli pigment reflect the Jain devotees' practice of commissioning copies of sacred texts and donating them to monastic libraries. The more costly the pigments and the more lavish the workmanship, the greater the spiritual merit accrued by the donor. By the late fifteenth century the richness of these productions had reached a point of balance, where the page was covered in precious pigments but attention to fine draftsmanship still remained a priority.

Possibly under Islamic influence, the borders and panel dividers in Jain manuscripts grew from simple lines (see cat. 1) into textile-like patterned bands that at times included figures, elements of landscape, and even small narrative scenes.[1] On this page, the top and bottom borders are formed of an interwoven blue and red pattern. The central vertical strip shows highly stylized vegetation punctuated by a gold diamond that is the vague descendant of the earlier red dot through which a binding string had been passed (see cat. 1), now merely a convention. On either short side, more elaborate borders depict male and female devotees and/or donors in courtly garb, each holding what appears to be a lamp. The male is crowned and has a red halo, perhaps indicating that he is a king. Each stands beneath a formalized tree, a parrot perched above that sheltering the man. The figures bear no relationship to the portion of text written on the page.

The figures themselves are close to those found on another Jain painting in the Bellak Collection (cat. 2), even to such details as the long line projecting from the outer corner of the eye. Although lacking the fineness and delicate detailing seen in Jain paintings of the previous century (cat. 1), these figures have a liveliness of line and an alertness of posture and expression that energize the entire page. DM

1. See, for example, a manuscript bearing a date equivalent to A.D. 1501 in the Ancalagaccha Bhandar, Jamnagar, Gujarat (Chandra and Shah 1975, figs. 26–29); and one of c. 1475 in the Devasano Pado Bhandar, Ahmedabad (Khandalavala and Chandra 1969, figs. 45–93).

4. *Mahavira Plucks Out His Hair*
Mahavira Assaulted by the Cowherds (reverse)

Page from a dispersed manuscript of the *Kalpasutra*
Uttar Pradesh, Jaunpur, manuscript dated 1465
Opaque watercolor, ink, and gold on paper
4 5/8 x 11 9/16 inches (11.5 x 29.4 cm)

The *Kalpasutra* manuscript from which this page comes is a significant landmark in the history of early Indian painting, for it carries a colophon giving, among other information, both the time and place of manufacture: A.D. 1465 in the city of Jaunpur, Uttar Pradesh.[1] Jaunpur was home to one of the Muslim sultanates of northern and western India, whose regional influence expanded as the centralized power of the Delhi sultans declined during the fifteenth century.

The *Kalpasutra* is a sacred text that tells the life of the *jina* Mahavira, the last of the twenty-four Jain savior-saints, who lived in the sixth century B.C. In Shvetambara Jain practice, this text is read aloud before the reading of the *Kalakacharyakatha* (see cats. 1, 3) during the annual festival of Paryushana. The lives of all the *jinas* (the word means "conqueror" or "liberator") follow a similar pattern, and five events assume primary significance: the *jina*'s descent into his mother's womb, his birth, his renunciation of material wealth to become a monk, his achievement of omniscience, and his death or great release from the cycles of rebirth (see cat. 2).

The front of this page shows Mahavira at the crucial moment when he takes his vow as a monk. He has already abandoned the princely clothing that is his birthright and now wears only the simple white lower garment of a Shvetambara (White-Clad) monk; his distended earlobes emphasize his absent jewelry. With one hand he grasps a hank of his long hair,

preparatory to plucking it out in the tonsuring (*diksha*) that will complete his renunciation. He leans toward the four-armed god Indra (Shukra), king of the gods' heaven, whose royalty is denoted by his crown and sumptuous clothing, including a lower garment with rich printed pattern and a diaphanous blue scarf, characteristically flying outward as if in a constant breeze. Indra has come to earth to honor the *jina* and will catch his cast-off hair in the golden "diamond" cup he holds in his raised hands. The scene is said to take place in the wilderness, but the landscape pictured here is one of orderly convention. Balloon-like trees bend over the figures, a pink leaf floats on the hot red ground, and alternating blue and striped-brown spikes indicate the rocky landscape.

The image on the reverse of the page shows a slightly later point in the story. Mahavira, now in the white garments of a monk, stands in *kayotsarga-mudra*, the body-denying pose of standing meditation. His meditation takes place in a lotus pond, indicated by the blue square beneath his feet and the lotus buds that seem to grow from his head. That he is further along on the path to enlightenment than in the earlier image is indicated by the presence of the *shrivatsa*, the diamond-shaped mark of a perfected being, on his chest. Over his head, as over a king, is a canopy ornamented in a pattern of *hansas* (ganders), a bird that symbolizes the connection between heaven and earth and a popular textile motif.

This episode tells of a threat to Mahavira's contemplation in the form of a cowherd who, finding his straying animals clustering around the monk in adoration, believes he has caught the *jina*-to-be in the act of cattle rustling and threatens him with an ax. The sage, however, has the power to ignore even such weapons to complete his endeavor. In a composition as formally symmetrical as the landscape on the other side, two nearly identical cowherds stand on flat lines of ground, an interesting convention that allows them to threaten Mahavira's head while remaining substantially smaller, as befits their status in the story. Below each cowherd are tiny bovines who, unlike their masters, have recognized the power and goodness of the sage and gaze up at him adoringly.

The neat gold writing is placed on a ground of deep red that is very different from the bright red pigment used as a background to the illustration. The three red dots reminiscent of earlier palm-leaf manuscripts (see cat. 1) have now become merely elements in the patterning and appear only on the front of the page, while a single blue dot marks center page on the reverse. Surrounding the written block and subdividing it without relevance to the text are margins of a variety of textile-like floral patterns on unpainted backgrounds. The blue lines that frame them as well as the illustration give the impression of interwoven strips that overlie a ground of text. DM

1. Translated in Khandalavala and Chandra 1969, p. 24.

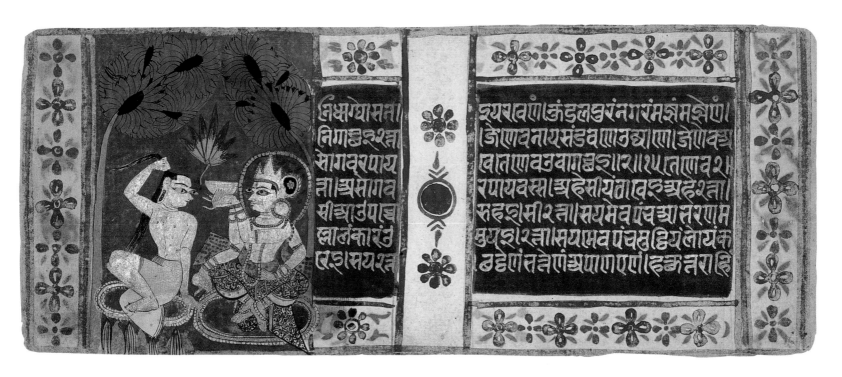

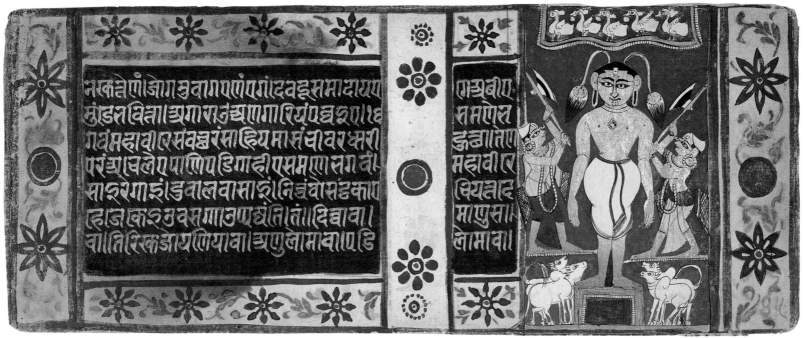

5. Double folio from a Qur'an

Sura 5, "The Table" (*al-Ma'ida*), Verses 72–74
Central Asia, or Turkey, Anatolia, c. 1330–50
Opaque watercolor, ink, and gold on paper
11 3/8 x 14 11/16 inches (28.9 x 37.3 cm)

Writing has special importance in Islamic culture. Revered as the means by which the Qur'an, the holy scripture of Islam, was recorded, writing in Arabic script became more than a functional means of communicating verbal information. It gradually acquired symbolic meaning in its own right and appeared as an auspicious decorative element on all kinds of objects. In this role and particularly in the copying of the text of the Qur'an, writing gradually gave rise to the fine art of calligraphy, the conscious aestheticization of the rhythms of the vertical, horizontal, and curved letters of the Arabic script. By the tenth century, the rules of fine writing had been codified and six different cursive scripts had been systematized. An angular script commonly known as Kufic had been used in most manuscripts of the Qur'an copied before this time; from the eleventh century on, the text proper of the Qur'an was normally written in one of several cursive scripts, and the more formal Kufic script was retained only for the titles of *suras* (chapters).

This continuous pair of folios from a well-known fourteenth-century copy of the Qur'an offers a compelling combination of formal elements of great power and delicacy. The Qur'anic text itself is written in the boldest of the cursive scripts, Muhaqqaq, whose very name means "strongly expressed." Its most characteristic features are the markedly extended vertical elements, which typically begin with an upward hooked stroke, and the flattened but sweeping shapes of letters that in most other scripts form a round bowl or descend in a slight curve at a 45-degree angle. (Both these features can be seen clearly in the uppermost line of the folio on the right, which reads from right to left, as do all forms of Arabic script.) The calligrapher penned only three lines per page, an extraordinarily spacious layout designed to accentuate the vigorousness of the Muhaqqaq script. Juxtaposed with the thunderous horizontal rhythm of the Muhaqqaq Qur'an is an interlinear Persian translation written in Naskh, a much less flamboyant cursive script. It defers appropriately to the larger Muhaqqaq script, rising and falling diagonally in a lively rhythm so as to complement rather than compete with the primary text. The elegance of the Muhaqqaq script is carried through in the textual illumination, which consists of a simple golden rosette marking the end of each verse.

Framing this complementary pair of texts and cursive scripts is yet another text, verses from the Hadith (Traditions of the Prophet Muhammad), written in a compact Kufic script. With this addition, in which red or blue ink is employed on alternate openings, elegant austerity yields to decorative exuberance. The Kufic text is overlaid on an ornate band of golden arabesques; where it failed to have a sufficient number of verticals to sustain the desired rhythm, this illuminator—one of two who contributed to the manuscript—interjected a floral or knotted motif in the contrasting color. This delicate and dense illumination takes a different turn at the corners, as geometric designs composed of a quatrefoil and four interlaced lozenges rendered in red, blue, and gold seem to bind up the thread of angular Kufic script that runs through the framing bands. Because these geometric designs match the large scale of the Muhaqqaq text and are significantly broader than the band of scrollwork, their imposing forms also anchor the illumination and give added structure to the framed manuscript opening.

There is little doubt that the Kufic commentary and accompanying decoration were executed some time after this Qur'an was copied, for another, incomplete section of this manuscript lacks the framing illumination altogether.[1] One scholar, David James, has noted strong similarities between the format and calligraphic style of this Qur'an and those of another Qur'an assigned an Anatolian provenance and a date of c. 1335.[2] Many other scholars have proposed an Indian provenance, primarily on the basis of the illumination, which is purportedly related to motifs found in fourteenth-century architectural monuments of Sultanate Delhi.[3] If this ultimately proves to be the case, this manuscript would document the existence of an Indian style of illumination far finer and more architectonic than what is currently known from this period.[4] JS

1. Massumeh Farhad, in Thomas Lawton and Thomas W. Lentz, eds., *Beyond the Legacy: Anniversary Acquisitions for the Freer Gallery and the Arthur M. Sackler Gallery* (Washington, D.C.: Smithsonian Institution, 1998), pp. 144, 146.
2. David James, *Qur'āns of the Mamlūks* (London: Thames and Hudson, 1988), pp. 170–71, 244. The interlinear Persian translation points to a provenance in eastern Islamic lands, which range from Anatolia to India and Central Asia.
3. See Schmitz et al. 1997, pp. 101–2, for a comprehensive review of the literature on this manuscript.
4. See, for example, a Sultanate Qur'an dated 1301 (with later additions), sold at Sotheby's, London, December 10, 1974, lot 473; and a *Kulliyyat* of Sa'di dated 1388, offered for sale at Sotheby's, London, April 18, 1983, lot 72.

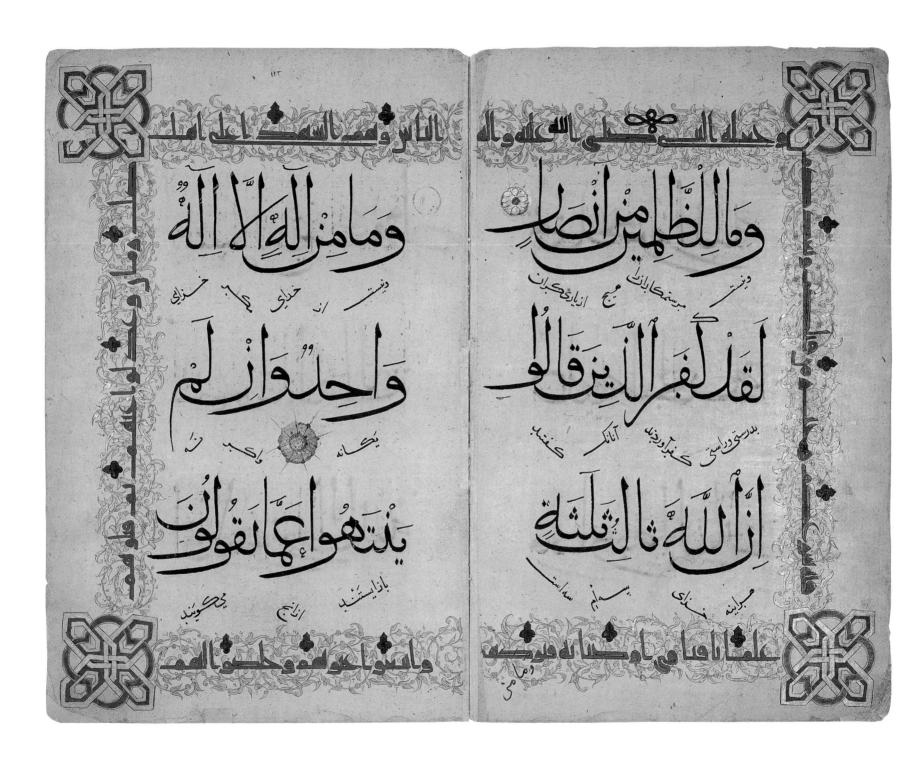

وَمَا مِنْ إِلَٰهٍ إِلَّا اللَّهُ

وَالظَّالِمِينَ مِنْ أَنْصَارٍ

وَاحِدٌ وَإِنْ لَمْ

لَقَدْ كَفَرَ الَّذِينَ قَالُوا

يَنْتَهُوا عَمَّا يَقُولُونَ

إِنَّ اللَّهَ ثَالِثُ ثَلَاثَةٍ

6. *Bizhan in the Dungeon*

Page from a dispersed manuscript of the *Shahnama* of Firdawsi
Central India (?), Sultanate, c. 1425
Opaque watercolor and ink on paper
12 5/8 x 10 1/2 inches (32.1 x 26.7 cm)

For many audiences, the sheer number of cultural traditions current at any one time in India can be bewildering. One common response to this situation is to create a somewhat simplified intellectual framework for a given work of art, a process that normally entails establishing relatively fixed sets of religious and artistic features for each culture, and defining each work in terms of the relevant category. Although this is quite feasible in many periods, it is much more difficult in the Sultanate period (c. 1198–1526), when Muslims made major inroads into a factious northern India. Muslim political control brought with it some material aspects of Muslim culture, but both were too sporadic to shape the bulk of artistic activity across this vast region. Instead, the new Muslim court elites and the largely Hindu populace accommodated each other by producing practically limitless combinations of their two cultures: mosques built with features of—or even with actual spolia from—Hindu temple architecture, illustrated Hindu manuscripts that mention the presiding Muslim ruler, Jain manuscripts adorned with figures and decorative patterns drawn from Persian art, and Persian-style manuscripts made by Indian artists with a halting command of Persian iconography and pictorial conventions.

One of the most unusual cultural hybrids of all is a dispersed *Shahnama* (Book of Kings), one of three manuscripts of Persian historical romances painted in a manner commonly found in illustrated Jain religious texts.[1] The manuscript retains the vertical format of the Islamic book tradition; its sixty-six known illustrations assume a well-established format too, filling a uniform rectangular painting field that spans the four columns of the Persian text. But the style of the paintings diverges quite conspicuously from the Persian pictorial tradition, and reveals the work of a small group of painters obviously trained in the western Indian one. The most prominent characteristic of this style is the palette, which features a vermilion red used for the background of every painting but one, and a limited number of other unmodulated colors. In many cases, the clothing and royal paraphernalia are also distinctly Indian in both shape and pattern.

The figures themselves are a still more complex blend of types. Whereas most Jain manuscripts restrict the use of figural conventions drawn from Persian painting—a three-quarter view of the face, a beard, and certain kinds of turbans—to a foreign ruler and his immediate entourage, this *Shahnama* manuscript shows them on every male character. The three-quarter view is applied even to women, whose angular outlines and generous proportions reflect Indian types. Such a perspective does not allow the further eye of the figure to project beyond the profile of the face (see cats. 1–4), a custom in Jain painting only beginning to fall into disfavor in this period. The eyes themselves are remarkably conspicuous by virtue of their large size, reddish upper edge, and heavy black eyebrows, as well as by a pupil that occupies fully half of each eye. The spade-like shape of the head and the flamboyantly curling nostril create a distinctive facial type, but the extraordinarily ruddy complexion and the unprecedented way in which the head is attached to a telescoping bull neck make for some truly peculiar figures. Even if one lacks a full understanding of their parent traditions, the striking originality of these figures and the compact compositions they dominate is immediately apparent.

This painting (folio 159b of the manuscript) strikes a quieter note than most illustrations in the manuscript. It depicts the forlorn Bizhan, an enemy hero who has had the temerity to fall in love with Manizah, the daughter of the Turanian king, Afrasiyab. When Afrasiyab learns of the affair, he metes out severe punishments: Bizhan is seized, bound head and foot with chains tied in intricate knots, and cast into a bottomless pit. Afrasiyab orders the pit sealed with a boulder so huge that only Akvan the demon can move it, and condemns Bizhan to languish in this living tomb until he either expires or comes to his senses. The king makes Bizhan's fate all the more bitter by compelling his humiliated daughter to witness the tragic spectacle.

The artist depicts little of this human drama, and focuses instead on the predicament of Bizhan, who, despite being fettered at the bottom of a water-filled brick dungeon seen in a cutaway view, shows no sign of despair. The massive capstone hoisted into place

by the demon is rendered as a gray slab, whose rectangular form complements those of the dungeon's base and walls. The highly geometric quality of the composition is tempered slightly by the presence of two flanking trees with busy, fanlike foliage and a wavy band of clouds.

This geometric effect is surely one that the artist sought to achieve, for there is evidence that he once considered, but ultimately rejected, an element that would have disrupted its pure symmetry. Above the right corner of the rocky slab and extending into the text area are vestiges of a helmeted figure. The only explanation for the appearance of a figure here, now revealed by a paint loss in the clouds and a faint helmet between the text columns above, is that the artist had initially sketched a guard peering in on the hapless prisoner. The painter must have decided to eliminate the guard not only because his action was entirely superfluous to the scene, but also because his presence diluted the powerful compositional focus on Bizhan. Indeed, the tendency to reduce compositions to a few dominant forms is a hallmark of the work of this particular painter, one of apparently two artists active in the manuscript.

The place at which this unexpected cultural blend was made remains to be determined. B. N. Goswamy has tentatively proposed Mandu, a center in westernmost Central India. None of the other varieties of Sultanate art produced at Mandu at the very end of the fifteenth century resemble this *Shahnama* in any way, but two Jain *Kalpasutra* manuscripts illustrated there, one dated to 1439, represent similarly innovative variants of the traditional Jain style (see also cat. 4). A *Kalpasutra* manuscript dated 1422, in a private collection, contains a pair of attendant figures with the same necks, facial types, and ruddy complexions as those seen throughout this *Shahnama*, and thus supports a date of c. 1425 for this manuscript. JS

PUBLISHED: B. N. Goswamy, *A Jainesque Sultanate Shahnama and the Context of Pre-Mughal Painting in India* (Zurich: Museum Rietberg, 1988), no. 14

1. The other two manuscripts are a *Hamzanama* manuscript in the Staatsbibliothek zu Berlin (Or. fol. 4181), and a lost manuscript of the *Iskandarnama*.

چو بر زد سر از کوه تابنده شید
جنین داک یاسخ بر لفراسیاب
چو بر زد بترز د تش نرتاب
چه بر پر ترت نه بیغ که کابر جامه کرد

بدهد بند کنون بین
کابحن از نامه مویلد د روبیان من
نه بیغ کریزین بر هر دختم
برایان توانت نام رزر رزق

کاهی مرد نیک لخرزدات
جو لود از دیکان ابرزد
بالود از دیکان ابرزد
کرت نیک تا جاودان بوم

یکی نبکرد تزرکف قدادمن
دلیکن بیین یلجی عیارت
جر از نام باکی نجودیی
برولیکی لغذ نام بدرد

بلندد زین مردی ماینت
بره بند کرید ابرایات
بکادار دکست باک رزکرات
جان جونکرا شاه جوییی

دلیلت بد انقرل برآیید
جان کرد سلام کو بلیک
دریان له دنام اوکرنخ اید
بتبک حاودا بلندکرات

که ندکران ماز نتاریک جاه
کمرزین ایکر بقرول شاه
درزنان شول شاه برکا ار
هرکه برندن نخونست مامر

ددهت دودوا یشریبز ددرا
بیبیند مهمارها مکرات
زهمکارهاکران جرجه به
زدتود باکیزه دراجبر

کران ثفز دریا جاه از زنگل
بیلان وکردن گرزنگل
که نیچ بره کرد بخرد و ه
یکی بلد ردی بلایس بند

جسره گرزی نیک بلدرد کو
ولیلغا بایوان بلم رمرهنر
نا بددد بلیان بان کرنین
بل لند نکون انزر انکن جاه

بره بای سواران زار تاج کن
نکس رسخن لگر سر تاج کن
بوای نغزین شور بنیکت
کربرتوز بلم همه تاج

7. Brahma Honors Krishna

Page from a dispersed series of the *Bhagavata Purana*
Northern India, probably Delhi-Agra region, c. 1525–40
Opaque watercolor and ink on paper
7 1/8 x 9 1/2 inches (18.1 x 24.1 cm)

The supremacy of the Hindu god Vishnu is lauded in a popular text known as the *Bhagavata Purana*. Composed about A.D. 900, its 18,000 verses sing the praises of a deity who manifests himself in many forms but none more compelling than Krishna, an endearing folkish incarnation who reveals his divinity to his parents, neighbors, and the other gods through a series of miraculous exploits beginning at his birth and continuing throughout his life as a cowherd. A few episodes from Krishna's life appear in stone reliefs on ancient and medieval temples, but it is only in the fifteenth century that painters responded to a growing cult of absolute devotion to this most accessible of Hindu deities by making the Krishna legend one of the mainstays of their art.

The series to which this illustration and the following two paintings (cats. 8, 9) belong is the earliest known illustrated version of this text. Like most illustrated copies of the *Bhagavata Purana*, this one depicts events related in Book 10, which is dedicated to Krishna's life. Only the first seventy-five of the ninety chapters are represented in the approximately two hundred known paintings, a pattern that may reflect either the wide dispersal of the series's folios or the possibly incomplete nature of the original series.[1] The paintings are typically full-page works in a horizontal format, with a variable number of relevant Sanskrit verses written on the reverse.[2] The text is thus noncontinuous, and serves to elucidate the imagery presented in the paintings. This relationship of text and image, in which the latter is dominant and physically removed from the text, is quite different than that found in the earlier manuscripts of the western Indian tradition (cats. 1, 4) or the contemporary Islamic tradition. Some pages (such as cat. 8) have brief captions written in vernacular Hindi above the painting, and others have labels written on

the painting near individual protagonists. Both kinds of inscriptions must have facilitated viewers' identification of the scene, but there is also some evidence that they are vestiges of a practice intended to guide the artist as he sketched and detailed the image.[3] This page displays an inscriptional feature unique to this series: written in its upper border is the enigmatic phrase *"Sā. Mīṭhārāma,"* which many scholars take to be the name of one of its later owners.[4]

This painting, which falls at the beginning of the fourteenth chapter, marks the culmination of an episode that leads the god Brahma to acknowledge Krishna's limitless existence. Having witnessed Krishna perform one supernatural feat after another, Brahma tests him once more, this time by employing magic to abduct a group of cowherds and their kine from Krishna's presence. Krishna recognizes Brahma's handiwork when he is unable to locate the missing cows and cowherds, and simply multiplies himself to replicate each one. The replacements resemble the original cows and cowherds in every detail, but they so strongly embody the divine presence that their mothers' affection for them grows exponentially. This remarkable development and Brahma's subsequent vision of each figure being transformed into Krishna in all his splendor move him first to marvel at Krishna's ability to transcend his own deception and then to recognize the deity's omnipresence. With this, he dismounts his swan vehicle and prostrates himself before Krishna.[5] Raising himself to his feet, Brahma joins his hands together in veneration, and begins a long hymn of praise to Krishna.

The artist pays tribute to the momentousness of the revelation by isolating each of the deities within a separate colored field. The stout, four-headed Brahma appears against a cool green background; Krishna, the object of his devotion stands opposite,

his superiority indicated not only by his receptive gesture, but also by the brilliant red rectangle positioned immediately and exclusively behind him. Krishna's theological advantage is carried through even to the trees that bracket and divide the two figures. Whereas Krishna stands erect on one leg between two trees with absolutely straight trunks, Brahma is backed by a date tree whose trunk bends close to him and his vehicle as if in imitation of his earlier prostration. A black sky and an undulating band of clouds set off the trees' luxurious foliage and a flowering creeper, which entwine in the upper reaches of the composition to bind the two halves together. The result is a painting whose masterful design matches its religious eloquence. JS

PUBLISHED: Enrico Isacco and Josephine Darrah, "The Ultraviolet-Infrared Method of Analysis: A Scientific Approach to the Study of Indian Miniatures," *Artibus Asiae*, vol. 53, nos. 3–4 (1993), p. 479, figs. 5-B1–2

1. Daniel Ehnbom (1984, p. 72) supports this latter suggestion by noting that a few of the last known folios have scrawled Hindi inscriptions rather than the usual full Sanskrit verses.
2. Ehnbom (ibid., p. 80) records that the text on the reverse may be as short as a half-line or as long as twenty-two lines. Some pages lack text altogether, but this is merely the result of the sheet of paper on which it was written being peeled off when the series suffered crude restoration in the 1950s.
3. John Seyller, "Painter's Directions in Early Indian Painting," *Artibus Asiae,* vol. 59, nos. 3–4 (2000), pp. 303–18. An isolated notation in the right margin on the reverse that reads *"Brahmastu[ti]* [Brahma's hymn of praise]" may have been occasioned by this practice.
4. It is complemented by the phrase *"Sā. Nānā,"* which appears on other paintings. *Sā.* may be an abbreviation of *sārthavaha* or *sāhu,* words that indicate possession. There is no possibility that these represent names of artists, as has sometimes been proposed. The words *Bāgha,* seen here in the lower margin, and *Hīrabāī,* found frequently throughout the manuscript, remain unexplained.
5. This scene is reproduced in Kossak 1997, p. 281, no. 3.

साल्वीशराम

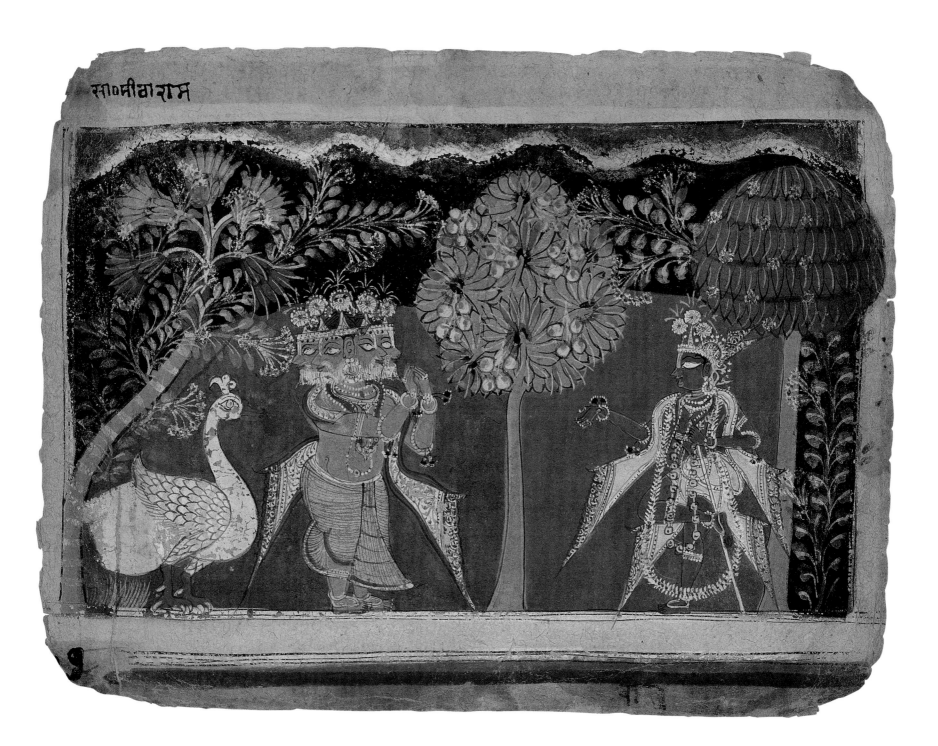

8. Rasalila

Page from a dispersed series of the *Bhagavata Purana*
Northern India, probably Delhi-Agra region, c. 1525–40
Opaque watercolor on paper
6 7/8 x 9 inches (17.5 x 22.8 cm)

One of the most potent expressions of the love that each devotee feels for Krishna is the *rasalila*, literally the "play of passion." Once Krishna reaches adolescence, he becomes more overtly sensuous and awakens powerful amorous feelings among the *gopis*, the wives and daughters of his cowherd companions. Their ardor grows daily, and is finally unleashed one autumn evening as Krishna begins to play his flute beside the Yamuna River beneath a full moon. They give themselves to him with utter abandon, engaging in all kinds of love play, and reject his entreaties to resume their normal lives. Suddenly he disappears. As the *gopis* search for their lord, they rekindle their memories of him by imitating his wondrous exploits, but eventually they grow despondent and succumb to frustration and jealousy. Then Krishna reappears, and explaining that his brief absence was merely a test of their love, slakes their yearning for him once more. Krishna invites the enamored *gopis* to join him in song and dance, and directs them to form a circle. Standing at its center, he begins to flute and dance, and all the *gopis* fall under the sway of his irresistible charms. But to satisfy the desire of each woman to be as close to him as possible, he also multiplies himself to match the number of *gopis*, leading each one to believe that she alone enjoys his embrace. The spectacle of the *gopis*, their voices raised in harmonious song and their faces and bodies flush with passion, attracts the attention of celestial beings, who appreciatively strew flowers from ahigh.

This magical dance, which is a metaphor for the union of the individual with the divine, is depicted frequently in Indian art. All representations of the *rasalila* include the blue-skinned Krishna and the circle of dancing *gopis*, but often differ considerably in detail. Krishna may appear with one or two *gopis* in the center, take a place between pairs of them, or be absent altogether from the ring of dancers. That these variations occur despite an explicit textual description of the scene reminds us that artists, like the *gopis* themselves, often forsake duty for rapture, and pay little heed to text-bound details when circumstances dictate otherwise.

This particular image, one of the earliest painted expressions of the *rasalila,* presents a troupe of eight dancing *gopis*, their hands joined lightly together, revolving around the solitary figure of a garlanded, fluting Krishna. A narrow yellow ring serves as a ground line for the dancers and provides a nominal measure of separation from Krishna, but this feature barely interrupts the red field that binds all the figures together and insulates them from the remainder of the painting. The ecstatic dance of Krishna and the cowmaidens transpires without a celestial audience, and only two flowering trees, the moon—its original gleaming white surface now reduced to a dull brown by a loss of paint—and the river filling the foreground evoke the luxuriant nocturnal setting. Similar paint losses have spoiled some of the subtlety of the painting, including the alternation of yellow and white on the *gopis'* bodices, the undulating strip of white clouds, and the once colorful lotuses and waterfowl studding the greenish waters of the Yamuna. They have not obscured, however, other powerful aspects of the composition, notably the lively rhythm of the *gopis'* heads and angular limbs and the pulsating repetition of triangles in the two-tiered skirts and flaring *patkas* (sashes) worn by alternate dancers.

This *Bhagavata Purana* series[1] is widely regarded as the most inventive and vigorous example of the Chaurapanchasika style, an appellation given to a major variety of sixteenth-century Indian painting that takes its name from an eponymous series now in Ahmedabad. The discovery of two series in this style with firm dates and places of manufacture has narrowed but has hardly laid to rest the controversy over the absolute chronology and provenance of this group. Most scholars place this *Bhagavata Purana* between the *Aranyaka Parvan*, painted in 1516 at Kacchauva, near Agra, and now in the Asiatic Society of Bombay, and the *Mahapurana*, painted in 1540 at Palam, near Delhi.[2] Both series share a number of elements with this *Bhagavata Purana*, including flat colors, compartmentalized compositions, angular movements, a large, leaf-shaped eye, and many details of costume. Both are far more rudimentary in material, composition, and execution, and thus are understood to be impoverished versions of a style that also flourished at a more sumptuous level. The colophons of the two dated series name sponsors who are minor landholders, so it is quite reasonable to attribute the qualitative gap between them and the more accomplished *Bhagavata Purana*, *Chaurapanchasika*, and *Gita Govinda* series to a wealthier class of patron. The proximity of Agra to Mathura, a center of Krishna worship, has led some scholars to propose this area as the provenance of the *Bhagavata Purana*, while the many formal affinities of the Chaurapanchasika group as a whole with early seventeenth-century painting in Mewar and Malwa have encouraged others to see the style generally as the precursor of many later local idioms across northern India (see cats. 18–22). JS

1. This series is sometimes termed the "Palam" *Bhagavata Purana* after the inscription "*Pālam nagar madhye,*" written after "*Sā. Mīṭhārāma*"; the folio on which this pair of inscriptions purportedly appears is now lost.
2. For two cogent but contradictory analyses of the development of this group see Pramod Chandra, *The Ṭūṭī-Nāma of The Cleveland Museum of Art and the Origins of Mughal Painting* (Graz: Akademische Druck- u. Verlangsanstalt, 1976), pp. 37–40; and Losty 1982, pp. 48–52, 64–65.

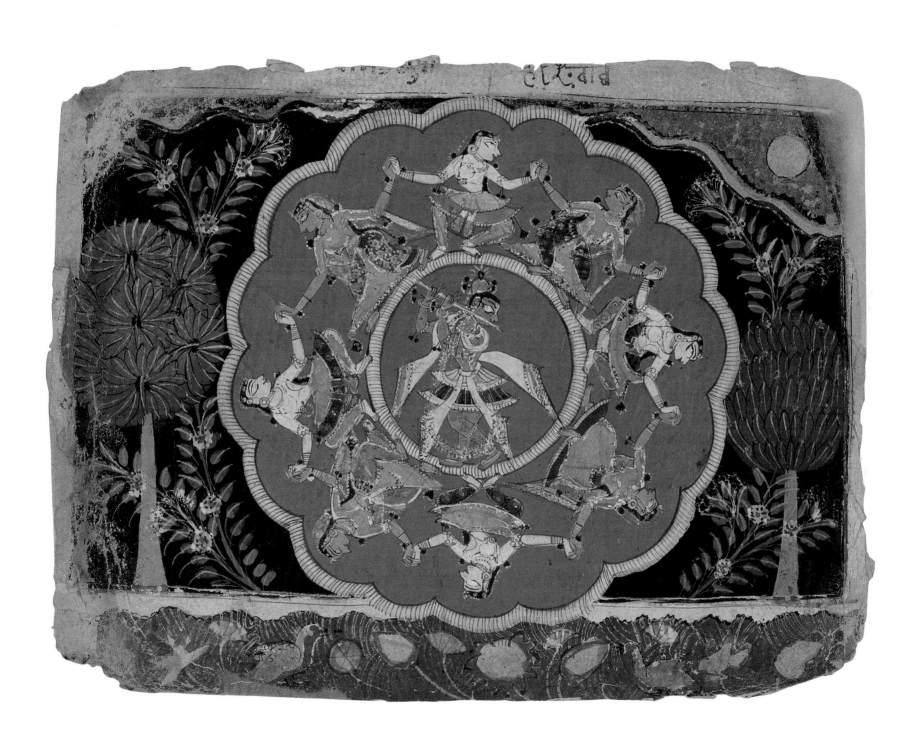

9. *The Earth Goddess Returns the Stolen Goods to Krishna and Pays Homage to Him*

Page from a dispersed series of the *Bhagavata Purana*
Northern India, probably Delhi-Agra region, c. 1525–40
Opaque watercolor on paper
7 x 9 1/8 inches (17.7 x 23.1 cm)

O f the three pages from this *Bhagavata Purana* series in the Bellak Collection (see also cats. 7, 8), this painting is the most complicated both thematically and compositionally. It appears midway through Chapter 59, a particularly heavily illustrated chapter from which sixteen illustrations are known.[1] These paintings recount Krishna's defeat of the demon Naraka, who had stolen a sacred bowl and earrings from the goddess Aditi and regalia from other gods as a calculated affront to their power. Krishna begins to right matters by devastating Naraka's seemingly impregnable fortress at Pragjyotisha, decimating his troops, and finally dispatching the demon himself. With the challenge squelched, Naraka's mother, the earth goddess Bhumi, sues for reconciliation by presenting to Krishna the stolen vessel and its contents, a garland of flowers, Varuna's royal umbrella, and a magnificent jewel. After lauding Krishna's matchless powers and acknowledging him as the supreme deity, the earth goddess begs Krishna to have mercy on her grandson, Bhagadatta, who has been sullied by his father's perfidy. Krishna grants her request, and installs Bhagadatta on the throne at Pragjyotisha. But Krishna's bounty does not end here, for he removes to his own capital of Dvaraka both the celestial Parijata tree and the 16,000 princesses Naraka had abducted into his harem. The former sweetens the garden of his wife,

Satyabhama, with heavenly fragrances; the latter implore Krishna to marry them, a feat that, in a manner typical of devotional texts, he carries out by miraculously multiplying himself so that each woman can become his wife and devotee.

Having rendered the decapitation of Naraka in the preceding illustration, the painter now focuses on the aftermath of the demon's demise. At left, raised aloft by his ornithoid vehicle, Garuda, Krishna sits with Satyabhama on a radiant lotus as he receives the homage of the earth goddess and her grandson. The four-armed Krishna holds the traditional attributes of Vishnu: a conch and club in his right hands, and a discus and lotus in his upper left hand. He extends his lower left hand toward Bhagadatta, who bows in a gesture of supplication. The earth goddess, occupying the very center of the composition, proffers the golden bowl that contains the magical earrings. Behind her is the fortress of Pragjyotisha, its battlements restored, albeit only to the upper section of its walls that tenders no possible resistance to Krishna. At its center sits Bhagadatta, whom Krishna has installed as the new king, beside the earth goddess and before an attendant or one of the abducted princesses.

The architecture that locates the secondary scene in a palace is absolutely rectilinear in construction and simply ornamented in detail, a treatment typical of this *Bhagavata Purana* series and other works in its general style. The architecture also begins to compartmentalize the painting, a favorite compositional device in this style of painting. In some sections, such as the black area above the roofline and in the garden below, color-coded compartments follow logical divisions; in others, the compartments are obviously arbitrary, and exist primarily to create interesting coloristic and compositional rhythms across the painting. Thus behind the lone tree rising up from the battlements of Pragjyotisha, which is probably the much-desired Parijata tree, is a zone of black springing upward in an arc that simultaneously complements the curve of city's ramparts and initiates a rough circular field around Krishna. The stepped green shape below the earth goddess might be a lotus-filled pool or an outlying garden, but it functions more visually than iconographically, at once elevating the earth goddess to her position of prominence and relieving the stark backgrounds of the many compartments with one of unexpectedly dense vegetal interlace. JS

PUBLISHED: Kramrisch 1986, pp. 6, 153, no. 5; McInerney 1982, pp. 54–55, no. 20

1. Book 10, Chapter 59, Verses 23–31. For an enumeration of the episodes in this chapter, see Ehnbom 1984, p. 235. Ehnbom attributes this work to his Painter H, one of ten painters he identifies in the series.

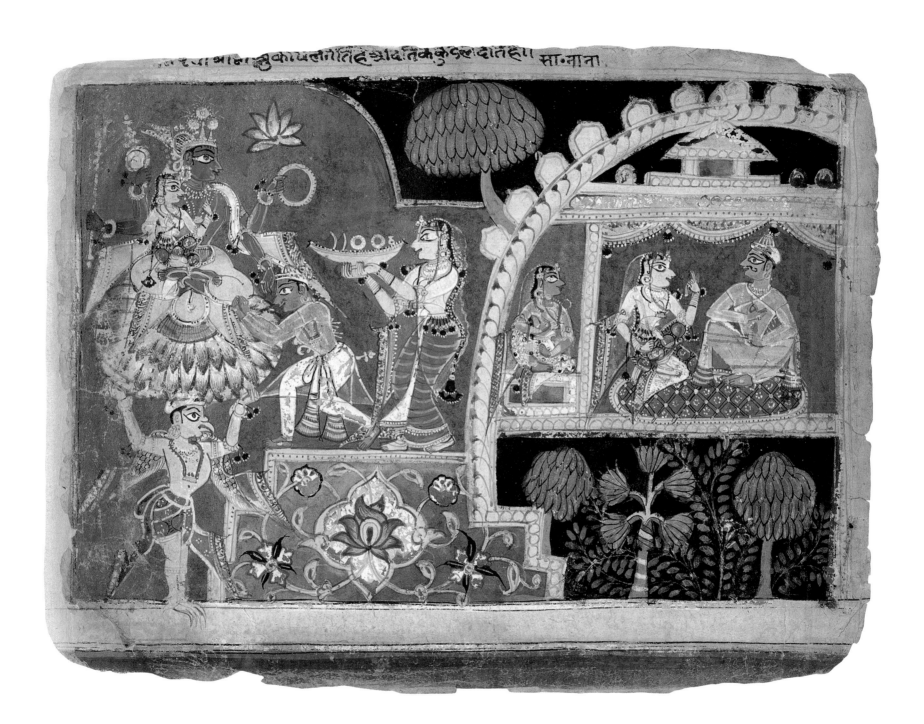

10. *Laurak Serves* Pan *to Six Men*

Page from a dispersed manuscript of the *Chandayana* of Da'ud
Central India, probably Mandu Sultanate, c. 1540
Opaque watercolor and gold on paper
10 1/8 x 7 9/16 inches (25.7 x 19.3 cm)

This painting illustrates a quiet scene from a manuscript of the *Chandayana*, a literary reformulation of an Indian folk romance that tells the tale of Chanda, a young woman bound in wedlock to a blind and impotent spouse. The great beauty that brought her this lamentable fate also releases her from it, for the unhappy maiden catches the eye of a wandering ascetic, who sings her praises wherever he wanders. Eventually these songs arouse the lust of a king, who attempts to seize this legendary beauty by force, but is repulsed by an alliance headed by the hero Laurak. Though mighty in battle, Laurak is laid low by the incapacitating beauty of Chanda, whom he glimpses during his victorious procession through her city. From this point on, the two are consumed with passion for each other. Such rapture rarely staves off interruption for long, and the lovers are forced to overcome obstacles ranging from their own irate spouses to thieves and poisonous snakes. To judge from the incomplete text, the lovers' plight is resolved not with the drama of confrontation but with the ambivalence of accommodation, and Chanda becomes Laurak's second wife.[1]

Many illustrations in each copy of the text repeat certain basic imagery, such as figures conversing, Chanda feuding with Laurak's wife Maina, or Laurak bemoaning his snake-stricken lover. This scene of Laurak distributing *pan*, a popular Indian digestive, to a group of six armed companions, has no parallel in this or any other copy of the text. The uniqueness of the illustration and the absence of foliation in the dispersed manuscript make it difficult to locate the episode within the text, but the fragmentary text on the reverse suggests that it is an event late in the story, when Laurak returns to his native city, an act that alarms his compatriots and agitates Chanda.

The bulk of the manuscript to which this painting belongs—seventy-three pages in all—is preserved in the Prince of Wales Museum in Mumbai. Twenty-eight paintings are in public and private collections across the world. The text was composed by Mawlana Da'ud in 1379, and dedicated to the minister of the ruler of the Delhi sultanate, Firuz Shah Tughluq. Da'ud, from a town near modern Kanpur, wrote his version of this popular romance in a vernacular language known as Avadhi Hindi. The geographical

range of this language, sometimes asserted to be limited to a region of northern India corresponding to the modern states of Uttar Pradesh and Bihar, has been used to argue that all five illustrated manuscripts of the *Chandayana* were produced in this region, a tenuous conclusion that does not account for the significant differences in their painting style. The text of this manuscript is written by at least two scribes in a vigorous if inelegant brand of Naskhi script, with a typical arrangement of seven couplets spread over twelve lines. The written page is embellished by red and black ink used for alternate pairs of lines.

The paintings themselves have long been heralded as one of the most beautiful fusions of the Islamic and indigenous Indian pictorial traditions. The artists adapt the vertical format of the Islamic tradition to Indian aesthetic sensibilities by dividing the full-page compositional field into two or occasionally three registers. By reducing the height of each register to that of a standing figure, they simplify enormously the task of organizing figures into easily legible and spatially coherent groups. Figures are habitually presented in evenly spaced series, and overlapping forms are avoided assiduously, so much so that the minor overlap of elbows on the left side of this scene is among the most spatially complicated gestures in the manuscript. Landscapes retain a Persianate flavor, being organized as a single field marked by a high, curving horizon and dominated by a lone tree with a swaying trunk and a circular mass of foliage. The narrow-waisted and somewhat large-headed figures are depicted in strict profile, a feature common in most varieties of indigenous Indian painting. One concession to the Islamic tradition lies in the narrowing of the eye, which in more purely indigenous expressions (cats. 7–9) is commonly large and leaf-shaped. As in many contemporary Chaurapanchasika-style series, the paintings' draftsmanship is perfunctory at best.

Yet it is the unusual pastels and exquisite, sometimes even exuberant patterns overlaid on cloth, architecture, and sky that impart the sense of refinement that sets this manuscript apart from nearly every other variety of sixteenth-century Indian painting. Hardly a surface is left unembellished. Delicate scrollwork traverses lintels, swags, and skirts; floral sprays and golden dashes animate otherwise plain settings; and

ribbonlike clouds flutter across streaky skies. By these means the artists transform simply bifurcated compositions into complex interplays of color, shape, and visual texture. This work, for example, is sustained not by the figures' arrangement or gestures, but by the juxtaposition of lavender, mustard yellow, and green zones; the rhythmic repetition of black swords against light clothing; and the contrast of a squadron of brilliant miniature golden clouds below with the more structured and subdued tiles above.

The stylistic consistency of the illustrations suggests that the manuscript was produced in a workshop established enough to have fashioned a cohesive style. At the same time, the extensive number of known paintings allows us to identify the visual tendencies of a limited number of artists, probably no more than five in all. The anonymous artist of this painting, for example, is recognized by his figures' heads, which have relatively large eyes, heavy jaws, and prominent sloping noses; these are quite distinct from the blockish heads with rounded features favored by several of his colleagues. All males sport a mustache, but this artist prefers a stiff bristle that sweeps straight back rather in a tapered curve, and usually combines it with a jaw grayed with stubble. Similarly, the golden hooks seen here in the lower register are well defined, and never descend to the level of slapdash marks or squiggles as they do in another artist's work. A few details show a casual attitude toward physical description, as, for example, the series of black dots distributed almost freely across the front of the turban, a detail that in other hands is either rendered more convincingly as the latticework pattern created by turban cloth over a dark cap or eschewed altogether. And while another artist uses assertive, Y-shaped tilework to fill passages of architectural space, this painter organizes his tilework in more subtle, interlocking patterns.[2]

Several elements in this mid-sixteenth-century manuscript point to a connection with Mandu. Although the manuscripts produced there at the end of the fifteenth century are derived more obviously from Persian models, certain female figural types and landscape elements seen in the *Ni'matnama* continue in this *Chandayana* manuscript, which was probably created some forty years later, when only vestiges

of the once-dominant Persian tradition remained.[3] Moreover, the striped domes and white crenellations silhouetted in black seen in this manuscript and its major stylistic successor, a *Chandayana* of c. 1560 in the John Rylands University Library in Manchester, England, bear an uncanny resemblance to architectural forms of later Central Indian painting of the mid-seventeenth century.[4] The rounded profiles and horizontally banded skirts in this *Chandayana* also recur consistently in Malwa painting (see cat. 22). In this light, the discovery of the manuscript at nearby Bhopal in the 1950s may further support a provenance in Central India. JS

1. The most complete account of the story appears in Karl Khandalavala et al. 1961.
2. Other paintings by this same artist are Prince of Wales Museum (PWM), 57.1/11 (Khandalavala and Chandra 1969, fig. 166); PWM, 57.1/25 (ibid., fig. 157); PWM, 57.1/61 (Khandalavala and Chandra 1959–62, fig. 21); PWM, 57.1/36; PWM, 57.1/37 (Khandalavala and Chandra 1969, fig. 171); PWM, 57.1/42 (Losty 1982, p. 69, no. 45, color plate XVI); PWM, 57.1/64; Brooklyn Museum of Art, 78.198 (Poster et al. 1994, pp. 52–53, no. 17); The Cleveland Museum of Art, 81.55 (Leach 1986, pp. 18–19, no. 7); The Metropolitan Museum of Art, New York, 1990.82; Asian Art Museum, San Francisco, 81 D33.2 and 81 D33.3 (Khandalavala 1985); and the Khalili Collection, MSS. 961.1 (Leach 1998, no. 1).
3. For the most thorough discussion of these connections, see Losty 1982, p. 69.
4. Goswamy with Bhatia 1999, no. 69, reproduces a page of a *ragamala* series, in the Goenka Collection, which is closely related to the style of this *Chandayana*. For a fragment of another painting from the same series, see Zebrowski 1983, plate III.

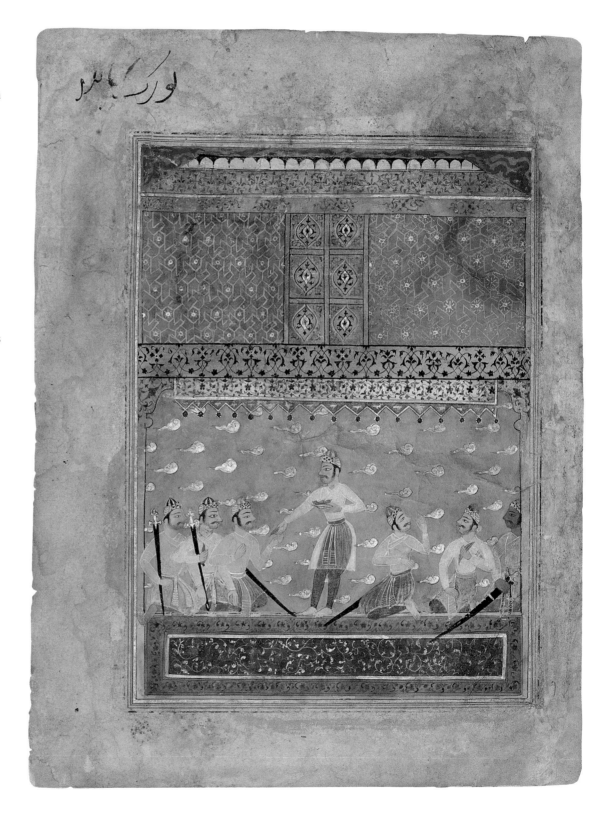

11. *Krishna Shares Food with Balarama and the Cowherds During the Rainy Season*

Page from a dispersed series of the *Bhagavata Purana*
Northern India, probably Rajasthan, c. 1570–75
Opaque watercolor on paper
7 7/16 x 9 7/16 inches (18.9 x 24 cm)

This pastoral scene of Krishna and his brother Balarama enjoying a midday repast with cowherds belongs to a series known as the Isarda *Bhagavata Purana*, so called because it was discovered in modern times in Isarda in eastern Rajasthan (see cat. 12). Like other paintings in this series, it forgoes an inscription of the complete verses of the *Bhagavata Purana* in favor of a one-line caption on the yellow border above the painting field. Much of this inscription is effaced, but it culminates in the number 30. A short inscription on the reverse provides the number 30 once more and the caption "Krishna is eating butter."[1] This phrase has led to the painting's identification as a representation of the pleasurable results of Krishna's childhood prank of stealing butter from his foster mother's pots, an endearing scene from the eighth chapter of the *Bhagavata Purana* illustrated frequently in painted copies of the text.[2]

This identification is belied by several features of this painting. First, Krishna and Balarama wear crowns, an attribute absent in all representations of their childhood exploits.[3] Krishna's companions here are also exclusively cowherds, and do not include the monkeys who normally partake of his pilfered delights. Finally, the inscribed 30 is a painting number, indicating that this is the thirtieth illustration of the series. Since illustrations with numbers below 30 depict events that are recounted well after Chapter 9, in which the account of Krishna eating the stolen butter is described, this scene cannot be one that occurs so early in the text. Instead, it belongs in Chapter 20, which describes the renewal of the earth and its inhabitants during the rainy season, and illustrates Verse 29, which speaks of Krishna and Balarama beholding the bounty of the rains as they sit near the water and share rice and curds with the cowherds.[4]

If this image is indeed faithful to the letter of the text, it is no less expressive of its devotional spirit. Trees establish the requisite forest setting, but it is their variety of form and richness of description that evoke the burgeoning environment. Similarly, the band of water at the bottom satisfies the textual prescription, but it is really its undulating contour, simultaneously echoing the rumbling rain clouds and stirring an assortment of earthen vessels to bob animatedly, which conjures up the life-giving power of water. Part of this correspondence of visual detail to textual spirit

is merely fortuitous, for this same artist creates equally lush vegetation in other paintings in which seasonal renewal is not extolled.[5] But part of it bespeaks a series-wide interest in elaborating certain aspects of the setting, whether natural or man-made, to match the resplendence that Krishna's devotees perceive all about their lord.

The artist enhances this impression by rendering all forms with a precision unprecedented in the indigenous Indian tradition, a point made clear by comparison with paintings from the earlier Palam *Bhagavata Purana* series (see cats. 7–9). In the former, the foliage is rendered by allowing the brush to play freely over the surface or by superimposing quickly drawn outlines of leaves over a uniform patch of green. By contrast, the foliage in the Isarda pages is executed with conspicuous care; for example, the ribs of the fanning leaves of the plantain trees form a continuous arc and crisp black outlines lend definition to their yellow stems. This attention to clarity of shape and design is carried through to other elements. Flaring garments terminate in well-defined shapes, gauzy scarves become convincingly translucent, and jewelry and garlands congeal to the point that individual stones and petals are clear. In some paintings from this series, the exact contours and angular poses of the high-waisted figures conspire to make the figures seem static, a fate avoided here by the seated positions and the implied liveliness of the act of eating. The figures themselves have very distinctive faces, with a sweeping jaw, an elongated eye, and a profile far more compact and rounded than the blocky one of their predecessors. So many figures have an unusual greenish complexion that it has become the series's hallmark.

The Isarda *Bhagavata Purana* sheds light on the direction and pace of the development of the Chaurapanchasika style in the sixteenth century (see cat. 8). All the features of the early series in this style are still evident, but now reach a level of refinement rivaled only by the *Chaurapanchasika* series itself, which probably dates to the 1550s. Here, for example, the red rectangle—a standard element in paintings of this style—is used to particularly brilliant effect. It rivets attention on the central core of the painting, primarily by virtue of the vibrant color contrasts it initiates with the blue Krishna, the white-skinned Balarama, the greenish cowherds, and the black sky, but also by

establishing an oasis of plain ground amid the surrounding vegetal exuberance. The sophisticated use of such features places this series at or just after the heyday of the Chaurapanchasika style.

This series also shows the first traces of exposure to Mughal painting. This is manifested not in figure or costume style, but in two minor motifs: the Mughal-style turbans and the rendering of water as irregular swirls. Despite suggestions to the contrary, the latter is surely a Mughal innovation, for it recurs throughout early Mughal painting and does not appear in any previous variety of sixteenth-century Indian painting.[6] It is present in four paintings in the Isarda series, all of which feature a river cutting a broad diagonal across the composition. Conversely, the traditional basketwork convention for surface ripples is retained in two paintings,[7] including this one. Since in both instances the water forms a horizontal strip at the bottom, and since paintings with each convention can be attributed to the same artist, it seems reasonable to conclude that the artist elected to adopt the swirling Mughal convention when he intended to convey turbulence and the older basketwork manner when he meant the water to be placid. In the conservative Indian tradition, such variability is characteristic of a time when new stylistic options were first becoming available. Because this frothy treatment of water does not occur in Mughal painting before the early 1560s, and because the diffusion of new features of imperial Mughal painting to regional painting centers typically involves some time lag, the Isarda *Bhagavata Purana* must date to c. 1570–75. JS

PUBLISHED: Falk and Lynch 1989, pp. 5–7, no. 3

1. The vernacular reads, "*Śrī Kṛṣṇa mākhan khāya chhai.*"
2. Falk and Lynch 1989, p. 7. The secretive consumption of the butter is recounted in Chapter 9.
3. See the painting from this series, in the Jagdish and Kamla Mittal Museum, Hyderabad, in which Krishna actually steals curd (Khandalavala and Mittal 1974, fig. 4).
4. Seen also in a painting in the Palam *Bhagavata Purana* (Virginia Museum of Fine Arts, Richmond, 64.36.2; Lee 1960, no. 3d).
5. See, for example, paintings of Krishna slaying Baka and Dhenuka in the Goenka Collection (Goswamy with Bhatia 1999, nos. 20–21). This band of undulating water occurs in several paintings of the Palam *Bhagavata Purana* as well.
6. Steven Kossak, in Lerner 1984, p. 150, argues that the swirls of water might have developed independently in the Chaurapanchasika tradition, and thus dates the series to c. 1560.
7. Sold Sotheby's, New York, September 21, 1995, lot 115.

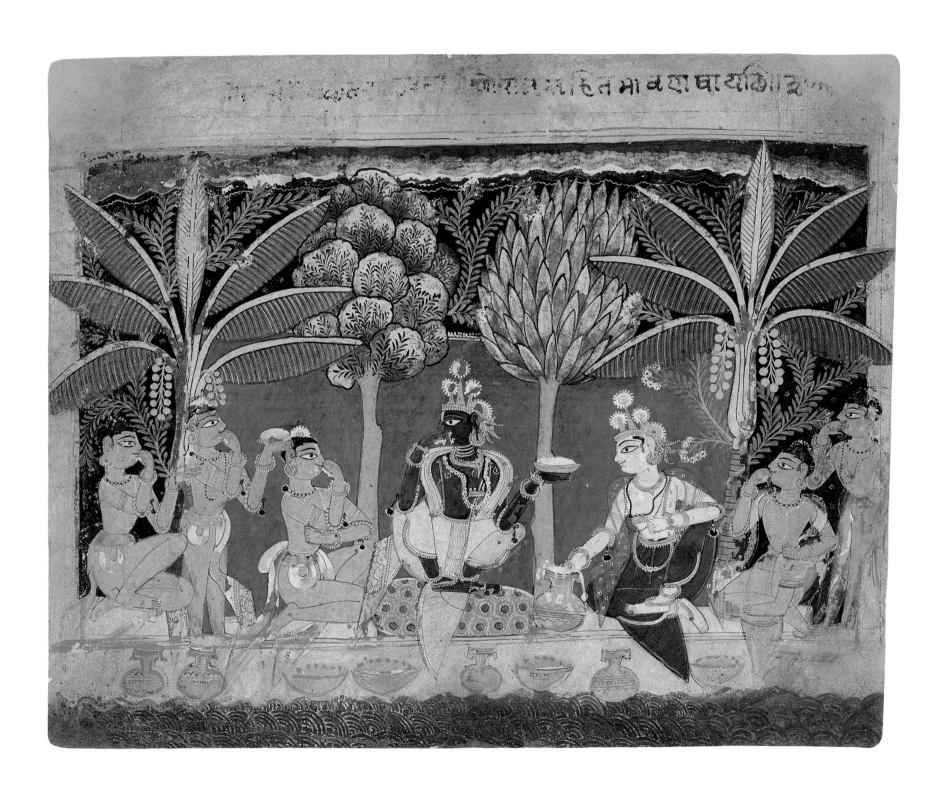

12. *Brahma Offers Homage to Krishna*

Page from a dispersed series of the *Bhagavata Purana*
Northern India, probably Rajasthan, c. 1570–75
Opaque watercolor on paper
7 x 9 1/8 inches (17.7 x 23.1 cm)

Brahma's spellbinding abduction of cowherd boys and their cattle, and their subsequent mystical reduplication by Krishna, events that preceded the episode depicted in a painting from an earlier series of the *Bhagavata Purana* (cat. 7), here form part of a similar illustration. The duplicate youths and cattle have flourished for a year, daily becoming dearer to their families, who intuitively recognize the pervasive presence of their lord. Balarama asks his brother Krishna to explain this phenomenon to him, and Krishna happily obliges. Brahma requires no such explanation, for finding that even he cannot distinguish the real figures he has abducted from Krishna's replacements, he experiences a vision of each cowherd as Krishna himself. Brahma thereupon prostrates himself before Krishna, arises, and begins to sing his praises.[1]

This Isarda *Bhagavata Purana* painting is less spatially ambitious than *Krishna Shares Food with Balarama and the Cowherds During the Rainy Season* (cat. 11). The protagonists—Brahma, Krishna, and Balarama—are sequestered again in the familiar red rectangle, but here the artist does not attempt to disguise the arbitrariness of its shape, which jogs downward to contain Brahma's standing form, thereby stripping its apparently structural frame of any semblance of logic. Similarly, he places the rectangle without subterfuge, allowing it to float unsupported above the cowherds rather than anchoring it along the common baseline, as is normally done in the Isarda series. He accommodates the many cowherds and cows by reducing the figure scale, and accordingly limits the setting to a lone tree and a rose-tinted band of sky. The figures have the same swelling chest

seen throughout the series; because they are seated with their arms lowered, they are not subject to the quirky anatomical problem that plagues some of their counterparts who stand with their arms upraised, namely, the head slipping back to an odd off-center position on the shoulders.[2] Only Brahma shows signs of the shortcomings of such a fundamentally segmented conception of the body, as his feet protrude well beyond the axis of his massive trunk and cluster of heads.

The stylistic consistency among the paintings of the Isarda *Bhagavata Purana*, which includes facial and figural style, exceeds what we expect from even a tightly knit workshop, and suggests that the series was the work of a single artist. This was certainly a feasible task, for there seem to have been about seventy paintings in all.[3] Such a number is dwarfed by the several hundred paintings of the Palam *Bhagavata Purana* (see cats. 7–9), but is entirely in keeping with the scope of a closely related series, the Ahmedabad *Bhagavata Purana*, which seems slightly more extensive.[4] The Ahmedabad series begins with the same Chaurapanchasika-style base, but exhibits many more Mughal features, most notably the lobed form and scumbled surface of the rocks, the somewhat more volumetric architecture, and the rounded faces and relaxed contours of the figures. Indeed, its women approximate some of the more conservative figures found in such Mughal series as the c. 1580 Chester Beatty Library *Tutinama*, a benchmark that dates the Ahmedabad *Bhagavata Purana* to c. 1585.[5]

The Isarda *Bhagavata Purana* was probably painted not far from the orbit of imperial Mughal

centers at Delhi and Agra, but its exact provenance remains uncertain. A Rajasthani or Gujarati origin has been proposed on grounds of the language used in the inscriptions above each painting.[6] JS

PUBLISHED: Martin Lerner, *Indian Miniatures from the Jeffrey Paley Collection* (New York: The Metropolitan Museum of Art, 1974), no. 1; Christie's, London, October 16, 1980, lot 215; Kramrisch 1986, pp. 7, 153–54, no. 6

1. A partially effaced two-line Sanskrit inscription in the upper margin culminates in the number 32 and the phrase "Brahma performs homage." An inscription written in a different hand on the reverse reads, "Brahma meets the children," and ends in number 24. Neither of these numbers corresponds properly with the otherwise reliable sequence of painting numbers found on other folios, but this discrepancy does not supersede the explicit visual and inscriptional evidence in the identification of the scene.

2. See, for example, the paintings sold at Sotheby's, London, April 29, 1992, lot 27; and Sotheby's, New York, September 21, 1995, lot 116.

3. The highest painting number known is 59, which is on an image depicting Krishna restoring Ugrasena to the throne, an episode described in Chapter 45, Verses 12–14. The painting is now in the Birla Academy of Art and Culture, Calcutta; see Karl Khandalavala and Saryu Doshi, *A Collector's Dream: Indian Art in the Collections of Basant Kumar and Saraladevi Birla and the Birla Academy of Art and Culture* (Mumbai: Marg Publications, 1987), p. 79, fig. 5.2. Only twenty-three paintings from this series have come to light.

4. See Ratan Parimoo, "A New Set of Early Rajasthani Paintings," *Lalit Kala,* no. 17 (1974), pp. 9–13. An episode of Kansa's washerman being slain, which is recounted in Chapter 42 of the *Bhagavata Purana,* is numbered 49 in the Isarda series and 57 in the Ahmedabad series.

5. The series is partially dispersed, but the bulk of it is published in Leach 1995, vol. 1, pp. 21–74, nos. 1.1–1.102.

6. Toby Falk and Brendan Lynch (1989, pp. 5, 7) maintain that the word *chhai* indicates this.

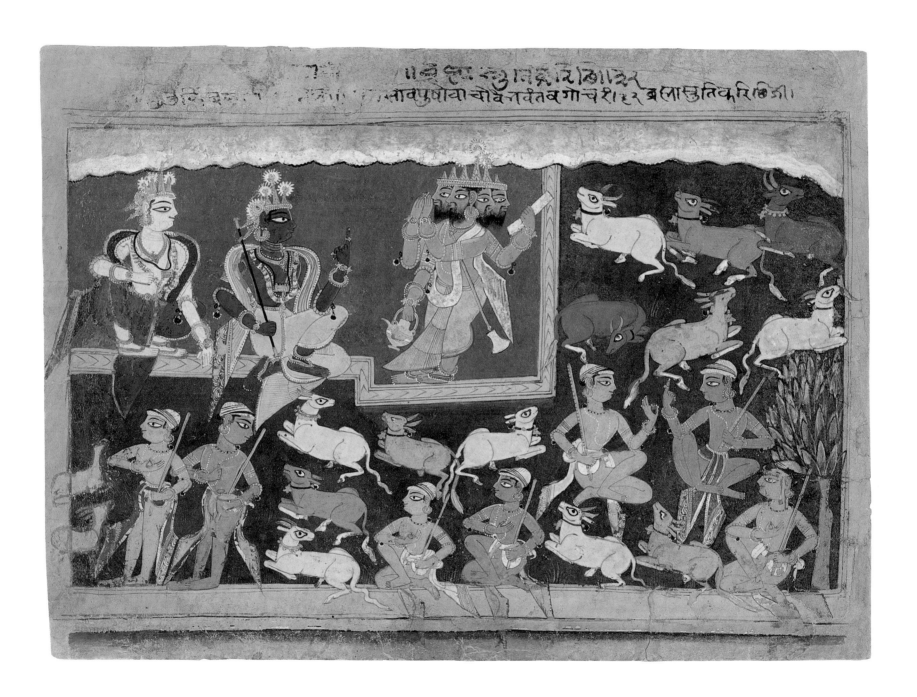

13. A Young Prince Riding

Attributed to Mir Sayyid 'Ali
Northern India or Afghanistan, Kabul; Mughal court; c. 1550–55
Opaque watercolor, ink, and gold on paper
12 11/16 x 9 inches (32.2 x 22.8 cm)

One of the most common types of books in the Islamic world was the album. Fine individual specimens of painting and calligraphy of different periods were gathered together in such albums, usually in alternation, so that one example of each would appear on any given opening of the book. The wide outer margin of the painting shown here, for example, indicates that it occupied the left side of an opening, opposite a work of calligraphy. To maintain the desired proportions of the image to the folio, the album's designer would often augment the central painted or written specimen with a painted extension or additional bits of writing.[1] He would then set it within a series of lavish borders, the outermost being filled with ornamental scenes of animals, birds, and flowers. These were typically rendered in gold washes against a background whose color was often varied by the use of different dyes.

The aggregate nature of albums makes them particularly susceptible to fragmentation and dispersal. To reconstruct albums—a notoriously difficult undertaking—scholars normally turn to such extraneous considerations as the general date of the paintings, the size of the folios, the style of the border decoration, and the occasional folio number. All these factors are relevant here because they clarify the original context of this rare folio, which bears an early Mughal equestrian portrait of a young prince on one side and a calligraphic aphorism on the other.

This painting has been associated with a group of paintings known as the Fitzwilliam Album, so designated because the majority of its folios are preserved in the Fitzwilliam Museum in Cambridge.[2] The initial publication of most of its dispersed folios seemed to shed new light on a hitherto murky stage of Mughal painting, that is, the period from the Mughal emperor Humayun's return from Persia in 1549 to his son Akbar's accession in 1556. The style of the fifteen known paintings accorded well with such an early date, with many showing discrete passages modeled in the Mughal manner, and one painting purportedly depicting a specific incident of 1555 in which Prince Akbar struck down a nilgai with his sword.[3] The early date of the group appeared to be corroborated further by one calligraphic specimen that provided a date of A.H. 953/A.D. 1546–47 and a provenance of Kabul, where Humayun had established his court in exile.[4]

Subsequent examination of these same folios has produced a surprisingly different conclusion. Most of the paintings were discovered to be overpainted, a practice that accounts for the unusual sense of Mughal-style faces and clothing grafted onto existing Bukharan-style images.[5] This discovery removes the group of paintings from the 1550s, when hints of what would develop into the Mughal style first appeared, and places them instead in the late 1560s, when the Mughal atelier was busy redoing other paintings in exactly this manner. Likewise, the precise identification of the scene of Akbar slaying a beast with a historical event of 1555 was undermined when various scholars recognized the fact that the prey that the young prince pursues in the painting is not a stout nilgai but an ordinary antelope. A systematic study of the measurements of the folios and their borders also turned up significant differences in their sizes, a feature that does not vary within a given book.[6] Finally, one group of nine paintings has original folio numbers, while the six remaining paintings do not.[7] The result of all this is that there is not a single Fitzwilliam Album, but three separate albums, each with some folios in the Fitzwilliam Museum.

The detachment of this painting from a putative album of early Mughal art in no way diminishes the importance of the painting, which remains one of the very earliest works by a Mughal artist. Its most distinctive feature is surely the rider's flamboyant golden turban, its surface tooled to catch the light and daubed with red, green, and white paint to simulate the effect of a generous studding with precious stones and pearls. Humayun himself is credited with the invention of its form: a tall, conical center rising above a squarish base. Although other representations of this turban type feature ties crossing at the base of the conical center, the plumed turban seen here appears only in images dating to Humayun's reign or in those deliberately evoking that period. Apart from his rich headgear, the figure's clothing is nondescript, the white sash cast over his shoulder meriting attention only for its opaque surface and scratchy arabesque decoration. But the figure's status is confirmed by the book he holds, for it conspicuously bears a Persian inscription that alludes to his divinely ordained future rule: "May the world grant you success and the celestial sphere befriend you. May the world-creator protect and preserve you."[8]

The combination of this lofty inscription, the luxurious Humayun-period turban, and a very youthful countenance leaves no doubt that this princely figure is none other than the emperor's son and heir, Akbar.[9]

In the 1550s, only three Mughal artists afford enough documentation to permit a discussion of their personal painting styles: Mir Sayyid 'Ali, 'Abd al-Samad, and Dust Muhammad. This painting compares most closely with the work of the first, notably the signed *School Scene* of c. 1540[10] and the ascribed *Portrait of a Young Scholar* of c. 1555.[11] The shape of the prince's face and rendering of the eyes and eyebrows in the equestrian portrait are particularly reminiscent of these works. The hands, clothing, and setting are considerably simpler than those found in these two highly accomplished works.

On the reverse of this folio is a fine specimen of Nasta'liq written by an anonymous calligrapher (see Appendix).[12] JS

PUBLISHED: Beach 1992, p. 21, fig. 9

1. The bits of Persian writing above and below this image read: "I'll give you some good advice. Listen and do not make excuses. Accept whatever the compassionate advisor tells you.
2. Beach 1987, pp. 17–49.
3. The episode is recorded in the *Akbarnama,* and is published in ibid., p. 21; the corresponding image is the frontispiece and figure 8 of the same publication.
4. Ibid., p. 48, fig. 33.
5. The evidence for the overpainting of these paintings is presented in John Seyller, "Recycled Images: Overpainting in Early Mughal Art," in Canby 1994, pp. 69–76.
6. Ellen Smart has graciously shared her data and thoughts with me on this matter.
7. The paintings that belong to this group are Fitzwilliam Museum (FM) 160-1948 (folio 9), FM 72-1948 (folio 16), FM 161-1948 (folio 28), FM 162-1948 (folio 34), FM 163-1948 (folio 35), British Museum (BM) 1948 10-9-076 (folio 37), BM 1948 10-9-053 (folio 40), BM 1948 10-9-054 (folio 41), and FM 164-1948 (folio 47). The fact that the folio numbers run as high as 47 indicates that many other folios may be extant.
8. This inscription, together with the others discussed in n. 1 above, was translated by Wheeler Thackston.
9. An inscription written in Devanagari in the lower margin identifies the figure as Sikandar Rūmī, or Alexander the Great.
10. Arthur M. Sackler Gallery, Washington, D.C., S1986.221 (A. S. Melikian-Chirvani, "Mir Sayyed 'Ali: Painter of the Past and Pioneer of the Future," in Das 1998, figs. 9–12).
11. Los Angeles County Museum of Art, M.90.141 (ibid., fig. 1).
12. It reads: "The Pir of Herat [Khwaja 'Abdullah Ansari] says: 'Make the most of your life, and know that obedience to God is a golden opportunity. Whoever makes ten good qualities [of the Prophet] his watchword has done his job in this life and the next.'" Thackston has identified the source of this passage as the *Munajat* of Khwaja 'Abdullah Ansari.

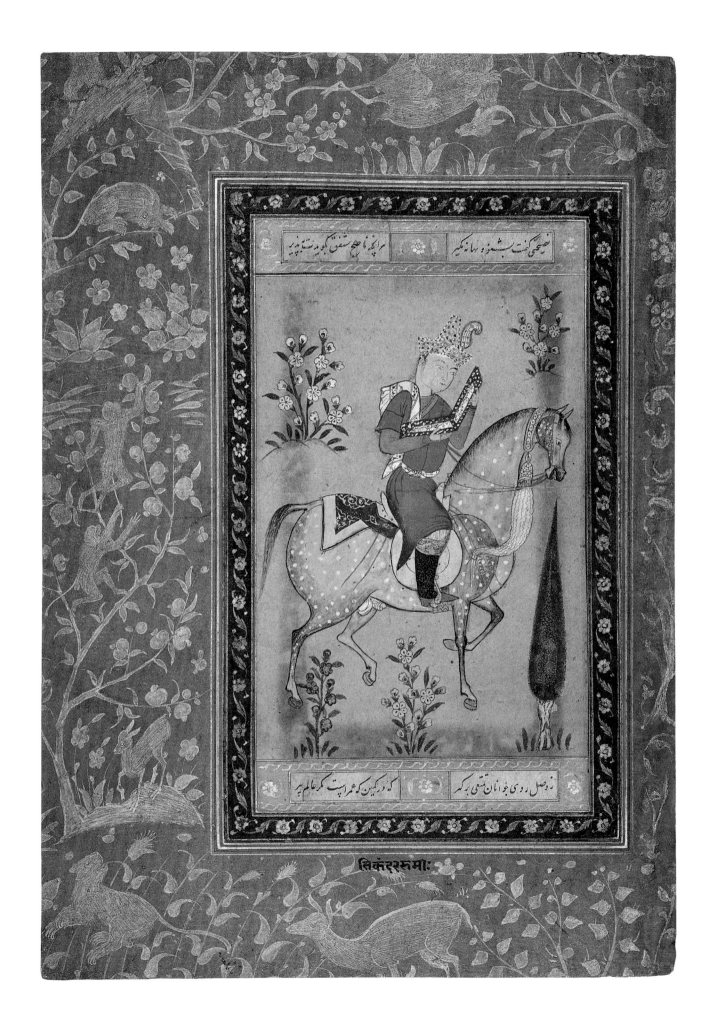

सिक्करसुमा:

14. Rustam Kills a Demon

Attributed to Mahesa
Northern India, Mughal court, c. 1575
Opaque watercolor and gold on paper
10 9/16 x 6 5/8 inches (26.9 x 16.8 cm)

Rustam, a figure central to the great Persian epic the *Shahnama*, upends a fierce spotted demon, who, despite his own formidable claws, fangs, horns, and spiky hair, is overwhelmed by the hero's prodigious strength. The demon extends his arms to try to break his fall and perhaps catch Rustam's foot, but his defeat is surely imminent, a point made clear by the artist, who positions the demon's tail literally between his legs. Although Rustam's exploits appear in most manuscripts of the *Shahnama*, a text illustrated many times both in Persia and later in Mughal India, it is relatively unusual to have a single episode excerpted as an independent painting, and particularly one with a figure scale as large as is found here.[1]

Rustam is traditionally identified by his costume, which consists of the hide and head of a tiger, a creature he slew in a test of his bravery and skill. Here, however, he wears the martial clothing standard in Mughal painting: an armored helmet, an orange tunic, and short pants tucked into high boots. But the hero's helmet has been altered; vestiges of the original drawing above its conical form reveal that it was, in fact, intended to be a tiger's head surmounted by a low cap. The odd juxtaposition of a black aigrette and grayish plume rising from the top of the helmet, and the two black feathers protruding incongruously from its front, is evidence that this change occurred late in the painting process.

This vigorous painting can be attributed to Mahesa, an artist active in Akbar's painting workshop from c. 1570 to 1599, during which time he almost certainly contributed to the creation of Akbar's monumental *Hamzanama* manuscript, although no works are signed. Several paintings in Mahesa's earliest documented work, the *Darabnama* of c. 1577–80, now in the British Library in London, depict similar scenes of struggle and the same facial type seen in the figure of Rustam.[2] Typical of this face are large almond-shaped eyes extending slightly beyond the contour of the face, pupils set centrally within them in an impassive gaze, and wavy eyebrows springing from hooked forms near the bridge of the nose. Mahesa often reduces his forms to flattened shapes, a tendency most evident in the heavy outlining of Rustam's boots and the rudimentary modeling of his tunic, which is limited to a series of schematic folds at the cuffs.

On the reverse of this painting (see Appendix) is a specimen of Persian calligraphy by Mahmud ibn 'Ishaq al-Shihabi, an eminent sixteenth-century calligrapher from Herat who was the pupil of the acclaimed Mir 'Ali.[3] Mahmud's accomplishment was so great that Mir 'Ali paid him the highest compliment that any teacher could give, exclaiming, "I have acquired a pupil better than myself."[4] JS

1. For a similar combat of Rustam and the white *div* painted in Tabriz in the mid-sixteenth century, see Robinson et al. 1976, no. III.227, plate 54.
2. Or. 4615. See especially folios 2b, 5a, and 90a–b. A nearly identical helmet appears in Mahesa's painting on folio 5b.
3. For a discussion of Mahmud's life and calligraphy, see Pratapaditya Pal, *Indian Painting: A Catalogue of the Los Angeles County Museum of Art Collection*, vol. 1, *1000–1700* (Los Angeles: Los Angeles County Museum of Art, 1993), pp. 237–38, cat. 61B; and Minorsky 1959, pp. 131–32.
4. Quoted in Minorsky 1959, pp. 131–32.

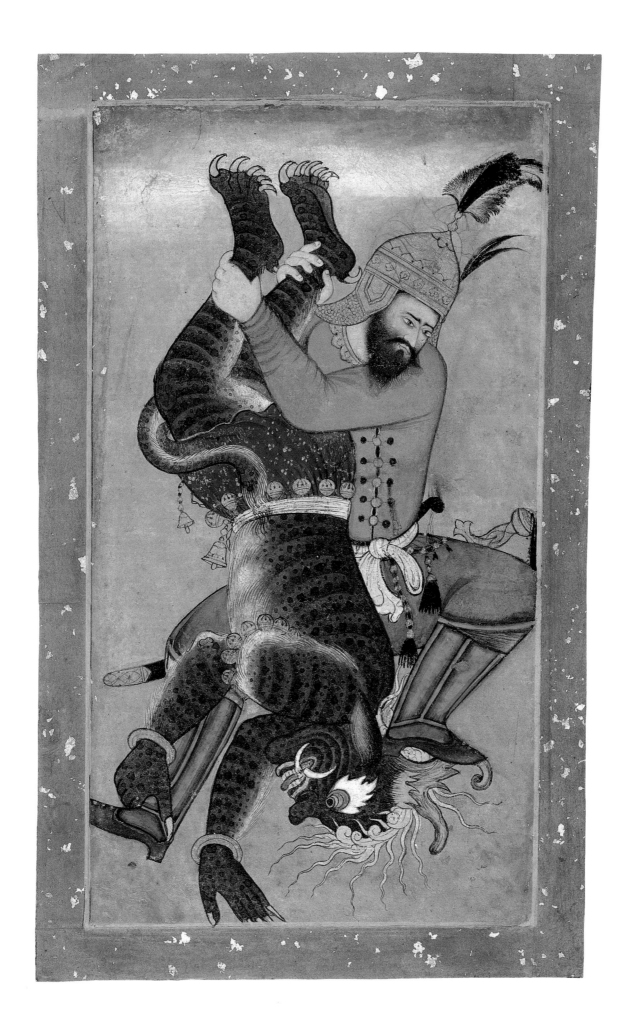

15. *Evangelist Writing with the Aid of a Woman Holding an Inkwell*

Attributed to Manohara
Northern India, Mughal court, c. 1595–1600
Opaque watercolor and gold on paper
10 1/2 x 6 5/8 inches (26.6 x 16.9 cm)

This scene of two figures huddled over a book demonstrates both the catalyst and the result of the most remarkable development in Mughal painting in the last two decades of the sixteenth century. Imperial Mughal painting produced before 1580 can still be located easily within the spectrum of Persianate painting. Many Mughal scenes from this period (see, for example, cats. 13, 14) are obviously indebted to Persian models in both subject and style. Even in those works that are clearly affected by Indian elements, such influence is primarily restricted to the frequent inclusion of indigenous female types and local vegetation. But from 1580 on, European art emerged as a new source of imagery and pictorial devices and began to exert a growing influence on Mughal art, thereby transforming what had been a robust variant of the Persian style into a unique, sophisticated fusion of the Persian, Indian, and European pictorial traditions.

A smattering of Mughal paintings from the late 1560s and 1570s show that some Mughal artists had already acquired a rudimentary knowledge of European visual devices, notably three-dimensional modeling and foreshortening. The source of this information was European prints, a limited number of which were introduced to the Mughal court as both artistic novelties and religious enticements. Mughal artists were quick to respond to the European rendering of volume, which contemporary accounts extol as wondrously lifelike, and began to simulate it in folds gathered conspicuously about sleeves and hems, and in colors newly tempered by tonal modeling. In 1580, a second Jesuit mission arrived at the Mughal court, bringing with it a much richer selection of European images, including oil paintings. Familiarity with these works soon introduced into the mainstream imperial style a broader range of European features, among them space-enclosing architecture, atmospheric perspective, and a greatly reduced scale in the deep distance.

Although most Mughal artists ventured in this direction, three artists incorporated European devices in their work in particularly systematic fashion: Kesavadasa, Basavana, and Manohara.[1] Of this trio, Kesavadasa is best known for his many adaptations and direct copies of European prints. The prints were most frequently mid-sixteenth-century Flemish or German engravings, but were often based upon earlier Italian compositions. They present both classical and religious subjects, with the latter more prevalent. For some overtly religious scenes, such as the Crucifixion, there is little doubt that Mughal artists strove to make faithful records of their models because the Jesuits had impressed upon them the sanctity of the religious message. For quasireligious subjects, however, Mughal painters generally adapted their sources more freely, sometimes to such an extent that the precise source and meaning of their own images are no longer identifiable.

Such is the situation with this scene of a seated man writing beneath a tree. A female figure stands before him to facilitate his labors, which she does by steadying the small book in his hand and holding a golden inkwell close by. The solemn pair immediately evoke images of the Evangelist Matthew and the angel who assisted him. Kesavadasa had, in fact, executed a close copy of that very subject in 1588.[2] In this painting, however, the artist has shorn the angel of its wings, made the figure more clearly female, and shifted the entire scene to an unrelated outdoor setting. A second book, its pages casually fluttering in a breeze, rests incongruously on a velvety cushion at the figures' feet.

The composition exemplifies all the larger pictorial trends of late sixteenth-century Mughal painting. The action transpires on a low platform that recedes at an abrupt angle, thereby defining the primary block of space in the painting's foreground. A tree whose voluminous quality withstands its unnatural blue coloring rises behind the seated author to close off the right side of the composition. Opposite it is a gently tilted landscape punctuated by low rises and outcrops, both mainstays of Mughal landscape. Beyond the largest cluster of rocks and trees, the Mughal world yields to a distinctively European vista. A river winds its way forward from the distance into the middle ground, carrying with it an ethereal boat and its skeletal crew. A pinkish cityscape nestles among trees and mountains, which become ever lighter and bluer until they practically merge with a blue-streaked sky.

Several subtle details support an attribution of the painting to Manohara rather than to Kesavadasa.

The most pronounced of these is the rendering of the Evangelist's robe. Here, as elsewhere in Manohara's work, the clothing clings to the figure; its surfaces are smooth, its folds limp, and its contours finely shaded. By contrast, Kesavadasa favors palpably heavy clothing with deep, crisp folds, their forms echoing more closely those of European engravings. While both artists render figures whose features resemble the Evangelist's narrow-set eyes and long nose, only Manohara consistently employs a female facial type with the tapering chin and heavy-lidded eyes seen here. Similarly, he habitually constructs his landscapes with a low-lying central zone, cloudlike mounds, and exceedingly spongy outcrops.[3] Cats and deer also appear frequently in his work, particularly in his European-inspired images.[4] Finally, Manohara's palette is dominated by secondary colors, such as the pale blue-green and light scarlet of the Evangelist's cloak, rather than by the primary colors preferred by Kesavadasa.

Manohara began his long career in the Mughal workshop under the tutelage of his father, Basavana, who must have fostered his interest in European subjects and effects. This painting must date to the late 1590s, the midpoint of Manohara's career, for it relates very closely to a series of ascribed illustrations in the most ambitious manuscripts of the period, namely the 1595 British Library *Khamsa* of Nizami, the 1596–97 British Library *Akbarnama*, and the 1597–98 Walters Art Museum *Khamsa* of Amir Khusraw. JS

PUBLISHED: Sotheby's, New York, October 6, 1990, lot 63

1. See Terence McInerney, "Manohar," in *Master Artists of the Imperial Mughal Court*, ed. Pratapaditya Pal (Mumbai: Marg Publications, 1991), pp. 53–68; and Okada 1998, pp. 84–95.
2. Bodleian Library, Oxford, MS. Douce Or. a. l, folio 41b. The image is published widely, most recently in Okada 1998, p. 89, fig. 5.
3. See, for example, folio 72a of the 1595 *Khamsa* of Nizami in the British Library in London, and folio 188a of the 1597–98 *Khamsa* of Amir Khusraw in the Walters Art Museum in Baltimore. These are easily distinguished from Kesavadasa's rock formations, whose outlines and internal striations are more typically jagged.
4. A very comparable deer is found in an ascribed drawing of Layla and Majnun in the Chester Beatty Library in Dublin (MS. 11A.12); see Leach 1995, vol. 1, pp. 143–46, no. 1.240.

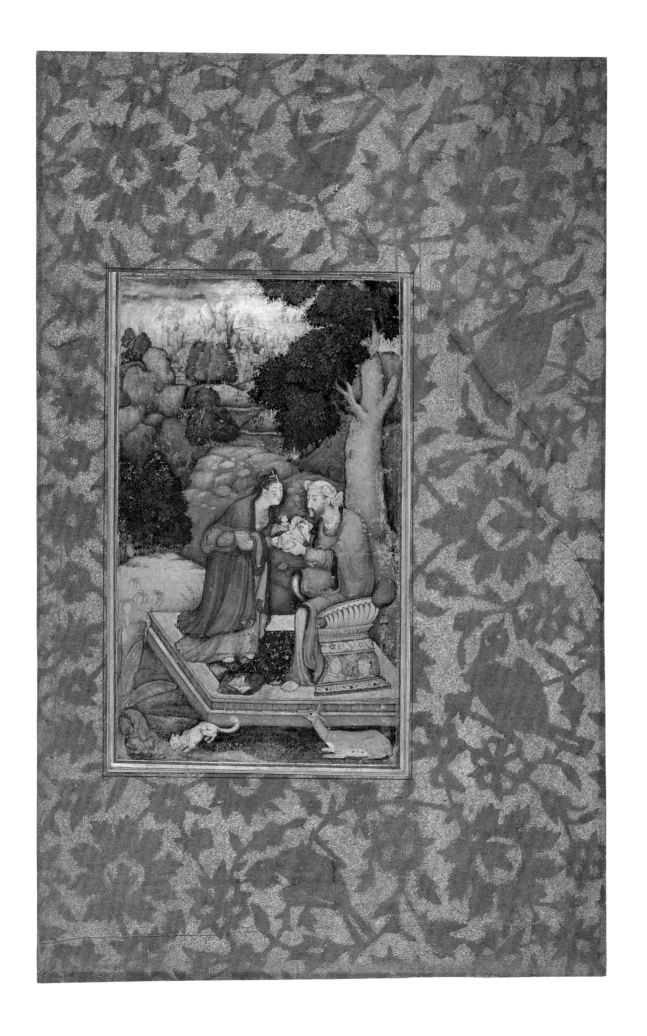

16. *Vishvamitra Asks Dasharatha's Permission to Take Young Rama and Lakshmana into the Forest*

Page from a dispersed series of the *Ramayana*
Northern India, subimperial Mughal, c. 1605
Opaque watercolor and gold on paper
9 5/8 x 7 7/16 inches (24.5 x 18.9 cm)

The *Ramayana*, one of the most important texts of the Indian tradition, recounts the tale of Rama, a legendary prince who lived in the city of Ayodhya in northern India and came to be regarded as a manifestation of Vishnu. Conceived when the three wives of King Dasharatha partook of a divine nectar, Rama and his three brothers were destined to vanquish the demon Ravana and thereby restore order to the world. Rama's valorous exploits, unflinching acceptance of the hardships of the fourteen-year exile his father was forced to impose upon him, and virtuous behavior made him an exemplary subject for kings to invoke and emulate.

It is somewhat paradoxical that illustrated manuscripts of the *Ramayana* were not produced until the emperor Akbar ordered the Sanskrit epic translated into Persian, the language of the Mughal court, so that he and his courtiers could hear and read the stories that much of the populace took to be the embodiment of ancient truths. Between 1588 and 1605, three copiously illustrated manuscripts of the *Ramayana* were produced for Akbar and his highest-ranking officer, each representing a different variety of the Mughal style. The presentation manuscript, dated 1588–92, commanded the services of the court atelier's finest artists, who, taking their cue from the vivid textual descriptions, produced exceptionally imaginative and spatially complex compositions. A second manuscript of 1594, illustrated by a half-dozen or so lesser imperial artists, does not keep pace with the most advanced developments in Mughal painting, but does incorporate some rarely seen features, notably narrators and listeners encapsulated in discrete areas and rock grotesques. The third copy, made between 1597 and 1605 in a subimperial workshop whose members had limited familiarity with imperial practices, so habitually simplifies its compositions, draftsmanship, and coloring that its paintings approximate the standard of the imperial idiom only occasionally.[1]

This fourth Mughal *Ramayana* series falls outside the pattern established by the first three manuscripts in several curious ways. First, it is not a bound volume with a continuous text, but an extensive unbound series of upright individual leaves with selected verses written on the reverse. Second, the language of those verses is not Persian but Sanskrit, which suggests that the patron was a highly educated Hindu.[2] And third, the paintings are not easily situated as another predictable stage in the gradual and general debasement of the imperial style. Rather, their artists retain selected aspects of the imperial style and dispose of others altogether, employing the typically fine figure style of imperial painting, but replacing space-enclosing architectural settings with an utterly original set of resplendent decorative elements. This unique synthesis may well have been a one-time affair, for it had no obvious stylistic successors in subimperial Mughal painting or among the many emerging regional styles of northern India. It does have, however, a demonstrable connection to the Mughal workshop, one that both sheds light on the date of the series and helps flesh out the fate of certain artists who had been dismissed from the imperial atelier at the end of Akbar's reign.

The connection comes through a group of minor artists who are known primarily from their contributions to the 1597–99 *Baburnama* in the National Museum in New Delhi and the 1598–1600 *Razmnama*, but who disappeared from the annals of the imperial library establishment immediately thereafter.[3] The best known of these artists is Jagajivana, whose figures typically have a sloping nose and an almond-shaped eye, whose delicately colored rocks are rendered with scumbled paint, and whose landscapes are muted by atmospheric effects.[4] Likewise, Makara's work in the 1598–1600 *Razmnama* compares very closely to at least two paintings in this dispersed *Ramayana* series.[5] Among the other former imperial painters who seem to have taken up employment with the patron of this *Ramayana* are Lohanka, Khemana, and Bhora. Because there is negligible stylistic distance between the key features of the 1598–1600 *Razmnama* and most paintings of this *Ramayana* series, the latter date no earlier than 1600 and no later than 1610. This painting illustrates an episode when Rama and his brother Lakshmana are first called to duty. Vishvamitra, the sage seated opposite the enthroned Dasharatha, entreats the king to grant him permission to take these two princes into the forest to destroy some nettlesome demons who are disrupting his ritual sacrifices. Dasharatha,

instinctively worried about the danger that might befall his four sons, whose youth is indicated by their diminutive size, initially demurs, yet ultimately acquiesces to Vishvamitra's request when the preceptor reminds him of Rama's inevitable destiny.

The scene is presented against a vivid architectural backdrop. The two central figures are framed by a large curving canopy with a densely beaded fringe. Between them stands a golden doorway, one side closed off by a half-door with unexpected orange panels, the other open to reveal a dense black-and-white checkerboard pattern at the bottom; this pattern reappears in several other paintings in this series, presumably by this unidentified artist, but nowhere else in Mughal painting.[6] Moreover, the doorway is strangely attached to nothing whatsoever; instead, it is isolated against an abstract black field marked with simple golden crosses. Above the canopy, the black field reads first as the negative space within a light blue arcade, and then more plausibly as a series of flattened crenellations floating before two different tiled patterns. This delight in abstract designs recurs throughout this artist's work, with brilliantly inventive ornamental panels often overwhelming the figures nearby and impeding any sense of pictorial space. This predilection for decorative forms carried through even into the sky, where it gives rise to blue-and-white streaked ribbon-shaped clouds, a motif virtually absent from Mughal painting since the days of the *Hamzanama* over thirty years before.[7]

The *Ramayana* series to which this painting belonged was damaged by fire soon after it was completed, a fate that explains the irregular shape of many of its now-dispersed paintings and some sketchy passages in the upper and lower corners of others. A number of the paintings have stamped impressions of the seal of the Datia Palace collection on the reverse, and one has three faint and unrelated Datia-style sketches as well, thus indicating that the series once belonged to the royal collection of that Central Indian state. This provenance is further corroborated by the fact that the gloss is written in a dialect of Hindi spoken in the region of Bundelkhand in Central India. On the basis of this connection, Terence McInerney has proposed that the original patron of the series was Bir Singh Deo Bandila, a wealthy Hindu noble

noted for his lavish patronage in the region.[8] Having served Jahangir while he was still a prince, and rising dramatically in prominence throughout his subsequent reign as emperor (1605–27), Bir Singh Deo would have enjoyed exactly the kind of social position necessary to commission cast-off imperial artists to make an illustrated *Ramayana* series for his edification and pleasure. JS

PUBLISHED: Christie's, London, June 11, 1986, lot 139

1. For these three manuscripts, see Seyller 1999.

2. Most pages also have a one-line gloss that Asok Das informs me is in the Bundeli dialect of Hindi.

3. The *Razmnama*'s colophon (British Library, London, Or. 12076) contains the date of A.H. 1007/A.D. 1598–99. A marginal note on one painting is dated 24 Farwardin Ilahi, regnal year 45, which is equivalent to April 13, 1600.

4. Compare his *Razmnama* painting (Baroda Museum and Picture Gallery, 198/15) with his *Ramayana* paintings: one now in a private collection (Seyller 1999, p. 34, fig. 13); National Museum, New Delhi, 56.93/4 and 56.114/9; Los Angeles County Museum of Art, M82.6.5; and two other works in a private collection.

5. Compare Makara's *Razmnama* paintings—British Library, Or. 12076, folio 51a; British Museum, 1923 11-15 013; and San Diego Museum of Art, 1990:306—with the following from this *Ramayana*—Bharat Kala Bhavan, Varanasi, 7653 (Chandra 1957–59, fig. 22); and *Bharata Before Rama,* in a private collection.

6. Other paintings by this artist are found in the Goenka Collection (Goswamy with Bhatia 1999, pp. 46–47, no. 36); Howard Hodgkin Collection (Topsfield and Beach 1991, pp. 26–27, no. 4); Bharat Kala Bhavan, 669 (Morley 1981, fig. 530); Leon and Cynthia Polsky Collection (Seyller 1999, p. 34, fig. 12); National Museum, New Delhi, 56.114/8 (Chandra 1957–59, fig. 24a) and 64.351; and a private collection.

7. For the sole example of this motif in the *Hamzanama*, dated c. 1557–72, see Victoria and Albert Museum, London, I.S. 1513–1883 (Guy and Swallow 1990, pp. 68–69, no. 46). A related cloud form appears in the Jaipur *Ramayana;* see Das 1999, p. 37, fig. 1.

8. For a summary of his career, see Nawwab Samsam-ud-Daula Shah Nawaz Khan and 'Abdul Hayy, *The Maathir-ul-Umara,* 2nd ed., trans. H. Beveridge, ed. Baini Prashad (Patna: Janaki Prakashan, 1979), vol. 1, pp. 423–25.

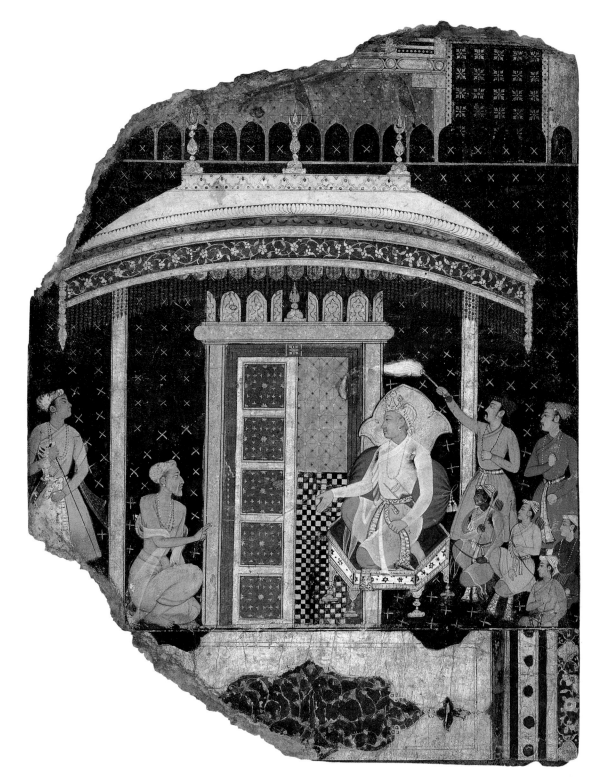

17. Kusha Kills Lakshmana

Signed by Fazl
Page from a dispersed manuscript of the *Razmnama*
Northern India, subimperial Mughal, dated 1616–17
Opaque watercolor, ink, and gold on paper
15 3/16 x 8 15/16 inches (38.5 x 22.7 cm)

A second variety of subimperial Mughal painting (see also cat. 16) is manifested in this illustration from the *Razmnama*, or "Book of Wars," the name given to the Persian version of the Indian epic of the *Mahabharata*. In this case, however, we have far more conclusive evidence about the patron who commissioned this manuscript and the group of artists who produced it.

The *Razmnama* manuscript was commissioned by 'Abd al-Rahim, the highest-ranking noble at the Mughal court.[1] The source of his prestige was his title of *khankhanan*, or commander-in-chief of the imperial army, a position he attained in 1584 after demonstrating his mettle on the field of battle. But 'Abd al-Rahim had many talents outside the military sphere. He spoke a number of languages, wrote poetry in Hindi, translated the emperor Babur's memoirs from Turki to Persian, and served for a time as tutor to Salim, the future emperor Jahangir. His exceptional cultivation and legendary generosity allowed him to attract a large coterie of eminent authors, calligraphers, and painters to his service. These artists worked exclusively for 'Abd al-Rahim, though at least seven entered his employ by way of the imperial painting workshop.

'Abd al-Rahim commissioned and collected many of the religious and literary texts standard in Persianate culture, but he also showed a profound interest in Hindu culture. In this, he followed the lead of Akbar, who had had a number of Hindu texts, including the *Ramayana* and *Mahabharata*, translated into Persian in the 1580s. Two dated paintings in 'Abd al-Rahim's copy of the *Razmnama* fix the years of this project as 1616–17, some thirty years after the imperial version of the manuscript had been translated and illustrated. Although 'Abd al-Rahim's manuscript has long been dispersed, the number of illustrations appears to have been great, perhaps even approximating the 168 of the imperial *Razmnama*, a manuscript preserved in Jaipur.

The format of the paintings is unusual for the time, with large paintings typically wrapped around substantial blocks of text. This feature had a detrimental effect on the manuscript in the twentieth century, for dealers who apparently had little use for the presence of a foreign script in the midst of colorful paintings excised the areas filled with writing on many pages and replaced them with snippets of painting cut from still other pages. This page has escaped that unfortunate fate, and thus affords a clear picture of the original appearance of the manuscript.

The text is written in an undistinguished Naskhi, a functional script rarely used in fine literary manuscripts. One measure of the indifference shown to the form of the text is a marginal correction to the left of the end of the thirteenth line. Finding himself with too little space to complete the word ("happiness") there, the scribe simply wrote the final syllable in the margin and drew a light protective circle around it. The painter was untroubled by this minor intrusion, and completed the design of the running blue horse with the writing perched somewhat incongruously on its hindquarters. Such corrections are common in this manuscript, whose thin paper probably would not have withstood the eradication of the word from the surface.

This scene features not the major protagonists of the epic struggle between the Pandavas and the Kauravas but Kusha and Lava, the forsaken twin sons of Rama, who are very peripheral to the central narrative of *Razmnama*. Because the Persian text follows an apocryphal version of the *Ashvamedhikaparva*, the fourteenth of the eighteen books of the massive *Mahabharata* text, these youthful heroes acquire a prominence in Mughal illustrated copies of the epic that they do not enjoy in other recensions of the text. Kusha, whose dark complexion reflects his divine lineage, has already dispatched Kalajita, Lakshmana's general, by decapitating him with a magic arrow. Now he proceeds to move against an enraged chariot-borne Lakshmana with five more arrows on which Valmiki had cast a spell. The last two lines of text above the painting specify his action exactly: "Kusha set those five arrows to his bow and struck Lakshmana with

them in the chest in such a way that Lakshmana sank like the sun in the sky, became unconscious, and fell to the ground."

This painting matches the corresponding work in the Jaipur *Razmnama* in both narrative moment and basic composition, a pattern that generally characterizes the relationship between the two illustrated manuscripts.[2] Yet the two paintings differ significantly in detail. Here the artist has reversed the orientation of the chariot so that the arrow-riddled Lakshmana tumbles toward Kusha. This change was probably motivated by a desire to avoid the visually complicated form of a figure overlaid on a chariot and its team, but it has the benefit of forcing the defeated king to strike a pose of prostration before his youthful conqueror. The ranks of Lakshmana's army have shrunk to a handful of dead or terrified soldiers, thereby setting off individual figures against patches of open space. Likewise, the landscape features the same kinds of outcrops, trees, and buildings as does its imperial counterpart, but here they are so radically schematized into bold, eruptive forms that they acquire an expressive capacity rarely seen in more naturalistically rendered Mughal environments.

The painting is signed prominently on the chariot by Fazl, the most original of the twenty-one artists in 'Abd al-Rahim's atelier. Fazl sometimes falters in his draftsmanship, as he does here in the cityscape above, but he rarely fails to produce a compelling design. What his figures lack in physical and emotional nuance, they more than gain in fiercely determined movements and intense facial expressions. JS

PUBLISHED: Sotheby's, London, April 23, 1979, lot 103; Christie's, London, October 16, 1980, lot 58; Seyller 1985, p. 64, no. 37 (text only); Sotheby's, New York, March 22, 1989, lot 59

1. Seyller 1999, pp. 252–57.
2. The Jaipur painting is no. 1805; see Thomas H. Hendley, *Memorials of the Jeypore Exhibition, 1883* (London: W. Griggs, 1884), vol. 4, plate 106. For a discussion of the relationship of these two manuscripts and a third copy of the same text, see Seyller 1985, pp. 37–66.

18. The Wedding of Satyabhama and Krishna

Page from a dispersed series of the *Bhagavata Purana*
Rajasthan, probably Bikaner, c. 1590–1600
Opaque watercolor and gold on paper
8 3/8 x 11 11/16 inches (21.3 x 29.6 cm)

Jewels, miraculously petrified bits of light, have long bedazzled humans, often to the point of provoking imprudent, even irrational behavior. Chapter 56 of Book 10 of the *Bhagavata Purana* recounts a sequence of events precipitated by the blinding effect of a particularly magnificent gem, the *syamantaka* jewel given by the sun god to his friend Satrajita. So pleased is Satrajita with the lustrous object and the auspicious occurrences that accompany it that he refuses to part with the jewel even when Krishna himself requests it. Satrajita's greedy attachment to the bauble has ruinous consequences. When his brother, Prasena, borrows the jewel one day to wear while hunting, it quickly attracts the attention of a lion, who kills him for it; the lion in turn is slain in his lair by the equally covetous king of the bears, Jambavan. Alarmed by his brother's disappearance, Satrajita begins to spread rumors that Krishna must be involved in foul play. Krishna follows Prasena's trail to Jambavan's cave, where Krishna and Jambavan battle over the jewel for twenty-eight days. The bear finally concedes defeat, acknowledges the divine nature of his opponent, and offers Krishna his daughter in marriage. The long duration of their struggle causes great concern among the populace, who worry about Krishna's safety and lament their own deprivation of his benevolent presence. They rejoice when Krishna emerges with the jewel about his neck and a bride at his side, but they also rebuke Satrajita for having caused so much sorrow. Satrajita realizes that his terrible greed has led him to malign so perfect a being as Krishna, and is duly contrite. Having once rashly denied Krishna the *syamantaka* jewel, he decides to make amends by offering him a still more precious one: his daughter Satyabhama, so esteemed for her beauty and virtuous demeanor that she is regarded as a jewel among women. Krishna graciously accepts the offer of Satyabhama's hand in marriage, but insists that Satrajita keep the *syamantaka* jewel. Satrajita's joy is short-lived, for Satyabhama's jilted fiancé, jealous at the loss of his potential bride and Satrajita's repossession of the jewel, murders him in his sleep.

This painting depicts the wedding of Satyabhama and Krishna as a humble affair, with little of the turmoil of the preceding events. Wearing special headdresses adorned by a modest floral spray, the seated newlyweds look on as the Brahmin priest propitiates the gods by pouring clarified butter into the sacrificial fire. A wedding canopy, festooned with auspicious leaves and supported precariously by five poles, joins the three figures together in the center of the painting. The remainder of the composition is filled sparsely by another Brahmin seated among ritual vessels, and two attendants bringing platters of flowers and fruit.

The painting demonstrates one of the many ways in which artists employed at one of the regional courts of Rajasthan introduced a few features of Mughal painting into an existing indigenous tradition. The painter attempts to impart a three-dimensional quality to the wedding canopy and the steps of the chamber at left; recognizing perhaps the limited success of his efforts, he is content to allow his figures to float before or above the spaces that in other hands might have been defined more convincingly by these architectural forms. Krishna wears Mughal-style garments, and all the priest and attendants have the relaxed contours of the Mughal style, but most of the figures retain the squarish heads and schematic faces of the indigenous tradition. The rectangular block of red featured consistently in many contemporary series is disguised here as the pavilion interior.

This *Bhagavata Purana* series also represents the process by which popular Mughal painting slowly germinated distinctive regional idioms. This series has long been associated with painting at Bikaner, primarily because some of its paintings bear a stamp indicating that they were part of the Bikaner royal collection.[1] Although that now-dispersed collection once contained works from many different schools of Indian painting, the spare compositions, cool palette, and pronounced linear quality of this *Bhagavata Purana* series are akin to those of paintings produced at Bikaner in the last third of the seventeenth century. It is reasonable therefore to see this series as a forerunner of the later Bikaner style. Nonetheless, the Bikaner style seems to have developed in a relatively fitful manner, as is suggested by the thoroughly Mughalized style of a painting inscribed as having been made at Bikaner by the painter Nur Muhammad about 1610.[2] The simpler base style and more superficial borrowing of Mughal elements of this *Bhagavata Purana* series support an earlier date of c. 1590–1600, or not long after that of the Isarda *Bhagavata Purana* (see cats. 11–12). JS

PUBLISHED: Kramrisch 1986, pp. 92, 176, no. 85

1. For other images from this series, see Ehnbom 1985, pp. 52–53, nos. 17–18; another folio was offered for sale at Sotheby's, New York, March 25, 1999, lot 205.
2. Goswamy with Bhatia 1999, p. 45, no. 35. The discovery of the signature of Nur Muhammad on one painting from the dispersed 1594 *Ramayana* (Christie's, London, October 10, 2000, lot 59) and the many similarities between the two paintings in facial type and decorative patterns allow us to associate both works with a single artist, and to begin to trace his path from the Mughal workshop to Bikaner about 1600.

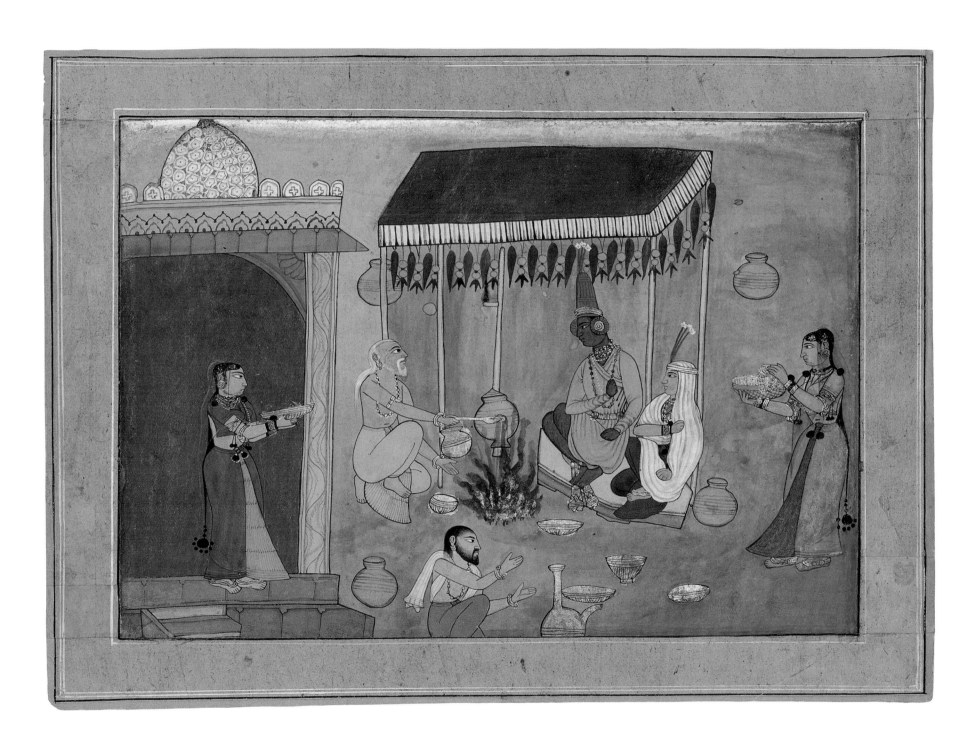

19. The Rainy Season

Page from a dispersed series of the *Bhagavata Purana*
Rajasthan, Mewar, c. 1630–50
Opaque watercolor and ink on paper
9 1/4 x 15 11/16 inches (23.5 x 39.8 cm)

The onset of the rainy season is a glorious time in India. It brings relief from the stifling heat, replenishes rivers, and refreshes a parched earth. The monsoon's arrival is still celebrated in song and festivals throughout India, but the sentiments that it continues to inspire are rarely expressed with the profundity and poignancy of the verses of the *Bhagavata Purana* written on and illustrated by this painting (see Appendix):

> Great clouds, charged with lightning, tossed about by violent winds, discharge their soothing, life-giving rain, as if feeling compassion for the dry world below. The earth, parched by summer's heat, flourishes under the clouds' soaking, as the body weakened by ascetic rigor becomes renewed upon achieving its fruit. During the all-encompassing darkness of the night, not stars but glowworms shine, as during the Kali age, those who are learned are blighted by the sin of those who are evil. Hearing Parjanya's [the Rain Cloud's] thunder, frogs who had been silent begin to croak, like Brahmins reciting at the close of their daily routine. Small streams, once dried up, now tumultously overflow their banks, as one who allows his body to be dependent upon passion strays on the wrong path.[1]

Such rich metaphorical language is common in the *Bhagavata Purana*, but it usually does not enjoy overt visual expression, being absorbed instead in details subordinate to the activities of gods and men (see cat. 12). Here, however, the artist ignores the references to ascetics and Brahmins, and features nature alone. Two peacocks call from their respective perches, and three other pairs of birds roost on trees and rocks. But most of all this is an image of rain itself, pouring from the storm clouds above in rhythmic rows, spurring crops to rise up in ranks no less regular, and causing a veritable procession of frogs to croak with joy at the water all about. Two pastel-colored outcrops, once a recognizably Mughal feature but by this time an integral part of Rajasthani visual vocabulary, dominate the center of the composition, interrupting a ground line that dips abruptly between them.

The full-page format of this painting is extremely rare.[2] More commonly, the paintings of this *Bhagavata Purana* series occupy a half or a quarter of the area normally occupied by the text. The physical relationship between image and text is exceptionally fluid, with paintings wrapped around text blocks, lines, and even individual letters, their edges approximating right angles only occasionally. This same casual approach to the frame is seen in the tendency to allow a few figures to spill over the ruling lines into the outer margins, a feature rarely found in manuscript illustrations outside the Persianate tradition. The paintings themselves are often divided into two registers. One benefit of this arrangement is that the artist could easily depict two separate actions, but another is that he could place the figures in simple rows and avoid complicated spatial constructions.

The figures are often remarkably squat, with a minimal neck, sweeping jaw, and pronounced sloping brow. In one painting from this series, three figures are rendered in three-quarter view, a striking departure from the profile view employed in almost all sixteenth- and early seventeenth-century paintings of the indigenous Indian tradition.[3] These three figures have a further eye projecting beyond the shape of the head, a throwback to a convention that had fallen out of fashion by the end of the fifteenth century. Together with the rudimentary architecture and the red rectangles behind the protagonists, the presence of this archaic feature has led some scholars to assign this series to the first quarter of the seventeenth century, occupying a position between the landmarks of early Mewari painting, the 1605 Chawand *Ragamala* and the 1628 *Ragamala*. Conversely, the Jahangir-period turbans and the Mughal-derived landscape elements support a later date. These features, along with elegant figures and elaborate architectural detail, appear first in Mewari painting in the 1628 *Ragamala*. This combination surely represents the most advanced kind of painting at the Mewar court, for it persists in many projects throughout the next two decades (see cat. 20). By contrast, the squat, somewhat folkish figures and old-fashioned compartmentalized compositions seen in this *Bhagavata Purana* virtually disappear from Mewari painting. Thus it seems that the artists who painted this series incorporated relatively simple and minor Mughal-derived features as a means of updating their work, which was probably done at a place outside Udaipur itself. JS

PUBLISHED: Kramrisch 1986, pp. 69, 170–71, no. 62

1. Book 10, Chapter 20, Verses 5–12; translated by Richard Cohen. The inscription written below in red restates this more concisely: "While it rains, birds perch singing on the hills, and jackals appear in the fields by the banks of the River Yamuna."
2. A painting in the Metzger Collection, published by Joachim Bautze, *Lotosmond und Löwenritt: Indische Miniaturmalerei* (Stuttgart: Linden-Museum, 1991), pp. 44, 46, no. 5, also exhibits this format. Bautze notes that a double-sided folio with full-page paintings is in the Huyck Collection.
3. Brooklyn Museum of Art, 83.164.2; see Poster et al. 1994, p. 202, no. 155.

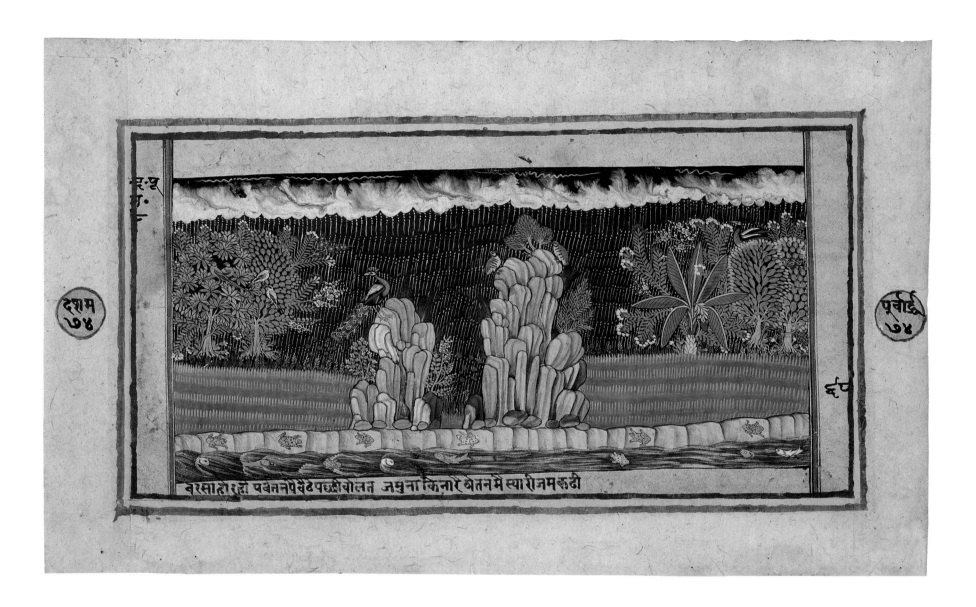

वरसा हो रह्यो पवन नपे बैठे पछी योलत जमुना किनारे बेतन में स्या रीज मक्ढी

20. *The Woman Who Is Driven by Passion to Meet Her Lover (Kamabhisarika Nayika)*

Page from a dispersed series of the *Rasikapriya* of Keshavadasa
Rajasthan, Mewar, c. 1640–50
Opaque watercolor and gold on paper
10 1/16 x 8 1/8 inches (25.6 x 20.6 cm)

Few Indian texts demand more of their audience than the *Rasikapriya* (Connoisseur's Delights), a medieval Hindi text composed in 1591 by Keshavadasa, a poet at the court of Orchha (see also cats. 21, 22). Written in a deliberately challenging rhetorical style, it encourages its readers to appreciate the subtleties of both its poetical form and its substance, which is the many faces of love. It displays an Indian fondness for classification, categorizing lovers in manifold ways: sometimes by physical appearance, other times by the circumstances under which they meet, and still other times by emotional complexion. These categories are further subdivided into manifest and latent expressions. By rich structure and language the reader is led to imagine or recall the many nuanced phases and emotions of a love relationship, such as the pleasure discovered with the first awakening of desire, the pangs of sorrow suffered at even temporary separation, and the indignation provoked by jealousy and neglect. The actors in this timeless drama are Krishna and Radha, presented here not as figures to worship, but as exemplars with earthly passions.

As one might expect of a text that dwells upon beauty and lovemaking, the *Rasikapriya* was a favorite subject of illustration. Its emphasis on states of being was perfectly suited to a visual aesthetic that rarely felt a need to individualize figures by means of explicit gestures and expressions, but was content to allude to the actions and emotions of archetypal figures by use of visual metaphor, compositional juxtaposition, and color. Text and image operate in tandem, with verses written in the yellow band above the painting proper alerting both painter and viewer to the nature of the situation below. The verse above this painting, for example, describes one of three types of heroine eager to meet her lover; this is a heroine whose physical desire for her beloved is so strong that she will brave any danger to meet him:

> Demons watch her from all sides as her
> feet trample the hood of a coiled snake. She
> neither heeds nor senses the gathering storm,
> nor hears the crickets, or sounds of thunder.
> Oblivious of her lost trinkets, or her torn
> clothing, she feels not the thorn's cut on her
> breast. The ghouls ask: "O woman! How
> did you acquire such fortitude, to pursue
> this tryst?"[1]

The painter responds to these verses by setting the woman a rigorous test, placing her as far as possible from the object of her desire and strewing her tortuous path with a host of obstacles. The text clearly inspires some features of the painting, such as the snake encircling the heroine's ankle, the bangle lying unnoticed on the ground behind her, the rainstorm assailing her, and the ghouls lurking in the hilly terrain. Other elements bear a more tangential relationship to the text. Ensconced in a brightly colored cave is a yogi with matted hair piled high, a figure probably evoked by the ghouls' mention of the yogic powers that they guess the heroine must possess to persevere against such adversity. Two Persianate *divs* (demons) add variety to the demons who menace the woman, while a tiger dozing peacefully poses only a dormant threat.

But these extratextual elements also demonstrate the limits of individual innovation in traditional Indian painting, for most of them appear in the same positions in two other contemporary Mewari images of the same scene.[2] Thus it is clear that what we see is not the result of a direct, personal response to the verses by a single artist, but a set of visual conventions developed in Mewar for the *Rasikapriya* within a half-century of its composition. Individual artists operated within this emerging tradition, and restricted their innovations to a few selected details. In this painting, for example, the painter installs Krishna in a pavilion rather than the bower seen in other images, and heightens the sense of imminent passion by coloring his chamber a brilliant red. He also manipulates the gestures of the two main figures so that both raise a small flower to the mouth. He maintains the coloring of the heroine's clothes and the general layout of the landscape, but achieves a stronger sense of compartmentalization by strengthening and varying the color blocks of the landscape, and by interlocking the rock and arboreal forms more tightly. The general style is derived from Sahibdin, the leading painter at the court at Udaipur in the second quarter of the seventeenth century, but these last features and the treatment of Krishna's face indicate the hand of another artist in the Mewar workshop. JS

PUBLISHED: Kramrisch 1986, pp. 68, 120, no. 61

1. Chapter 7, Verse 3; translated by Richard Cohen. The specific identification as *kamabhisarika* rather than the more general category of *abhisarika* is established by the inscription on the related painting in the Government Museum, Udaipur (1097 26/142); see *The Dictionary of Art* (London: Macmillan Publishers, 1996), vol. 7, color plate VI, fig. 2.
2. One is in Udaipur (see n. 1 above). For the other, now in the Goenka Collection, see Goswamy with Bhatia 1999, p. 128, no. 100.

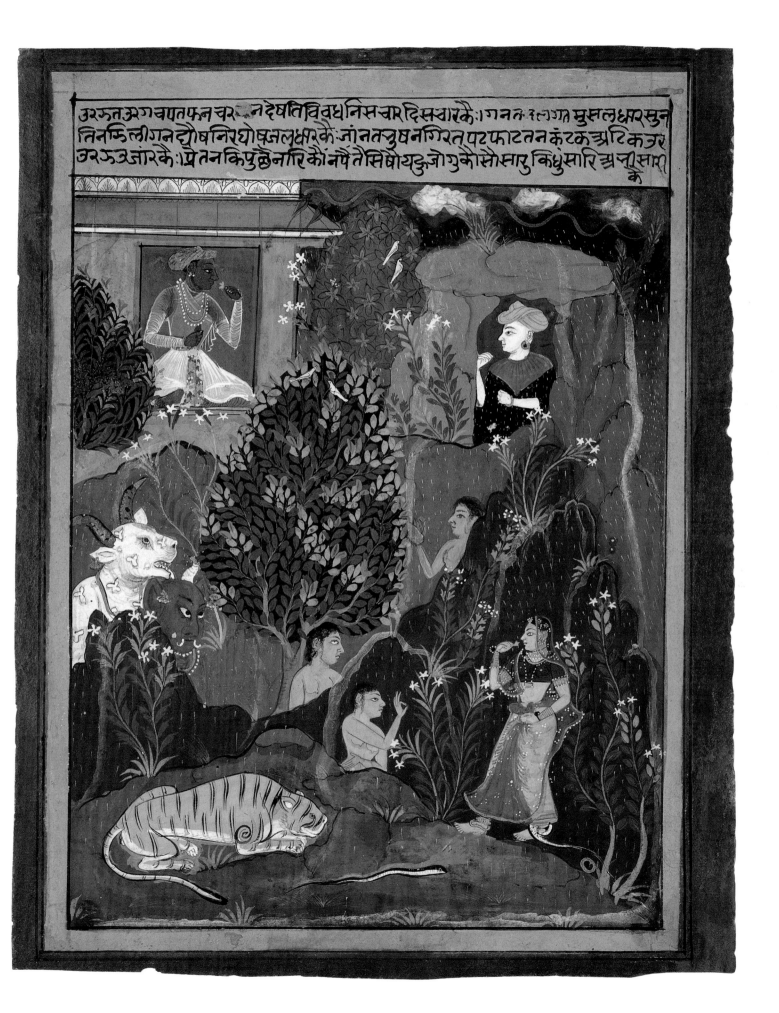

21. *Krishna Slays Arishta, the Bull Demon*

Page from a dispersed series of the *Rasikapriya* of Keshavadasa
Central India, Malwa, c. 1640
Opaque watercolor and gold on paper
8 1/16 x 6 7/8 inches (20.4 x 17.5 cm)

Krishna and his cowherd companions enjoy many a blissful day at Braj and its environs. On one occasion, however, their tranquil existence is shattered by the demon Arishta, who, in the form of an enormous bull, rampages into their midst, fouling the earth and terrorizing the helpless populace with menacing snorts and glares. The cowherds rush to seek the aid of their protector. Krishna arrives and taunts Arishta, prompting the bull to charge him. But Krishna quickly catches hold of Arishta's horns and demonstrates his obvious supremacy by dragging the beast about at will. Refusing to concede defeat, the enraged Arishta charges again. This time Krishna grabs him by the horn and wrestles him to the ground, where he pins him with the force of his foot. Then, wrenching one of Arishta's horns from his head, Krishna dispatches the mighty demon to his death by impaling him with his own horn.

This episode, which is recounted in Chapter 36 of Book 10 of the *Bhagavata Purana*, is strangely out of place in an illustrated series of the *Rasikapriya*, a text with a decidedly romantic nature (see cat. 20; see also cat. 22). Yet its depiction at the very beginning of this *Rasikapriya* series reveals much about Indian literary and artistic sensibilities, which admit a divine presence in most situations, and conceive of the gods in terms of popular legends, paying little heed to the exact textual source of those stories and images. In this case, for example, the representation of Krishna's heroic quelling of a demonic threat is inspired by a brief invocation to Krishna, which follows a similar homage to Ganesha, the elephant-headed deity invoked customarily at the inception of all undertakings. To judge from the sequence of painting numbers, this *Rasikapriya* series was designed to be so extensive that the team of artists could illustrate even such tangential or introductory passages.[1]

A terse inscription on the reverse of this painting appears to allude to the subject in a most oblique manner, for it reads: "Fearsome when Keshi he overcame."[2] Yet Keshi, a horse demon who meets a similar fate at the hands of Krishna, is certainly not represented here.[3] Keshi is, however, the subject of the first half of the *Rasikapriya* verse that concludes "courageous when Vatsasura [the calf demon] he killed." Thus, it seems that rather than being a simple mistake, this abbreviated verse was enough of a verbal prompt to lead the artist to extol Krishna's physical prowess with a scene of his subjugation of one of these two infamous animal demons. Accordingly, scholars have taken this painting to be an image of Vatsasura, the calf demon whom Krishna seizes by the hind legs and tail and hurls to its death.[4] However, the inexplicitness of the inscription had unforeseen consequences, for the artist illustrates neither Keshi nor Vatsasura. Instead, as is indicated by Krishna's action of taking the bull by the horn, the painter allows himself to stray into the story of Arishta, a similarly bovine demon, albeit one not mentioned at all in the *Rasikapriya* text. While this substitution was probably occasioned by the painter's faulty knowledge of the precise *Rasikapriya* verse, it would be entirely acceptable in a world of mythic legend because the episode and image still speak eloquently to the essential truth of Krishna's insuperable power.

The illustration itself is a fine example of painting from Central India. Although the Malwa region was among the first to fall under Mughal control in the mid-sixteenth century, its artists absorbed few features of Mughal painting until the second half of the seventeenth century. The large-headed figures here, for example, are only slightly more rounded and finely featured than those of the Palam *Bhagavata Purana* (cats. 7–9), made a century earlier; in fact, the sole concession to contemporary metropolitan styles is the plumed Jahangir-period turbans that the cowherds sport. This conservatism is a virtue in many respects, for the Malwa style retains much of the raw vigor of early Indian painting. The cowherds, for example, assume forceful, angular poses as they hasten to assist Krishna. For his part, Krishna grasps Arishta's horn in a most untenable way, and lands what can only be a glancing blow with his foot; despite the pictorial imprecision of these actions, there is no doubt that Krishna will subdue the demon imminently. Two monkeys, creatures ubiquitous in this series, leap from tree to tree, simultaneously echoing the agitation of the scene below and enlivening the upper stretches of the composition. This work, like the best of early Malwa painting generally, strikes a compelling balance between areas of detail—restricted to a few elements such as Krishna's plumed crown—and large blocks of primary color. The simple backdrop, which in this series alternates between dark blue and canary yellow, accentuates the painting's strong two-dimensional quality and imparts a sense of timelessness to its actions. JS

PUBLISHED: Kramrisch 1986, pp. 97, 177, no. 90

1. This painting is inscribed with the number 6, which indicates that it was preceded in the series by five other paintings; conversely, a painting sold at Sotheby's, New York, September 16–17, 1998, lot 544, bears the number 288.
2. The translation is by Richard Cohen. The Hindi phrase is "*kesi prati ati raudra.*"
3. The episode of Keshi is described fully in Chapter 37 of Book 10 of the *Bhagavata Purana*.
4. Kramrisch 1986, p. 177, no. 90.

22. *Krishna and Radha Beside a Pavilion*

Page from a dispersed series of the *Rasikapriya* of Keshavadasa
Central India, Malwa, c. 1660
Opaque watercolor on paper
10 3/8 x 8 7/8 inches (26.4 x 22.5 cm)

This painting of Krishna and Radha in the courtyard of a pavilion is more typical of *Rasikapriya* imagery than, for example, *Krishna Slays Arishta* (cat. 21). A four-line inscription on the reverse identifies the subject as a sentiment defined in the *Rasikapriya*'s sixth chapter: *Vilasa hava*, or the external manifestation of merriment.[1] As the text describes, such a state can be brought on by the simplest action—a twinkling glance, a warming smile, or a leisurely stroll. The manifestation of this kind of pleasure is described in the following verses:

> *The lustre of your lovely looks,*
> *And of your țīkā mark, proclaim*
> *Your eyebrows have turned the abode*
> *Of playfulness, and filled with shame*
> *Your eyes are dancing all the way:*
> *The brightness of your teeth has robbed*
> *All reason; Shrī Kṛiṣṇa's mind enslaved*
> *Have you by charming laughter soft,*
> *And your mouth's fragrance; though I ween*
> *He clever is: to captivate*
> *Shrī Kṛiṣṇa's body and soul it seems*
> *Your lips the vow of silence take.*[2]

Just as the poet acknowledges the ineloquence of words in a situation of such intimate bliss, so the painter tacitly recognizes the inadequacy of his repertoire of facial expressions. Instead, he uses other means to convey the pleasure that Krishna and Radha take in each other's company. He isolates the lovers so that they can begin to partake of each other, but postpones any physical contact until they have savored fully the delights of this appetizing moment. Krishna raises his hand slowly to his mouth, all the time gazing deeply into his beloved's eyes; Radha responds silently with outstretched arms. Despite the stiff position of her arms and the peculiarly reversed rendering of her hands, one cannot fail to understand her amorous gesture, if not by virtue of the situation alone, then certainly with the cue of the courtyard's brilliant red coloring, which transforms the otherwise bare space into an emotional combustion chamber.

Immediately above Krishna and Radha, two monkeys allow themselves to give more obvious expression to their own mirth; one mimics Krishna's gesture while the other playfully looks away as he clings to a mango tree. The exuberant foliage of the trees and flowering creepers behind them extends the unrestrained quality of their actions to nature itself, and complements the order of the pavilion and its courtyard.

This Central Indian artist still uses a patchwork of primary colors to organize his composition, but here he exemplifies the general mid-seventeenth-century trend in Malwa toward compositions with quicker coloristic rhythms. The draftsmanship has become more assured, a quality most apparent in the figures' more elongated proportions, smaller heads, and finer features. Radha, like most female figures in Malwa painting of this period, wears a skirt with richly colored horizontal bands. The architecture is still relentlessly two-dimensional, but it too has benefited from selected elaboration. Where buildings once consisted of little more than simple white slabs, they have now developed into crisply delineated forms embellished with crenellations, minute step patterns, and vegetal brackets. This particular *Rasikapriya* series rises well above the level of other contemporary or slightly later series, which sometimes are refined to the point of sterility or are allowed to lapse into folkish ungainliness. This painting possesses a courtly grace unknown in early Malwa art, but retains such lively, whimsical touches as a salivating *makara* (crocodilian) finial and a horse-headed towel rack. JS

1. The number 113 appears above the painting and at the end of the inscription on the reverse; the number 24 is also written on the reverse. For another painting from the same series (number 117), see Colnaghi 1978, pp. 73, 105, no. 83.
2. Keshavadasa, *The Rasikapriyā*, trans. K. P. Bahadur (Delhi: Motilal Banarsidass, 1972), p. 98.

23. *Bhadrakali Within the Rising Sun*

Page from a dispersed "Tantric Devi" series
Panjab Hills, Nurpur or Basohli, c. 1660–70
Opaque watercolor, gold, silver-colored paint, and beetle-wing cases on paper
8 3/4 x 8 5/16 inches (22.2 x 21.1 cm)

Against a pure black ground, a great golden sun beams forth, its rays pouring out past an architectural frame of pillars, awning, and threshold. At the sun's core stands Bhadrakali, the Dark Goddess, matching its intensity with her saffron skirt and charismatic expression—eyes hypnotically widened, red lips stretched in a fang-baring smile. She does not float in the light, but stands with her jeweled and hennaed feet solidly planted on the corpse of a male Brahmin.[1] Its huge body follows the lower curve of the globe and hovers within it, yet it is twisted unnaturally, horrifically, feet pointing downward and head upward.[2] The arms encircle a haggard face, mouth agape and pupils rolling up inside the eye slits. Perhaps better than any other painting in the entire history of Indian art, this work illustrates the concept of divine power at the very moment of embodiment.

The three-eyed goddess is opulently attired. Gold borders her skirt and matching scarf, and every conceivable variety of jewelry covers her exposed limbs and head, each gilded piece enhanced with fragments of iridescent beetle-wing cases and raised dots of pearly white paint. A crescent moon embellishes her crown, which is topped by full pink lotuses. Additional lotuses form a long garland that contrasts with the two gray and white cobras that entwine her neck and arms, their tails mimicking the long, loose locks of hair. In her right hand she displays a page of a *pothi* (religious manuscript).

On the reverse of the painting, as on each known page of this series, is inscribed a verse explicitly coordinated with the image. Vidya Dehejia's excellent recent translation reads:

She loves to reside
in the mandala of the rising sun
with a face full as the forest lotus
dark-hued One
with gait graceful as a young swan
breasts high, rounded and mature
wearing a garland of lotus blossoms
book in hand
clad in yellow garments
standing upon a corpse
She constantly visits the sacrificial space
I praise Bhadrakali
with the seed mantra bhaim.[3]

The Bellak Collection includes two pages of this superb and significant set (see also cat. 24), which, for lack of an actual title, is known as the "Tantric Devi" series. The paintings are characterized by flat backgrounds of solid color, simple compositions of a few figures, full and rounded bodies, and a love of rich materials and vibrant enamel-like color. Works in this so-called early Basohli style were considered the oldest examples of painting from the Panjab Hills until the 1977 discovery of an illustrated Pahari manuscript apparently dated to the second half of the sixteenth century.[4] The "Tantric Devi" series relates closely in style to the so-called early Basohli *Rasamanjari,* which was probably painted by the same hand, perhaps that of Kripal, who came from Nurpur, a town across the Ravi River from Basohli. Kripal's son Devidasa in turn based his own *Rasamanjari* (see cat. 26) on his father's work.[5]

Thought to have originally included over seventy paintings, most of the thirty-two known pages of the "Tantric Devi" series can be traced back to 1920, when a number were in the possession of the prominent collector-dealer Radha Kishan Bharany of Amritsar.[6] In 1922 eighteen of these pages, including the two Bellak paintings, were acquired by a collector who brought them to the United States. In 1979 they were placed in the hands of an American dealer and subsequently dispersed to collections in the United States and Europe.

Worship of the great Hindu goddess Devi in many of her forms, including as Bhadrakali, has a long history in the Panjab Hills region. Indeed, it was the primary focus of worship before the influx of *bhakti*-based Vaishnavism in the sixteenth century (see cat. 82), and remains strong to this day. However, the particular text inscribed on this series is not otherwise known. Nevertheless, the pattern for such invocations of the goddess by her many names, each verse elaborating one name in the sequence, is found not only in other texts but in popular *bhajans* (religious songs) sung in the Panjab Hills, and indeed across India today.

This Bellak painting is the only one of the thirty-two known pages from the series where the goddess is set within an architectural frame. The text talks about her in a "sacrificial space," or *yagagrham*

(literally a "house where acts of worship are performed"). This word, rather than the more common *mandir* (temple), was probably chosen more to achieve the desired poetic meter for the verse than to convey a clearly differentiated meaning. As Terence McInerney writes, this architectural frame "situates Devi's remote presence in the approachable temple of her initiated devotees."[7] Like the entry to a shrine, it is a door providing the visual—and actual—link between the divine and human worlds. Although other paintings in the set depict the face of the corpse, here it is far more naturalistic and, indeed, tragic. Its pathos combines with the radiating power of the goddess and the drama of the golden orb to make this, the most strictly iconic of the "Tantric Devi" images, nevertheless the most dramatic. DM

PUBLISHED: Kramrisch 1981, pp. 216–17, no. P-47; Kramrisch 1986, pp. 109, 179, no. 99; Ajit Mookerjee, *Kali: The Feminine Force* (London: Thames and Hudson, 1988), repro. p. 64; Robert Bly, *Sleepers Joining Hands* (New York: Harper Perennial, 1991), cover; Goswamy and Fischer 1992, pp. 44–45, no. 12; Dehejia et al. 1999, p. 260, no. 29

1. Stella Kramrisch (1981, p. 217, no. P-47) wrote that the *tripundra* (three-line) marks on the corpse related it to Shiva. However, in the Pahari region these marks are called *chhapa* and indicate the vital body points one touches during any Hindu worship.
2. Kramrisch (ibid.) related this to *pretas* (ghosts of the dead), whose feet are attached backward. Indeed, *preta* is used in the inscription to indicate the corpse.
3. Dehejia et al. 1999, p. 260, no. 29. The number on the front of the painting identifies it as folio 10.
4. B. N. Goswamy, V. C. Ohri, and Ajit Singh, "A 'Chaurapañchāśikā Style' Manuscript from the Pahāri Area," *Lalit Kala,* no. 21 (1985), pp. 9–21. See also Catherine Glynn, "Early Painting in Mandi," *Artibus Asiae,* vol. 44, no. 1 (1983), pp. 21–64; and Glynn, "A Sixteenth-Century Devīmāhātmya Manuscript from Kangra" (Ph.D. diss., University of Southern California, 1979).
5. Terence McInerney (in Dehejia et al. 1999, p. 124) agrees with B. N. Goswamy and Eberhard Fischer (1992, p. 44, no. 12) in linking the "Tantric Devi" series to this early *Rasamanjari,* and follows Ohri (1991, p. 13) in stating that it is uncertain if these works were painted in Basohli or Nurpur.
6. For a description of the provenance of the set and a reconstruction of the known pages, see McInerney in Dehejia et al. 1999, pp. 119–34.
7. Ibid., p. 126.

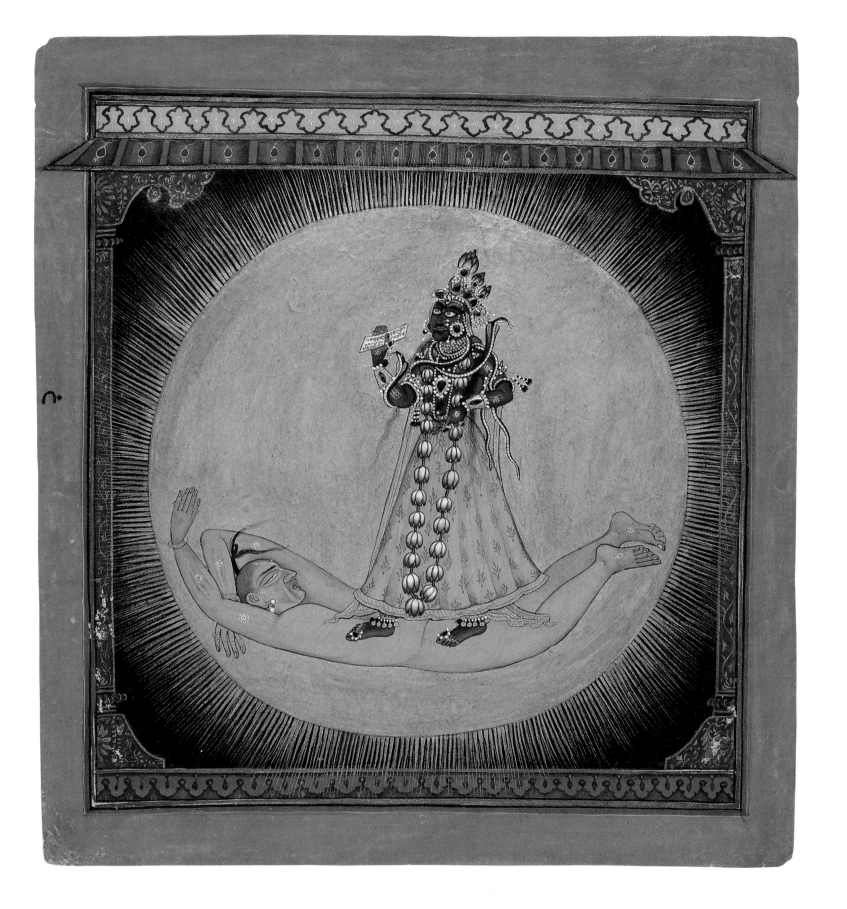

24. Bhadrakali with Companions

Page from a dispersed "Tantric Devi" series
Panjab Hills, Nurpur or Basohli, c. 1660–70
Opaque watercolor, gold, silver-colored paint, and beetle-wing cases on paper
8 1/4 x 8 15/16 inches (21 x 22.7 cm)

Although nearly as savagely lush as *Bhadrakali Within the Rising Sun* (cat. 23), the other Bellak painting from the "Tantric Devi" series, and depicting the same dark form of the goddess, *Bhadrakali with Companions* is in feeling entirely different.[1] Despite the lack of temple-like frame and the active poses of the three participants, this image is indeed iconic. The intensity is not in the goddess bursting into being, but in the adoration of her companions. The goddess herself, like a sculpture in a temple sanctum, rests on the corpse as if on a throne, golden wine cup at her lips, flute and lotus blossoms held casually in her other hand. To emphasize her status, one of her companions lofts a fly whisk (*chauri*), the age-old Indian symbol of attendance on the royal and the divine. As with the other Bellak painting in the series, the verse on the back agrees with the image's iconography in all details:

In her hands a flute
and two full-blown lotuses
She drinks wine
seated upon a corpse
with the crescent moon adorning her crown
accompanied by companions
In my heart I meditate upon Bhadrakali
with the seed mantra bhaim.[2]

This painting has as its backdrop the landscape that is typical of most pages in this set. Figures are placed against a flat expanse of dark green with a narrow line of wet clouds at the top, with green wash and indications of grass along the bottom. The massiveness of the corpse is emphasized by the fact that it not only spans the width of the painting, but cannot fit within its borders—its toes, with the white nails of rigor mortis, break the red border. Bhadrakali's clothing also differs from that in the other Bellak "Tantric Devi" page (in fact no two garments are identical in color or pattern within this set). Here she wears a *choli* (blouse) in a shade of bright green that forms an odd contrast with her blue-gray skin. The fact that the inner lining of her skirt is the only yellow in the composition serves to focus the eye on the goddess, despite her distance and shadowy coloring.

The goddess's face, elegant in full profile, lacks the fangs and glaring eyes found in *Bhadrakali Within the Rising Sun*. Instead of displaying the equal combination of the fierce and the benevolently beautiful, here she appears benign, with eyes curving upward to corners tinged in pink like the lotus petals, red lips slightly parted in a gentle smile. Like both of her female companions (called *parivara yuktam*, literally "family members," in the text), Bhadrakali displays a third eye in her forehead that connects her with the god Shiva. She prominently quaffs a glass of liquor (*madya*), an important component in many of the tantric (esoteric-magical) rituals from which this series derives its modern name. These elements, together with her dark coloring, remind the viewer that, as in the other Bellak painting from the set, this Bhadrakali also partakes of the blending of beneficent and terrifying aspects that characterize Mahadevi, the Great Goddess. DM

PUBLISHED: McInerney 1982, pp. 70–71, no. 30; *Festival of India in the United States* (New York: Harry N. Abrams, 1985), repro. p. 73; Kramrisch 1986, pp. 108, 179, no. 98; Dehejia et al. 1999, p. 271, no. 40

1. B. N. Goswamy (personal communication, 2000) speculates that the known "Tantric Devi" pages may actually separate into two sets on the basis of hand rather than iconography. In this structure, the images in the squarer format that show rather squatter figures and a slightly bolder, more "folkish" hand (including cat. 23) would be of one set, presumably by Kripal. The others, those in a slightly oblong format with elongated figures and more refined detailing (including this painting), may be attributable to Devidasa, in a situation much like that of the two *Rasamanjaris*.
2. Translated by Vidya Dehejia in Dehejia et al. 1999, p. 271, no. 40. On the reverse of the page, there is also a small inscription on the lower left, oddly written in reverse (mirror writing). The number on the front of the painting identifies it as folio 57.

25. The Pampered Princess

Panjab Hills, probably Mankot, c. 1680–90
Opaque watercolor, gold, silver-colored paint, and beetle-wing cases on paper
8 9/16 x 10 5/8 inches (21.7 x 27 cm)

It is the huge silver throne, sumptuously ornamented in slivers of iridescent beetle-wing cases, that dominates this composition.[1] On it rests a woman clearly of royal rank. With one hand she drinks from a golden wine goblet, with the other she holds the pipe of a *huqqa,* her dainty tasseled slippers abandoned below the seat. Female attendants flock around her: one carries the *huqqa* and pinchers, another massages her foot, and a third proffers the wine flask and a cloth-covered plate of delicacies. Along with this pampering, she is also entertained by two female musicians—both are singing while one strums a tambor and the other claps. The clothing of all the women is rich, with a preponderance of finely woven, diaphanous fabrics. Yet the garments of the seated figure are the richest by far, heavy with gilding, embroidery, and pearl strands. The composition, which is similar to that of *Bhadrakali with Companions* (cat. 24), is here set against a background of bright Indian yellow. At the bottom is a light green wash of ground, dabbed with blades of grass; and across the top appears a high horizon of blue and white sky.

Unlike male royal portraits at this period (see cats. 36, 37), which, though idealized, yet have distinctive features clearly drawn from life, female portraits throughout the history of Indian painting tend to be generic likenesses. As in most of northern India, *pardha,* or the seclusion of women from men other than those of their immediate family, was a practice in the courts of the Panjab Hills in the seventeenth century (and even into the twentieth). It is thus unlikely that male painters were permitted to view royal women and instead could only imagine them as stock feminine ideals.[2]

This painting possesses a near duplicate, now in the Goenka Collection.[3] While the two are almost precisely the same in composition, they are close but not identical in detailing, and may shed light on workshop practice. They do not appear to be pouncings or tracings, one from the other, as some of the relative positions differ slightly.[4]

B. N. Goswamy dates the Goenka page to c. 1700 and speculates that it may have been painted in a workshop in the small kingdom of Mankot (see cat. 32), and its heavily outlined eyes and narrow faces certainly do resemble contemporaneous portraits and other paintings that he attributes to the "Master at the Court of Mankot."[5] The Bellak page does show very slightly different physiognomy, with fuller faces, more lotiform eyes, and proportionally larger heads. In addition, there is a greater grace of movement and delicacy of draftsmanship (for example, the skirts of the standing women in the Goenka page fall in stiff, even bells, while those of the Bellak page are softer and drop more naturalistically). Finally, the figures display more intensity of expression in the Bellak painting. This is particularly noticeable in the three women standing before the throne, who gaze upward with solemn reverence at the princess. In the Goenka page, they smile slightly, and their stares are impassive. It thus seems likely that the Goenka painting is a copy of the Bellak page, although probably painted in the same workshop, perhaps even by the same artist. While the figures in the Bellak painting certainly bear a close resemblance to those from the workshop responsible for the so-called early *Rasamanjari* (probably located in Basohli; see cat. 26), and the handling of the very high, wet skyline also links them to this idiom, other details of treatment and iconography—including the specific high-backed throne—add further weight to a Mankot attribution. DM

1. The page is known to have once been in the collection of the well-known painter Abdur Rahman Chughtai (1894–1975) in Lahore, and both his Persian and English seals are stamped on the reverse.
2. However, this point has been debated in the realm of Mughal painting, and the issue remains open. See Ellen Smart, "A Mid-Seventeenth-Century Mughal Painting of Jahanara Begum," paper presented at the symposium of the American Council for Southern Asian Art, Philadelphia, May 12–14, 2000.
3. Goswamy with Bhatia 1999, p. 217, no. 164. The Goenka painting, which measures 6 1/2 x 8 7/8 inches (16.6 x 22.5 cm) (image), and 13 x 18 1/2 inches (33 x 47 cm) (full page), was at some point remounted in later borders and may also have been cropped slightly, since the line of sky at the top is absent.
4. For example, in the Bellak page the *huqqa*-bearer is placed higher in relation to the throne.
5. In Goswamy and Fischer 1992, pp. 95–125. Possibly the closest painting stylistically to the Bellak and Goenka pages is *Raja Kripal Pal of Basohli Smoking with Girl Attendants* in the Dogra Art Gallery, Jammu (see Archer 1973, vol. 2, p. 287, Mankot no. 16). Archer's logic in attributing this painting to a Mankot workshop is that it was found in a Mankot royal collection and that another "noticeably . . . more florid" painting of the same ruler represents the contemporaneous Basohli idiom (Archer 1973, vol. 1, p. 375, Mankot no. 16). Perhaps tellingly, it is the pages of the "horizontal" Mankot *Bhagavata Purana* depicting the infancy of Krishna that most resemble the Bellak and Goenka pages.

26. *The Awakening of Trust (Vishrabdhanavodha Nayika)*

Page from a dispersed series of the *Rasamanjari* of Bhanudatta
Series ascribed to Devidasa
Panjab Hills, Basohli; series dated 1694–95
Opaque watercolor, gold, and silver-colored paint on paper
8 1/8 x 10 1/4 inches (20.6 x 26 cm)[1]

In writing the *Rasamanjari* (Bouquet of Delights), the poet Bhanudatta, who lived toward the end of the fifteenth century in the eastern Indian state of Bihar, elaborated upon a much older tradition of Sanskrit poetics (see also cat. 20). These works deal with the mood of love *(shringara rasa)* by classifying *nayikas* (heroines) and *nayakas* (heroes), although it is the former who are the focus. This painting falls within Bhanudatta's large section on the classifications of heroines, who are subdivided in terms of their fidelity, age, and experience. The label for the verse, written in Takri script in the upper margin of the image, identifies her as the Vishrabdhanavodha Nayika. She is the third of the four naive or artless types, the young wife who has just begun to learn of love and trust. Still newly married, she has become conscious of her sexuality and is no longer paralyzed by fear, yet she does not quite have full confidence in her husband nor comfort with herself.

On the back is the full verse in Sanskrit, together with commentaries and interpretations: "The new bride sleeps, with eyes half-open, with one hand on her bodice, the other hand on her breast, bringing her thighs together, next to a young man."[2]

On a white bed with striped bolster lie the couple. She wears no blouse or skirt, but is wound in a single diaphanous garment, her tightly crossed legs entrapping its end and anchoring it in place. Her eyes are half-shut, drowsy, yet she scrutinizes her lover. With her right hand she shyly covers both breasts, while her left hand indecisively fingers the knot of her garment. The young bearded hero wears only a turban, loin cloth, and jewels. He supports his head on his right forearm so that he can meet her eyes. His right knee presses against her, insistently, while with his left hand he reaches over, encouraging her to undress. It is impossible not to fasten on the locked eyes of the couple, and the emotional tension is tangible; her longing mixed with apprehension, his ardor and gentle persistence.

They lie in a red room ornamented with niches holding fruit in golden vessels and blue and white porcelain. His sword rests on a stand at the head of the bed, next to a small, gold water container. The prominence of the sword and the verse itself may indicate that he has just returned from a journey and snuck into the room to awaken her. Indeed, she may be slightly uncertain that this is really her husband, so new is she to the relationship. Outside of the room, on the left, the background is solid bright yellow. To the right, where the page was unfortunately half-eaten away by mice, the room undoubtedly continued as it has been reconstructed, with no additional architecture, focusing the scene on the expanse of mattress and the lovers themselves.

This illustration is from a *Rasamanjari* series of extraordinary historical importance for its colophon page, which survives in the collection of the Bharat Kala Bhavan, Varanasi.[3] The colophon gives not only a concrete date of completion of the series (January-February 1695), but also the names of both artist (Devidasa) and patron (Raja Kripal Pal of Basohli), as well as the place of production (Basohli). Devidasa's *Rasamanjari* follows closely in style and format an extensive earlier *Rasamanjari*, probably dating to about 1660–70. This latter series has been attributed to the same hand responsible for the "Tantric Devi" pages (see cats. 23, 24), a hand that B. N. Goswamy believes to be no other than Devidasa's father, Kripal of Nurpur.[4]

Like the "Tantric Devi" paintings of c. 1660–70, the brilliant images from the contemporaneous *Rasamanjari* are divided into patches of pure enamel-like color, whose sumptuousness is highlighted by the application of tiny pieces of iridescent beetle-wing cases to emulate the glimmer of emeralds. The Devidasa series of the next generation dispenses with the beetle wings but retains the rich color, and closely follows the earlier series in composition and style. Yet there are changes as well. In Devidasa's version, forms are more rounded by shading, the sense of space can be deeper, and colors move further beyond the primary shades. Perhaps an even greater change is the accentuation of the emotional content. Not only does the setting no longer compete with the human drama, but faces show an intensity and subtlety of expression not seen before in this workshop. Unfortunately, this is the only image of the Vishrabdhanavodha Nayika among the pages from the surviving Basohli *Rasamanjaris*, so it is impossible to compare interpretations.

Another major difference between the Devidasa series and its predecessor is that in the earlier example the hero is regularly depicted as the blue-complexioned god Krishna. Devidasa, on the other hand, follows the text precisely in showing the *nayaka* as a young, lightly bearded man except where the verse itself specifies a divine identity. Goswamy argues that the iconographic shift, rather than resulting from an overarching religious trend, more likely arose from the specific patron's decision to follow the actual descriptions in the text.[5]

While a good portion of the c. 1660–70 *Rasamanjari* exists in collections both inside and outside India, many fewer pages of the Devidasa series are known, although it was originally comprised of at least 130 pages.[6] Recent publications list the known pages as 17,[7] all of which are in public collections; the painting in the Bellak Collection adds an eighteenth to that *oeuvre*. DM

1. The right third of the painting is a removable modern reconstruction.
2. Translation by Signe Cohen. The verse is followed by the number 7. Filling the lower section on the reverse are three additional verses in various formats, which each explains and elaborates the original Sanskrit verse. The final one of these includes a new description of the sweet scents that waft into the room. See Appendix.
3. For the full text see B. N. Goswamy's essay in this volume and Das 1998a, p. 17.
4. Goswamy and Fischer 1992, pp. 30–31. Through study of genealogical and land revenue documents, Goswamy was the first to connect Devidasa with a large family of painter-carpenters from the city of Nurpur, near Basohli. There is also a third *Rasamanjari*, clearly following Devidasa's within the family tradition, which Goswamy (in Goswamy and Fischer 1992, pp. 60–61) attributes to Golu, Devidasa's son. W. G. Archer (1973, vol. 1, pp. 41–42, Basohli nos. 10[i–ii]) called the Devidasa series the third, because he actually dated the "Golu" series earlier and called it the "second" *Rasamanjari*.
5. Goswamy and Fischer 1992, p. 62.
6. This can be determined by the fact that the colophon page is numbered 130 (Das 1998a, p. 19).
7. Goswamy and Fischer (1992, p. 61) list them as follows: four in the Lahore Museum; four in the Bharat Kala Bhavan, Varanasi; three in the Dogra Art Gallery, Jammu; two in the National Museum, New Delhi; two in the Metropolitan Museum of Art, New York; one in the Government Museum and Art Gallery, Chandigarh; one in the Museum of Fine Arts, Boston; and one in the Binney Collection, San Diego Museum of Art. Das (1998a, p. 19) repeats that number but also gives additional information on provenance.

27. Bharata and Shatrughna Take Leave of Their Grandfather

Page from a dispersed series of the *Ramayana*
Panjab Hills, probably Bahu, Jammu region, c. 1690–1700
Opaque watercolor, gold, and silver-colored paint on paper
8 3/4 x 12 15/16 inches (22.2 x 31.5 cm)

A perfectly balanced stage-like set has been established to present this formal leave-taking. Two chariots have just driven onto the scene, their seats covered in fabric flounces, their wooden yokes carved, and their harnesses laden with bells. The horses stomp and whinny in their sudden cessation of movement, as the still-mounted charioteers clutch their whips and pull at the reins. The inscription on the reverse of this painting reads only *"Ayodhyakanda,"* the name of the second section of the epic *Ramayana* (see cat. 16), making it difficult to identify which specific episode within the text the scene represents.

Most likely, however, the painting shows the departure of Rama's brothers, Bharata and Shatrughna, from their stay with their maternal grandfather, Kekaya, king of the city of Rajagriha.[1] The mustached Kekaya, in a white *jama* with a thrusting dagger in his belt, has dismounted and stands in conversation with his orange-clad grandson Shatrughna. Bharata is depicted with blue complexion like that of his brother Rama, a characteristic that has caused confusion in the identification of several paintings from this series.[2]

Bharata lays aside his bow and bends down to touch his grandfather's feet honorifically. This quiet and formal leave-taking assures the viewer that he has heard nothing during his visit of the tragic incidents taking place in his home city of Ayodhya. There, Bharata's mother has connived to force her husband, King Dasharatha, to promise Bharata the throne in place of the rightful successor, his elder half-brother Rama, and to secure Rama's forest exile. On reaching Ayodhya, faithful Bharata will be further distressed by learning that grief and guilt have caused his father's death.

This series (see also cats. 28, 29), which may or may not actually have been conceived as a whole, is called the "Shangri" *Ramayana.* When "discovered" in 1956 by M. S. Randhawa, the now-dispersed 270 pages were in the collection of Raja Raghbir Singh of Shangri (a town in the Kulu Valley), who was a member of the royal line of Kulu. In 1973, W. G. Archer used formal characteristics to divide the known pages into four groups, which he termed "Styles I–IV." He also attempted to give a historical justification to the Kulu origins of the work.[3] More recently, however, the portions of the series that Archer dated as earlier (which also come earlier in the narrative) have been reassigned by B. N. Goswamy and Eberhard Fischer[4] to Bahu in the northeasterly region of Jammu. In the late seventeenth century, Bahu was a major capital with an impressive fort. Not until later did the main branch of the royal family rule from the nearby town of Jammu itself.

Only the three protagonists and their chariots interrupt the monochrome background of somber olive green that matches the mood of the scene, but is also a favorite of the painter Goswamy labels the "senior master" of the "Shangri" *Ramayana,* responsible for those works in Archer's Style I.[5] Oversize heads, long faces with prominent chins, and lips pressed together and spanning the depth of the thick noses are all characteristics associated with this hand; so too are the solid wheels of the chariots, overlaid with a delicate pattern, the lively depiction of the animals, and the wide red border into which the figures freely intrude. DM

1. Sarga 64 *(Rāmāyana* 1984–94, vol. 2, pp. 218–20).
2. Randhawa 1959, p. 68, plate 16. Randhawa describes the scene as representing Rama and Lakshmana taking leave of their father, Dasharatha, before their forest exile, an incident that never actually occurs in the *Ramayana.*
3. Archer 1973, vol. 1, pp. 325–29.
4. Goswamy and Fischer 1992, pp. 76–77.
5. Ibid., pp. 78, 88.

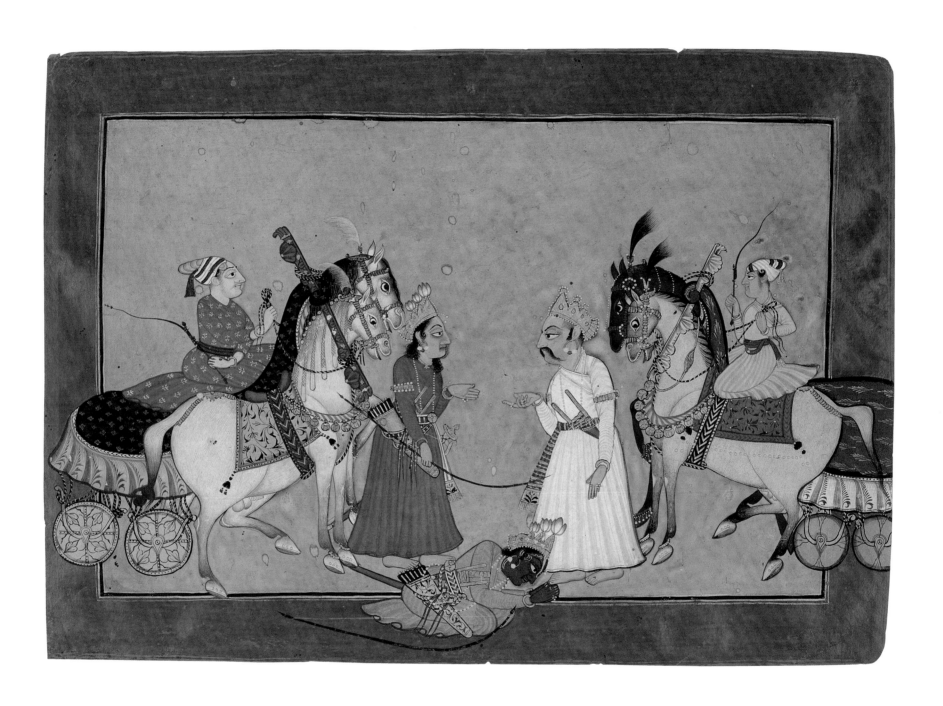

28. King Janaka Greets King Dasharatha Before Rama's Wedding

Page from a dispersed series of the *Ramayana*
Panjab Hills, probably Bahu, Jammu region, c. 1700–1710
Opaque watercolor on paper
8 15/16 x 13 1/8 inches (22.7 x 33.3 cm)

On a flat ground of bright yellow, a composed state event transpires.[1] Young Rama has won the hand of Sita, daughter of King Janaka of Mithila, by accomplishing the amazing feat of bending—and breaking in two—the huge bow of Shiva, given to Janaka by the gods. Janaka has sent an envoy to Rama's father, King Dasharatha of Ayodhya, requesting that he come immediately to Mithila to seal the arrangement and perform the marriage ceremony. This scene shows Janaka greeting Dasharatha as he arrives with his Brahmins, courtiers, and soldiers.

Two tents—one closed and domed; the other open over a graceful rug and a large striped bolster—depicted as if from above, indicate that Dasharatha has set up his camp just outside the city. The tents and tree occupy the upper half of the evenly divided composition, while the lower is filled by the participants and, at each side, the fronts of the two horse-drawn chariots that have brought them together. Three Brahmin priests, shirtless and with their hair in topknots, stand among the attendant courtiers.

The two kings who meet in the center are clearly distinguished by their lotus-topped crowns and the elaborate umbrellas held over their heads by attendants. On the right, in a pink *jama*, is probably Janaka, who holds his hands together in the gesture of greeting and honor. Rama and his brother Lakshmana

are depicted as youths, without turbans and with boyishly curling locks, substantially smaller than the men beside them. Yet despite their age they both carry weapons—Rama a sword and quiver of arrows, Lakshmana a thrusting dagger. Rama reaches out to greet his green-robed father, who places one arm around the boy's shoulders in an approving, paternal gesture that perfectly combines great solemnity and emotional warmth.

Pattern is paramount here, not only the perfect vertical and horizontal balance of the composition, but the careful attention to textiles, particularly the elaborately striped *jamas*. Indeed, stripes are the leitmotif of this image—from tent ribs to horse blankets, to robes and turbans, they add an ordered visual richness that imbues the otherwise calm meeting with the pomp of a major court function. They even, oddly, appear as a separate element on the blue robe of one attendant, where the fly whisk is tucked not into the garment, but only through the stripes! Various feet of men and horses overlap the bottom border to bring the scene closer to the viewer. The warm red of the border is particularly complementary to this composition, and is undoubtedly an essential element in the master's choices of color.

Compared to another Bellak painting from the same series (cat. 27), both the faces and the finish

differ substantially. Here, for example, the chins are smaller; noses are narrower and much more pointed; eyes are more lotiform. There is also less shading of the figures and bolder detailing. In addition, light yellow rather than worked gold is used for such metallic elements as crowns and weapons. W. G. Archer defined this as the second of the four distinctive styles into which he divided the "Shangri" *Ramayana* pages. B. N. Goswamy and Eberhard Fischer believe that these "Style II" paintings were probably done by a pupil or associate of the master responsible for Archer's Style I (the "Master of the Bahu 'Shangri' *Ramayana*"), possibly from that master's own drawings.[2] DM

PUBLISHED: McInerney 1982, pp. 74–75, no. 33; Kramrisch 1986, pp. 115, 181, no. 105; Goswamy and Fischer 1992, p. 88, no. 31

1. The painting is inscribed on the reverse, "*Val* [for *Balakanda*, the name of the first book of the *Ramayana*], 71." It depicts Sarga 68 *(Rāmāyaṇa* 1984–94, vol. 1, pp. 253–54).
2. Goswamy and Fischer 1992, pp. 78, 88. Steven Kossak (1997, p. 76, no. 42) has tentatively attributed these "Style II" *Ramayana* pages to Devidasa, the artist responsible for the 1694–95 *Rasamanjari* (see cat. 26). He bases his attribution solely on what he sees as similarities of detail. Certainly there are similarities, but these must be thought of as resulting from a confluence of general time and region, rather than any actual identity of hand.

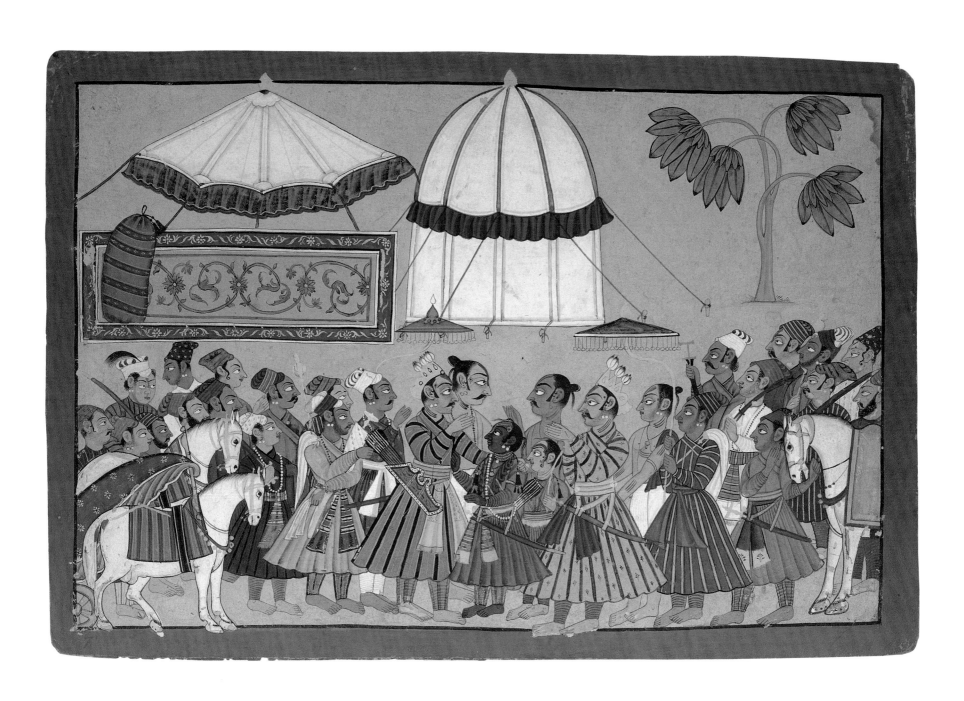

29. Rama Pierces the Seven Shala Trees

Page from a dispersed series of the *Ramayana*
Panjab Hills, probably Mandi, c. 1725–50
Opaque watercolor, gold, and silver-colored paint on paper
8 1/2 x 14 inches (21.6 x 35.6 cm)

This page of the so-called Shangri *Ramayana* is quite different in feeling and finish from the other two pages of this series in the Bellak Collection (cats. 27, 28), which illustrate earlier sections of the text. Comparatively, this image lacks surface polish, shows "wetter"-looking paint, and is generally less sophisticated in composition and detailing. W. G. Archer, who divided this series into four styles (by which he implied artists' hands), designated this as Style III, calling the hand of the other Bellak pages Styles I and II, respectively.[1] While the earlier sections can be connected with the city of Bahu, ancient capital of the Jammu area, this section, illustrating the fourth book of the *Ramayana (Kishkindhakanda)*, is inscribed in the distinctive lettering of the city of Mandi (Mandiali).[2] It is thus likely that someone in Mandi acquired the first portions of the set not long after their creation and hired a painter, possibly itinerant, to enlarge the series. This artist worked in his own, distinctive hand, yet attempted, especially in his rendering of physiognomy, to simulate one of the earlier styles (see cat. 28) to make the addition coherent. Indeed, this Mandi connection may explain why the entire series was found in the Shangri royal collection in the Kulu Valley, a region bordering on Mandi (see cat. 27).

In this fourth book of the *Ramayana*, the monkey kingdom has had troubles. Valin, king of the monkeys, had gone off through a tunnel chasing an evil *asura* (demon) who had terrorized the region. When Valin did not return from his quest, the monkeys, presuming him dead, closed off the tunnel with a huge boulder to seal in the demon. They then made Sugriva, Valin's younger brother, the new king. After some time, however, Valin did return, and, in anger at his apparent usurpation, deposed and exiled his brother, even going so far as to steal Sugriva's wife. Sugriva, however, desired to regain the throne and, while wandering in the forest, met the exiled Rama. He suspected that this unknown warrior could help him recapture his kingdom. First, however, he wished to test Rama's strength. He asks Rama to perform two feats previously accomplished by Valin: to throw the body of a dead demon a great distance (see cat. 30) and to shoot an arrow through a series of shala trees (*Vatica* or *Shorea robusta*). Rama shoots the arrow but far surpasses expectations. Not only does he shoot through seven trees with the same shot, but the arrow then returns to his bow.[3]

In the left half of the painting stands Rama, his bow drawn back, having just loosed the arrow that has cleanly pierced the seven trees, its flight indicated by a wavy line. It has created seven identical holes, and is visible at the far right where it pierces the earth after the final tree—a necessary visual departure from the actual text. Behind Rama stands his brother, Lakshmana, his hand held out to highlight the spectacular feat. Sugriva, depicted with white body and lotus crown, stands next to Lakshmana, and two of the monkey army take up the rear. The figures are suspended in the flat green ground, their faces impassive despite the drama that has just occurred. The monkeys have caplike heads with no eyebrows and sharply delineated red-pink snouts. The fact that the trees, all exactly alike, line up along the ridge of a pink hillock and reach uniformly the narrow line of white and blue sky, differentiates this painting from the earlier parts of the series (see cats. 27, 28); never would the painters of those sections have missed such an opportunity for patterning and differentiation as the trees provide. DM

PUBLISHED: Sotheby's, London, July 9, 1974, lot 207

1. Archer 1973, vol. 1, p. 326.
2. This folio is inscribed on the reverse, "29, *Kishkindha,*" below "27."
3. Sarga 12 (*Rāmāyaṇa* 1984–94, vol. 4, p. 78).

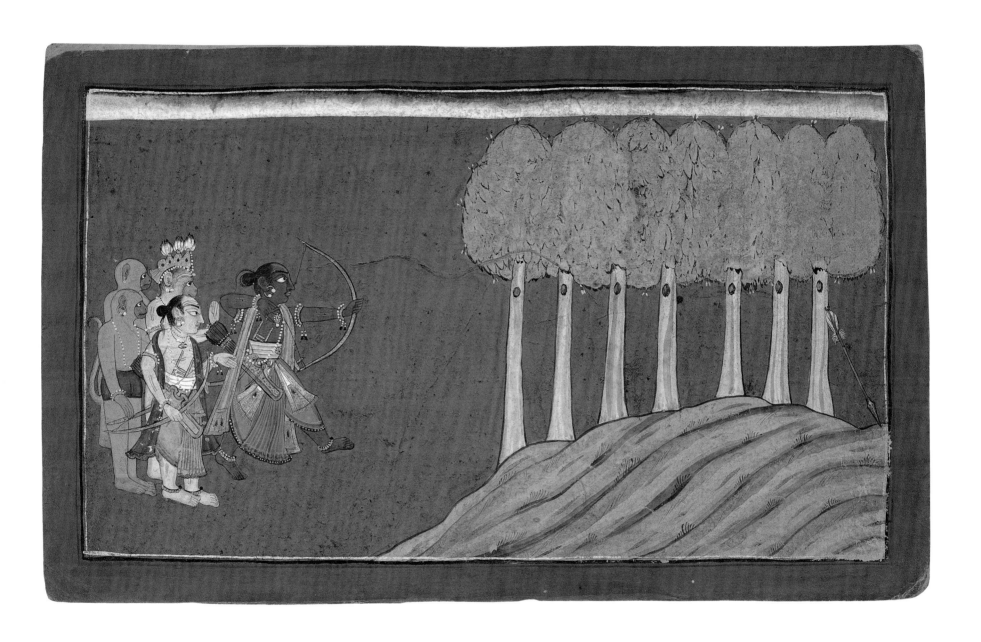

30. Rama Kicks the Demon Dundubhi

Page from a dispersed series of the *Ramayana*
Panjab Hills, c. 1720
Opaque watercolor, gold, and silver-colored paint on paper
7 7/8 x 12 1/16 inches (20.2 x 30.6 cm)

Although this scene and the painting of Rama piercing the shala trees (cat. 29) are from different series of the *Ramayana,* they both illustrate tests of strength set for Rama by the deposed monkey king Sugriva. Sugriva's brother, Valin, had fought and killed the huge buffalo *asura* (demon) Dundubhi, and then flung his body a great distance, contaminating a hermitage with the *asura's* blood. Sugriva's first test was to challenge Rama to throw the corpse the same distance as had Valin. As narrated by the verse on the back of this painting,[1] Rama, with his great arms, easily lifted Dundubhi's body, using only his big toe, and threw it ten leagues *(yojanas)* away. In this he far surpassed Valin's feat.

As in the other Bellak page from this series (cat. 31), Rama and his brother Lakshmana wear the leaf garments of their forest exile—skirts and hats of leaves, with the stems still attached to the crowns of the hats, making them into little foliage caps. Between them stands Sugriva in a short fighting garment, crowned and adorned with various court sashes. To the lower right is the body of the horned, fanged, and bearded demon, his brown skin scrofulously spotted. Although the text specifies that he had taken the form of a buffalo before death, here he is humanoid and bears a likeness to earlier Mughal depictions of demons (see cat. 14), though his parrotlike feet are a distinctive Rajput addition. Despite the text's description of Dundubhi as a desiccated corpse, "like straw, light and without flesh," he here seems fully alive, looking back at his pursuer with his ugly face gnarled in surprise as he seems to fall off the page. Rama is caught in the act of nudging the demon with his big toe. Sugriva holds one finger toward his mouth in astonishment while Lakshmana remains impassive, well aware of his brother's power. The wilderness landscape is tame, depicted as a grassy ground with clumps of lively and individualized trees. There is a high line of sky, as in the second Bellak page from this series (cat. 31), here cursorily painted with a wiggle of wet white and blue paint, but there is little sense of spatial depth.

Pages from this *Ramayana* series were first published by W. G. Archer in 1976,[2] at which time he attributed it to a Mankot workshop. Other scholars[3] have repeated the attribution over the years. However, the paintings little resemble the more highly finished pages also attributed to Mankot at approximately the same period, such as the various *Bhagavata Purana* series (see cats. 32–34), as well as another *Ramayana* series, a page of which is published by Archer.[4] As opposed to pages of the "Shangri" *Ramayana* in the so-called Style III (see cat. 29), the faces in this series are longer, with slightly upturned noses and heavily shaded jaws. The eyes are composed of bisected ellipses—half-eyeball, half-lid. The faces of the monkeys also differ substantially from those in the "Shangri" Style III paintings. Here they are rather more human, with head and snout of the same color, the line of the eye merging into the snout, and humanlike eyebrows. DM

1. Sarga 11 of the *Kishkindhakanda,* the fourth book of the *Ramayana (Rāmāyaṇa* 1984–94, vol. 4, pp. 77–78).
2. Archer 1976, pp. 122–25, nos. 65–66.
3. Pal 1978, p. 160, no. 55; Ehnbom 1985, p. 208, nos. 102–3; Poster et al. 1994, p. 288, no. 241.
4. Archer 1973, vol. 2, p. 376, Mankot no. 26.

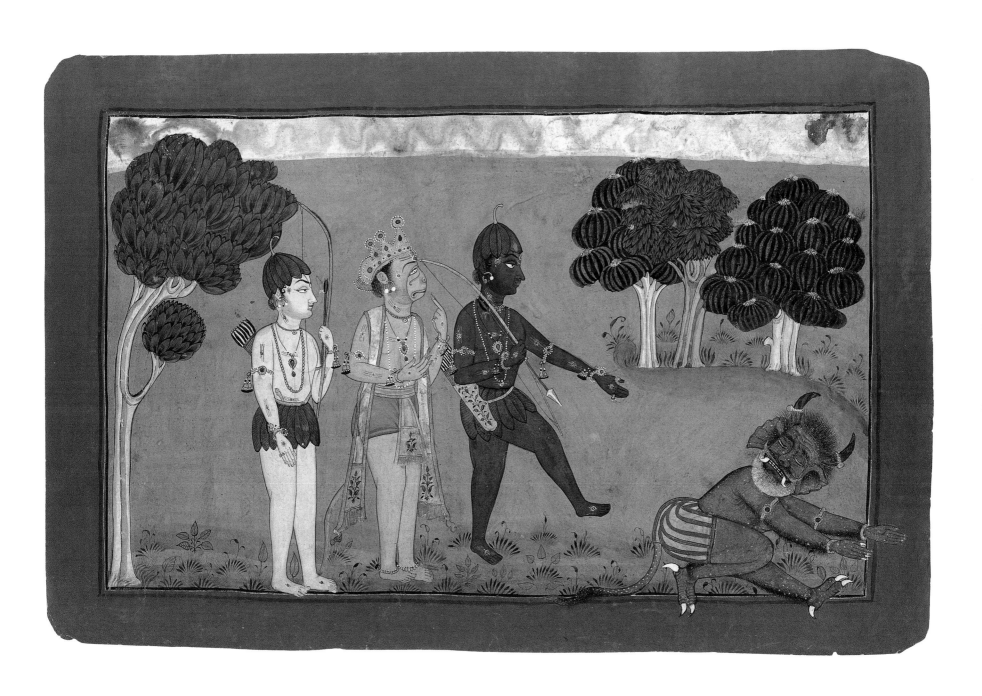

31. *The Death of Valin and Tara's Discourse*

Page from a dispersed series of the *Ramayana*
Panjab Hills, c. 1720
Opaque watercolor, gold, and silver-colored paint on paper
8 1/4 x 12 1/8 inches (21 x 30.8 cm)

From the same *Ramayana* series as the painting of Rama kicking the demon (cat. 30), this scene is the climax to the struggle for the rule of the monkey kingdom that is begun elsewhere in the *Kishkindhakanda* section of the text (see cats. 29, 30).[1] After Rama has proved his strength by his feats with the shala trees and the corpse of the demon Dundubhi, he and Lakshmana accompany Sugriva as he goes to confront his brother Valin. Rama, in one of his few morally questionable moments, kills Valin, the legitimate king of the monkeys (the excuse given is that Valin, on retaking the throne, sinned by stealing his brother's wife).[2]

This painting shows the moment after the fight. The white-bodied Valin lies dying, blood oozing from a chest wound, his arms decorously by his sides. Valin's wife Tara (who is not the one he had taken from Sugriva) cradles his head and laments

with her maids. The women's hair is loosened in mourning, their faces human rather than monkey. A lone tree leans from the rocky mountain behind Tara, bent as if joining her in grief. Gray-brown Angada, Valin's young son, grasps his father's feet, as the monkey general Hanuman kneels nearby and talks with the bereaved Tara. Sugriva, now mourning his brother and feeling intense guilt at his role in the slaying, stands at the side conversing with Rama and Lakshmana, who wear the same leaf garments with inverted-blossomlike caps as in the painting of Rama kicking Dundubhi (cat. 30).

The long section of text on the reverse primarily recounts the moving words of Tara, who in her grief tells Angada, "My son, greet the proud king, your father, whose body was like the rising sun, for he has gone to the abode of Yama [god of the underworld]." When Angada attempts to speak to his

father, Tara laments to Hanuman, "Even if I had a hundred sons like Angada, I would rather embrace the body of this warrior, even though he is dead."[3] She goes on to suggest that Rama, born to uphold world order (*dharma*), has sinned against it in his unjust murder of her husband. DM

PUBLISHED: Ehnbom 1985, pp. 208–9, no. 102

1. The verse inscribed on the reverse ends in a summary line written in red ink, as opposed to the black used for the rest of the text; this change of color indicates the end of a chapter. Under the inscription the number 18 is written in a different hand. It is from Sarga 21 (*Rāmāyaṇa* 1984–94, vol. 4, pp. 99–100).
2. The page that presumably came just before this one in the text, showing Valin already wounded but still conversing with Rama, is in the Goenka Collection (Goswamy with Bhatia 1999, pp. 234–35, no. 178).
3. Translation by Signe Cohen.

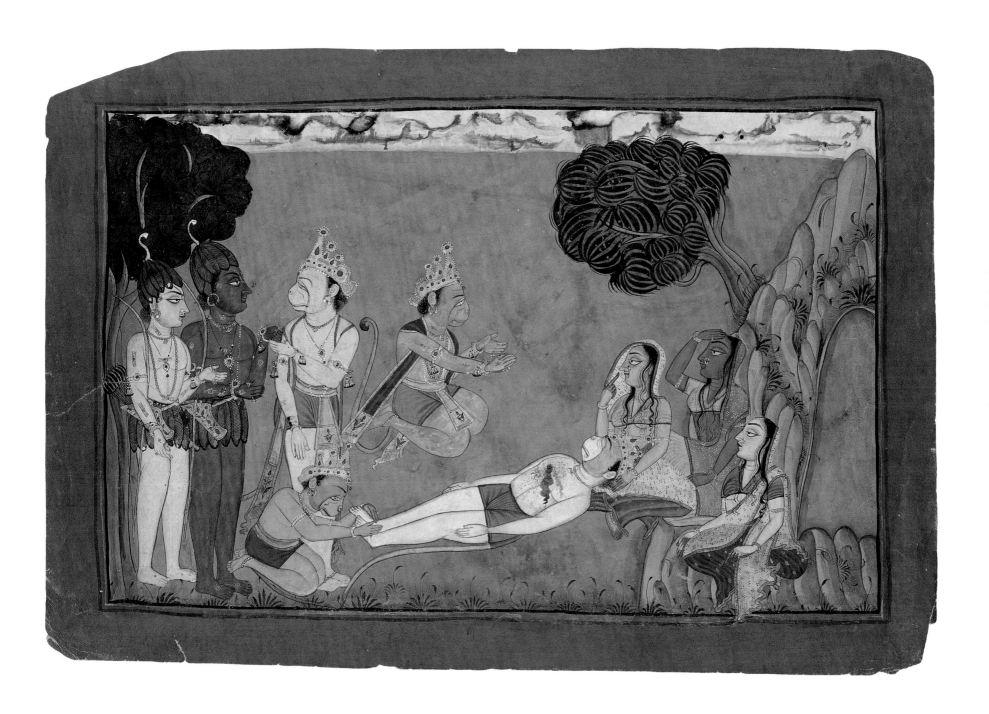

32. *Krishna Lifts Mount Govardhana*

Page from a dispersed series of the *Bhagavata Purana*
Panjab Hills, Mankot, c. 1700–1725
Opaque watercolor, gold, and silver-colored paint on paper
11 9/16 x 8 7/16 inches (28.8 x 21.4 cm)

Krishna dominates the center of this scene that depicts his youthful feat of lifting Mount Govardhana to shelter his cowherd village of Vrindavan from a devastating rainstorm invoked by the god Indra, Lord of Storms (see also cat. 71).[1] Blue-skinned and saffron-clad, wearing an elaborate court sash, blithely whistling on his flute, one sandaled foot crossed at the front—Krishna appears here in his typical iconic posture as Venugopala, the Cowherd Lord, worshiped in shrines and homes across India. His white-skinned brother Balarama and another cowherd stand to his left, his graying stepfather, Nanda, to his right. They hold up thin poles with handles, the flimsy cowherds' staffs that, thanks to Krishna's power, can support the page-spanning bulk of Govardhana.

The mountain itself appears as a dish of flesh-pink rocks spotted with trees and shrubs. A host of surprised animals—cobras, antelope, tigers, a leopard, and various birds—inhabit its crags, underscoring both the suddenness and the gentleness of the god's action. Above the mountain, the rain pounds down in unbroken lines, and dark storm clouds rage across the indigo sky punctuated by bright gold snakes of lightning. The land to the horizon is black, but below the mountain it is dark green, shadowed but peaceful in its haven. The colors are intensely saturated but not limited to the primary; an impressive array of pinks, ranging from lavender to flesh-orange, is used.

On either side of the composition two village women gaze upward at the mountain as they raise their hennaed fingers to their mouths in amazement. Two cowherd boys kneel, each holding a hand above his head as if to ward off the lowering mass. Overlaying the figures are four cows, smiling in their worship of the Cowherd God. To the far right appears Indra, identifiable by the many eyes spotting his body. He presses his hands together in a gesture of adoration toward Krishna: Indra has called down the torrent, but he yields to defeat and, with the others, recognizes the paramount power of the Lord incarnate.

The *Bhagavata Purana* series of which this page was a part[2] is believed to have been painted by a workshop located in the tiny kingdom of Mankot (now called Ramkot), in northeasterly Jammu district. Although no records of painters living in Mankot have as yet been discovered,[3] the connection is made for this series by several factors. First, pages from this manuscript, together with pages of an earlier, closely related illustrated copy of the text along with many portraits of the Mankot rulers, were in the collection of a descendant of the royal house of Mankot until the late 1950s.[4] Unlike the vertical format of this *Bhagavata Purana*, the slightly earlier series displays larger, horizontal compositions. The artist of this "vertical" series took the compositions designed for the horizontal pages almost directly, only minimizing them to fit into the new orientation, excluding in the process all elements not immediately pertinent to the narrative. The Mankot attribution is made firmer by a second bit of evidence: the *vasli* (layered paper) on which one of the "horizontal" *Bhagavata Purana* pages was painted includes as its back layer a letter written to the Mankot raja Mahipat Dev (reigned 1650/60–1680/90),[5] whose own portraits are so close in style as to be arguably from the same hand.[6] DM

PUBLISHED: Randhawa 1959, pp. 56–57, plate 10

1. The painting is inscribed in the lower left border: "33"; in the top border: "*govardhara dhar[i]ya* [the lifting of Govardhana]."
2. The pages, of which at least seventeen are known (and another nine if the *Dashavatara* pages are taken as part of the set; see cat. 33), are fairly widely dispersed, although a number remain in collections in India.
3. Goswamy and Fischer 1992, p. 96 and especially p. 99 n. 4.
4. Tikka Indra Vijay Singh, then living in a village in Kangra district. See M. S. Randhawa, "Paintings from Mankot," *Lalit Kala*, no. 6 (October 1956), pp. 72–75; and Archer 1973, vol. 1, p. 370. This page, however, was not part of Singh's collection; it is known to have come from the collection of Raja Dhrub Dev Chand of Lambagraon, descendant of the Kangra rulers.
5. B. N. Goswamy first discovered this information and published it in *The Bhāgavata Paintings from Mankot*, Lalit Kala Series, Portfolio No. 17 (New Delhi: Lalit Kala Akademi, 1978); he reproduces the letter itself in Goswamy and Fischer 1992, p. 97, fig. 30. The date of the raja's reign is from Archer 1973, vol. 1, p. 369.
6. Goswamy and Fischer (1992, pp. 96–125) call this artist the "Master at the Court of Mankot." A very closely related second image of Krishna lifting Govardhana in vertical format, now in the Government Museum and Art Gallery, Chandigarh, was published by Archer (1973, vol. 2, p. 292, Mankot no. 26). It differs very slightly from the Bellak painting, with, for example, slightly thinner faces and rain shown as lines of white dots. Archer (1973, vol. 1, p. 377, Mankot no. 26) called it more "sensitive and delicate in treatment" than the other "vertical" pages, leading him to speculate that there were two "vertical" *Bhagavata Purana* series from the same workshop, and that the Chandigarh page was from the earlier. What is more likely, however, is that the Chandigarh page comes from the same series but shows the Krishna incarnation as part of the *Dashavatara* section (see cat. 33), while the Bellak page was part of the story of Krishna itself. Unfortunately Archer does not include the upper border, so the inscription, or lack thereof, is obscured.

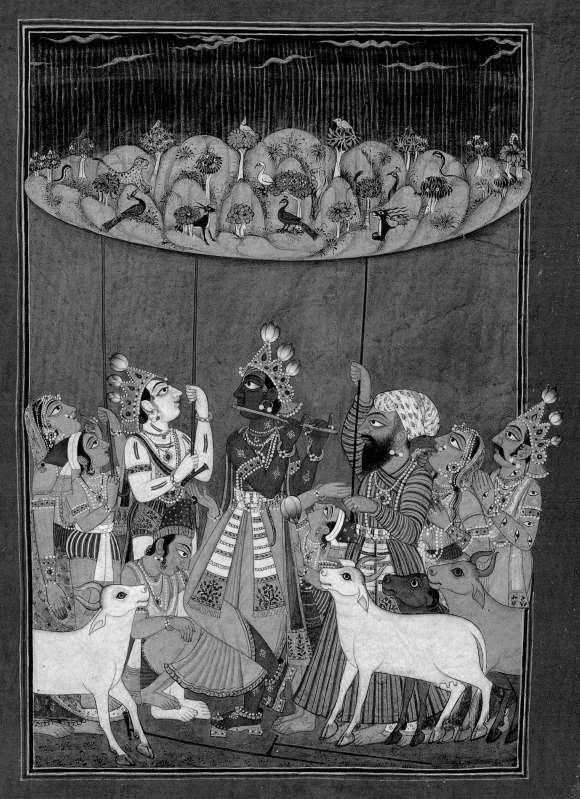

33

33. Vamana, the Dwarf Avatar of Vishnu

Page from a dispersed series of the *Bhagavata Purana*
Panjab Hills, Mankot, c. 1700–1725
Opaque watercolor, gold, and silver-colored paint on paper
11 5/16 x 8 13/16 inches (28.7 x 22.4 cm)

Vamana, the dwarf, is the fifth of the ten avatars *(Dashavataras)* of the god Vishnu. Through great religious practice and asceticism, the *asura* (demon) king, Bali, had conquered the gods and driven out Indra, king of the gods' heaven. To vanquish Bali, Vishnu was born as a Brahmin. Appearing as a dwarflike religious student, he came to the place where King Bali was performing a sacrifice. The king honored the Brahmin student and asked what he would like as a gift. However, Shukra, Bali's guru and advisor, recognized the Brahmin's true identity as Vishnu and warned the king to beware, but Bali ignored his advice. Vamana then requested that Bali grant him only as much land as his stumpy legs could cover in three steps.

As the king was about to seal his promise by pouring a libation of holy water, Shukra attempted to stop the transaction, shrinking to tiny size and jumping into the spout of the water vessel. To clear the obstruction, Bali poked at the spout with a leaf of the sacred *kusha* grass used as part of the sacrifice, which not only removed Shukra but also blinded him in one eye. The king then completed the vow. Suddenly, Vamana-Vishnu grew to enormous size and took three steps. With his first two he encompassed the earth, the middle world, and the heavens—and returned them to Indra's rule. There being nothing left to claim with his final step, the pious Bali, finally recognizing Vamana as Vishnu, offered his own head. Vamana, now called Trivikrama (Conqueror of the Three Worlds), used the pressure of his foot to send Bali to the netherworld, to rule there over the *asura* kingdom with Vishnu's blessing.

In this painting Vamana, blue like the god of whom he is a manifestation, is depicted as a mendicant Brahmin with saffron-orange garment, topknot and beard, walking staff, and parasol. He is shown as a sage in the prime of life, rather than the boy-student of the text. Over his shoulder is slung the antelope skin of a wandering ascetic, yet he wears courtly jewelry. He gazes up at King Bali, himself tonsured, crownless, and dressed to perform the ritual. Between them lie a variety of ritual implements, including the

sheaf of *kusha* grass; several water containers; a flower-shaped holder for incense and ritual powders; and a flat tray used for *arati* (worship with fire). Shukra stands behind the king with a hand on his shoulder and one finger raised in a warning gesture. His head is turned in three-quarter view, a deliberate break from the usual profile depiction that allows his pupil-less right eye to be visible,[1] and thus accurately depicts the tense moment in the story after he has been blinded, just as the king pours out the water.

The broad background of solid Indian yellow is broken only by a high horizon and by the figures. Vamana's dark body and the sharp diagonal composition make the masquerading god the focus and pivot of the scene. Action seems to hold its breath in anticipation of the next moment in the story, when Vamana will shed his disguise and grow to cosmic size, engulfing the world with his three steps.

This page relates closely to the *Bhagavata Purana* that included the scene of Krishna holding aloft Mount Govardhana (cat. 32). It is certainly stylistically identical, apart from the lack of white inscriptions in the borders. Among the other, related pages showing the *Dashavataras* are four representing different points in the story of one avatar—Narasimha, the man-lion and fourth incarnation of Vishnu.[2] It is likely, therefore, that the original set also included paintings of other points in the narrative of Vamana and the other avatars. Beginning with W. G. Archer, most scholars have implied that the *Dashavataras* formed a separate set, independent from the *Bhagavata Purana* with its pages narrating the life of Krishna. In the Pahari region, sets of ten paintings showing the individual *Dashavataras* were created as independent entities. Such *Dashavatara* images could also act as the opening pages for copies of the *Gita Govinda*. In these cases, however, they are shown as ten iconic images, not as small series of narratives giving multiple scenes from each incarnation. When they do appear as narratives, they are invariably part of the *Bhagavata Purana,* and other illustrated Pahari *Bhagavata Purana* manuscripts[3] do include narrative sequences of each of the ten avatars, and

the text itself certainly tells these stories. Further evidence that this page was indeed part of a *Bhagavata Purana* is the fact that there exist narrative *Dashavatara* images in the format of the "horizontal" Mankot *Bhagavata Purana* on which the scenes in this "vertical" set are based (see cat. 32).[4]

Indeed, this image of Vamana is clearly adapted from a page in the "horizontal" *Bhagavata Purana,* one that is now in the Museum Rietberg, Zurich.[5] In this earlier work, however, the right third of the painting is taken up with an elaborate depiction of Bali's palace, complete with attendant. Vamana stands mid-height in the picture plane, balancing the king and the guru. The god gazes straight ahead, the king's eyes look toward the pot in Vamana's hand, and Shukra places both hands together on the king's shoulder. In the Bellak page, the condensed version, not only are all nonessential elements of the story removed, but its drama is emphasized by the guru's gesture, the diagonal composition, and especially the intense eye contact of king and dwarf. DM

1. This is seen also in depictions of Shiva (see cats. 85, 86) in which his head is turned in three-quarter view so that his third eye is visible.
2. They are a painting in the Walter Collection (Pal 1978, pp. 166–67, no. 58); two in the National Museum, New Delhi (62.1770 and 62.1771; see Hayward Gallery 1982, p. 203, nos. 375–76); and one in the Goenka Collection (Goswamy with Bhatia 1999, p. 222, no. 168). Paintings of other avatars include those in the Binney Collection (now in the San Diego Museum of Art); the Bickford Collection (now dispersed); and the collection of Doris Wiener in New York. A final image, showing Vishnu and Lakshmi, which B. N. Goswamy speculates may be the introductory page, is in the Goenka Collection.
3. For example, the version attributed to Manaku.
4. Goswamy and Fischer 1992, p. 96. "Horizontal" pages with *Dashavataras* include an image of Matsya in the Bickford Collection (Czuma 1975, no. 103); and paintings of the following in the Boner Collection of the Museum Rietberg, Zurich: Vamana (RVI 1211), Varaha (RVI 1209), Narasimha (RVI 1210), Kalkin (RVI 1213), and possibly Rama (RVI 1212) (see Georgette Boner et al., *Sammlung Alice Boner: Geschenk an das Museum Rietberg, Zürich* [Zurich: Museum Rietberg, 1994], p. 97, nos. 266, 264, 265, 267, 263, respectively).
5. Cited in n. 4 above.

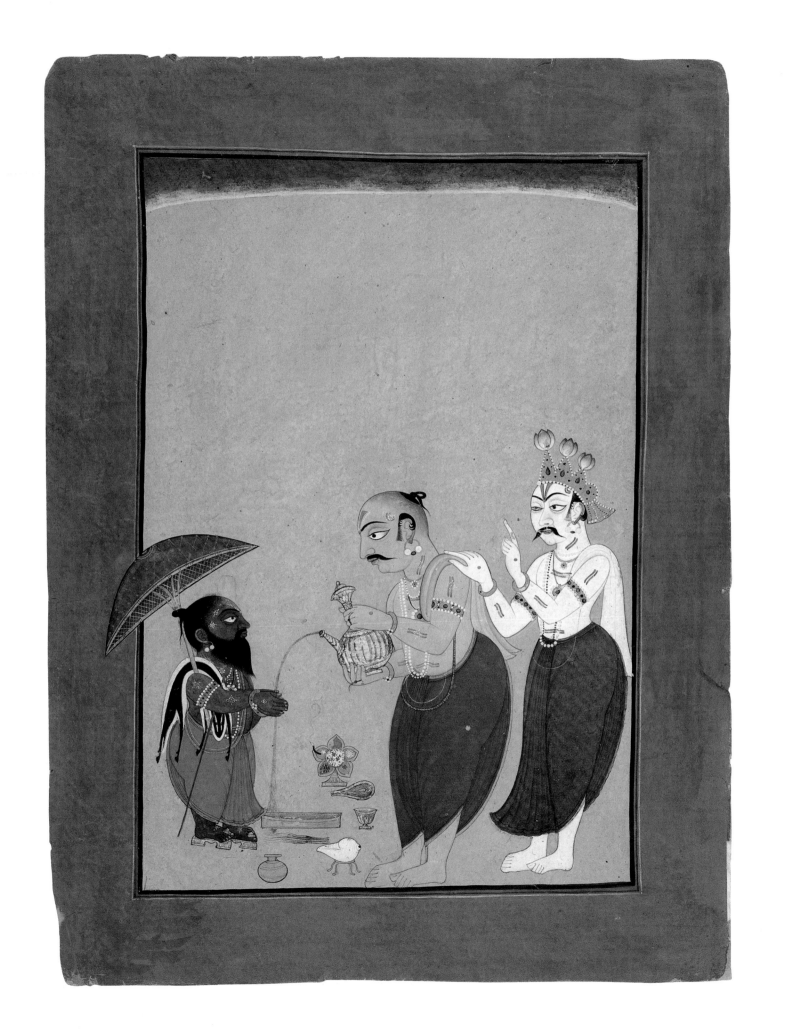

34. The Adoration of Cosmic Vishnu

Probably a replacement page for a dispersed series of the *Bhagavata Purana*
Panjab Hills, Mankot, c. 1710–25
Opaque watercolor and gold on paper
5 ¹³/₁₆ x 9 ¹⁵/₁₆ inches (14.9 x 25.2 cm)

In a dream-vision, a perfect circle defines the cosmic ocean, the ocean of ultimate reality. Within, the snake named Endless (Ananta), depicted with seven heads, curves to accommodate the round space, its shape a solidification of the white-contoured ocean waves. On the snake lies Vishnu, in yogic sleep with open eyes. Saffron-clad with dark blue body, he carries his four attributes of discus *(chakra)*, mace, lotus flower, and conch shell. He is the *chaturbhuj,* or four-armed iconic form of the god, as worshiped in temple sancta throughout India. He wears a typical early Pahari lotus crown and a long, multicolored garland. Lakshmi, his wife and the goddess of wealth, massages his foot.

As is usual with an image of Vishnu asleep on the cosmic ocean, a lotus stem grows from the god's navel. Here, however, instead of the four-headed god Brahma who usually sprouts from the flower's center, four small figures appear, all kneeling with hands reverently folded toward the Lord. They are dressed as sages, three flesh-colored, the fourth and front blue-skinned like the god. They likely represent the four Vedas, the fundamental sacred texts of Hinduism— a revealed body of knowledge—also represented by the priestly god, Brahma. Thus while the image is closely related to the more usual birth of Brahma, it seems to emphasize the birth of the sacred texts as anterior and necessary to the birth of the phenomenal world. The painting was most likely the first page of Chapter 10 of the major Vaishnava text, the *Bhagavata Purana,* which details the life of Krishna, an avatar of Vishnu (see cat. 7).

Outside of the unbroken circle that describes the ocean of unchanging absolute, yet also within an abstract and transcendent space of the solid, hot-red ground, stately divinities pay homage to the godhead. To the right of the circle stands Indra, distinguished by the many peacock-like eyes that cover his body. He sports a mustache and sideburns, seen frequently in the mythological courtly figures attributed to the Mankot workshop that was probably responsible for this painting. Below Indra is Shiva, turned three-quarter face to display his third eye, his body whitened with ash and a tiger skin wrapped tightly around his waist as a lower garment.

To the left of the circle gathers a more complex crowd. They include another figure of Vishnu himself, depicted almost as he is within the circle but with two rather than four arms, no garland, a simpler scarf, and only a lotus flower between his folded hands. Thus, as opposed to the Vishnu within the circle, who is equivalent to the primary deity in a temple, the outer Vishnu is himself an incarnate form, part of the periodically manifest world. Below and in front of him stands the third Brahmanical male deity, the priestly creator Brahma himself. His four visible heads look in all directions, and in one of his four hands he carries a book on which is written standardized phrases honoring Lord Vishnu.

Behind these deities stand two men in ritual-performing garb. Like Indra, they have mustaches and sideburns as well as crowns and jewelry, but no attributes distinguish them. It is thus impossible to say if they are additional deities, as Stella Kramrisch believed, or some other type of being.[1] In front of them is a white cow gazing at Vishnu with an expression of blissful devotion. She is Surabhi, foremother of all cows, who emerged from the primeval ocean of milk to bless the world with plenty, as she comes out of the strip of ocean that runs along the bottom of the page. (A balancing strip of sky would have originally appeared at the top but has been cut away, leaving only a thin blue line.) In the text, Surabhi holds primary importance in this episode, for it is she who first approaches Vishnu to beg him to incarnate and rid the world of the demonic Kansa, a feat he accomplishes as the avatar Krishna.

Except for the cow, who worships with her eyes, all figures stand with hands folded in the posture of devotion and hold rosaries or lotus flowers. Through these ritual trappings they worship the ultimate divinity within the circle of unchanging, all-encompassing reality. Indeed, the entire painting may be thought of as paradigmatic of the Hindu temple itself, or perhaps the temple may be seen as a physical re-creation of the concept expressed in this story. Within an apparently circumscribed yet infinitely inclusive space—the sanctum—is enshrined the ultimate, iconic form of the godhead, surrounded and worshiped by the inhabitants of each temporary, illusory creation.

Kramrisch first attributed this painting to Mankot.[2] It certainly bears a stylistic resemblance to the *Bhagavata Purana* manuscripts attributed to that region (see cats. 32, 33): eyes are large, open, and curving upward; black mustaches are common; garments are pneumonically rounded; faces show upturned noses and distinctive outlines; and there is a preference for a solid, hot background color, dark swirling water, and a few large figures of equal scale. Yet the painting differs from works arguably from the Mankot workshop as well. Not only is it less polished and finely detailed, but some of the details themselves deviate. Here, for example, the eyes are even larger and more heavily outlined around the lower lids, faces are fuller and features more pointed, and the lotuses of the crowns are minimized.

Two published paintings—*The Adoration of Rama,*[3] in the Museum Rietberg, Zurich, and *Kali Triumphant,*[4] in the Victoria and Albert Museum, London—may also be related to the Mankot workshop. While it cannot be argued that all three are by the same hand, they do show variations from the *Bhagavata Purana* pages that have been securely assigned to Mankot (cats. 32, 33), which begin to tell a broader tale of paintings produced in that workshop early in the eighteenth century, perhaps transforming what at first appear to be inconsistencies into workshop variations. Indeed, it seems likely that this painting of Vishnu on Ananta may have been intended to replace a missing first page in the "horizontal" Mankot *Bhagavata Purana*. Not only do its dimensions concur if the cropped borders are taken into consideration, but another replacement page, now in the Government Museum and Art Gallery, Chandigarh, appears to relate to this work in style.[5] It is likely that the replacement pages were made not long after the completion of the original series, perhaps only ten or fifteen years later, although clearly not by the same accomplished artist responsible for the "vertical" *Bhagavata Purana* series (cats. 32, 33) from the Mankot atelier. DM

PUBLISHED: Kramrisch 1986, pp. 118, 182, no. 108

1. Kramrisch 1986, p. 182, no. 108. Terence McInerney has speculated that they are the sages Markandeya and Narada, who witnessed the primeval creation, yet their royal regalia seems to belie this possibility.
2. Ibid.
3. RVI 1206.
4. I.S. 126-1951; Archer 1973, vol. 2, p. 52, Chamba no. 7.
5. *Shiva Comes to Yashoda to Gain Darshan of Krishna* (B. N. Goswamy, personal communication, 2000).

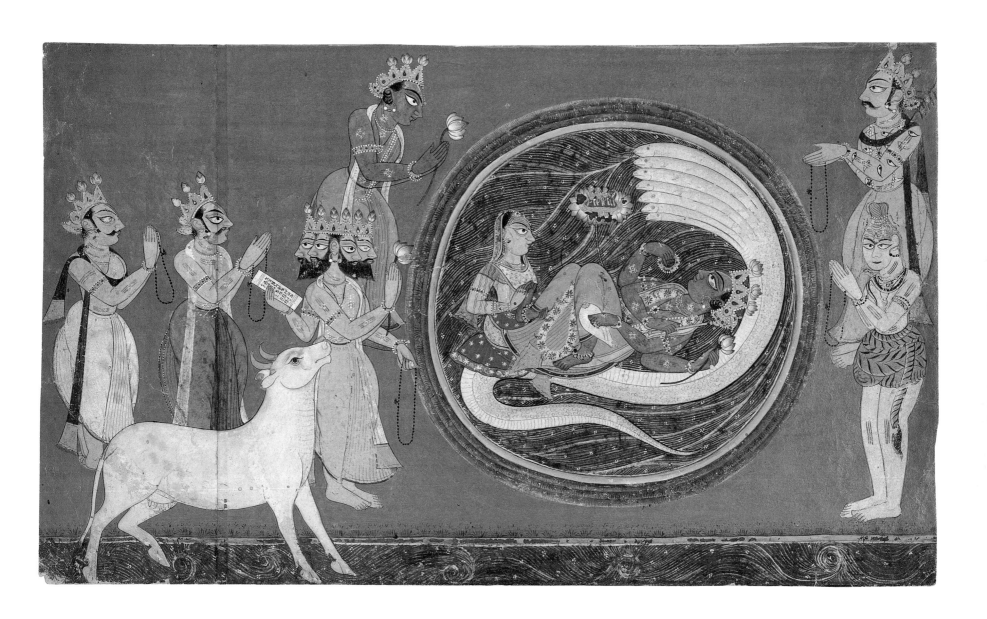

35. *Krishna and Radha*

Panjab Hills, Nurpur or Mankot, c. 1700–1720
Opaque watercolor, gold, and silver-colored paint on paper
11 7/16 x 8 7/16 inches (29.1 x 21.5 cm)

A thick red border frames a silver oriel that acts as a second frame to hold an exceptionally large image of Krishna and Radha embracing.[1] They are depicted as if sitting in a balcony window, with only their upper torsos and heads visible. The oriel, covered in a variety of floral scrolls created in impasto, is composed of a front ledge with border, resembling a carpet or other woven textile hung over a railing, and foliage-topped fluted pilasters on which rests a wide arch. The background of the interior is dark green.

Krishna and Radha gaze at one another, her left arm around his shoulders, his right out of sight around her waist. Her right hand, overlapping the front ledge, fondles his pearl necklace as he fondles hers behind the parapet. Krishna wears an orange *jama*, elaborate ornaments, and a mauve-colored cap with single peacock feather plume tied by a double white fabric band twisted with gold. This gold textile, ornamented with flowers, hangs from the back of the cap, and a gold and pearl pin depends from the band at his forehead. Around his neck is a floral garland known as a *vanamala*, traditionally made of five kinds of wildflowers, which refers to Krishna as Vanamali, or He Who Wears a Garland of Wildflowers.[2] Krishna's forehead is marked with a gold Vaishnava *tilik*; his neck and the side of his eye also bear devotional body markings.

Radha wears a diaphanous blouse of the same mauve, a color particularly popular in the Mankot workshop. Her breasts and nipples clearly show through its swirling shading. Although the neckband is high and ornamented, the blouse itself reaches only partway down her chest to leave her young breasts provocatively exposed, as if they have outgrown the garment. The sleeves are short, and the right one forms an elegantly continuous arch with the bottom line of the blouse. She wears a wide cuff bracelet and bands low on her upper arms. Her head is covered with a yellow floral scarf, placed far back to reveal her ear and long hair. Around the rim of the ear she wears a series of small earrings, a jewelry form rare in the Pahari region but relatively common in neighboring Kashmir. The gold mark *(tilik)* on her forehead, in the shape of a crescent moon with a teardrop, denotes her Shakta (Goddess) affiliation. Her hands are very small, with the fingers darkly hennaed from the knuckles. Her wrists curve as if lacking this joint.

The faces of the couple have large, heavy chins marked off from the neck by light shading; extremely high foreheads that curve into a shadowy hairline almost at the center of the skulls; tiny pursed mouths that abut the long, pointed noses. The cheeks are pouchy; large eyes are curved below and nearly straight above, with corners that are red-pink like lotus leaves; pupils are placed about a third of the way back from the nose; eyelids have heavy double creases; and brows are painted in a single flourish from nose to hairline. These features, although here enlarged to unusual size, link the painting with works from Mankot and neighboring Nurpur. The predilection in works from Nurpur, such as three early *Rasamanjari* sets (see cat. 26), for pursed mouths and women with such small, high breasts, makes this origin likely. In addition, the impasto technique used to ornament the silver oriel appears to have been particularly popular in workshops at Mankot, Nurpur, and Chamba.[3] DM

1. The painting was formerly in the collection of Svetoslav Roerich, son of the painter Nicholas Roerich (1874–1947).
2. B. N. Goswamy, personal communication, 2000.
3. Amy G. Poster (in Poster et al. 1994, pp. 246–48, no. 200) speculated that a similar image with a raised frame in the collection of the Brooklyn Museum (37.122) might have been used as an icon or set into an architectural framework. The presence of a long poetic verse on the back of this painting, however, seems to suggest that such images could have been used to illustrate literary series (see Appendix). While the inscription here agrees in format with the verses of the *Satasai* of Bihari (see cat. 71), it is as yet unidentified.

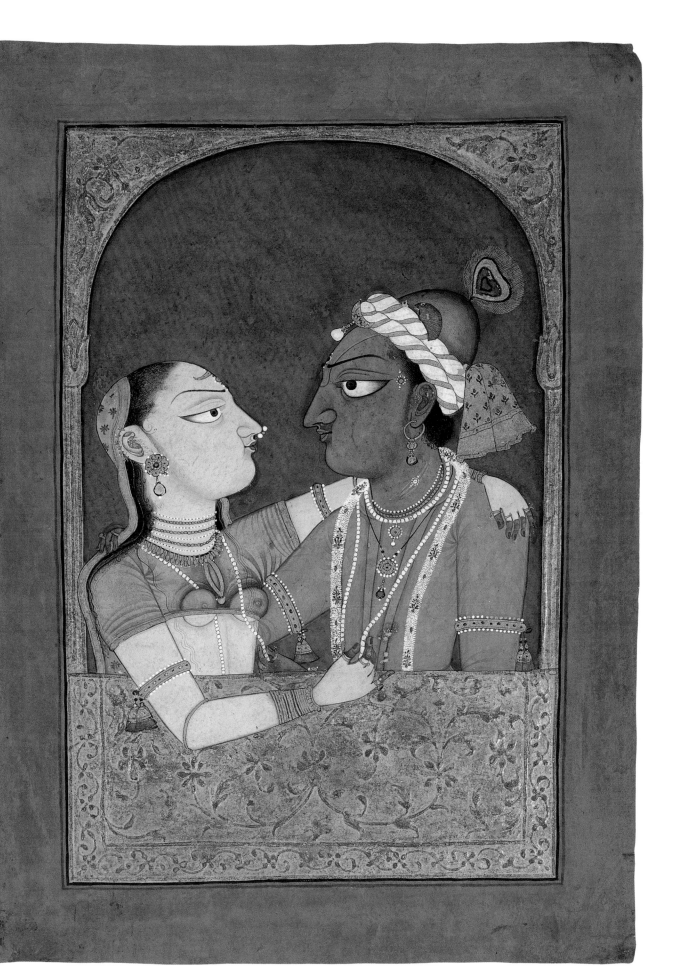

36. *A Prince Smoking a* Huqqa

Panjab Hills, possibly Mankot, c. 1700–1725
Opaque watercolor, gold, and silver-colored paint on paper
8 13/16 x 7 3/8 inches (22.4 x 18.7 cm)

Much like the portrait of Dhrab Dev (cat. 37) in format, here a prince is placed against a deep brown sky tinged with clouds, kneeling on a red-checked carpet bordered in blue with a bold floral scroll. He leans against a huge orange bolster and smokes a silver *huqqa*, deeply carved with overlapping acanthus-type leaves, that rests on a silver tray in front of him. In his other hand he holds a bundled cloth. He is attended by a servant, who supports the stem of the *huqqa* and gazes upward at the prince. The tools of *huqqa* smoking—a bowl for tobacco and pincers—rest nearby. Behind him stands a second servant, in a gray-striped *jama* with striped pajama pants. He holds a red peacock-feather fan, the prince's sword wrapped in an elaborate floral textile sheath, a thrusting dagger, and a *rumal* (handkerchief). The prince himself wears a white *jama* ornamented with delicate green foliage, his underarms shaded by a yellowish wash and darker flecks. He also wears a gold court sash tied below his pot belly. The turbans of all three men are small and flat, the prince's with floral strands hanging from the back. All are beardless; the prince has long side curls, indicating his youth. Double horizontal red marks with a dot below on his forehead show his Shakta (Goddess) affiliation.

Although representing a leisurely scene, this is a formal court portrait. The prince stares straight ahead, frozen with the *huqqa* mouthpiece poised at his lips. This image falls within a long tradition of formal princely portraiture from not only the Panjab Hills but across India (see cat. 48). Just who this ruler is, however, remains speculative. A flyleaf originally attached to this painting was said to have been inscribed with the name of Dhota Dev, who ruled at Mankot from c. 1680/90 to 1710.[1] However, a portrait of Dhota Dev in middle age, dating to c. 1690, depicts a paunchy man in a very similar format and somewhat earlier style,[2] which would suggest a date of not earlier than c. 1700 for the Bellak painting. However, because this image shows a much younger man, if it were indeed Dhota Dev before his accession, a date no later than c. 1660–70 would be indi- cated, although this is not supported by the stylistic evidence. An alternate identification, suggested by B. N. Goswamy, is that he is Udai Singh of Chamba (reigned c. 1690–1720). Indeed, the beardless young man with ringlets, high forehead, and pot belly certainly resembles a well-known painting of that ruler in the National Museum in New Delhi.[3] This apparent likeness, however, may be only the result of the two using common characteristics for depicting young men. DM

PUBLISHED: McInerney 1982, p. 72, no. 31

1. Terence McInerney (1982, p. 72, no. 31) used the inscription to identify the subject as "Dotha [*sic*] Dev." It is possible that the flyleaf was misread, and perhaps actually said "Dothain," which means "second in order of succession," instead of "Dhota Dev." However, if this were the case, it would argue against an identification of the subject as Udai Singh (see text below), who was the first-born of Raja Chattar Singh.
2. W. G. Archer (1973, vol. 2, p. 286, Mankot no. 11) dates this work, now in the Prince of Wales Museum, Mumbai, to c. 1690.
3. Archer 1973, vol. 2, p. 51, Chamba no. 4.

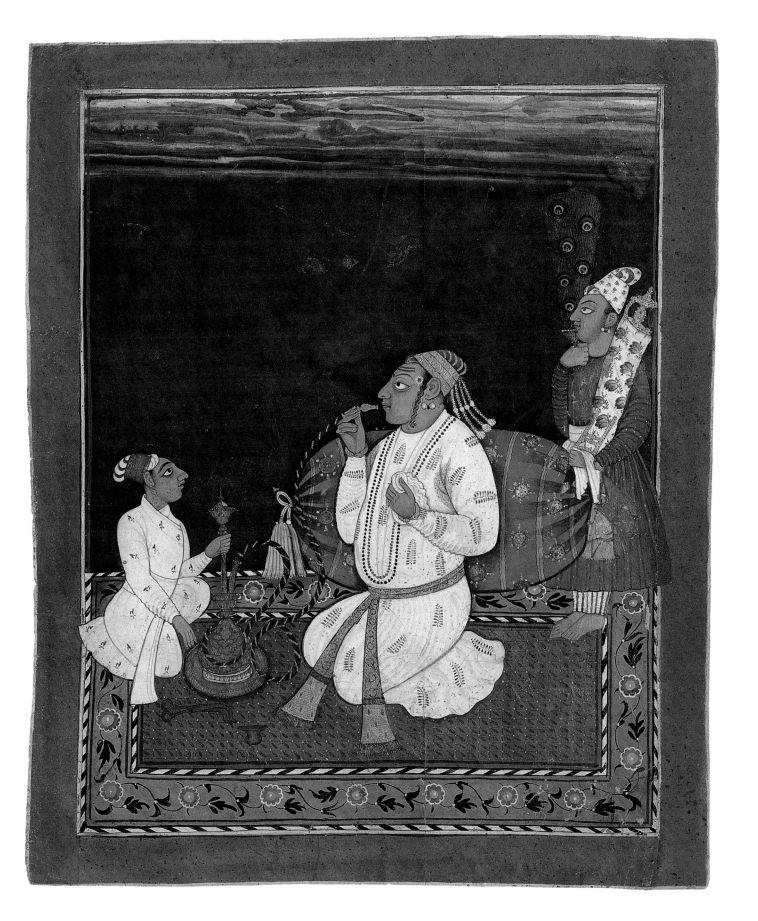

37. Dhrab Dev of Jasrota

Panjab Hills, probably Mankot, c. 1700–1710
Opaque watercolor, gold, and silver-colored paint on paper
8 13/16 x 12 5/16 inches (22.4 x 31.5 cm)

A black-bearded prince sits smoking his *huqqa*, attended by a young retainer holding a peacock-feather fan. The ruler is being approached by a visitor of minor rank who grasps a sword in one hand and bears a thrusting dagger tucked in his belt. He humbly touches his forehead in greeting. In his turban is stuck an egret feather, indicating that he is the prince's groom, perhaps arriving to announce the readiness of his horse. The composition is somewhat unusual for a Pahari painting of this period, because the artist has chosen to keep all the figures strictly within the red borders, allowing only the fan to project into the margin. Thus only the front third of the groom can be seen, as if he were just entering the royal presence.

In an often-repeated formula for Pahari court portraits, the lower portion of the painting is entirely covered by a vertically striped rug, here in the distinctive blend of lavender-pink and mauve popular in Mankot. Overlaying this is a smaller rug with floral border on which the prince himself rests against a bolster, his leg crossed in front to display his striped pajamas. The upper section of the painting is a ground of solid yellow topped by a thin line of sky (see also cat. 25).

On the reverse the sitter is identified as *"Jasrotie Mian Dhrab Dev,"* or "Prince Dhrab Dev of Jasrota."[1] Dhrab Dev ruled Jasrota, which lies only some eleven miles from Mankot, from about 1710 to about 1730. If the inscription is contemporaneous with the painting, its use of the word *mian* (prince) to identify the subject would date the work before his accession. However, since the painting certainly portrays a man in his prime, and since W. G. Archer speculates that Dhrab Dev was born about 1680,[2] it would be unlikely that the image would date long before 1710, while he still held the title of prince. It is more likely that the inscription, which is casually phrased, is a later inventory labeling and cannot be used to date the work itself. There are at least four other inscribed portraits of Dhrab Dev.[3] All resemble this image in basic ways—especially the high, beaked nose and prominent chin. In all he appears older, however, and none corresponds to this work in style. DM

1. There is also a seal of Abdur Rahman Chughtai (1894–1975), the Lahore painter, indicating that this painting was once in his collection.
2. Archer 1973, vol. 1, p. 214. Unless specific inscriptions are mentioned, Archer derived his dating of rulers from Hutchison and Vogel 1933.
3. Three of them are also inscribed with the title "Mian" rather than "Raja." Since these paintings clearly show Dhrab Dev at a much older age, Archer (1973, vol. 1, p. 214) takes this to indicate that he abdicated. The four portraits are in the following collections: British Museum, London (ibid., vol. 2, p. 133, Jammu no. 3); Victoria and Albert Museum, London, I.S. 188-1951 (ibid., p. 141, Jammu no. 35); National Museum, New Delhi (ibid., p. 294, Mankot no. 32); and Government Museum and Art Gallery, Chandigarh (ibid., p. 163, Jasrota no. 1).

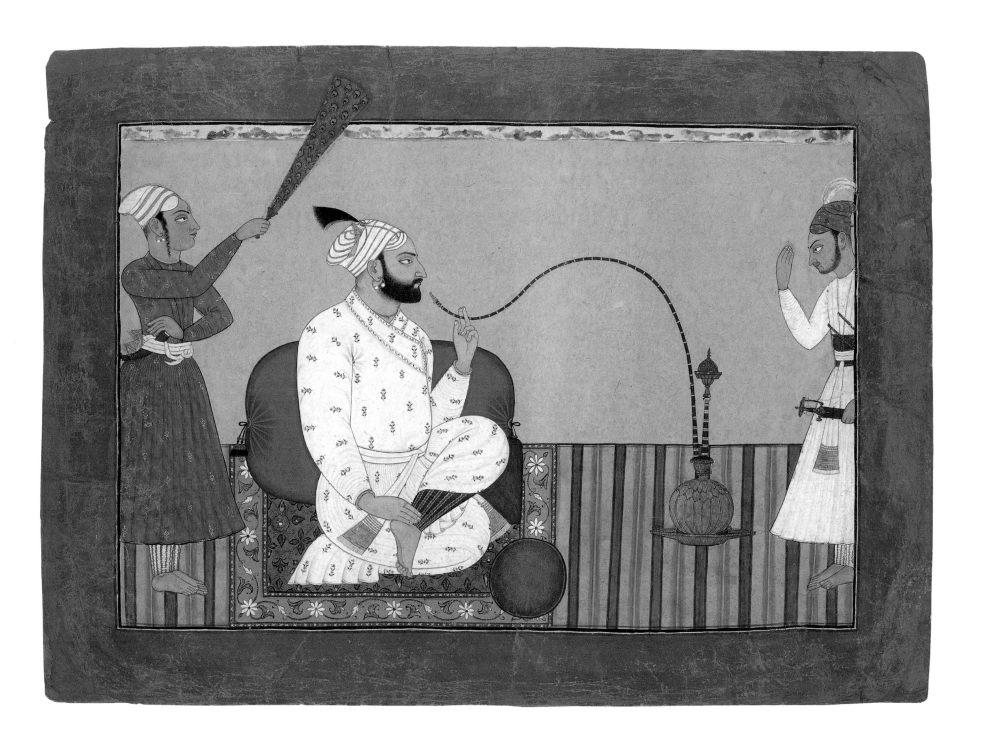

38. Raja Sidh Sen of Mandi

Panjab Hills, Mandi, c. 1700–1725
Opaque watercolor on paper
12 1/2 x 7 11/16 inches (31.7 x 19.5 cm)

Raja Sidh Sen ruled over the state of Mandi on the Beas River from c. 1684 to 1724. He was famous as a giant warrior and ardent devotee of Shiva, proficient in tantric (magical-devotional) practices, and was credited with a host of supernatural powers, including the ability to fly. His great size is emphasized in this portrait, where he fills nearly the entire picture. Apart from his stature, Sidh Sen is recognizable by his face with its large eye, five-o'clock shadow, curl of hair at the ear, receding chin, and wide, prominent nose. He is dressed in a long orange *jama*, a typical Mandi flattish turban with plume, sandals on his oversize feet, and a sumptuously yellow ornamental woven shawl. In his right hand he carries a sheathed sword. His devotion to the Goddess is emphasized by the prominent Shakta *tilik* on his fore-head, and his connection to Shiva by the *rudraksha* beads and amulet around his neck. Simple gold bangles, a thumb ring, and pearl necklaces and earrings add a regal note to the ensemble. The ground is a dark grayish green with little tufts of yellow grass, the sky a schematized line of white shading into dark blue and punctuated by regularly spaced tiny black birds, both characteristics of the distinctive Mandi style of this era.

Numerous portraits of Sidh Sen are known, some painted during his lifetime, others posthumously. Compared with this work, the posthumous paintings are more linear and harder, with dots replacing the flying birds. This lush image was undoubtedly done during Sidh Sen's life by his master painter (see cat. 39).[1]

Although in Mandi, as in other parts of the Panjab Hills region, the worship of Vishnu as a state religion had increased since the advent of the *bhakti* (devotional) movement of the fifteenth and sixteenth centuries, in Mandi it never overpowered the underlying focus on Shiva and the Goddess. Sidh Sen in particular minimized the importance of Vishnu, never styling himself *diwan* (regent) of Vishnu, as did his predecessors and successors. Although opinion is still divided, it is likely that Mandi as a center of painting production can be traced back well into the sixteenth century.[2] Yet it is certainly under the energetic patronage of Sidh Sen that it reached its apogee. DM

PUBLISHED: Sotheby's, New York, March 25, 1987, lot 173

1. B. N. Goswamy and Eberhard Fischer (1992, pp. 189–93) called this artist the "Master at the Court of Mandi."
2. See also cat. 23; and Ohri 1991, pp. 24–25.

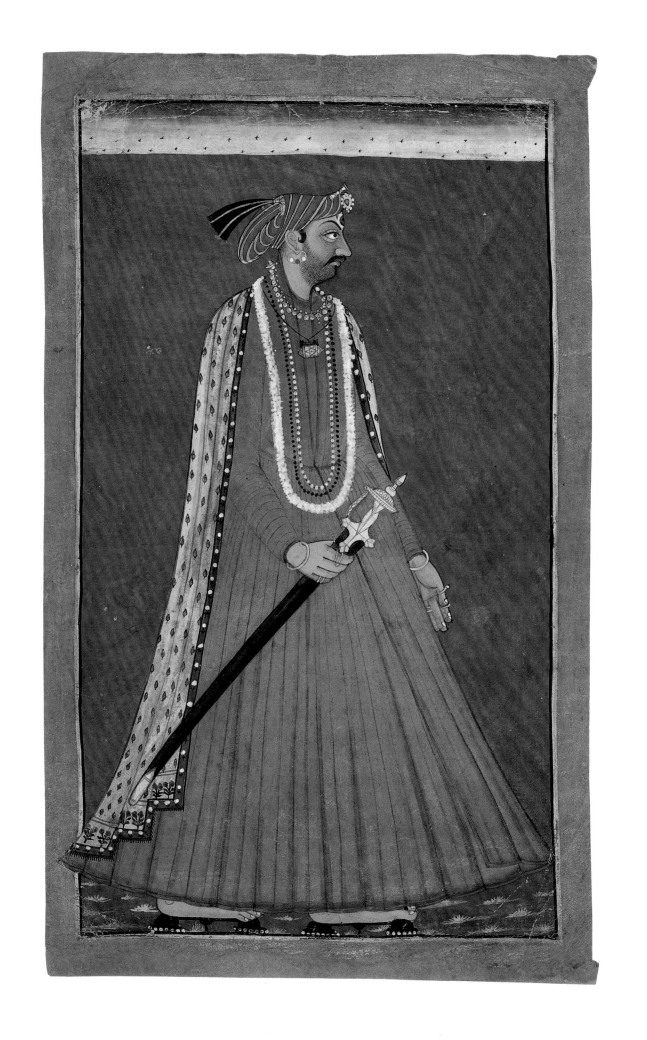

39. The Goddess Kali Slaying Demons

Panjab Hills, Mandi, c. 1700–1725
Opaque watercolor, gold, and silver-colored paint on paper
8 1/8 x 11 3/8 inches (20.6 x 28.9 cm)

The Great Goddess in her form as Kali, the Black One, is here envisioned at her most macabre moment in a painting where style and subject collaborate to create one of India's most vivid depictions of horrific power. Her greasy, unbound hair streams around her dark body, clad only in a belt of blood-stained human arms. Strings of tiny severed heads form her necklace, anklets, and bangles. In one right hand she brandishes a murderous, curved sword. In the opposite hand she holds an even more gruesome object: a drinking bowl formed of a human skull and brimming with blood, a lock of hair still hanging from its crown.[1] In her front hands she clutches by their hair the bleeding heads of four demons. Three are shown with closed eyes and lips pulled back in rigid death-grins; the fourth has an animal snout and long, slack tongue. The decapitated bodies of the demons, carefully color-coordinated to their heads, sprawl on the ground to form a grisly platform for the slippered feet of the Goddess Triumphant.

Although Kali is powerfully built, her drooping breasts and sunken cheeks indicate old age, for the dark form of the Goddess represents the female power of destruction, embodiment of barrenness and polar opposite of the fertile goddess-wife. Kali's mouth opens in a roar of protruding tongue and fangs that is echoed by the tiger, her vehicle and complement. At the center of her forehead is a vertical third eye. It, together with the gold crescent moon in her hair, emphasizes the Goddess's close connection with Shiva. At the right of the painting, two scavenger jackals gleefully sniff the blood-saturated air.[2] To the left, three more demons—one with a leopard-like body—edge warily out of the picture, their shields held protectively against Kali's glare.

No architecture or landscape interrupts the solid brown background. As in many other Pahari paintings of the seventeenth and early eighteenth centuries, however, the artist has used the painted borders as an active element in the composition. The limbs of some figures are contained within the borders, others

protrude into them, and one arm actually crosses under the white inner border to project into the red surround. But rather than clarifying the placement of the figures, this play with the limits of the frame serves to press the whole frightening episode into a space shared, ambiguously, with the viewer.

There is no accompanying text on this painting,[3] and no other pages from this series are known to indicate whether it once formed part of a narrative set. Yet, unlike the iconic images from the "Tantric Devi" series (see cats. 23, 24) as well as closely related contemporaneous images of deities from Mandi, this painting clearly depicts a specific narrative moment. It is the moment immediately after the killing. The neck stumps of the dead demon bodies still pulse fountains of blood and their heads drip blood from hanging arteries, introducing a realistic depiction of decapitation into an otherwise surrealistic scene.

The most likely textual reference for the scene is the *Devi Mahatmya*,[4] which tells of the Great Goddess and her conquest of a variety of demons (see cat. 53). In one scene she appears as Kali to slay the demon-generals Chanda and Munda, and thus bears the epithet "Chamunda." Numerous illustrated renditions of this text were created in the Panjab Hills region later in the eighteenth century and into the nineteenth. In those images, however, the standard representation of Chamunda shows her holding only two heads—those of the demon-generals—not the four seen here.

The subject, as Stella Kramrisch speculated,[5] suggests that the work was created for Raja Sidh Sen of Mandi, an ardent devotee of Shiva and the Goddess and famed tantric practitioner (see cat. 38). This identification is confirmed by the style of the painting itself. The powerful, seemingly crude drawing; thick-bodied figures; distinctively stippled shading; love of body hair; and specifics of physiognomy allow this painting to be attributed[6] to the artist who has been called the "Master at the Court of Mandi."[7] This painter appears to have worked under the patronage of Sidh Sen and of his grandson and successor,

Shamsher Sen (reigned 1727–81), for the first part of his rule. Although his attributed *oeuvre* consists solely of iconic depictions of deities and portraits (including cat. 38), there can be no question that this is the work of the master at the height of his powers.[8] Indeed, Kali's face, shown in profile with its thick nose and slightly receding chin, is reminiscent of certain portraits of Sidh Sen himself.[9] Might the artist be evoking his magician-warrior patron in this startling vision of the Great Goddess as an active icon of salvation through destruction? DM

PUBLISHED: Kramrisch 1986, pp. 124, 183, no. 114; Kossak 1997, p. 78, no. 44

1. The single lock of hair indicates that the skull is that of a tonsured Brahmin. The bowl *(kapala)* is depicted in precisely the same manner in a painting of the seated Harihara Sadashiva in the Victoria and Albert Museum, London (I.S. 239-1952), attributable to the same artist (Goswamy and Fischer 1992, pp. 206–7).
2. Stella Kramrisch (1986, p. 183, no. 114) identifies these creatures as antelope. Steven Kossak (1997, p. 78, no. 44), apparently following her identification, calls them deer. However, there can be no doubt that the animals are jackals or feral dogs. Not only do they make much more sense in this charnel scene, but the oversize, erect, pointed ears; the shape of the animals' heads and muzzles; and the thickness of the barely visible rear leg are clearly canine. Other images of the Goddess from Mandi also show her accompanied by jackals (Goswamy and Fischer 1992, no. 85; Archer 1973, vol. 2, p. 268, no. 20).
3. The numbers 50, 30, and 98 appear on the reverse, but it is unclear whether any of these constitutes a sequence number, or if they even relate to the painting.
4. See Thomas Coburn, *Encountering the Goddess: Translation of the Devī Māhātmya and a Study of Its Interpretation* (Albany: State University of New York Press, 1991), esp. pp. 61–62.
5. Kramrisch 1986, p. 183, no. 114.
6. Kossak 1997, p. 78, no. 44.
7. Goswamy and Fischer 1992, pp. 190–93.
8. The feature here that is unusual for this artist is the use of gold. In other works (such as cat. 38), he consistently uses bright yellow for metals and in other places where gold would be expected.
9. Most notably the well-known painting of the raja, partially clad, in the Government Museum and Art Gallery, Chandigarh (no. 2725; see Goswamy and Fischer 1992, pp. 194–95, no. 76).

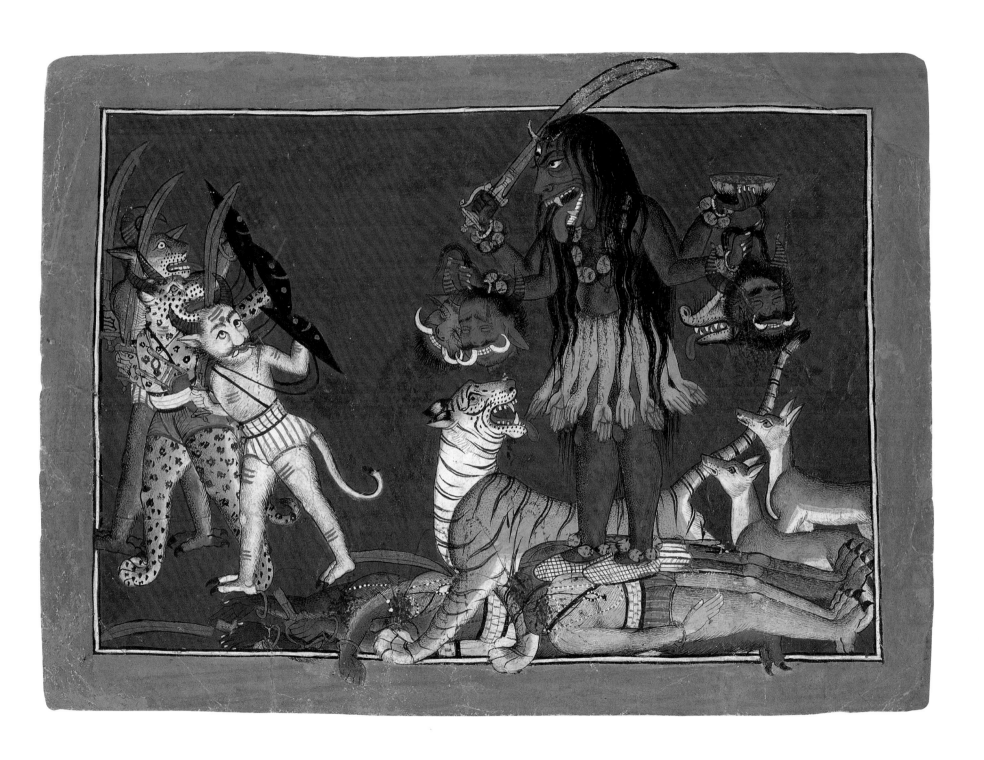

40. Sultan 'Ali 'Adil Shah II

Deccan, Bijapur, c. 1670
Opaque watercolor and gold on paper
10 5/16 x 6 1/16 inches (26.2 x 15.4 cm)

At the southern frontier of the Mughal empire lay the Deccan, a region whose wily rulers, inconstant alliances, and rocky terrain frustrated Mughal designs on its wealth and territory for more than a century. But the Mughals persisted, and when the political winds were right, their armies managed to subjugate each of the five Islamic kingdoms of the Deccan, a process that culminated in the capitulation of the two largest states, Bijapur and Golkonda, in 1686 and 1687, respectively. Before this time, however, the Deccani sultanates enjoyed the fruits of a cultural amalgam very different from that of the Mughal colossus to the north. Their location at one of the major crossroads of the subcontinent encouraged a continuous influx of people and goods from adjacent Hindu kingdoms as well as from more distant lands, including Portugal and Central Asia. Regular direct contact with Iran and Turkey led the sultanate of Bijapur in particular to embrace Shi'ism as its state religion and to promote artistic styles with a subtle West Asian flavor.

Painting assumed a distinct character under each of the major Bijapuri rulers. During the reign of Ibrahim 'Adil Shah II (1580–1627), a great flurry of artistic activity formulated and then rapidly refined a style that blended elegant figural detail with lyrical, even fantastic settings. The pace of stylistic change slowed under Muhammad 'Adil Shah (reigned 1627–56). The genre of portraiture became ever more prominent and showed the heaviest concentration of naturalistic features derived from Mughal painting. The steady infiltration of a Mughal visual aesthetic accelerated in the late 1630s, when renewed Mughal military activity in the region brought nobles from all parts of the Mughal empire into the Deccani cultural orbit. Conversely, at the beginning of the reign of 'Ali 'Adil Shah II (1656–72), when Mughal bluster turned into a real military threat, the underlying decorative conception of form in Bijapuri art reasserted itself once more.

This portrait of 'Ali 'Adil Shah II holding a falcon represents this last stage of Bijapuri art. The eyebrow, rising in a high arc from near the bridge of the nose to the very edge of the swept-back eye, is the most obvious of the many figural abstractions. This feature occurs in every portrait of this ruler, but here it completely dominates the face, for the hitherto long straight nose has become a hooked extension of the eyebrow. In other portraits, this figure's massive shoulder is distinguished from his powerful arm by a change in dress or tone; here, the artist exaggerates that discontinuity, hardening the rumpled brownish cloth encasing the arm so that the limb has all the pliancy of a cornucopia. Likewise, the hand that rests on the large black shield is bent downward at an impossible angle, an effect fostered not by an inability to render anatomy accurately, but by a willingness to subordinate prosaic physical description to the aesthetic appeal of an abstract reflex curve. Indeed, so far removed is this portrait from being a careful visual record of an individual at a specific time and place that the very pose of holding a falcon appears to have been arbitrary. A pentimento visible between 'Ali's right arm and body indicates that a thinner right arm was formerly upright and very near to the body. To hold a bird of prey so close to one's face would be both practically and visually undesirable, so the artist must have originally intended to have the Bijapuri ruler tender a fragrant flower instead. Once he altered the gesture and attribute, he had ample room to endow 'Ali with a solid gold nimbus, a form almost never seen in Bijapur painting.

The oval nimbus insulates 'Ali 'Adil Shah II from a strange environment. The space immediately around him is an abstract field of gray, its ostensible uniformity marred by rather scrubby brushwork and modern abrasion. The dark green mound on which 'Ali stands caps a compressed foreground in which waterfowl alternate with rocks of similar size and color. When the landscape resumes after the long gray hiatus, it begins and ends abruptly, terminating in a cluster of solid trees on one side and an upswept outcrop of brightly colored rocks on the other. Beyond this is a sky whose three discrete bands of color are disturbed only by the graceful arcs of willows and a pair of birds performing aerial tricks. JS

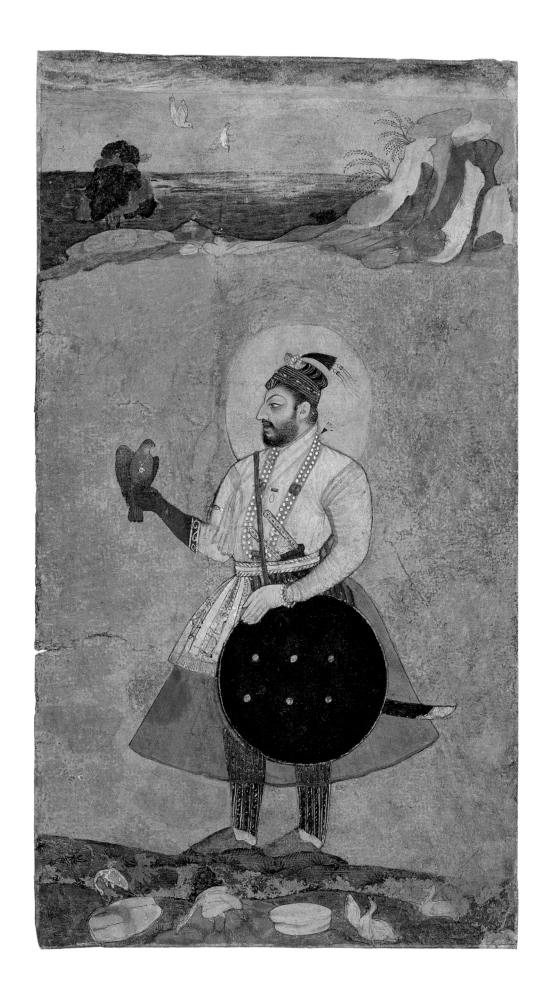

41. A Balsam Plant

Deccan, c. 1660–80
Opaque watercolor and gold on paper
11 7/8 x 7 1/8 inches (30.1 x 18.2 cm)

Flowering plants and the gardens they adorn are potent metaphors in Islamic culture. To the mystic, they represent the realization of perfection, and thus are inevitably likened to the spiritual state of grace. To the artist, they evoke notions of the splendors of paradise too, but the marvelous beauty of their forms is savored rather more indulgently. Their order and ephemerality may ultimately provoke intellectual musings, but their color and pattern never fail to satisfy a human desire for sensory pleasure. Recognizing intuitively that flowers function effectively at both these levels, artists everywhere in the Islamic world have covered all kinds of architectural surfaces, textiles, and luxury objects with floral imagery, extending the natural beauty of the garden into the furthest reaches of the man-made environment.

In Islamic painting, flowers overlay even the most unlikely settings, such as the blood-spattered ground in scenes of battle. In most cases, they are small in size and generic in form, and are used simply to brighten large expanses of an uptilted landscape. In the foregrounds of some seventeenth-century Mughal and Deccani portraits, they are reduced to a miniaturistic scale, a device that simultaneously aggrandizes the figure and makes the ground below appear to recede dramatically into the distance; in other Deccani works, they assume outlandish proportions, rising knee-high on visionary figures who inhabit a magical world.

Rather different in intent are Mughal and Deccani paintings of individual flowering plants, in which the features of a particular botanical specimen are recorded. This nominally scientific interest in flora was spurred by the emperor Jahangir, who, ever fascinated by the phenomena of the natural world, was so moved by the spectacle of the vale of Kashmir in the spring that he had his painter Mansur render more than a hundred examples of flowers. The artist's few surviving paintings of this type indicate that their format is modeled after European engraved herbals, examples of which were probably available in India even before 1620.[1] This format presents the flowering plants in large scale against a plain background; if a ground line exists at all, only rarely does it extend to the edge of the frame, thus isolating the flower in an abstract space.

This striking painting of a balsam plant *(Impatiens balsamina)* represents a later stage in the development of the floral portrait, which continued to enjoy favor at the Mughal court, throughout the Deccan, and at the Rajasthani court of Kishangarh. The seven brilliantly colored petals issue from the central stalk in an absolutely symmetrical manner, each shell-like blossom displaying exactly the same amount of red. This regularity is not a quality found in the plant itself or even in other Indian depictions of the balsam plant, but an expression of a strong preference for formal order.[2] The anonymous artist admits a hint of spatial complexity in the sawtooth leaves, several of which bend to reveal their undersides or pass over adjacent leaves, but controls their angle and length so that they form an exceedingly orderly shape around the blossoms. The strip of earth below the balsam plant is no less contrived, as an array of miniature plants sprouting at regular intervals rise just high enough from a series of interlocking mounds to break the horizon. This tidying impulse extends even to the heavens, where tightly coiled clouds creep methodically across a narrow band of orange sky.

Although Mughal and Deccani images of flowers share many characteristics, Mughal examples tend to be more three-dimensional and naturalistic. The stylized treatment of foreground and sky in this example points to a provenance in the Deccan. JS

1. See Robert Skelton, "A Decorative Motif in Mughal Art," in Pal 1972, pp. 151–52.
2. For an earlier and much less regular Deccani rendering of this plant, see Robert Skelton, "Indian Painting of the Mughal Period," in Robinson et al. 1976, no. V.99, color plate 40.

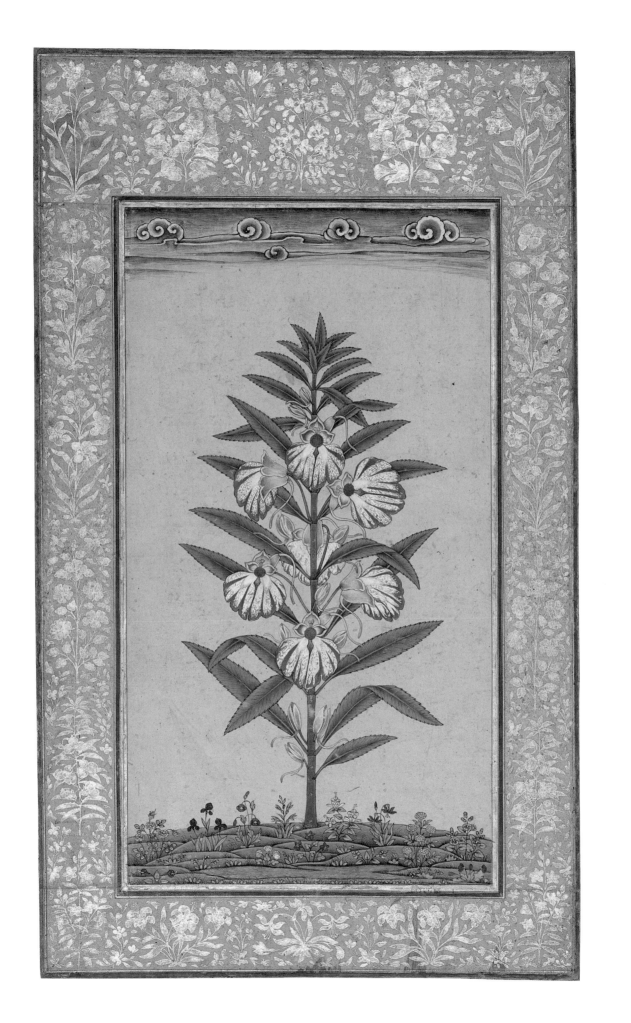

42. A Lady of the Court

Deccan, probably Hyderabad, c. 1700
Opaque watercolor and gold on paper
15 1/8 x 9 13/16 inches (39.4 x 24.9 cm)
Collection of Jennifer Bellak Barlow

This comely woman is one of a pair of courtesans who once locked gazes across the opening of an album.[1] Her counterpart, who is dressed in floral-patterned trousers, tenders a flower near her face, a gesture intended to liken its fragrance and perfect form to her own. This maiden plies a different inducement to love sport: a wine flask and cup. Both vessels are remarkably delicate and diminutive; indeed, the latter is no larger than a thimble, a ploy, perhaps, to whet rather than drown the desire of her unseen admirer.

The obvious appeal of such images of beautiful women made this type of painting one of the most common in all Indian painting. In most such images, an individual woman is shown standing in full-length view, occupying no more than a third of the compositional field. In another major variant, she is presented in bust-length format, sometimes with an architectural frame, with either flower or flask at the ready. The anonymous artist of this work reinvigorates this time-honored subject by fleshing out the entire compositional field with a full-length view of a seated woman.

This innovative formal solution has the advantage of keeping both head and torso prominent. Both are thoroughly idealized. As usual, the face is dominated by an elongated, leaf-shaped eye and a high, arching eyebrow. A long and perfectly straight nose is adorned by a dainty, pearled nose ring, while a tiny mouth and well-formed chin are defined by a crisp outline. With the skin smoothed and the jawline omitted, the head becomes a study of two-dimensional shapes, from the sweeping curves of the mass of black hair

and *dupatta* (scarf) edge to the circular hair ornaments and undulating wisps of hair.

The body is no less of an abstraction. Exceptionally broad shoulders and full breasts taper to a narrow waist, which is accentuated by a plunging garland and framed by the woman's cascading hair and striped *dupatta*. Hips and legs are released from anatomical considerations and are subordinated to great rhythmic curves. Only the foot does not conform easily to this rhythmic interest, a fact that leads the artist to sheathe it almost completely with a skirt end in this painting and to pass over it altogether in the companion work.

Although the artist uses sweeping curves and a bright yellow background to fashion simplified shapes into a compact body, he also delights in linear play. The most striking example of this is the network of major and minor folds running across the woman's lower garment. All folds radiate from a point between the woman's abdomen and thigh, which is cleverly obscured by the dense green cuff bracelet. This same interest in linear rhythms continues in the multiple necklaces and lightly striped *dupatta*.

The calligraphy on the reverse (see Appendix) is a specimen of an interesting type of writing known in Turkish as Karalama (blackening). While some versions of this form of calligraphy are purely practice exercises, others are intended to produce a particular formal order. A calligrapher first chooses random Arabic phrases and words for their interesting ligatures, and then attempts to fill the page as fully and harmoniously as possible, ever striving for complex lateral rhythms within a line as well as vertical tension between lines.[2] To maximize the possibilities of

such connections, he may manipulate at will the orientation of successive lines of writing. In this case, for example, the writer has inverted the first and fourth lines so that their vertical elements project deeply into the space above predominantly horizontal letters or around a single vertical one. The most flamboyant instances of such calculated interlocking are the three examples of the *lam-alif* (the letters *L* and *A)* combination, whose complementary diagonals are normally joined in a loop along the baseline. In lines one and four, the conjoined letters are suspended like calipers above portions of the words of the following lines; in one case (in the proper upper right when the page is viewed with the script oriented normally), the diagonal is extended by another *lam-alif* combination and a following vertical from two words two lines below.

The script selected for this work, Thuluth, was particularly popular in Turkey, but it also found favor in eastern Islamic lands as well, especially the Deccan, which had strong cultural connections with the Ottoman Empire. The occurrence of this specimen in a Deccani album, together with its sometimes faltering control of the Arabic language, suggests that the calligrapher, too, came from the Deccan. JS

PUBLISHED: Kramrisch 1986, pp. 37, 162, no. 32

1. Cincinnati Art Museum, 1991.139; see Ellen S. Smart and Daniel S. Walker, *Pride of the Princes: Indian Art of the Mughal Era in the Cincinnati Art Museum* (Cincinnati: Cincinnati Art Museum, 1985), pp. 47–48, no. 25.
2. I am indebted to Dr. Irvin Cemil Schick and Mr. András Riedlmayer for this information.

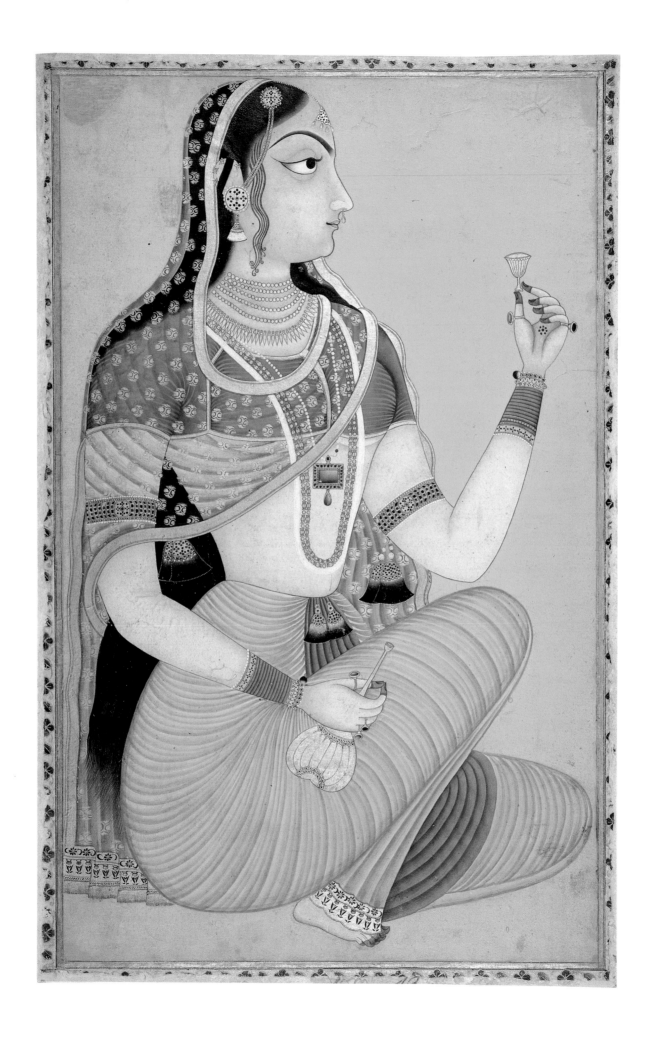

43. *A Nobleman Returns to the Hunt*

Northern Deccan, c. 1680 (mounted on an eighteenth-century Deccani album page)
Opaque watercolor and gold on paper
13 x 8 7/16 inches (33 x 21.4 cm)

Beside the shore of a lotus-clogged lake, a Persian nobleman mounts his horse. Two servants on foot occupy the empty spaces to the right and left. The smaller attendant is restraining two remarkably aggressive dogs, who snarl and lurch forward like beasts from hell. The larger attendant stands at a safe distance, to steady the reins of the nervous horse. At the top of the page, loosely brushed streaks of red and blue indicate the time of day: this scene takes place in the late afternoon. The nobleman and his attendants have paused to retrieve the quarry their falcon has killed. Once the nobleman has remounted, the hunt will resume.

From the style of his loosely tied turban, we know the central figure is a native of Persia, the homeland of legendary hunters like Rustam (see cat. 14) and Bahram Gur. In a traditional hunt scene, he would ride on horseback or stand on foot. To be shown in the prosaic action that is depicted here, however, lessens his status and dignity. The kennel boy is Indian, and wears the closely tied, late seventeenth-century turban that is distinctive to the Deccan.[1] But the more important attendant is also Persian, and quite a dandy, wearing the soft, fur-lined cap of a Persian page boy, and the high-fronted, swallow-tailed coat of a Persian groom.[2] He also wears a diaphanous overshirt and a pair of boots laced with enormous pompoms. These final, "over-the-top" embellishments are important clues to meaning, for in this quietly subversive picture, the Persians are being mocked for their inappropriate behavior and outlandish dress.

When compared to other Deccani paintings of this date (see cat. 40), this picture has an intensity of color and line that is remarkable. The compositional format, oversize flowers, and leaf-and-tendril arabesque suggest the influence of Golkonda, where a sophisticated style of Islamic court painting flourished until 1687, when the city fell to the Mughals.[3] But the warm palette—orange, yellow, and brown—differs substantially from the cool colors typical of Golkonda taste. Also, the blunt, overcharged line lacks the calligraphic niceties of contour that are equally typical of Golkonda. As the satire is closer to a Hindu-Rajput point of view than a Muslim-Deccani one, the place of origin is probably the northern Deccan, where Rajput influence was always very strong. Aurangabad, the principal city of the region, is in fact closer geographically to Rajasthan than to Golkonda. There are many late seventeenth-century paintings in a similarly mixed Rajput-Deccani idiom.[4] A surprising number are notable for their humorous or satirical depiction of human folly.[5] TM

1. For another example, see Zebrowski 1983, p. 210, fig. 181.
2. For the page boy's cap, see Sheila R. Canby, *The Rebellious Reformer: The Drawings and Paintings of Riza-yi Abbasi of Isfahan* (London: Azimuth Editions, 1996), cat. 39, fig. 22. For the same coat, see Ivan Stchoukine, *Les Peintures des manuscrits de Shāh ʿAbbās Iᵉʳ à la fin des Safavīs* (Paris: Librairie Orientaliste Paul Geuthner, 1964), plates I, LVII, LXIV; and Anthony Welch, *Shah ʿAbbas and the Arts of Isfahan* (New York: Asia Society, 1973), p. 53, no. 40.
3. The reverse is inscribed with Nastaʿliq calligraphy signed by Muhammad ʿImad al-Din (see Appendix).
4. For an example, in the collection of Ismail Merchant, New York, see Welch 1973, pp. 134–35, no. 80; and Zebrowski 1983, p. 233, fig. 205.
5. See Welch 1994, pp. 92–96, figs. 12–15.

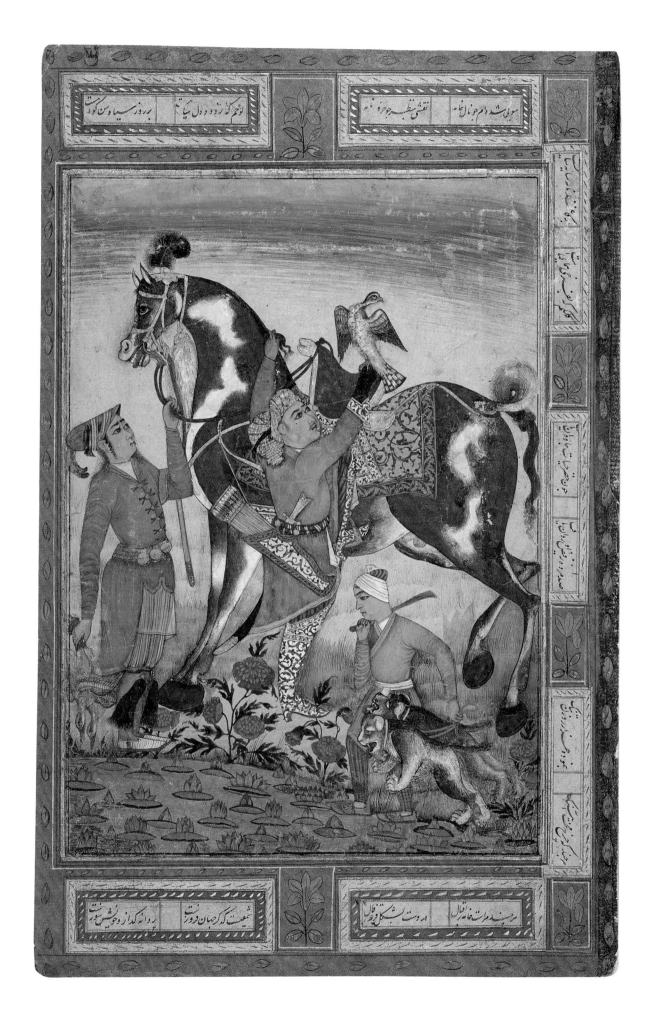

44. *The Piebald Stallion Sadaji and His Groom*

Attributed to Wajid
Rajasthan, Isarda, c. 1685
Opaque watercolor and gold on paper
8 15/16 x 15 3/16 inches (22.7 x 38.5 cm)

A powerful, frisky beast, Sadaji fills the painting with energy, looking out at the viewer with a wary eye. The prancing hoof and great curves of his neck and haunches convey his enormous power. His stiff front legs reveal a slightly obstinate character. He wears gold trappings and a dark green and red blanket with saucy red and gold tassels at the corners. The tiny groom grasps the stallion's lead with both hands, but he seems unable to control the huge animal as his hooves dance into the red border. An inscription on the reverse identifies the animal as a "multicolored stallion [named] Sadaji" (see Appendix). A second inscription, rendered faint by a layer of paper applied to the painting to arrest disintegration and add strength, may give the name of the artist Wajid.

Between 1680 and 1700 Wajid painted at the small court of Isarda, a *thikana*, or dependent state, of Amber.[1] The painting was probably one of a series of portraits of the horses in the Isarda stud. Judging from such "Mughal" features of his work as floral decorative motifs, Wajid appears to have been trained at Amber, where the painting studio had very close ties to the imperial Mughal workshops.[2] When Amber fell into a decline after the death of Mirza Raja Jai Singh in 1667,[3] Wajid apparently migrated to Isarda, where he then had a very productive career for three decades. That Wajid's paintings are inscribed with the names of his subjects and with his name made it possible for Indar Pasricha to identify Wajid with

Isarda, to determine his approximate dates, and to describe the characteristics of his work.[4]

Pasricha notes a specific arabesque textile pattern in either white on brown or white on white as being characteristic of Wajid's paintings from his time at Isarda.[5] The blanket on the stallion Sadaji has this same arabesque pattern in gold on dark green. The blanket has a red border with the quintessential Mughal decorative motif of formal flowers, cypress trees, and scudding Chinese clouds that betrays the Isarda connection to the Mughal court through Amber.

Blankets similar to that on Sadaji are to be seen on a somewhat earlier portrait of a white stallion, which, like the Bellak portrait, has ragged edges and has been backed,[6] and on the black horse illustrated by Pasricha.[7] The stallion in the third horse portrait, ascribed to Wajid,[8] has a different type of blanket, but shares with the other two an unusual, finely braided mane with each strand, including several over the horses' faces, ending in three bells or flowers. This treatment of a mane is also seen in an ascribed Wajid painting of two Isarda princes riding.[9] All of Wajid's known paintings are relatively large, and all that still have borders or traces of borders have the quite fat black line at the join of the red border and ground of the image.

The Bellak portrait of Sadaji thus shares characteristics of paintings ascribed to Wajid and other characteristics of paintings identified by inscription

as being from Isarda. Nevertheless, unlike any of the horses in other Isarda paintings, Sadaji sports a collar with gold bells around his chest. That Sadaji is so large compared to his groom is an indication of his importance, as is the amount of gold in his bells, bridle, and blanket. Sadaji was an important animal.

The tradition of making portraits of favorite animals at court derives in India from Mughal painting, where we find images not only of elephants and horses, but of other animals and birds as well. Used for transport and for waging battles, horses and elephants were essential rather than merely decorative status symbols. At Isarda, as elsewhere in the subcontinent, artists painted the raja's best horses with the servants who tended them, and inscriptions identified the subjects (see cats. 45, 89). It is somehow touching to find these animals held in such high regard that court artists portrayed them, exaggerating their size and meticulously painting braids and blankets. ES

1. Amber, or Amer, became Jaipur in 1723.
2. See Glynn and Smart 1997.
3. Pasricha 1982, p. 259.
4. Ibid., passim.
5. Ibid., p. 265 ff.
6. Sotheby's, London, April 4, 1978, lot 319.
7. Pasricha 1982, fig. 8.
8. Kramrisch 1986, p. 88, no. 81.
9. Pasricha 1982, fig. 7.

45. The Stallion Kitab

Attributed to Bhavanidas
Rajasthan, Kishangarh, c. 1735
Transparent and opaque watercolor and gold on paper
10 1/8 x 13 3/16 inches (25.7 x 33.5 cm)

Indian painting was greatly changed by the Safavid sensibilities and training of the sixteenth-century Iranian master artists directing the work of the indigenous artists at Akbar's court as the Mughal style of painting was formed (see cat. 13). With the succession of Mughal emperors, whose tastes and needs in painting varied, artists left the imperial court and moved to provincial ones, bringing their imperial Mughal style and conventions of painting to the provinces. The evidence of this "ripple effect" has been known for some time from the actual paintings from the Mughal court and others from such Rajput courts as Marwar, Bikaner, and Amber/Jaipur. Some Rajput paintings are in fact so close to Mughal pictures in style and subject that they have been understood to be Mughal.[1] However, in the case of the artist Bhavanidas, who made this portrait of one of the stallions in the Kishangarh stud, his migration from the center to a smaller court is documented.[2]

In 1719 Bhavanidas came from the Mughal court at Delhi to Kishangarh to work at the court of Raj Singh (reigned 1706–48).[3] Like the rest of the Rajput nobility, as a servant of the Mughals, Raj Singh had spent time at the Mughal court partaking in the political and cultural life. His blood tie to the imperial family was through his sister (some sources say aunt), who was the wife of the emperor Bahadur Shah I and the mother of the heir apparent Prince Muhammad Azim ush Shan. It is perhaps significant that of Bhavanidas's Mughal paintings, that is, the paintings he executed before leaving the Mughal court, three out of four appear to include or feature Azim ush Shan.[4] Prince Azim ush Shan died in 1712 during the fratricidal war of succession after the death of Bahadur Shah I.

Whether Bhavanidas had been in some way connected to the Kishangarh court before 1719 is un-known. His paintings of the heir apparent, son of a Kishangarh princess, may be an unrepresentational sample of his complete output. Raj Singh brought Bhavanidas to Kishangarh, where his Mughal-trained hand had a tremendous influence on the development of Kishangarh court painting. At 90 rupees per month, he was the most highly paid employee of the court.[5]

Bhavanidas's painting of the stallion Kitab is one of the last in his series of equine portraits, and the most strikingly elegant.[6] The great beast catches the viewer's eye with his vivid colors and voluptuous curves. His ghostly attendants, though deftly drawn, are given only faint washes of color and literally pale in comparison to their charge. The four *syces*, or grooms, tend the huge beast, two waving *morchals* (sheaves of peacock feathers bound with handles), usually associated with royalty,[7] one holding the reins in one hand and a cloth in the other, and the fourth raising a smoking incense burner to the horse's rearing head. The incense burner, upraised *morchals,* and cloth are seen in a painting in the collection of Sven Gahlin as well, suggesting that these items were used in a ceremony performed with the Kishangarh horses.[8] The orange-red color on Kitab's legs and lower body and tail is a common decoration on horses in Kishangarh paintings, and must reflect an actual practice of applying color to the animals.

Bhavanidas's Mughal training is manifest in the elegant lines of the drawing of the figures and in the deft portraits of the grooms. The choice of subject derives from Mughal painting, and before that Safavid painting. But the exquisite depiction of the stallion's head and mane and the extravagant outlines of his body are Bhavanidas's own. ES

PUBLISHED: Kramrisch 1986, pp. 81, 173, no. 74

1. For a painting from Amber long thought to be Mughal, see Glynn and Smart 1997, fig. 1. The painting is now in the Los Angeles County Museum of Art, M.80.6.6.
2. I am greatly indebted to Navina Najat Haidar for sharing with me her forthcoming article "A Mughal Artist at a Rajput Court: The Role of Bhavanidas in the Development of the Kishangarh School of Painting," in which she attributes this painting to Bhavanidas on the basis of similar signed paintings of the same horse. The article is based on research for her doctoral thesis, "The Kishangarh School of Painting, c. 1680–1850," Oxford University, 1995.
3. Randhawa and Randhawa 1980, p. 11.
4. See *A Visual Genealogy of the Mughal Emperors*, c. 1700, in which Azim ush Shan does not appear (Nour Collection, London; Linda Leach, "The Timurids as a Symbol for Emperor Jahangir," in Canby 1994, p. 88, plate 6); *Six Princes on a Terrace*, signed by Bhavanidas, c. 1705, in which Azim ush Shan is in green at the lower left (San Diego Museum of Art, 1990:365; Pratapaditya Pal et al., *Romance of the Taj Mahal* [New York: Thames and Hudson, 1989], p. 26, color plate 17); *Aurangzeb Receives Bahadur Shah*, c. 1705, in which Azim ush Shan may be the prince seated beside his grandfather (Chester Beatty Library, Dublin, 4.7; Leach 1995, vol. 1, color plate 74); and *Bahadur Shah Receives a Sarpech from Prince Azim ush Shan*, c. 1710 (Sotheby's, London, October 15, 1997, lot 65 [color]).
5. Randhawa and Randhawa 1980, p. 11.
6. This painting is inscribed on the reverse, "Kitab, the wonderful Iranian [stallion], aglow with nine splendors" (transliterated it reads, "*kitaab iran achambha daaha Nau angrang*"). Although obscure, the inscription has been read using as a model the inscription on another horse painting by Bhavanidas, *Piebald Stallion Named Jukaldan Iraqi*, c. 1730, collection of Michael and Henrietta Spink, London (Sotheby's, New York, June 2, 1992, lot 149; Falk 1992). For other equine portraits by Bhavanidas, see two views of the same stallion on either side of one page, c. 1725, formerly in the Heeramaneck Collection (Alice N. Heeramaneck, *Masterpieces of Indian Painting from the Former Collections of Nasli M. Heeramaneck* [N.p.: Alice N. Heeramaneck, 1984], plates 74, 75; Sotheby's, New York, November 2, 1988, lot 47 [both]); *Brown Stallion with Four Attendants*, c. 1735, collection of Sven Gahlin (Sotheby's, London, October 12, 1990, lot 55); and *Horse and Two Attendants*, c. 1735 (Falk 1992, fig. 2 [detail]).
7. For similar *morchals* see the Beatty painting cited in n. 4 above.
8. Cited in n. 6 above.

46. *Swami Hanuhaak*

Ascribed to Nihalchand
Rajasthan, Kishangarh, c. 1755
Transparent and opaque watercolor, ink, and gold on paper
10 9/16 x 7 3/8 inches (27.3 x 18.7 cm)

Nihalchand, otherwise famous for his delicate, precise paintings of the Krishna legends and of other lovers,[1] apparently joined Bhavanidas (see cat. 45) in the rollicking good fun of making satirical paintings at the Kishangarh court. Navina Najat Haidar has recently documented a group of sometimes wickedly witty pictures that ridicule girth, pomposity, and occupations ranging from those at the court to those at the bazaar.[2] Clues to eighteenth-century Kishangarh humor are found in the often-cryptic inscriptions, as is the case with this painting. The inscriptions here say that the subject is Swami Hanuhaak and that the painting was made by Nihalchand (see Appendix).

The swami stands on his wooden sandals, wearing a short, orange wrap around his hips, a white cummerbund into which a long sword is tucked, two necklaces, and an amazing peacock-feather crown.[3] His body is smeared gray with ashes, except for his forehead and cheeks, which are painted red. His huge belly protrudes so far beyond his body that most of his right arm is hidden, but his navel is just visible above his sash. He holds a set of bells in his right hand, which, with the bell hanging at his ear from the rim of the crown, suggests that the swami was a mendicant storyteller or singer. Such storytellers still ply their trade in India, going from village to village, belting out their tales, and accompanying themselves with shakers, bells, or drums. Such an occupation requires a loud voice, considerable stamina, and a fearless sense of style.

The swami's appellation, Hanuhaak, can mean several things. *Hanu* is "jaw," "jawbone," or "chin," but it also means "armed." *Haak* means "great shout," "call," or "din," but it also means "collard greens." In translation in the twenty-first century the hilarity is perhaps somewhat diminished, but there he stands, an armed swami with a jaw like a collard leaf, shouting out his stories. Another example of "vegetable satire" can be found in the inscriptions in a painting from either the Deccan or Kishangarh, in which at least two players have vegetable names.[4]

In the satirical paintings described and published by Haidar, the corpulent figures are most often those being lampooned.[5] Here, Swami Hanuhaak's curved sword complements and echoes the curves of his monstrous belly and arm. As the viewer's eye takes in the figure from feet to head, the ever-widening legs below and lack of neck above reinforce the solid mass of his upper body. The huge headdress with its straight sides draws the eye to his belly and emphasizes its roundness. Yet even with the mockery made of Swami Hanuhaak, he still looks a nice enough, dignified man. ES

PUBLISHED: McInerney and Hodgkin 1983, no. 13

1. See, for example, Randhawa and Randhawa 1980, p. 18, plate III; p. 26, plate VII; and Kossak 1997, p. 95, no. 56.
2. Haidar 2000, pp. 78–91.
3. Similar peacock headgear is worn today by the tribal Bhils in Gujarat when they come into town during Holi celebrations.
4. I thank Navina Haidar for telling me about this painting, *Twenty Strange People and a Bewildered Dog* (Welch 1994, p. 94, fig. 13). *Tindu* and *Bhindu*, or "Squash" and "Okra," are clearly written above the figures at the upper left.
5. Haidar 2000, plates 2, 3, 5, 7–10.

47. *Muhammad Ibrahim, the Khan Alam*

Rajasthan, Mughal style at Kishangarh, c. 1700
Transparent and opaque watercolor, gold, and silver-colored paint on paper
16 3/4 x 9 13/16 inches (42.5 x 25 cm)

Muhammad Ibrahim, entitled Khan Alam (Lord of the World) and later Ghairath Khan (Lord of Courage), stands on a high parapet, framed by a bird's-eye view of his marching army. The deep green of the distant landscape, and the bright red of Muhammad Ibrahim's turban and sheath, accent the whitened paleness of the surrounding color. For all practical purposes, this painting is really a colored drawing. The entire surface is covered with paint, but the eye focuses on its carefully drawn outlines.

Muhammad Ibrahim was a senior officer of state during the reign of the Mughal emperor Aurangzeb (1658–1707), also known as 'Alamgir. A Persian inscription along the top of the painting states that he led the vanguard of troops against Prince Dara Shikoh (1615–1659), Aurangzeb's elder brother.[1] The siblings fought two great battles to determine the succession to the Mughal throne: the first took place at Samugarh, eight miles east of Dholpur, in 1658; the second at Deorai, four miles south of Ajmer, in 1659. The inscription must refer to the battle of 1658, since Muhammad Ibrahim would not have led the troops in the 1659 battle, when he was described as being "attached to [Aurangzeb's] stirrups," that is, kept near to the emperor's person.[2]

Following the battle of 1658, Muhammad Ibrahim was awarded the title Khan Alam and elevated to a high rank. In the third year of Aurangzeb's reign (1661–62), he was awarded a new title, Ghairath Khan, and reconfirmed in his already lofty standing. In the next decades he fought with Prince Muhammad Muazzam (1643–1712), Aurangzeb's second son, in the Deccan, and served as *fawjdar* (military superintendent) at Jaunpur in the Gangetic plains.

This portrait commemorates the years Muhammad Ibrahim spent in Rajasthan, that is, the period 1680–81, when he became a hero to the Rajputs and a villain to the Mughals. Muhammad Ibrahim went to Rajasthan with Prince Akbar (1657–1707),

Aurangzeb's fourth son. They had been sent to subdue the rulers of Marwar and Mewar, but ended up joining with the rebels to wage war on Aurangzeb. On the evening before a critical battle, when the suddenly suspicious Rajputs abandoned the field, Aurangzeb's triumph was ensured. On the following day Prince Akbar was driven to the far corners of India; the Rajputs were pursued with redoubled fury; and Muhammad Ibrahim was captured and thrown into prison, where he remained for some twenty years.[3]

Muhammad Ibrahim's turncoat defiance of Aurangzeb did little to affect the ultimate outcome of the Mughal-Rajput wars. But it made him a hero in Rajasthan. In this aggrandizing portrait, the eye focuses not on Muhammad Ibrahim's ageless features, but on his curiously youthful torso and leaf-like hands. His body has an oversize largeness that mocks the bird's-eye smallness of the soldiers and elephants in the distant background. Masterfully depicted in aerial perspective, the background army marches to Muhammad Ibrahim's sole command.

Another painting by this same artist can be identified: a stately head-and-shoulders portrait of Prince Azim ush shan (1664–1712), the son of Prince Muhammad Muazzam.[4] Both paintings have carefully balanced compositions and firmly drawn outlines, but their color is so thinly applied it fails to conceal the numerous pentimenti, or corrections to the underdrawing, that are visible beneath the painted surface.[5] (Note the ghostly smudge to the right of Muhammad Ibrahim's face and the penumbra of lines around his hands.)

The two paintings are closely related in figure drawing, palette, and scale, but differ in date. As Azim ush shan is framed by an imperial halo, his portrait must postdate 1712. (He declared himself emperor in 1712, but was killed the same year.) The portrait of Muhammad Ibrahim is less typical of the Kishangarh style, suggesting an earlier stage in the artist's development, a period when his understanding of format and space was more firmly rooted in Mughal aesthetics. This, together with the faultlessly painted background vista, suggests a date of c. 1700.

Both paintings portray Mughal grandees with important Kishangarh connections. Muhammad Ibrahim was the champion of the Rathor clan, to which the Kishangarh royal house belonged. Azim ush shan was the son of a Kishangarh princess, and the nephew and cousin of two Kishangarh rulers: Man Singh (reigned 1658–1706) and Raj Singh (reigned 1706–48), respectively. According to legend, Raj Singh carried Azim ush shan's corpse to Kishangarh for burial.[6] As both paintings are roughly equal in size, and closely related in subject, they might have been painted for the same family album. TM

1. The painting is inscribed as follows: in Persian along the top, "A painting of Khan Alam, the son of Najabat Khan, who led the vanguard of 'Alamgir's army in the battle against Dara Shikoh"; in Rajasthani along the top, "A painting of Khan Alam, the son of Najabat Khan"; in Persian on the reverse, "Son of Najabat Khan, [who] fought in the war of succession." I am grateful to B. N. Goswamy for this translation.
2. Nawwab Samsam-ud-Daula Shah Nawaz Khan and 'Abdul Hayy, *The Maathir-ul-Umara,* 2nd ed., trans. H. Beveridge, ed. Baini Prashad (Patna: Janaki Prakashan, 1979), vol. 1, p. 578. For an account of Muhammad Ibrahim's life, see ibid., pp. 577–79.
3. He was released in the forty-third year of Aurangzeb's reign (1699–1700) and sent to his old post in Jaunpur. He was still alive in the year 1706, but the date of his death is unrecorded. See Saqi Must'ad Khan, *Maāsir-i-'Ālamgiri: A History of the Emperor Aurangzib-'Ālamgir (Reign 1658–1707 A.D.),* trans. Jadunath Sarkar (Calcutta: Royal Asiatic Society of Bengal, 1947), pp. 246, 305.
4. Both paintings have a known Kishangarh provenance. For the portrait of Azim ush shan, see Toby Falk and Simon Digby, *Paintings from Mughal India* (London: Colnaghi, 1979), pp. 68–69, no. 32.
5. For another Kishangarh painting, or colored drawing, with the same type of surface, now in the Harvard University Art Museums, Cambridge, see Welch 1994, p. 97, fig. 16.
6. William Irvine, *Later Mughals* (New Delhi: Oriental Books Reprint Corporation, 1971), vol. 1, p. 177.

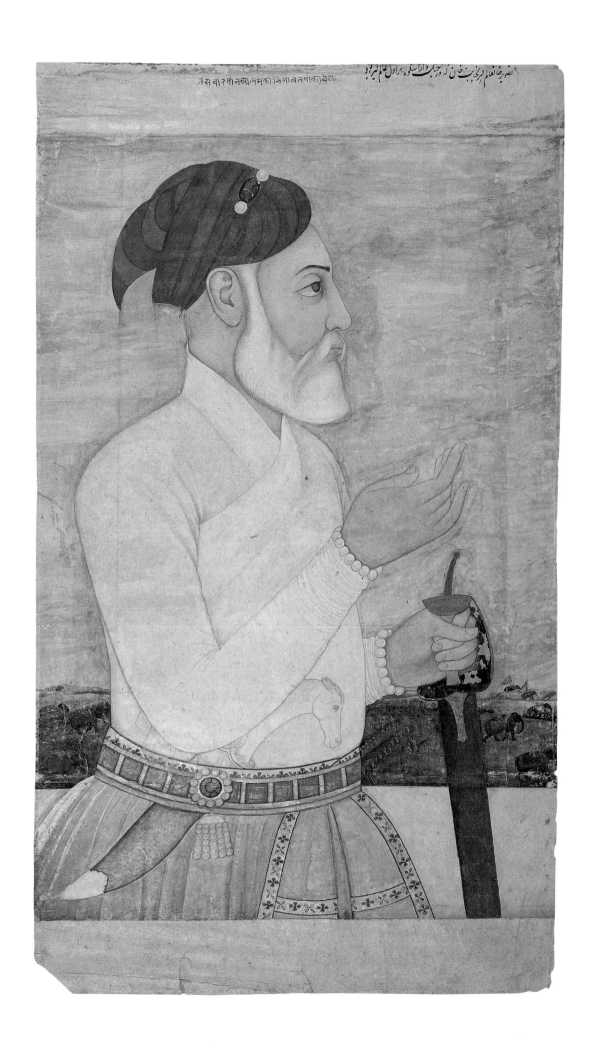

48. Prince Pratap Singh of Ghanerao

Rajasthan, Marwar, Ghanerao, c. 1710
Opaque watercolor, gold, and silver-colored paint on paper
11 1/2 x 9 11/16 inches (29.2 x 24.6 cm)

Prince Pratap Singh of Ghanerao (reigned 1714–20) is relaxing in an elegant, formally planted garden, attended by two ladies from his harem.[1] Seated on an embroidered summer carpet and supported by a fat bolster, the prince is holding the snaking pipe of a *huqqa* in one hand, while reaching for a tiny cup of wine with the other. These actions barely affect the quality of the stillness that permeates this exquisitely understated picture. Nothing ripples its surface: each object has its appointed place in the overall design. The foreground is not just a garden, but also a Mondrian-like arrangement of rectangles and squares.

Only one other securely identifiable portrait of Pratap Singh has come to light: a stately and finely executed audience scene *(darbar)* dating from c. 1715–20 in the Harvard University Art Museums in Cambridge.[2] Painted by the same fine artist, the Harvard portrait makes use of a similar foreground and a similar white, green, and buttercup-yellow palette. But there are eight attending figures in the picture rather than two, and the attending figures are not harem girls, but actual courtiers.

In the years 1700–1725, this same nameless painter worked not just at Ghanerao, but elsewhere in Marwar. It would appear that he did not have a permanent base of operation, but wandered from one town to the next, as portraits of three of Pratap Singh's neighbors can also be attributed to his hand.[3] To judge by his naturalistic drawing style and use of color, he was almost certainly a Mughal, or Mughal-Deccani, trained painter. This was not an unusual

distinction, as a number of Mughal-trained painters had worked in Marwar during the reign of Maharaja Jaswant Singh (1638–78).[4]

They disappeared from the local scene in the troubled years that followed the maharaja's death, but reappeared once conditions in Marwar returned to normal. During the years 1700–1750, Mughal-trained painters worked for maharajas Ajit Singh (reigned 1707–24) and Abhai Singh (reigned 1724–49), and for a number of Marwar's leading noblemen, including Pratap Singh of Ghanerao.[5] Their great influence was not entirely beneficial, as it undermined the prestige of locally trained painters, and stymied the development of a cohesive regional school. The Mughal tradition and the local style, with its rougher and more boldly colored approach to form, did eventually coalesce. But this development only occurred after the year 1750: of all the great traditions of Rajasthani court painting, Marwar's was the last to develop a trademark style of its own.

Situated on the border between Marwar and Mewar, Ghanerao is one of the twelve main *thikanas*, or fiefs, of Marwar state. The territory is small, yet "its rich and beautiful plains, well watered, well wooded, and abounding in fine towns," occupy the most fertile land in Marwar.[6] The imposing palace (seventeenth–nineteenth century) that still dominates the center of Ghanerao town testifies to the great wealth and regional power that the ruling family once enjoyed.

Thakur Pratap Singh initiated a tradition of patronage that flourished at Ghanerao for about 150 years. His successors Padam Singh (reigned 1720–42),

Viram Dev (reigned 1743–78), and Ajit Singh (reigned 1800–1856) were also patrons of painting who had a great fondness for being portrayed in *darbar* with other members of their clan.[7] But it is misleading to associate their patronage with a coherent program or local school, for the painters were employed on an ad hoc basis. Some were Marwar trained; others were not. Some tarried a decade or more at Ghanerao; others did not. During the years 1700–1750, this fitful, improvised circumstance gave Ghanerao painting the same heterogeneous appearance that characterizes Marwar painting as a whole.[8] TM

1. A Rajasthani inscription along the top border identifies the subject: "Prince Pratap Singh/Picture of Prince Pratap Singh."
2. 1995.120; see Crill 1999, p. 80, fig. 52. As the Harvard portrait is inscribed "Maharaja Pratap Singh," it must have been painted in the years 1714–20, when Pratap Singh was the ruler *(thakur)*, and not the heir apparent *(kumar)*, of Ghanerao. In the Harvard portrait his neck and body are thicker, and he looks a bit older. For another possible portrait of Pratap Singh painted by a Mewar-trained artist, see Crill 2000, p. 94, fig. 2. This painting is now in a private collection.
3. They are now in the collection of the late Sangram Singh of Nawalgarh (Crill 1999, p. 61, fig. 33); a private collection (ibid., p. 63, fig. 35); and the National Museum, New Delhi, 56.59/44 (R. C. Sharma et al., *Alamkara: 5000 Years of Indian Art* [Singapore: National Heritage Board, 1994], p. 103, no. 59).
4. Crill 1999, pp. 35–53.
5. Ibid., pp. 56–85. The greatest of these Mughal interlopers in Marwar was Dalchand, the son of Bhavanidas (active 1700–1740). See ibid., figs. 37–40.
6. Tod 1971, vol. 1, p. 547.
7. Crill 1999, pp. 81–83.
8. For further discussion of painting at Ghanerao, see Crill 2000, pp. 92–108.

49. A Mounted Marwari Bridegroom and Three Attendants

Rajasthan, Marwar, Jodhpur, c. 1715–20
Opaque watercolor, gold, and silver-colored paint on paper
12 13/16 x 8 13/16 inches (32.5 x 22.3 cm)

Astride a painted, beribboned white horse, an elegant Marwari aristocrat holds a *chhari* (a long stick covered with flowers arranged in stripes) and is accompanied by three footmen bearing a small bouquet, assorted weapons and shield, and a white vessel slung over a shoulder on a stick. The *chhari* reveals that the mounted man is newly married. He is on his way, four days after the wedding, to his bride's family's residence. There, after feasting, the couple will playfully beat each other with *chharis*. The turbans indicate that the men in the painting are from Jodhpur during the first quarter of the eighteenth century.[1] The method by which a turban is tied into its distinctive shape is specific to family, clan, court, religion, and/or ethnic group. The type of turban on the men in the painting—swept back, wrapped around the crown of the head with loops falling back into a snood-like roll—is seen only in paintings from the middle of the reign of Maharaja Ajit Singh (1707–24; see cat. 50).

However, the main figure is not Ajit Singh, as there are a number of contemporary inscribed paintings of him that look nothing like the Bellak gallant.[2]

Ajit Singh had a sharply hooked nose and a backward tilt to his head. From the amount of jewelry the man with the flower kebab wears, and from the quality of the painting, one can conclude that he is one of Ajit Singh's sons or brothers.

The painting is in the exquisite, finely worked Jodhpur style of Ajit Singh's reign, when Mughal influence was great, no doubt partly due to the migration of Mughal artists from the imperial workshop to the smaller courts (see cat. 45). The concept of equestrian portraiture derives from seventeenth-century imperial Mughal paintings, which often include clouds above and occasionally have no ground line.[3] The meticulous rendering of textile patterns, drape, and texture seen here also derives from Mughal painting. The Marwari artist of this painting has rendered the brocaded floral designs on the ends of the sashes so realistically that the type of weaving can be recognized as a triple-weave with a gold ground.[4] The yellow *jama* and the trousers of the nobleman are likewise printed with a cypress-tree pattern known from early eighteenth-century textiles.[5]

While the textiles, profiles, and skin tones are carefully observed and precisely rendered, the painting is quite flat, with shading applied only to model the jaws of men and beast, and to make the beast's left rear leg recede slightly. Some notion of space is created by the overlapping figures, but distance is conveyed only by the roiling black clouds. Because the edges of the Bellak painting are gone, one cannot tell if there was once a ground line. ES

1. For the same turban type, see Crill 1999, p. 78, fig. 50.
2. Ibid., figs. 29, 32, 34, and especially 36.
3. See, for instance, Raymond Head, *Catalogue of Paintings, Drawings, Engravings, and Busts in the Collection of the Royal Asiatic Society* (London: Royal Asiatic Society, 1991), p. 144, no. 053.001; plate XIX; and dust jacket; and Robinson et al. 1976, pp. 260–61, no. v.71, plate 128.
4. See Chandramani Singh, *Textiles and Costumes from the Maharaja Sawai Man Singh II Museum* (Jaipur: Maharaja Sawai Man Singh II Museum Trust, 1979), plate 35B; M. H. Kahlenberg, "A Study of the Development and Use of the Mughal *Patkā* (Sash) with Reference to the Los Angeles County Museum of Art Collection," in Pal 1972, pp. 153–66, especially plate XCIV.
5. For one example, see Mattiebelle Gittinger, *Master Dyers to the World: Technique and Trade in Early Indian Dyed Cotton Textiles* (Washington, D.C.: Textile Museum, 1982), p. 71, no. 60.

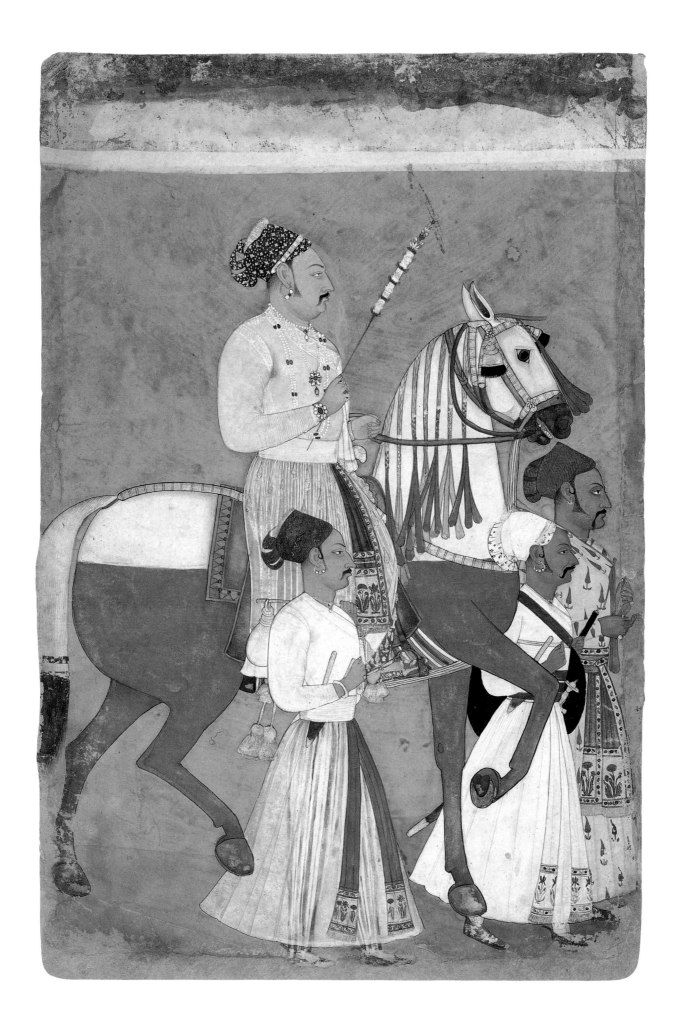

50. The Six Sons of Maharaja Ajit Singh of Jodhpur on a Visit

Rajasthan, Marwar, Jodhpur, c. 1720
Opaque watercolor and gold on paper
15 3/8 x 14 inches (39.1 x 35.6 cm)

Under an arched pavilion on a terrace, a luxuriantly mustached nobleman receives six young men. The smallest, who sits on his lap, is very young, for he wears a baby hat and plays with a flower. The other boys can be identified from a painting of Ajit Singh (reigned 1707–24) and five of his sons, inscribed with their names and the date 1721.[1] Although the paintings are by different artists, five of the boys wear the same clothing, jewelry, and turbans in both pictures, and their characteristic noses match as well. The headgear on the five is the type worn for celebrations and festivals such as Diwali, which is the subject of the 1721 painting. In that image, the boys are facing left, giving full view of the gold disks or pompoms on the upper left sides of their turbans. In the Bellak painting, where the sons face right, the gold disks are just visible over the turban tops.

The identification of the central figure is a puzzle. He also appears in a painting of a Rathor noble and his son visiting a holy man, but he is not identified by inscription.[2] His white turban is of the Marwari sort worn during Ajit Singh's reign, with the broad band wrapped to let folds appear to cascade out the back. The man's attendants to the right hold cloth-covered swords and a *morchal* (sheaf of peacock feathers, bound, with a handle), both of which are emblems of royalty. From his position in the painting, his attendants, and the fact that the youngest boy sits on his lap, one would expect him to be Maharaja Ajit Singh himself. He may be, his portrait rendered by a different artist and in a less formal pose than in other paintings of the ruler. Or he might be an uncle of the boys. Nevertheless, he is not, as a later inscription pasted on the reverse says, Jai Chand of Kanauj, a twelfth-century king and one of the mythical progenitors of the Rathors, the ruling clan of Marwar.

On the white terrace before the pavilion, two slightly older men sit facing each other. At the left, a third is seated, and three others are positioned behind him. The only men not dressed in white are the three musicians, who sing, clap, and play. At the right is a dovecote, from which the pigeons have been released to court, the males puffing up and ducking their heads and the females pretending not to notice, and to mate. A lone mynah, chained to his perch, observes the scene. A peacock dances to impress the white peahen in front of him, but she daintily ignores his advances. Or is she bowing to acknowledge his superior form and beauty? In the foreground, fifteen fountains squirt up from a sliver of the edge of a garden on this side of the terrace.[3] The central fountain divides the painting and points to the central figure (whomever he may be).

There is some particular event depicted in this painting, but what the event was may not ever become clear. Because peacocks dance in the summer, that may be the time of year. The courting and actual mating of the birds may refer to an engagement or wedding of one (or all) of the sons. Indeed, weddings are often held in the summer. The four men at the left, who are the only armed people in the painting, wear a slightly different turban type. Could they be members of a bride's family? The two men in the center are seated, an indication that they are not attendants but rather participants in the event. What were their roles? As more paintings and documents from Jodhpur come to light, these questions may be answered. ES

1. Harvard University Art Museums, Cambridge, 1995.131; Crill 1999, p. 62, fig. 34.
2. Private collection; ibid., p. 77, fig. 49.
3. For a similar fountain in a Marwari painting see ibid., p. 63, fig. 35.

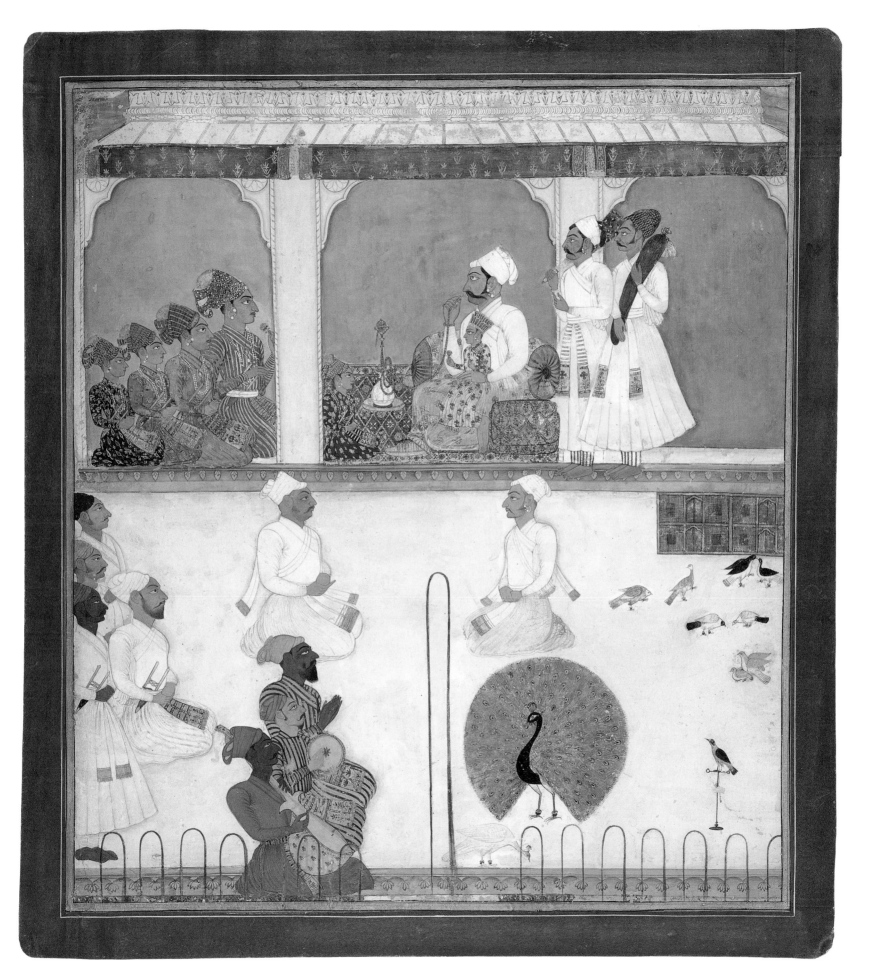

51. *Bakhat Singh Holds a Pink Rose*

Rajasthan, Marwar, Jodhpur, c. 1750
Opaque watercolor, ink, and gold on paper
14 x 11 3/4 inches (35.6 x 29.8 cm)

Bakhat Singh wears a pale pink, long-sleeved garment, decorated with green leafy sprigs, many gems and pearls, and a printed cotton turban worn in the style of Marwar. He commands an extraordinary mustache. A son of Maharaja Ajit Singh of Jodhpur, Bakhat Singh was born in 1706, murdered his father at the behest of an older brother in 1724, and ruled Nagaur (as a reward for the parricide) until he succeeded to the throne of Jodhpur in 1751.[1] James Tod, the English chronicler of eighteenth-century Rajasthan, reports that Bakhat Singh was poisoned the following year.[2]

In a portrait from about 1730, painted while he was at Nagaur, Bakhat Singh wears a similar set of jewelry and a similarly decorated *jama*, but he is gracefully thin.[3] As in the Bellak painting, he holds a rose and sports a mustache. In a painting made in about 1740, Bakhat Singh has gained a few more pounds, his heavy eyelids are more obvious, and his mustache has grown considerably.[4] A painting of Bakhat Singh that Rosemary Crill dates to 1751–52 shows the maharaja even stockier but with the same mustache as in the Bellak painting.[5]

Large-scale Mughal portraits that include the head and part of the shoulders of the subjects were first seen in the middle of the seventeenth century[6] and continued on into the eighteenth.[7] These Mughal paintings are normally drawings with touches of color and very finely executed details such as hair and textile patterns. One of the earliest Jodhpur adaptations of this type of portrait is a posthumous work from c. 1670 of the Bakhat Singh's great-grandfather Maharaja Gaj Singh (reigned 1619–38).[8] There the Jodhpur artist adapted the Mughal prototype, keeping the large size and format, but emphasizing outline and pattern, which resulted in a flatter, more stylized image. During the ensuing century, as Marwari artists continued to make these large portraits, they dispensed with shading almost completely. ES

1. Topsfield and Beach 1991, p. 72, no. 26.
2. Tod 1971a, vol. 2, p. 867.
3. Howard Hodgkin Collection; see Topsfield and Beach 1991, p. 73, no. 26.
4. Goenka Collection; see Topsfield and Beach 1991, p. 72, fig. 4; and Crill 1999, p. 92, fig. 67.
5. Private collection; see Crill 1999, p. 92, fig. 68.
6. For example, see the portrait of Iltifat Khan in the Howard Hodgkin Collection; 16 15/16 x 12 7/16 inches (43 x 31.6 cm); in Topsfield and Beach 1991, p. 45, no. 12.
7. For example, see Victoria and Albert Museum, London, I.M. 36-1922; 11 x 7 1/8 inches (28 x 18.1 cm); in Guy and Swallow 1990, p. 107, fig. 89.
8. National Museum, New Delhi, c. 1670; see Crill 1999, frontispiece; p. 41, fig. 19.

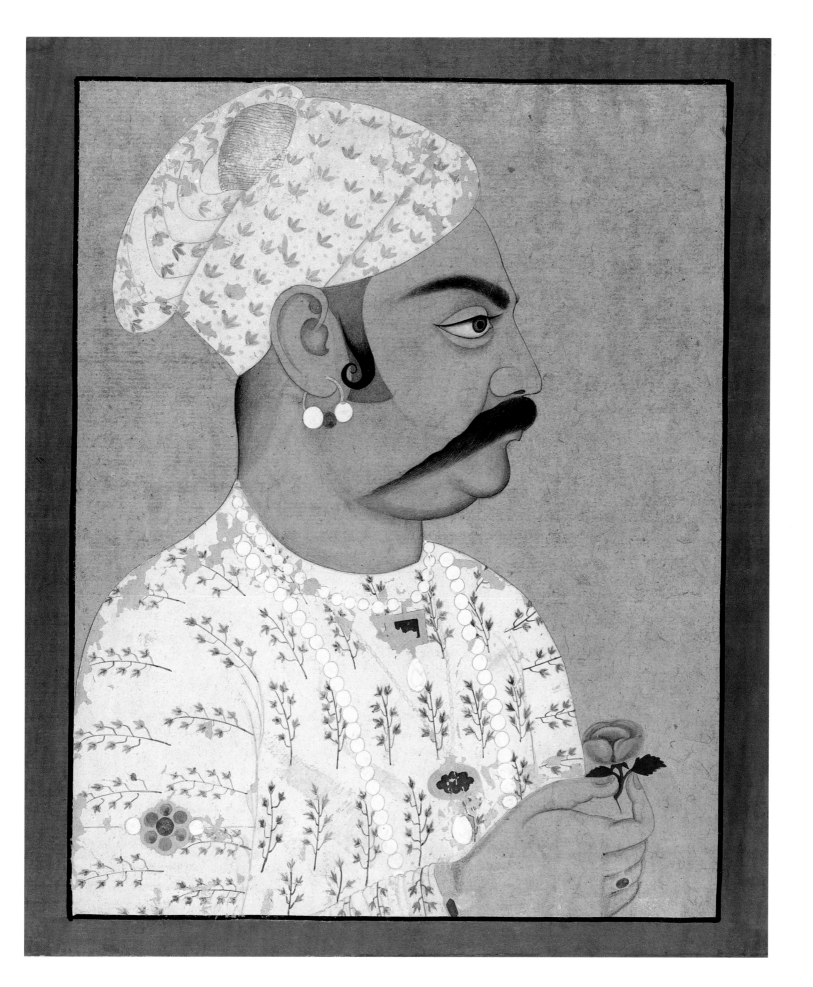

52. *Swami Devakinandan with Raja Sujan Singh of Bikaner and Prince Zoravar Singh*

Rajasthan, Bikaner, c. 1712
Opaque watercolor and gold on paper
13 9/16 x 9 1/16 inches (34.4 x 23 cm)

Raja Sujan Singh (reigned 1700–1735) and his son Zoravar Singh (reigned 1736–46) sit neatly before the Brahmin Swami Devakinandan Maharaj on a terrace overlooking a garden.[1] Father and son wear much finery, including pearl, ruby, and sapphire jewelry, aigrettes in their turbans, and long, formal, striped *patkas* (sashes) that curl over their knees. Zoravar Singh's outfit is identical to Sujan Singh's but a smaller size; they have the same black shield, small sword, and even earring. The two sit with their hands folded in an attitude of great respect as they listen to the swami expound upon the contents of the book in his left hand. The swami holds his other hand in the traditional *mudra* (gesture) for teaching. The inscription on his book ("Shri Rama Shri Rama Shri Rama Shri Rama") is used as a mantra to call upon the deity of that name, but also serves as an abbreviated indication of a religious text in a painting.

Swami Devakinandan wears his sacred thread over his left shoulder, beneath his garland of jewels and chain with a large gold pendant, and a smaller pendant on a third necklace at his throat above his hairy chest. Earrings, finger rings, several sets of bracelets on each wrist, and armbands complete his jewelry outfit, but his relatively austere clothing consists of a simple saffron-colored shawl around his shoulders and a saffron *dhoti* with a thin red border. His long hair is twisted into a knot at the back of his head. Judging from Devakinandan's adornments and physique, neither austerity nor self-deprivation played a significant part in his personal path to God.

The three sit on a large white floorspread with a ground of repeated green and red floral arabesques and an arabesque border within green guard stripes. The colors and the technique of outlining and filling in the design give the floorspread the appearance of an embroidery. Beneath Devakinandan is a brown pile carpet with white geometric designs in the ground and knotted fringe along the short ends. The fringe is the indication that this is a pile carpet.

At the edge of the terrace stands a white pavilion with tapering ribbed columns supporting three cusped arches, sloping eaves, and a superstructure of three domes of types found throughout northern India. The central dome, however, is here wonderfully askew, setting up a dance with the graceful trees on either side. An image made in 1695 by Nur Muhammad for a *ragamala* set in a somewhat stiff, formal, Mughalized style likewise features a central dome askew to the left, strikingly similar to the one here.[2] The formal seriousness of the visit scene is also enlivened by the decoration on the white pavilion, echoing the patterned textiles spread on the terrace.

Receiving advice and teaching from holy men is a tradition that stretches back for millennia in South Asia. Some of the earliest surviving Indian paintings show such visits,[3] and the theme continued through the ensuing centuries. In the sixteenth and seventeenth centuries a number of paintings recorded the visits of the men and the women of the Mughal aristocracy to spiritual teachers.[4] The preceptor imparted wisdom to the seeker, and the seeker acquired not only wisdom but also the spiritual aura of a true prince. Presumably here, since the meeting takes place in a palace setting, Swami Devakinandan has come to his devotees.

The date in an inscription on the reverse of the picture, the equivalent of July-August 1748, is an inventory notation rather than the date of the painting.[5] However, the approximate date can be deduced from internal evidence and from similar dated paintings. The evidence in the painting is the apparent ages of Sujan Singh and his son Zoravar Singh. Zoravar Singh was born in 1703, when Sujan Singh was thirteen years old. Since here Sujan Singh appears to be in his early twenties and Zoravar Singh appears to be about nine years old, a date of approximately 1712 is proposed for this painting. The dated, stylistically related paintings include one from 1710, by Murad;[6] another, dated 1712, of three women on a terrace;[7] and three paintings from a *ragamala* series of 1714.[8] This group of paintings shares a distinctive type of textile and architectural decoration that is not seen elsewhere, as well as a similar organization of space. Stylistic differences, however, preclude suggesting that the group is by one artist. ES

PUBLISHED: Ehnbom 1985, pp. 150–51, no. 69

1. Inscribed on the front on the upper margin: "Shri Devakinan-danji Maharaj, son of Goswami Shri Chhota Raghunathji, before Bikaner Raja Sujan Singh Kunwar Zoravar Singhji"; on the book in the swami's hand: "Shri Rama Shri Rama [repeats]." On the reverse is an inventory notation: "This is a likeness of Maharaj Shri Sujan Singhji Samvat 1805, the fifteenth day of the light half of the month Shravana [A.D. July-August 1748]."
2. Sven Gahlin, *The Courts of India: Indian Miniatures from the Collection of the Fondation Custodia, Paris* (Zwolle: Fondation Custodia/Waanders Publishers, 1991), pp. 57–59, no. 56.
3. For a thirteenth-century example of a painting of a Shvetambara monk instructing a princely figure, now in the San Diego Museum of Art, and a painting dated 1278 of monks preaching to women, now in The Cleveland Museum of Art, see Pal et al. 1994, p. 202, no. 81; and p. 200, no. 80, respectively.
4. For instance, Jahangir, who often visited the mystic Gosain Jadrup, wrote about him, "Since I was anxious to talk to him, I went to see him and spent a long time alone with him without interruption. He is truly a great resource, and one can enjoy and derive much benefit from sitting with him" (*Jahangirnama* 1999, p. 313, repro. p. 312). There are women in the entourage visiting Shaykh Phul in a painting from c. 1610 in the Bharat Kala Bhavan, Varanasi (Welch 1985, pp. 212–13, no. 140).
5. Poster et al. 1994, p. 151.
6. Goenka Collection. I thank Catherine Glynn for providing this information.
7. Goetz 1950, p. 172, no. 81.
8. Elvehjem Art Center, University of Wisconsin, Madison, *Indian Miniature Painting: The Collection of Earnest C. Watson and Jane Werner Watson* (Madison: University of Wisconsin Press, 1971), p. 108, nos. 176–77; and Brooklyn Museum of Art, 81.192.5 (Poster et al. 1994, pp. 151–52, no. 114). The paintings are the same sizes and identical in style; I accept the date on the Brooklyn page in view of its similarity to the dated paintings in this group. A sixth painting from Bikaner, of a prince shooting birds, is often published as being dated 1710 (Harvard University Art Museums, Cambridge, 1995.123; see "A Decade of Collecting: Recent Acquisitions by the Harvard University Art Museums," *Harvard University Art Museums Bulletin*, vol. 7, no. 2 [Spring 2000], pp. 37–38, repro.; and Naveen Patnaik, *A Second Paradise: Indian Courtly Life, 1590–1947* [New York: Doubleday, 1985], p. 92, no. 28). However, on the reverse the Harvard painting is clearly dated Samvat 1758, or 1701, and is published with that date by Milo Cleveland Beach (1992, p. 191, no. 143).

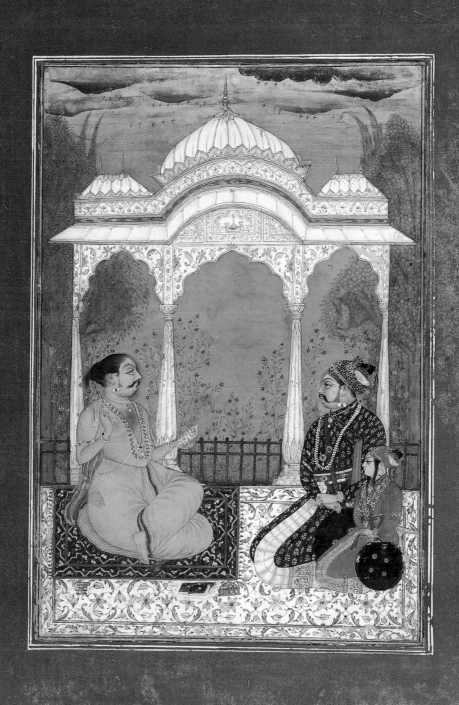

53. The Great Goddess as Ishwari, with Bhadragaura

Rajasthan, Junia, c. 1700–1725
Opaque watercolor, gold, and silver-colored paint on paper
8 x 9 3/8 inches (20.3 x 23.7 cm)

The inscription in the top margin, "Shri Isvariji Bhadragaura," identifies the figures in the painting.[1] Ishwari is one of the many names of the Great Goddess. When she takes the form of a beautiful woman, well armed with a multitude of weapons and riding a fierce lion, she is known as Durga. She is the only deity who was created; the others have always been, since before time began. She was invented by the male gods when they were impotent against the demon Mahisha. David Kinsley relates one account of her creation:

[When] the demon Mahiṣa was granted the boon that he would be invincible to all opponents except a woman[, he] . . . defeated the gods in battle and usurped their positions. The gods then assembled and, angry at the thought of Mahiṣa's triumph and their apparent inability to do anything about it, emitted their fiery energies. This great mass of light and strength congealed into the body of a beautiful woman, whose splendor spread through the universe. The parts of her body were formed from the male gods. Her face was formed from Śiva, her hair from Yama, her arms from Viṣṇu, and so on. Similarly, each of the male deities from whom she had been created gave her a weapon. Śiva gave her his trident. Viṣṇu gave her his *cakra* [discus] . . . , Vayu his bow and arrows, and so on. Equipped by the gods and supplied by the god Himalaya with a lion as her vehicle, Durgā, the embodied strength of the gods, then roared mightily, causing the earth to shake.

The creation of the goddess Durgā thus takes place in the context of a cosmic crisis precipitated by a demon whom the male gods are unable to subdue. She is created because the situation calls for a woman, a superior warrior, a peculiar power possessed by the goddess Invariably Durgā defeats the demon handily

Durgā's distinctive nature, and to a great extent probably her appeal, comes from the combination of world-supportive qualities and liminal characteristics that associate her with the periphery of civilized order. In many respects Durgā violates the model of the Hindu woman. She is not submissive, she is not subordinated to a male deity, she does not fulfill household duties, and she excels at what is traditionally a male function, fighting in battle. As an independent warrior who can hold her own against any male on the battlefield, she reverses the normal role for females and therefore stands outside normal society. Unlike the normal female, Durgā does not lend her power or *śakti* to a male consort but rather *takes* power from the male gods in order to perform her own heroic exploits. They give up their inner strength, fire, and heat to create her and in doing surrender their potency to her.[2]

Durga has been worshiped in various forms throughout India for millennia. Although she has taken her place in the male-dominated Hindu pantheon, she has never relinquished her great appeal as a powerful, beautiful woman who is also an outsider or renegade. Her universal attraction may relate to her historical origins, which stem from the indigenous, non-Aryan, inhabitants of the subcontinent.[3]

In the painting the proud Durga sits on a lotus saddle astride her powerful cat, which is here a combination of lion and tiger. Even though the traditional mount for Durga is a lion,[4] artists often place her upon a tiger and occasionally on a hybrid feline. Here, Durga's multiple arms, which hold her many weapons, have an unusual configuration. While four arms originate at her shoulders, each elbow sprouts five forearms, producing something like a windmill on each.

In her twenty hands she holds the weapons traditionally given her by the gods and a few more up-to-date weapons as well. Starting at her lowest proper right hand she holds a pennant on a pole, a flexible stick (a whip?), a trident (provided by Shiva), a ser-

rated sword, a spear (provided by Agni), a wire hoop, a mace, a dagger on a shaft, an ax on a shaft (from Vishvakarma), a discus (from Vishnu), a dagger, Shiva's drum, a curved sword, the bloody head of the demon Mahisha on a platter (evidence of her victory over him), a short curved dagger, a conch shell (from Vishnu) that partly obscures a shorter straight dagger in the next hand, another curved dagger, a small manuscript (which may represent the *Devi Mahatmya*), and a large flat sword that she rests on her left shoulder. Brandishing this arsenal of weapons, the emblems of the greatest gods, holding a sacred text, and controlling her fierce beast, Durga is all-powerful.

The inscriptions reveal that the figure carrying the umbrella is the somewhat obscure Bhadragaura, one of the eight Bhairavas, which are manifestations of Shiva. Bhadragaura is the Pale Bhairava, a counterpart to Bhadrakala, the Dark Bhairava. A painting dated 1870 in the National Museum, New Delhi, shows an enthroned Durga with her lion nearby, attended by both Bhadrakala and Bhadragaura.[5]

This painting may be from Junia, a small state in Ajmer district about halfway between Kishangarh and Bundi. The Junia ruling family were of the Rathor clan of Rajputs, closely connected to the Mughal court at the end of the seventeenth century and less so as Mughal dominion of Rajputana waned.[6] ES

1. The painting is also inscribed on the reverse, "Shri Nine Durga 9 Ishwari." On the reverse there are also two ownership seals, one of Kumar Sangram Singh of Nawalgarh, and one that is illegible.
2. David Kinsley, *Hindu Goddesses: Visions of the Divine Feminine in the Hindu Religious Tradition* (Berkeley: University of California Press, 1988), pp. 96–97.
3. Ibid., p. 95.
4. For a discussion of the *Devi Mahatmya*, the Sanskrit text that deals with the Great Goddess, see Thomas B. Coburn, "The Threefold Vision of the *Devi Mahatmya*," in Dehejia et al. 1999, pp. 37–58.
5. 47.110/567; see Rita Pratap, *The Panorama of Jaipur Paintings* (New Delhi: D. K. Printworld, 1996), pp. 80–82, fig. 34.
6. For a short discussion of Junia and two paintings from Junia, see Topsfield and Beach 1991, p. 70, no. 25.

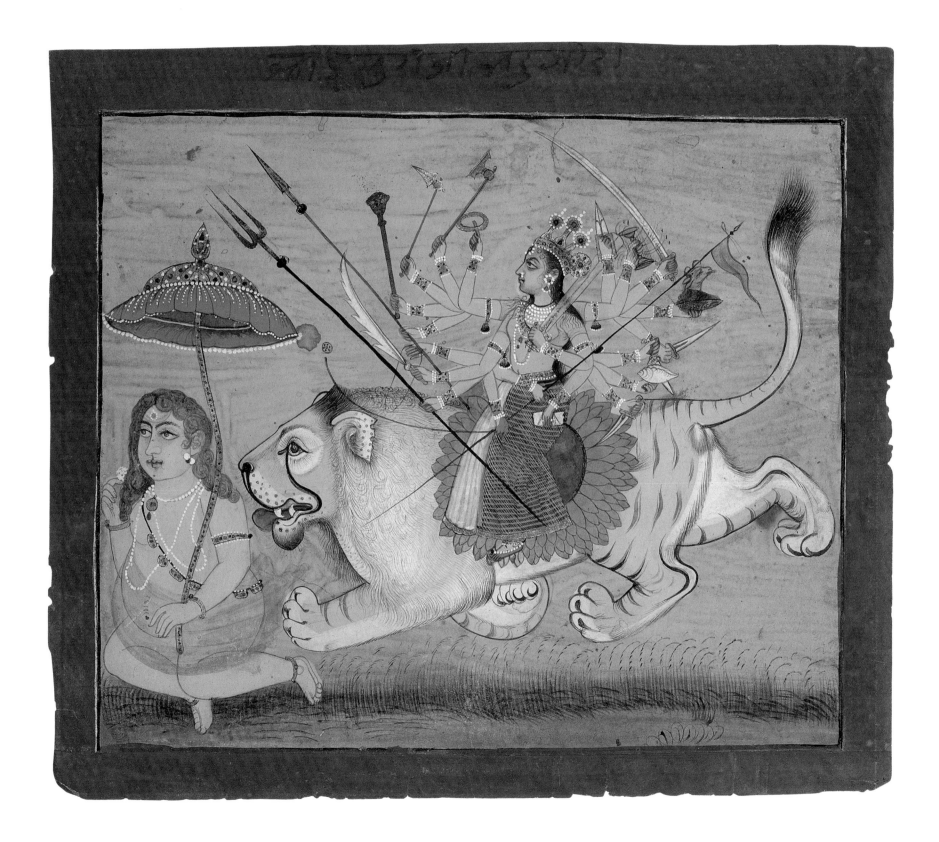

54. *Maharaja Sundar Das of Sawar*

Rajasthan, Sawar, c. 1660–80
Opaque watercolor and gold on paper
10 11/16 x 13 5/8 inches (27.1 x 34.6 cm)

With its abbreviated forms and glowing blocks of saturated color, this starkly dramatic painting embodies a conception of beauty that is distinctly Rajasthani.[1] The format is borrowed from Mughal art, but the tonal shading and modeling that would have characterized a Mughal portrait of this date are almost entirely absent. The bodies of Maharaja Sundar Das (1606–1668; reigned 1650–68) of Sawar and his diminutive offspring, Prince Raj Singh and Prince Badam Singh, have the flatness of paper cutouts. And the accessories, birdcage, and bolster that define their surrounding space are equally two-dimensional. Only the bold variations in scale, and the glorious interplay of color—orange, white, and two shades of green, with touches of red, pink, and gold—enliven the flat surface, to jolt the painting to life.

The Sawar maharajas were descendants of a collateral branch of the Mewar ruling family. Little is known about Sundar Das, "except that he was immensely fat; seven yards of muslin were required for his cummerbund."[2] Maharaja Gokul Das (1585–1650), his father, was a battle-hardened veteran of the Mughal war machine. The family title and estate, a

tract of land with eighty villages in the Ajmer district of Rajasthan, were granted as a reward for service by Gokul Das's principal patron, the Mughal emperor Shah Jahan (reigned 1627–58).

Sundar Das's great weight suggests a life of idleness rather than action. We do not know whether he initiated the tradition of patronage that would flourish at Sawar during the reigns of maharajas Pratap Singh (reigned 1668–1705) and Raj Singh (reigned 1705–30). This is his only known portrait, and our understanding of Sawar painting is too sketchy to permit more than a rough approximation of its date. It may have been painted in the years 1660–68, or in the ten or twelve years that followed.[3]

Sawar was a politically insignificant court, yet in matters of art, it punched well above its weight. The school is justly admired for a group of tinted drawings on plain backgrounds that date from the reign of Raj Singh.[4] Although the present portrait dates from a somewhat different period and is fully colored, it displays the same flatness of background and outline, and the same boldness of composition and scale, that are visible in the later tinted drawings.

Following the death of Maharaja Raj Singh in 1730, there is little evidence of artistic activity at Sawar, apart from a brief period in the early nineteenth century when Pemji (see cat. 55), a native of Chittor in neighboring Mewar state, made a number of paintings under the patronage of Maharaja Ajit Singh (reigned 1802–12). Pemji's brilliant yet idiosyncratic style was little affected by the legacy of painting that was stored in the Sawar maharaja's palace, but he inspected Ajit Singh's ancestral collection and made a reasonably faithful copy of the present portrait, which he greatly admired, around the year 1810.[5] TM

1. The Rajasthani inscription along the top border reads, "Maharaja Sundar Das Sagtavat, Raja of Sawar."
2. Pasricha 1982, p. 258.
3. For another possible portrait of Sundar Das, see Filippi 1997, p. 88, no. 41.
4. See Topsfield and Beach 1991, pp. 64–69, nos. 22–24.
5. Kanoria Collection, Patna; see Pasricha 1982, p. 258, fig. 1. The inscription on the reverse of Pemji's copy allows us to identify the small princes in the present work. See ibid., p. 268 n. 3.

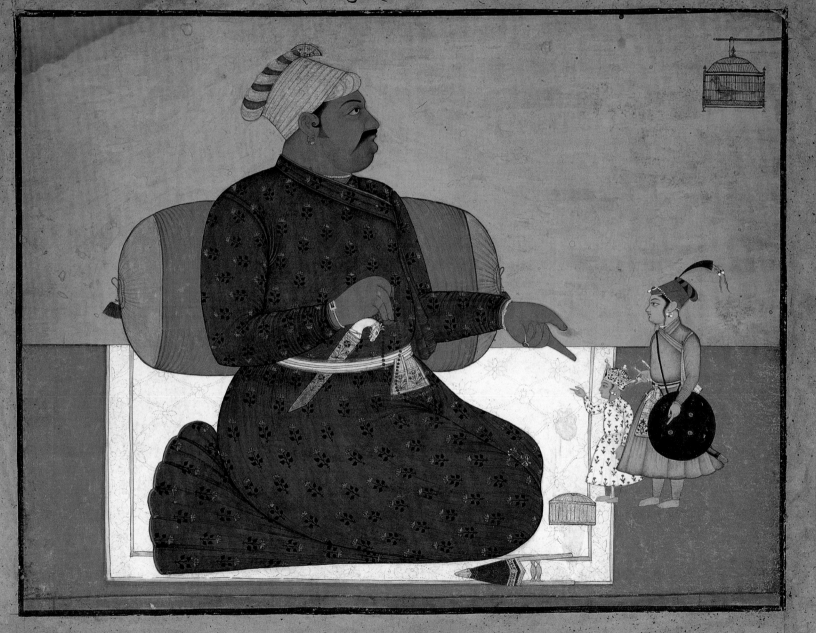

55. *Thakurao Sagat Singh and Kunwar Saman Singh Entertained*

Ascribed to Pemji
Rajasthan, Sawar, c. 1790
Opaque watercolor, gold, and silver-colored paint on paper
10 1/16 x 15 inches (25.5 x 38 cm)

Although Pemji is known from fewer than a dozen ascribed paintings,[1] his distinctive style is recognizable, and his pictures are often extremely droll.[2] He deftly captures the cocky tilt of a head, a beady stare, a skinny arm, the shawl that must be tugged to cover an enormous haunch. Pemji worked at Sawar during the time of Udai Singh (reigned 1752–1802), of his son and successor Ajit Singh (reigned 1802–12), and of his son and successor Jaswant Singh (reigned 1812–55). Granted their territory by Shah Jahan in 1627, the Sawar ruling family were descended from a younger brother of the sixteenth-century Mewar maharana Pratap Singh and were thus Sisodia Rajputs.[3] Sawar is located in Ajmer district about fifty miles southeast of the town of Ajmer.

Stuart Cary Welch informs us that Pemji was "born at Chittor but [painted] at Sawar."[4] Chittor was the capital of Mewar until the Mughal emperor Akbar sacked it in 1568, forcing Maharana Udai Singh to flee west to the Aravalli hills, where he built a new city, Udaipur.[5] Chittor is a district as well as a demolished city, and it may be that Pemji hailed from somewhere in the district of Chittor, and not from the ruined former capital. Sawar is about seventy miles northeast of Chittor, closer to Kishangarh, Kota, and Bundi in distance, but closer to Mewar in terms of feudal kinship.

In the painting, Kunwar (Prince) Saman Singh, to the left of center, wearing a red turban decorated with a spray of white flowers and a white garland, faces a rotund older man, Thakurao Sagat Singh. The inscriptions in the borders provide the names of many of the people in the painting, their status (such as prince or dancer), and the degree of respect due them.[6] The latter is revealed by the number of times the honorific title *shri* and the honorific particle *ji* are included in the name. While it is not clear exactly who the Thakurao (Important Lord) Sagat Singh is or what his connection to Sawar may have been, his title, his placement in the painting, and the fan over his head make it clear that he is a very important person. However,

although Saman Singh commands only two *shris* to Sagat Singh's four, Saman Singh's head is placed ever so slightly higher in the painting, indicating that he, too, is an important person. Saman Singh appears to have been a son but not the successor of Ajit Singh.

With scudding clouds polishing the stars and crescent moon above, Sagat Singh and Saman Singh are engaged in intense conversation, ignoring the musicians and dancers on the striped rug. That there are clouds in the sky, that the characters wear thin white garments, and that the dance is taking place in the cool of the night combine to indicate that this performance occurred in the summer, when the monsoon clouds began to gather.

The musicians and their instruments are a tambura player who is singing and gesturing with her right hand, a white-bearded drummer seated with his tabla, and a dark-bearded man who uses a bow with his violin-like instrument. The two dancers, one in red and a very young girl in white, wear long-sleeved dress-like garments associated with the Kathak style of dancing. Inscriptions at the right margin and on the reverse identify them as "young dancers." At the upper right a torchbearer augments the light of the moon and holds ready an oil container to replenish the fuel in the torch. The only man actively engaged in watching the dance sits with his back toward the viewer, hand resting on the inner black border of the painting, feet and seat extending into the margin. Pemji has incorporated the border into the whole of the painting by setting minor characters against the red and by grounding two figures on the black line of the inner border. This obvious use of the border as part of the painting is not uncommon in Indian painting, but serves to emphasize that the colored borders are integral with the painting.

Below the figure of Sagat Singh is a very small boy identified as Prince Adar, apparently Saman Singh's son, who is chatting with Pachili Nathuram. Between them on the carpet is a penbox with inkwell attached and scissors to recut the ends of the quills or reeds. At the left Adot Singh tells his beads, with his shield in

his lap and dagger at his waist. Two standing retainers hold the shield, covered swords, and fan, which are emblems of the status of the *thakurao*.

There is in the Edwin Binney 3rd Collection a painting ascribed to Pemji of Prince Saman Singh, Prince Adar Singh, and a group of courtiers engaged in the courtly activity of teaching the young prince to shoot birds.[7] The Bellak painting and the Binney painting would be the same size if the Binney painting had not lost three of its four borders. Both display the same wry humor, and both have most of the characters identified. The two paintings seem to be from a series documenting the busy days and nights of Saman Singh and his young son. ES

1. Andrew Topsfield (1990, p. 67) mentions a procession scene of 1784 by Pemji, in the Sangram Singh Collection. For other paintings ascribed to Pemji, see *Kunwar Saman Singh and Kunwar Adar Singh Shoot Birds* and *Bhang Eaters Before Two Huts*, San Diego Museum of Art, 1990:639 and 1990:642, respectively; *Ajit Singh's Revels in the Garden* (Welch 1973, p. 37, no. 14); *Maharaja Sundar Das* (Pasricha 1982, p. 258, fig. 1); *Thakur Akshay Singh Hunts*, Jagdish and Kamla Mittal Museum, Hyderabad, 76.220 (Hayward Gallery 1982, pp. 77, 155, no. 213); *Warriors Dance with a Maiden* (Sotheby's, New York, March 2, 1990, lot 168 [text only]); and *Intoxicated Sadhus* (Ehnbom 1985, no. 57).

 The Bellak painting is inscribed on the reverse: "A gathering of the very young dancers. The work of the painter Pemji." This inscription was apparently written when the painting was relined when it belonged to Sangram Singh of Nawalgarh. There may have been a contemporary inscription on the back of the painting before the relining. The writing now on the work is not contemporary with the painting. Many of Pemji's paintings have been thus treated. My thanks to Shridhar Andhare for this information.

2. I thank Catherine Glynn for generously sharing her slides of Pemji's work.

3. Pasricha 1982, p. 257.

4. Welch 1973, p. 37, no. 14.

5. Tod 1971a, vol. 1, pp. 371–84.

6. The painting is inscribed on the front margin with the names of the characters and their occupations, clockwise from the middle of the lower left corner: "Adot Singhji, Jalam Jarambo [or Janabo], Chakar Sabu, Shri Shri Thakurao Shri Shri Sagat Singhji, Shri Kunwarji Shri Saman Singhji, Jubani Naya[ka], Dhabhadiji Sabati, Pachiliji Nathuramji Shri Kunwarji Adarji."

7. San Diego Museum of Art, 1990:639.

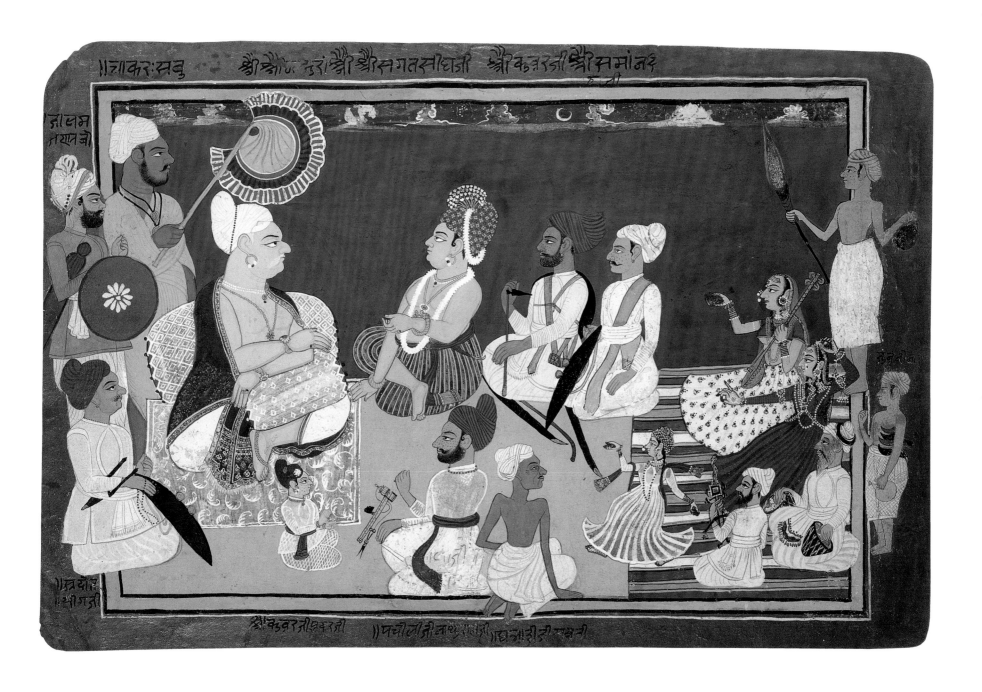

॥जालम
तायानजी

श्रीनालोका

॥रुव्वदोरु
॥श्रीगरुजी

56. A Woman with an Ascetic (Kedara Raga)

Page from a dispersed *Ragamala* series
Rajasthan, Sirohi, c. 1680
Opaque watercolor on paper
9 3/16 x 7 inches (23.4 x 17.8 cm)

The *ragamala* (garland of musical modes) is one of the most common and attractive literary subjects of Indian painting, but also one of the most elusive for Western audiences. As is the case with the *Rasikapriya* (see cats. 20–22), *ragamala* verses and paintings are intended to serve as poetical and visual personifications of a series of emotional and sometimes quasireligious states. The complexity of this process is further compounded by an intermediary relationship in which *ragamala* verses draw upon several ancient musical texts that enumerate various sets of *ragas*, or musical modes, purportedly eliciting these same sentiments. These *ragas* are conceived as families, each with a husband (*raga*) and five or six wives (*raginis*), and often sons and daughters as well. A typical *ragamala* series, therefore, comprises thirty-six or forty-two paintings that are keyed to these musical modes. Although each *raga* is associated with a particular season, time of day, and mood, the connection between its name, imagery, and melody is usually not apparent even to specialists. In most instances, the origins of the imagery are quite obscure; indeed, some iconographic features have never been explained satisfactorily. Once the imagery for each *raga* was established, its iconography was quickly codified. Hence, there is some consistency within each of several overarching regional traditions (such as the so-called Rajasthani Tradition), and still more within each local school of painting.[1] Nonetheless, any expectation of a nuanced and precise system

of classification is soon confounded by a welter of iconographic variants.

This painting, for example, is identified as Kedara Raga by an inscription in the upper border; it usually belongs to the family of Shri and corresponds to a melody to be sung on wintry nights.[2] Images of Kedara almost always feature an ascetic and music, but combine these elements in a surprising number of ways. Sometimes the ascetic is conceived as a lovesick female, who, assuming the ash-smeared and emaciated demeanor of an ascetic, plays the *vina* as she yearns for her absent beloved; other times, the lone ascetic is decidedly male.[3] Still other variations depict an ascetic listening to a disciple play music, or greeting a royal visitor and his retinue.

This particular painting exemplifies the highly idiosyncratic nature of *ragamala* series from Sirohi, a small state in southern Rajasthan. Seated on the right is a young ascetic, his physical renunciation of the world indicated only by his matted locks and limited clothing. The performance of music, elsewhere a leitmotif of the Kedara Raga, is altogether absent from the scene; in its place is a woman offering her visitor a garland, a standard sign of welcome. Yet this omission is no oversight on the part of the individual artist who made this painting, but a local and unexplained iconographic choice. This point is established by the absence of music in a virtually identical painting that shows the same two figures engaged again in conversation, but this time as they are about to share *pan*, a popular digestive.[4] Both

paintings have a colorful cushion near each figure, a pet deer and three domestic vessels in the foreground, and an exuberant tree along the right side of the composition. The artist of the Bellak painting takes the liberty of adding a bed and a second story to the chamber behind the woman.

Although artists working in Sirohi seem to have made as many as a dozen *ragamala* series in the last quarter of the seventeenth century, this particular *ragamala* series is distinguished by its pervasive elaboration, a quality evident in features ranging from the sprigs of vegetation in the foreground to the floral scroll below the bed and the busy patterns in the soaring superstructure.[5] These delicate touches complement wonderfully the bold forms that dominate the composition, notably the sweeping curves of the woman's clothing and the luxurious cusps of every arch. Like other works from Sirohi, this painting exults in an exceptionally vibrant palette with strong contrasts of hue and tone. JS

PUBLISHED: Kramrisch 1986, pp. 66, 169–70, no. 59

1. See Ebeling 1973, pp. 56-62.
2. The painting is inscribed with the number 34. In other systems, Kedara belongs to the family of Dipak.
3. For examples of these two types in Malwa painting, see two works in The Cleveland Museum of Art (Leach 1986, pp. 213–16, nos. 83–84).
4. For the painting, which is in The Cleveland Museum of Art, see Ebeling 1973, fig. 293.
5. For two other paintings from this series, see Beach 1992, color plate I; and Ebeling 1973, fig. 219.

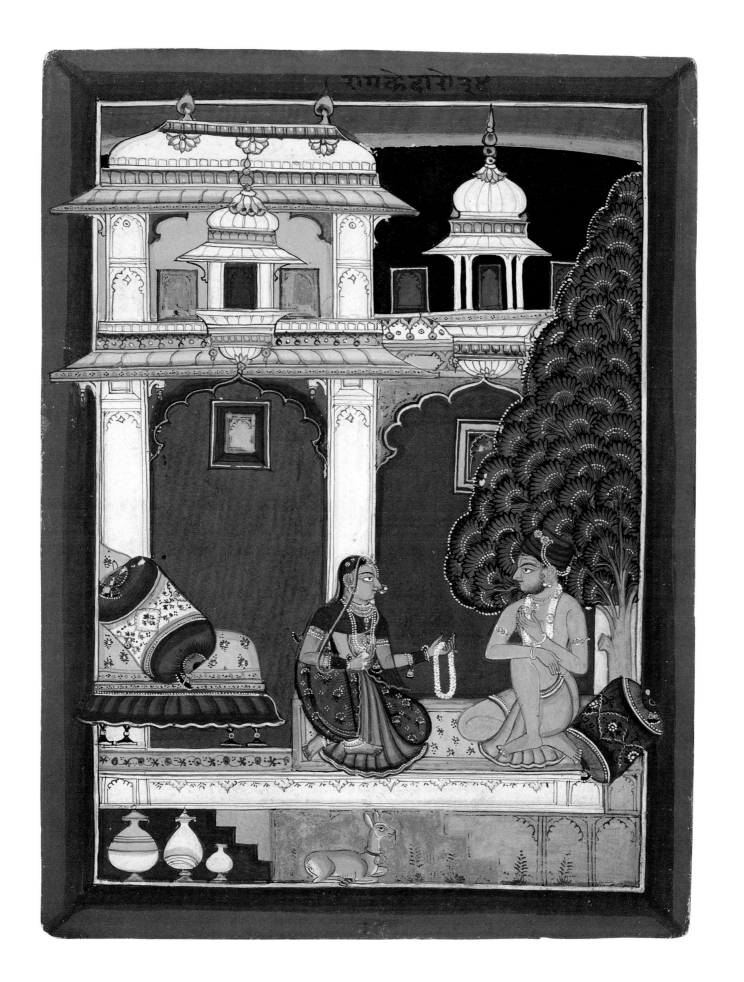

57. *The Child Krishna Destroys the Ogress Putana*

Page from a dispersed series of the *Bhagavata Purana*
Rajasthan, probably Sirohi, c. 1725
Opaque watercolor and gold on paper
9 3/8 x 10 1/2 inches (23.8 x 26.7 cm)

Kamsa, the evil king of Mathura, learns of an ominous prophesy that he will meet his end at the hand of his own sister's eighth son, who is destined to be none other than Krishna. The alarmed king takes no chances, and has each of his sister's first six offspring slain as soon as it is born. The gods intervene to spare her seventh and eighth children, once by transferring the embryo to another woman, and a second time by magically allowing her imprisoned husband to free himself long enough to exchange the newborn Krishna with the infant girl of another woman, Yashoda. Kamsa viciously dashes the replacement baby to the ground, but she miraculously rises to the heavens and reveals herself to be a goddess. Thereupon the relentless Kamsa decides that a wider net of death is in order, and urges a child-killing demoness named Putana to purge the area of newborns.

Thus it is that Putana, in the guise of a wetnurse, arrives one day at Yashoda's house in Vrindavan. This pernicious nursemaid does not arouse suspicion, for she is so wondrously beautiful that Yashoda and her companions take her to be the goddess Lakshmi herself. Putana gathers the infant Krishna into her arms, and prepares to suckle him. Krishna immediately recognizes the disguised ogress for what she is, and knows her breast to be filled with the most virulent of substances. He accepts it nonetheless, and sucks on it greedily. But rather than succumbing to the poison, which would kill any mortal, Krishna drains the breast so forcefully and completely that Putana herself falls into death throes. As she does, the wanton creature reverts to her natural state, her swollen tongue and disheveled hair only adding to the hideousness of her fanged mouth, cavernous nostrils, and mountainous body.

Krishna continues to play at Putana's breast until his nonplussed foster mother sweeps him up with relief and bundles him off for ritual purification. Meanwhile, men set about destroying Putana's colossal corpse, first dismembering it and then beginning to cremate it. To their astonishment, an amazingly fragrant smell issues from the pyre, a divine sign that even one so vile as Putana can be redeemed by contact with Krishna. This promise of redemption has heartened sinful beings to this day.

This episode is one of the most frequently depicted in the *Bhagavata Purana*. Most artists select the moment of Krishna sucking the poison from a fallen Putana, probably because the juxtaposition of the grotesque demoness with the divine babe simultaneously demonstrates the powers that Krishna possessed even as an infant and inverts the usual nurturing relationship of mother and child.[1] Others aspire to create more comprehensive images, and render as ancillary scenes Kamsa dispatching the ogress and a disguised Putana making her way to Krishna's crib.[2]

This artist chooses a singular and less dramatic moment, when Yashoda comes to retrieve her child from the breast of the dead ogress while her companions look on with wonderment. The narrative choice is facilitated in this series by the two images that precede and follow this one, which respectively show a disguised Putana arriving in Vrindavan and the ogress reverting to her horrific form.[3] Here, having finally relinquished Putana's breast, Krishna conveys his triumph over the demoness by kneeling contentedly on her chest. Putana's awkward position, disheveled hair, and distended tongue all indicate a level of distress, but her body and face are otherwise unmarked by the pangs of death, and are still far from the monstrous state that they will assume once more.

Although Krishna is naturally the religious focus of the composition, his small size and position within the contour of Putana's body make it easy to overlook him. Instead, the painting is dominated by female figures, most of whom are quite peripheral to the story. Yashoda and a complementary figure do reach toward Krishna, thereby directing the viewer toward him, but the three women to the right express undifferentiated surprise and simply fill out the horizontal composition. Indeed, it is their brightly colored clothing, particularly its dense floral patterning, that organizes the painting into busy shapes and voids.

This aesthetic principle is also manifested in the remarkable series of framing devices around the painting and folio. The broad and surprisingly unadorned white strip that runs along the bottom of the painting is connected to the rudimentary doorframe behind Yashoda by color alone; its real purpose is to provide visual relief from the continuous mass of color and pattern above. Similarly, just as the row of alternately colored tassels consumes the space immediately above the heads of Yashoda's companions and refocuses attention on the lower half of the composition, it is answered by another relatively plain element, this time a brilliant white

eave. The band above the eave in turn has no recognizable architectural form, but is an unabashed excuse for yet another pattern. Pattern yields to plain form again in the red frame that binds the composition together and contains a caption describing the scene. The wide outermost border displays the most exuberant pattern of all: a heavy floral scroll with enormous yellow flowers. The border is unique in all of Rajasthani painting for its extraordinary width and flamboyant patterns, no two of which are alike.[4]

This series is usually placed to Sirohi (see cat. 56), a minor school of painting that has features related to styles current in the neighboring courts of Mewar, Marwar, and Gujarat. Although there is unusually meager documentation of painting at Sirohi, the figure style and decorative motifs of an illustrated scroll dated 1737 and sent by a Jain congregation in Sirohi to an itinerant religious teacher greatly resemble those of this *Bhagavata Purana* series.[5] B. N. Goswamy has also suggested the possibility of some connection with painting of the Kutch region of Gujarat.[6] The language of the caption above and the four-line inscription on the reverse is described as a mixture of Rajasthani and Gujarati, and thus does not clarify the situation further. JS

PUBLISHED: Christie's, London, July 3, 1980, lot 2

1. For an eighteenth-century Mewari example in the Bharat Kala Bhavan, Varanasi, see P. Banerjee, *The Life of Krishna in Indian Art* (New Delhi: National Museum, 1978), fig. 33.
2. See Pal 1978, pp. 96–99, nos. 25–26.
3. The two images were offered for sale at Sotheby's, London, April 8, 1975, lots 108 and 107, respectively.
4. See Joachim Bautze, *Indian Miniature Paintings, c. 1590– c. 1850* (Amsterdam: Galerie Saundarya Lahari, 1987), p. 65, no. 25, for a partial list of other paintings from this series. Paintings published subsequently include: *Celebrations at the Birth of Krishna (Bhagavata Purana [BP]*, Book 10, Chapter 5, Verses 13–14), Goenka Collection (Goswamy with Bhatia 1999, p. 189, no. 148); *Nanda Requests That Krishna's Horoscope Be Determined (BP*, Book 10, Chapter 8, Verses 11–20), Brooklyn Museum of Art, 78.260.5 (Poster et al. 1994, pp. 223–24, no. 178); *Krishna Fights the Demon Bakasura (BP*, Book 10, Chapter 11, Verses 47–53), The Pierpont Morgan Library, New York, M.1035.4 (Schmitz et al. 1997, cat. 61.27, fig. 279); *Krishna Enjoys a Midday Repast with the Cowherds (BP*, Book 10, Chapter 20, Verse 29), Goenka Collection (Goswamy with Bhatia 1999, p. 188, no. 147).
5. See Khandalavala et al. 1960, no. 82.
6. In Goswamy with Bhatia 1999, pp. 188–89.

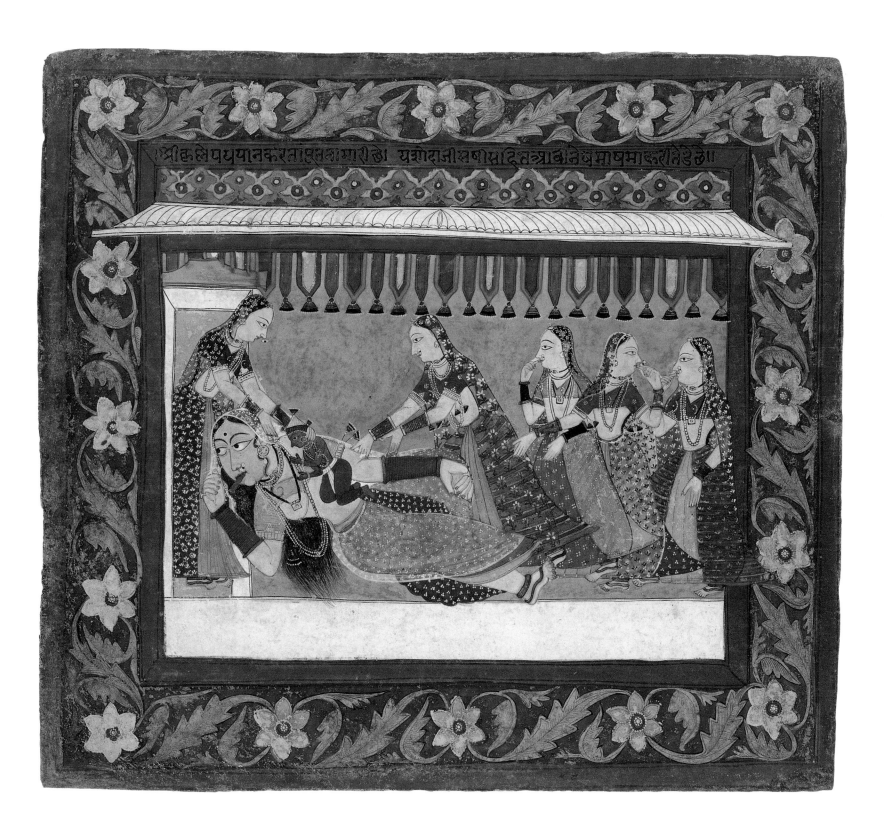

58. *Maharana Sangram Singh of Mewar, His Two Sons, and Courtiers*

Rajasthan, Mewar, c. 1715–20
Opaque watercolor and gold on paper
12 7/16 x 21 1/4 inches (31.6 x 53.9 cm)

Portraiture came to Mewari painting only about 1670, but Mewari rulers quickly succumbed to the appeal of having a visual record of their earthly glory. Taking their cue from the Mughals, they began to commission individualized likenesses of themselves engaged in assorted courtly activities. In the eighteenth and nineteenth centuries, the sheer variety of these activities easily outstripped that of any other school of painting in Rajasthan. The most popular portrait type was the equestrian portrait, in which the ruler appeared astride a powerful mount, sometimes alone, but more often towering above a cluster of retainers. A more active demonstration of physical prowess occurred at the hunt, when the king subdued ferocious beasts from either the height of an elephant or horse or the cover of a hunting blind. Within the confines of palatial quarters, the maharana was often shown presiding over a variety of state functions, such as formal audiences and seasonal or religious festivities. Sometimes he permitted himself to be seen in less ceremonious moments instead, and was depicted enjoying a *huqqa,* game of chance, or dance performance with an elite coterie.

No matter what the situation, the image of the ruler in Mewari painting remained immutable. Apart from gradual increments in height and bulk, no sign of age ever debased his body, and no expression ever flickered across his face to suggest a personal mood or thought. It was not beyond the capacity of Mewari artists to describe such transitory effects; it was rather a conscious conceptual decision to identify nearly every individual by means of a very restricted set of physical features—sometimes no more than the shape of the nose and eyes, and the cut of the beard—and then to maintain that highly conventionalized form in every circumstance. And when the dictates of court fashion led scions and courtiers to emulate the sovereign's hairstyle, artists ensured that there could be no possible confusion of status by making the maharana alone nimbate, by aggrandizing him physically, and by isolating him at the center or some other prominent focal point of every composition. In the end, the subject of these portraits was not so much an individual to be scrutinized physically and psychologically as much as the royal *presence,* an idea that superseded the importance of any individual who might hold that title for a time.

This portrait of Sangram Singh (reigned 1710–34) shows the maharana promenading with his sons and a few courtiers through an unidentified passageway in the palace. The action is unusually nondescript, representing neither an official duty nor a typical leisure activity. It is, instead, a kind of casual dynastic image, a point indicated by the detailed listing of the figures in a long inscription written on the reverse (see Appendix), but one implied even by the arrangement of the figures. Sangram Singh, identified by his radiant halo and central position, is preceded immediately by his two sons, Jagat Singh and Nathji. Behind the maharana are figures identified (from left to right) as "his prince at hand," Babaji Bharath Singh (cats. 59–60), and Maharaja Sundar Singh; before him are Tulsidasa (in yellow, bearing a *chauri,* or fly whisk); Prince Kisan Singh, son of Maharaja Sundar Singh; and Amar Chand (the *chauri*-bearer in the foreground). The painting can be dated by the age of the heir apparent, Jagat Singh II (born 1709), who is depicted as a youth in a number of other contemporary paintings.[1]

Although the setting is also extraordinarily plain, it subtly reinforces the hierarchy of the family group and imparts the slightest sense of motion to the plodding ensemble. The large gray doorway immediately above Sangram Singh, for example, complements the maharana's central position by extending the central axis to the top of the composition; a smaller doorway performs the same function for the two named *chauri*-bearers before him. Likewise, the wall behind the figures jogs downward just before the two princes, simultaneously marking the end of the central section and strengthening the visual association of the two small princes with their father. The flanking arched doorways, seen in perspective view, provide a modest sense of direction within the composition as well as some relief from the rigid compositional grid. JS

1. See, for example, Sotheby's, London, April 26, 1994, lots 23–25. Several of the other figures depicted in this painting appear in those works as well.

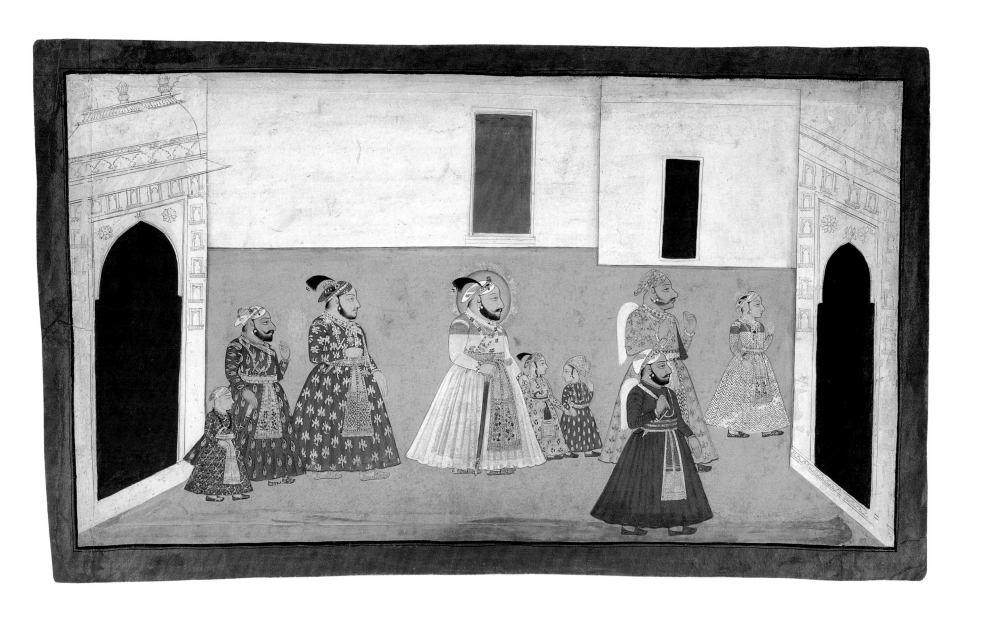

59–60. *Baba Bharath Singh, Dressed and Undressed*

Rajasthan, Mewar, c. 1750
Opaque watercolor and gold on paper
Dressed 17 x 10 1/16 inches (43.2 x 25.4 cm)
Undressed 17 1/4 x 9 13/16 inches (43.8 x 25 cm)

In both physique and movement, most figures in eighteenth-century Mewari painting are strangers to grace. Many, such as the members of Sangram Singh's entourage in *Maharana Sangram Singh of Mewar* (cat. 58), are encumbered by massive heads, stumpy necks, and squat proportions, an inelegant combination exacerbated by the artistic convention of rendering the *jamas* that cloak these bodies as opaque, tentlike forms. This curious physique is found on maharanas and ordinary foot soldiers alike, and so does not appear to denote either good breeding or coarseness, as it does in some other cultures. Nor is it the hallmark of certain artists or ateliers, as it is in some circles in seventeenth-century Europe. Some figures do escape this corporal compression, but on the whole they seem to be either women or figures inhabiting images of a literary nature. The overall impression is that Mewari artists enlarged the heads of figures in portraits or courtly scenes in order to accommodate their growing concern with facial description.[1]

But when Mewari artists did deviate from this conventional stocky body type, they did so with a vengeance. This pair of portraits of Baba Bharath Singh, a member of a lesser branch of the royal family of Udaipur, demonstrates the ruthless possibilities when artistic convention was displaced by callous observation. Portrayed in courtly attire (cat. 59), Bharath Singh takes on mountainous proportions, his sheer bulk emphasized by the solid white *jama*.[2] Both belly and rump protrude well beyond their usual contours, and the portions of the golden sash tied about the waist disappear under the belly's overhang, which is accentuated by the slightly whiter surface of the portion of the *jama* clinging to it. The noble rests his hand lightly on a slender walking stick, a concession to the tottering gait that his enormous girth has imposed. Nonetheless, the formal pose, placid expression, and golden turban lend considerable dignity to the portrait, so the figure's conspicuous corpulence might be shrugged off as an unabashed gesture to reality.

Once we see the accompanying portrait (cat. 60), however, that possibility vanishes, and we begin to suspect that something more insidious is afoot. Stripped to the waist but still turbaned, Bharath Singh is clearly presented as an object of ridicule, as what might conceivably have been construed as stately corpulence becomes unvarnished obesity. The artist draws attention to this condition in the most unflattering way, not only by the obvious means of articulating the mounds of flesh exposed by the absence of an upper garment, but also by the sly one of using two articles of clothing with contrasting stripes and colors to highlight every ballooning bulge fore and aft. Even Bharath Singh's feet, once given a semblance of refinement in luxuriously embroidered slippers, are unshod to reveal blockish forms. The artist provides no pretense for his subject's undressed condition, which in a formal Indian portrait normally would be sanctioned only by participation in some sort of religious ritual.[3] On the contrary, by having Bharath Singh gratify himself with a tidbit, the painter implies that he is devoted to something else altogether.

Baba Bharath Singh was not always depicted with this kind of derision. As a noble of Shahpura, one of the *thikanas*, or fiefs, of Mewar, he appears in a number of Mewari paintings, once even as the primary subject of an equestrian portrait.[4] In three paintings dating from 1736 to 1746, Bharath Singh enjoys a prominent position, close by Jagat Singh II, the reigning maharana; not coincidentally, in those works he is rendered as a man no heftier than any of his companions.[5] The situation seems to have changed in the late 1740s, when Jagat Singh's brother, Nathji, conspired with Baba Bharath Singh to usurp the throne; once the plot was discovered, Bharath Singh fell into disfavor and was banned from Udaipur.[6] This satirical painting of a bloated and undressed Bharath Singh may have been commissioned by Jagat Singh in retribution for his treason.[7]

In addition to the caption in the upper border identifying the subject, each of these paintings bears a series of numbers found on many paintings that once belonged to the royal collection in Udaipur. The first of these are inventory numbers, which place the paintings within specific categories.[8] The second represents a monetary assessment of each painting, a valuation apparently determined by the type of painting and the estimated amount of labor involved in its making. Both paintings are inscribed with a value of twenty-three rupees, an above-average amount for a Mewari portrait, particularly one of a single nonroyal figure. JS

PUBLISHED: Andrew Topsfield, "The Court Painters of Udaipur," *The V and A Album*, no. 1 (1982), p. 186, figs. 6–7; Andrew Topsfield, *An Introduction to Indian Court Painting* (London: Her Majesty's Stationery Office, 1984), p. 36, fig. 28 (cat. 42); Cimino 1985, pp. 7–8, figs. 6–7

1. This same phenomenon of ill-fitting, oversized heads occurs in some Jahangir-period *darbar* scenes, where artists drew the heads and bodies separately because they relied upon model sketches for their portraits.
2. A late eighteenth-century copy of this painting was offered for sale at Sotheby's, New York, May 21, 1981, lot 73. The painting is nearly identical in size, but is harder throughout and has three cloud groups added to the streaky sky.
3. See, for example, a portrait of Sangram Singh bare-headed and bare-chested in a group devotional scene of c. 1725–30 in Topsfield 1980, pp. 78–79, no. 81.
4. See Czuma 1975, no. 67. The painting should be dated to c. 1735 rather than c. 1750, as it is in Czuma's catalogue. Andrew Topsfield (in Cimino 1985, p. 7, no. 6) rightly raises doubt whether these two figures are in fact the same individual.
5. For a painting of a 1736 *rasalila* performance in which he is separated from Jagat Singh only by a prince, see Sotheby's, London, April 26, 1994, lot 34. A work published in Topsfield 1990, no. 10, places Bharath Singh directly behind Jagat Singh on an elephant. For an image of Bharath Singh attending Jagat Singh at an elephant fight of 1746, see Sotheby's, London, April 23, 1996, lot 38.
6. See Topsfield in Cimino 1985, p. 7, no. 6.
7. For another painting of the same period that intriguingly presents an ascetic in the states of dress and undress within the same image, see B. N. Goswamy, *Essence of Indian Art* (San Francisco: Asian Art Museum, 1986), no. 80.
8. The fully dressed portrait is numbered 19/133, and has "134 n. [number]" crossed out; the half-dressed portrait is 19/132, with "133 n. [number]" similarly revised.

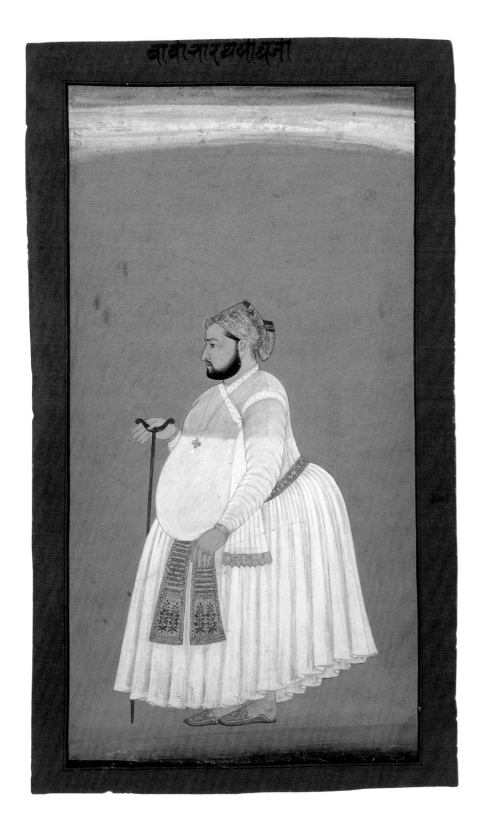

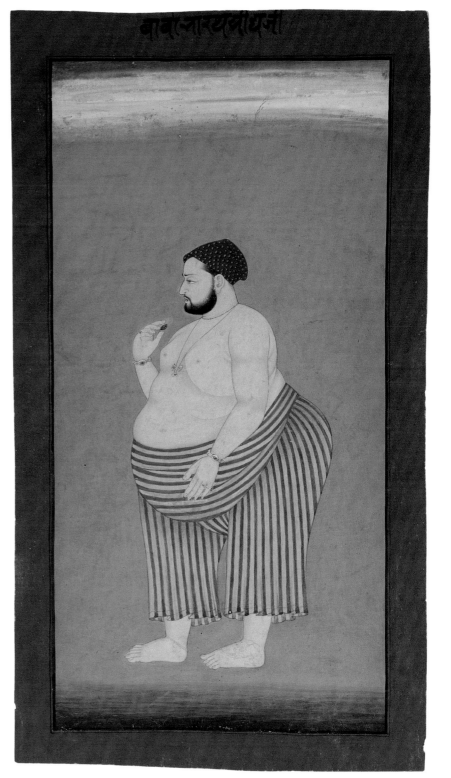

61. *Maharana Jagat Singh II of Mewar Holds a Feast for Yogis*

Ascribed to Syaji
Rajasthan, Mewar, c. 1743
Opaque watercolor, ink, gold, and silver-colored paint on paper
20 5/8 x 34 5/8 inches (52.4 x 87.9 cm)

It is, at first, a most incongruous sight, this throng of naked yogis who daily undertake rigorous physical austerities for their spiritual conditioning, now partaking of a banquet held in a sumptuous palatial setting. In India, however, kings have always recognized that their own authority is only enhanced by association with those credited with spiritual enlightenment, and thus they have made a habit of seeking the counsel of various religious groups and individuals. In this large painting, Maharana Jagat Singh II (reigned 1734–51) is depicted upholding the custom established by his predecessors of paying respects to the leaders of a group of ascetics devoted to Shiva.[1] Rather than journeying to their spartan retreats or receiving only the most eminent members of the sect at court, the maharana hosts a feast for an entire chapter of ascetics in the spacious refectory of his own palace.

The esteem in which Jagat Singh II holds his guests is conveyed in the broad composition, which is so evenly packed and unhierarchical in appearance that for once the sovereign seems to have eschewed most of the privileges of the throne. He is still nimbate, of course, but occupies little more space than other members of the royal entourage, and does not even command their attention. Even the bay that frames him at the right end of the painting is only marginally wider than the nine others that stretch endlessly across the composition. In fact, what draws us to him visually is the concentration of color and gold on the royal figures and the termination of the wavering rows of yogi hair and colorful platters.

Three senior yogis—identified in a long inscription on the reverse as Necalnathji, Kisangirji, and Santhok Puriji—sit to the maharana's right and converse among themselves, while Jagat Singh II directs his gesture of respect toward the two young disciples opposite him.[2] Among the five princes and nobles beside and opposite Jagat Singh II are his brother, Nathji, and his son, Prince Pratap Singh. Pratap

Singh's presence in such a favored position suggests that this is an event that occurred in or shortly before 1743, when he was imprisoned for rebellion.[3] A few trusted fly-whisk-bearers, their mustaches and sideburns grown white over years of service, stand immediately below.[4] Two musicians serenade the ensemble, while only three servants attend to the task of plying the visitors with food. These two ancillary groups are balanced by Rawat Sangram Singh and his attendants, who arrive late but unobtrusively. The four trees flanking the gateway to the compound and the steps to the hall are an attempt to anchor the painting at its center, but these small patches of dark color are simply overwhelmed by the overall lightness of the gleaming white edifice and the vast array of ashen-bodied yogis.

The artist takes obvious delight in the yogis' unusual physical appearance. All are naked, a state mitigated in all but a few instances by strategically crossed legs and extended arms. Some figures are depicted in frontal view, a technically difficult view rare in most periods of Indian painting; others are shown directly from the rear. The artist celebrates their variety, whether in body type, which ranges from bony to plump and from smooth to hairy, or in facial hair, which runs from wispy to dense. And for figures who disdain the distractions of the world, they sport an incredible array of hairstyles. All are matted and colored with dung, to be sure, but some are piled high in a tight snail-shell coil, others fashioned into flattened coils set to one side, and still others layered in a shag cut. Perhaps the most fetching coiffure of all is the splayed set of bristles found on a figure who throws his head back to drink in the lowermost row to the right of the staircase.

These individualized figures are marvels that reward prolonged examination, and collectively they leaven what otherwise might have been a tedious composition. But they also had pragmatic implications as well, for their sheer number transformed the

painting from a modestly priced work to one that commanded the high value of 130 rupees. The inclusion of portraits of Jagat Singh II and the rest of his royal party was certainly a major factor in this assessment as well, but given the relatively small size of these figures, it is very likely that the elevated value is a nod to the amount of labor involved in painting 135 different yogis.

As in many Mewari paintings of this period, the name of the artist, Syaji, is included in the lengthy inscription on the reverse. Syaji is known from at least five other paintings, the latest of which is dated 1760.[5] In most cases, however, he collaborated with one or two other artists. This efficient workshop habit, apparently common in the mid-eighteenth century, has impeded thus far the study of the personal styles of artists active at the Mewari court. JS

PUBLISHED: Spink 1987, no. 42

1. For a reference to images of Mewari rulers and ascetics, see Andrew Topsfield in Spink 1987, no. 42.
2. The inscription (see Appendix), as translated by Andrew Topsfield, reads:

 Shri. Shri Maharajadhira Maharanaji Shri Jagat Singhji [is with] the Jogesvari Math [?] in the Rasora [refectory], [with] Necalnathji, Kisangirji, and Santhok Puriji; the Maharana [Shri Hazur] is seated next to Maharaja Nathji and Maharaja Bakhat Singhji; seated with [or opposite] them are Maharaja Takhat Singhji and Shri Kunvar Pratap Singhji; seated in the middle [of this group] is Thakur Sirdar Singhji. Standing below are the *camardar* Tulsidasa, the *camardar* Manji, the *paryar* Lalji, the *derasari* [?] Harihara, the *tarvari* [or *talwari* (?)/sword-bearer] Ghansyam, the *dhabhai* [foster brother] Devaji. Rawat Sangram Singh arrives in the Presence [with] the *bhai* Goradhan, the *chauridhar* [fly-whisk-bearer] Pitho. By the artist Syaji.

3. Topsfield in Spink 1987, no. 42.
4. One of these figures, Tulsidasa, also appears in a painting made about twenty-five years earlier (cat. 58).
5. In addition to those paintings listed by Topsfield in Spink 1987, no. 42, another is published in Topsfield 1990, p. 53, no. 16.

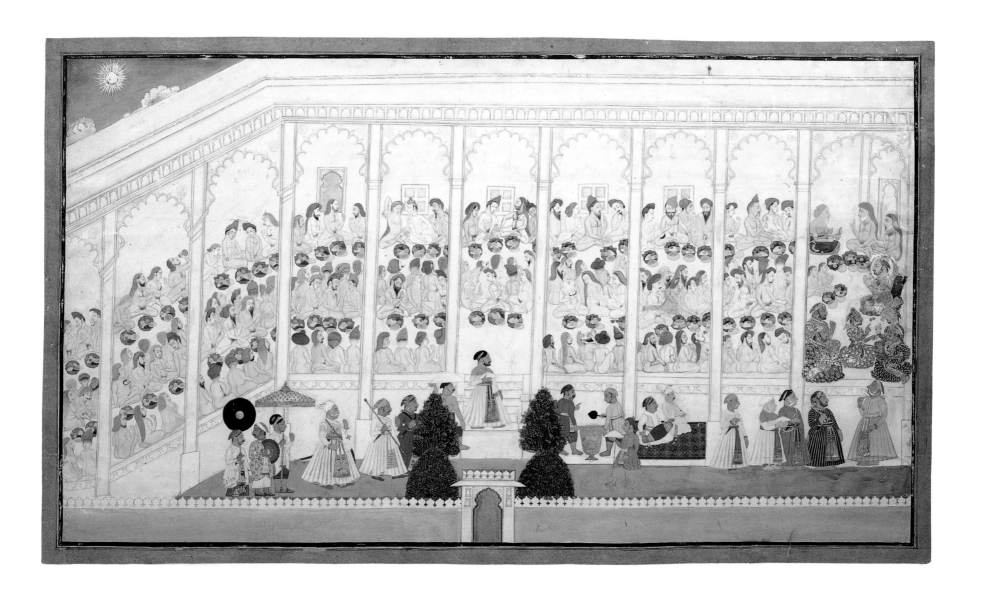

62. Men with Fireworks

Rajasthan, Mewar, c. 1730–40
Opaque watercolor and gold on paper
9 13/16 x 10 inches (25 x 25.4 cm)

The Indian calendar is filled with holidays that both mark the seasons and honor the gods. Among the most important and spectacular of these is Diwali, the festival of lights, which celebrates the end of the rainy season in the month of Karttika (October-November) and pays homage to Lakshmi, the goddess of wealth. As dusk descends upon towns and villages, people everywhere symbolically invite the goddess (and thus prosperity) into their homes by lighting scores of oil lamps all around their dwellings. Colonel James Tod, an English agent at Mewar in the early nineteenth century, described Diwali in this way:

> On the Amavas, or Ides of Karttik, is one of the most brilliant fêtes of Rajasthan, called the Diwali, when every city, village and encampment exhibits a blaze of splendour. The potters' wheels revolve for weeks before solely in the manufacture of lamps *(diwa)*, and from the palace to the peasant's hut every one supplies himself with them, in proportion with his means, and arranges them according to his fancy. Stuffs, pieces of gold and sweetmeats are carried in trays and consecrated at the temple of Lakshmi, the goddess of wealth, to whom the day is dedicated.[1]

Like so many other aspects of daily life, Diwali celebrations caught the attention of Mewari artists. In most cases, they rendered them in panoramic views of the palaces of Udaipur and its neighboring states. A late seventeenth-century Mewari painting, for example, depicts a ruler at Kota under a moonlit sky enjoying the company of a bevy of women in a courtyard illuminated by rows of golden lamps; although the sedate courtyard scene occupies the center of the painting, its sweet sounds are inevitably drowned out by the din of the multifarious activities occurring just beyond the palace walls, where buck fights, acrobatics, impromptu musical performances, and fireworks all convey a general raucousness.[2] Similarly, three paintings made during Sangram Singh's reign feature glowing lamps atop every wall and roof of the palace at Udaipur.[3] In these examples, too, the lamps are part of a controlled environment in which the maharana smokes a *huqqa*, staid retainers assemble in orderly rows, and the palace is seen from such an elevated perspective that it brings to mind the image of a teeming ant colony.

This very original painting presents a different side of Diwali. Unfettered action crowds out serene ceremonies, and blazing fireworks relegate twinkling lamps to unseen domiciles. Men young and old cavort about pell-mell. Most brandish fire sticks, tracing serpentine streaks of light and plumes of smoke against the darkness; a few become incensed in other ways and begin to tussle. The composition, whose center is practically empty and whose lateral edges cut off figures arbitrarily, has no discernible structure whatsoever; indeed, the painting seems more like an enlarged detail than a complete composition. Such an unorthodox presentation is perfectly suited to a glimpse of the boisterous mood of ordinary men at Diwali. JS

PUBLISHED: Kramrisch 1986, pp. 72, 171, no. 65

1. Tod 1971a, vol. 2, p. 695.
2. Topsfield 1980, p. 23, color plate 8; p. 52, cat. 52.
3. Spink 1987, nos. 38–39. A third painting is in a private collection. For Sangram Singh, see cat. 58.

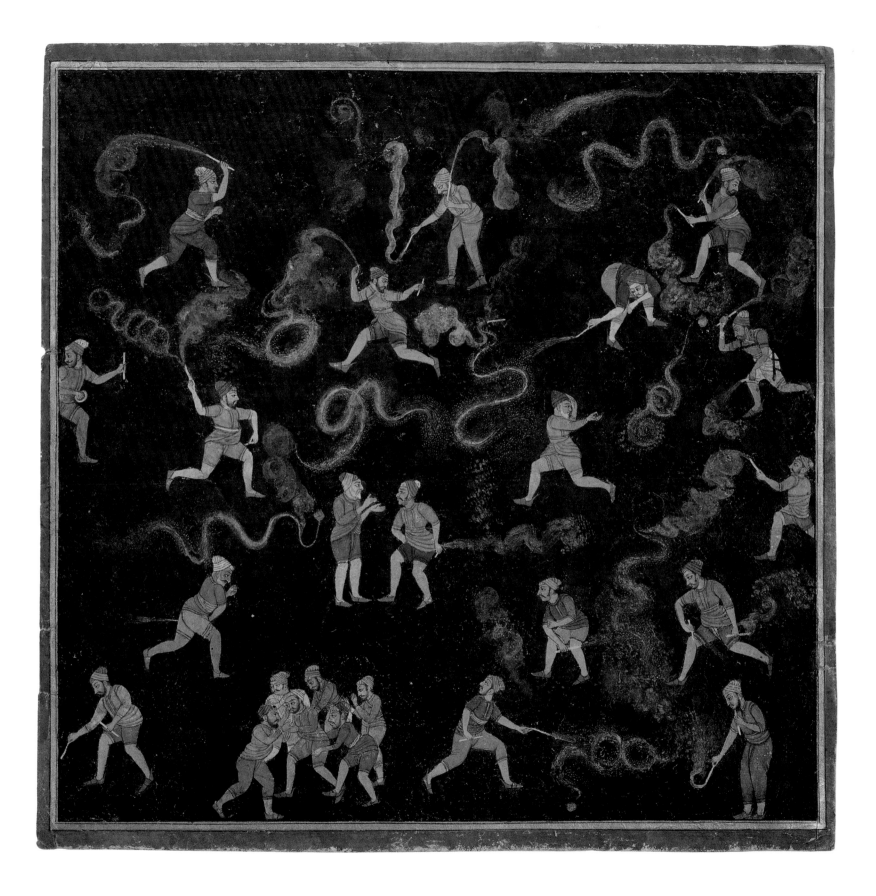

63. A European Concoction

Rajasthan, Mewar, c. 1760
Opaque watercolor, gold, and silver-colored paint on paper
8 15/16 x 15 3/16 inches (22.7 x 38.5 cm)

In India, foreigners attract much attention, not all of it benevolent. Beginning with the Mughals, Indian artists have often looked at European figures with a bemused eye, finding them to have curious faces, exotic clothing and hats, and sometimes strange customs. In most cases, their early encounters with Europeans were not with actual flesh-and-blood individuals, but only with images of them, normally in the form of prints and paintings (see cat. 15). The cultural distancing inherent in this second-hand exposure was compounded by the conventions of an alien visual tradition, which employs shadows where few Indian artists would ever conceive of using them, and iconography that defies immediate comprehension.

In Mewar, homemade images of foreigners became something of a minor genre from the early eighteenth century, a trend apparently inspired by the Dutch East India Company trading mission led by Johan Ketelaar in 1711–13.[1] Many of the subsequent paintings of foreigners depict single standing figures dressed in Dutch fashion, culminating in a broad-brimmed and plumed hat. The general effect of these images is one of exotic dandies with unfamiliar, but still unremarkable faces amplified by luxurious wigs.[2]

This compelling painting is no such neutral display of fashion, but a bizarre image of three quirky characters lounging on a wildly animated carpet. The pair of figures huddled together at left set the jarring tone of the work. Their brightly colored Indian-style robes contrast strongly with each other, but even more so with the long-nosed, light-skinned faces emerging unexpectedly from them. One figure wears an English-style wig of the eighteenth century, but his companion, having abandoned his own wig as well as the decorum it demands, exposes a large, close-cropped pate. Both their expressions, probably originally mirthful, have degenerated into comical leers, an effect carried by their toothy grins, clownishly outlined lips, onion-like arcs of flesh around the eyes, and sidelong glances. Even the hands seem odd. The pliant fingers of the bewigged figure's left hand wrap about the thin stem of a long European pipe, while those of the right contort into a peculiar pinched gesture resting against his companion's forearm. The larger man's right hand comes from anatomical limbo to abut his friend's left hand, thus reciprocating the light embrace. His left index finger is extended to press the opposite side of his nose, a gesture that suggests the use of snuff.

However perplexing this giddy scene is to this point, it is made positively weird by the third adult, who leans forward casually but simultaneously opens his mouth wide to emit a blood-curdling shriek. The provocation for this cry is not apparent at first, but turns out to be a snake that has risen between the figure's exposed ribs, wrapped itself about his scrawny neck, and unleashed its fangs on his chin. Linked to this figure by glance and color are a child and his dog, both implausibly clambering up the pleated robe of the central figure. Around this curious conglomeration of figures is an eddy of tiny creatures. These animals—prowling cheetahs, running deer, entwined tigers and dragons, and assorted goats—nominally pass as motifs on a pictorial carpet, but they are rendered much too three-dimensionally and are interspersed too freely among rocks and lilliputian vessels for anyone to believe for more than a moment that such a carpet—indeed, such a scene—ever existed in India.

Instead, we recognize that the painting is a fantastic concoction of elements drawn from disparate European sources. The intertwined figures almost certainly entered the creative mix as one unit, and the child and dog as another, a fact that would explain their incongruous physical relationship. The screaming figure is surely an independent motif, as can be demonstrated by the existence of two separate paintings of the same snake-bitten figure.[3] Both these works offer a bust-length view of a man facing left and dressed in European clothes, and both naturally depict a snake biting his chin, for it seems that this calamity was always understood as the pretense for the opportunity to render a face contorted by pain. In all three examples, the artists fabricate such an expression with cleft jowls, bared teeth, and a coiled tongue, but they deviate widely from the common model in the arrangement of the hair about the ear and in the very idiosyncratic handling of the facial modeling. One of these comparative images is inscribed with the date of 1764, which places the three variations to the 1760s.

The sources of this inspired hodgepodge remain to be determined. The two figures to the left resemble many a character in the engravings of the eighteenth-century English artist William Hogarth and his contemporaries, while the anguished figure may be derived from studies of physiognomy and expression. The meaning of this strange ensemble is equally enigmatic, but there is no mistaking the satirical bent that the anonymous artist has visited upon this group of Englishmen. JS

1. See Andrew Topsfield, "Ketelaar's Embassy and the Farangi Theme in the Art of Udaipur," *Oriental Art,* n.s., vol. 30, no. 4 (1984–85), pp. 350–67.
2. See, for example, ibid., figs. 8–11.
3. The two unpublished paintings are in the Goenka Collection, and the Jagdish and Kamla Mittal Museum, Hyderabad.

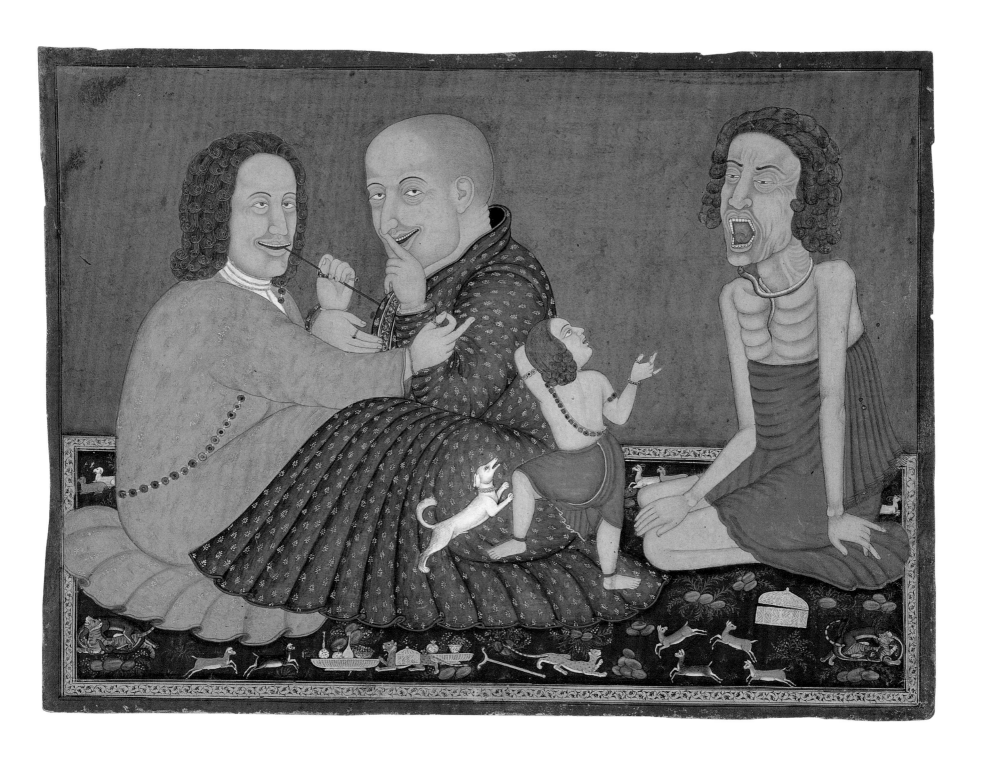

64. Mother and Child

Attributed to Chokha
Rajasthan, Mewar or Deogarh, c. 1810
Opaque watercolor and gold on paper
9 7/16 x 6 7/8 inches (24 x 17.5 cm)

Since the late sixteenth century, when regular contact with Europe was first established, the fantasy life of the Indian male has often been enriched by a persistent theme: the flagrant sexuality of European society, as reflected in the shameless dress and behavior of its female members. With her painted face, uncovered head, bare shoulders, and exposed breasts, the European woman is at once an object of intense and forbidden desire, and a threat to one's religion and soul.[1]

Without an awareness of this idea, one cannot easily understand the strange dynamics at play in the present painting, which is loosely based on a European engraving of a Madonna and Child. These Christian sacred figures would have had very little meaning to a Hindu artist living in Rajasthan in the year 1810. From his point of view, European iconography was a hodgepodge of exotic nonsense. It eluded his comprehension, yet stimulated his daydreams, fantasies, and mirth (see cat. 63).

This compelling image of a tipsy Madonna/provocateur can be attributed to Chokha (active 1799–1824), a brilliantly idiosyncratic artist who worked at the Mewar royal capital of Udaipur and at neighboring Deogarh. Chokha painted another version of this same heavy-lidded beauty, now in the collection of the marchioness of Dufferin and Ava, London.[2] She wears the same sacklike dress with plunging neckline and back-turned sleeves, and occupies the same darkened chamber, lit by a single candle positioned to one side. In the Dufferin and Ava picture, the lady is seated at a dressing table. The painting focuses not on her face, but on her enormous breasts. Given the way that fashion and culture shape ideals of eroticized beauty, it is difficult to know whether Chokha's painting was intended as an act of homage or an object of mirth.

We are on firmer ground with the present painting, as it makes use of the same infant child who appears in one of Chokha's indisputably erotic works (Howard Hodgkin Collection, London).[3] Executed on cotton and inscribed with the single word *phutadya* (a beauty), the Hodgkin picture depicts a nubile Indian temptress arching her back and stretching her hands "overhead in an attitude of love-longing."[4] A chubby child bids for her attention, but his action is ineffective. Infants are generally scarce in Rajasthani paintings. Chokha's eroticized version acts as a stand-in for the artist, or male viewer, himself.[5]

In the present painting, this same kinetic imp has a more active role to play. With face turned to the viewer, he reaches for his mother's neckline to reveal her naked breast. "Mother" attempts to tidy the drinking vessels that "baby" has overturned. But her mind is elsewhere, lost in a private world of her own. The overscaled candle is one of many double-entendre symbols that indicate the probable direction of her train of thought.

This riveting, yet disturbing, depiction of the Oedipal urge represents a high point in the "stippled" phase of Chokha's evolving style. It can be dated to c. 1810, when his interest in modeling in light and shade was most pronounced.[6] TM

1. Afsaneh Najmabadi, "Reading for Gender Through Qajar Painting," in *Royal Persian Paintings: The Qajar Epoch, 1785–1925,* ed. Layla S. Diba with Maryam Ekhtiar (Brooklyn: Brooklyn Museum of Art, 1999), p. 84. For an interesting discussion of the impact of the European woman on nineteenth-century Persian thought, see ibid., pp. 76–85. The sexual paranoia described by Najmabadi was endemic to nineteenth-century India as well.
2. Stuart Cary Welch, *Room for Wonder: Indian Painting During the British Period, 1760–1880* (New York: American Federation of Arts, 1978), pp. 132–33, no. 59. This painting is incorrectly labeled "Bundi, c. 1765."
3. Topsfield and Beach 1991, pp. 106–7, no. 41.
4. Ibid.
5. In both paintings his forehead is marked by a crescent moon. According to Topsfield (in ibid.), this mark denotes the child's Mewar royal birth. Therefore, the probable patron, and intended viewer, was Maharana Bhim Singh (reigned 1778–1828), the lusty ruler of Mewar state.
6. For discussion of Chokha's style and career, see Shridar Andhare, "Painting from the Thikānā of Deogarh," *Prince of Wales Museum Bulletin,* no. 10 (1967), pp. 43–53; Milo Cleveland Beach, "Painting at Devgarh," *Archives of Asian Art,* vol. 24 (1970–71), pp. 23–35; Ratan Parimoo, "More Paintings from the Deogarh Thikānā," *Lalit Kala,* no. 20 (1982), pp. 12–15; Shridhar Andhare and Rawat Nahar Singh, *Deogarh Painting,* Lalit Kala Series, Portfolio No. 16 (New Delhi: Lalit Kala Akademi, 1977); and Topsfield and Beach 1991, pp. 106–7, no. 41.

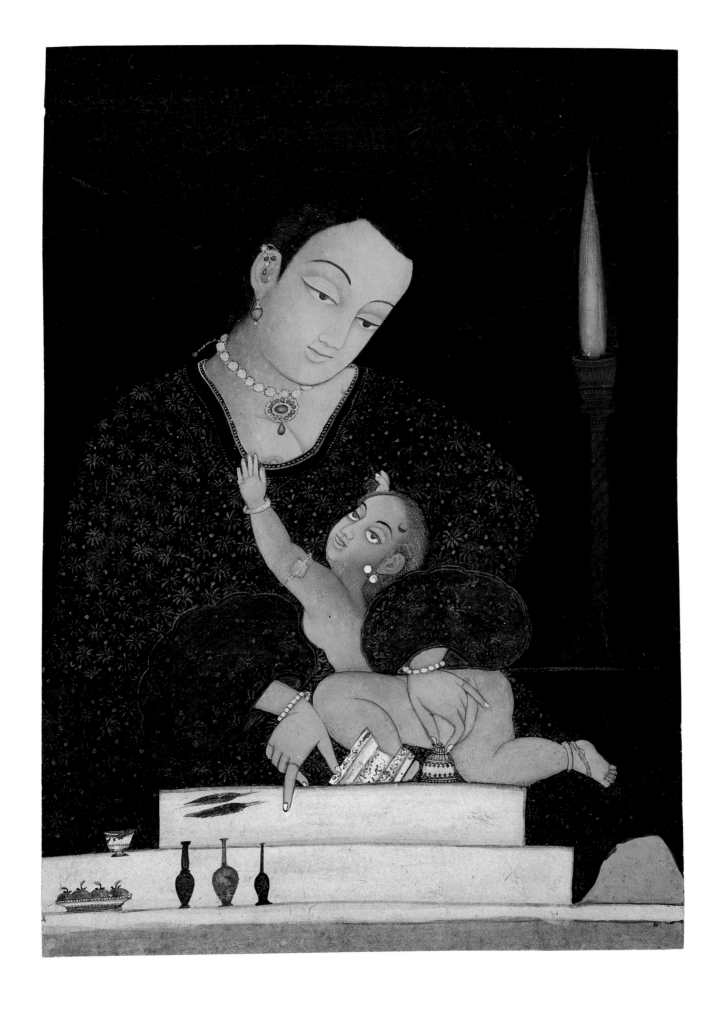

65. An Elephant Combat

Rajasthan, Kota, c. 1660
Ink and transparent and opaque watercolor on paper
10 1/4 x 12 3/8 inches (26 x 31.4 cm)

This wrenching elephant combat is seen from above, that is, from the same lofty vantage that Rao Jagat Singh (reigned 1658–83) of Kota occupied when he viewed the original event. At Kota, elephant combats were staged in a great courtyard near the palace gate. The rao and his principal courtiers watched from a high balcony. On the ground below, a wall three to four feet wide, and five to six feet high, separated the contestants. In the words of the French traveler François Bernier, who was in India at the time this drawing was made:

> The shock [when the elephants make contact] is tremendous and it appears surprising that they should even survive the dreadful wounds and blows inflicted with their teeth, their heads, and their trunks. There are frequent pauses during the fight; it is suspended and renewed, and the mud wall being at length thrown down, the stronger or more courageous elephant passes on and attacks his opponent and, putting him to flight, pursues and fastens on him with such obstinacy that the animals can be separated only by means of cherkys, or fireworks, which are made to explode between them.[1]

This drawing condenses the climatic sequence described by Bernier. Having battered his adversary to pulp, the stronger elephant has vaulted the wall. The two elephants collide in midair, but no final chase will ensue. Disabled by the victor and falling to the ground, the weaker elephant has collapsed, his body an exploding confusion of flattened parts. The impact of this tremendous encounter has sent the elephant handlers flying. As if lifted by a seismic wave, they circle helplessly in a pinwheel at the outer edge.[2]

This great work exemplifies Kota accomplishments in elephant portraiture and drawing—the subject and medium for which this important atelier is widely praised. It can be attributed to the significant artist Stuart Cary Welch has dubbed the "Master of the Elephants" (active 1640–80). Although the master's name is not known, his personality and development as an artist can be reconstructed from a group of mid-seventeenth-century drawings that are clearly the work of a single, highly innovative artist.[3] Welch believes the master was trained in Agra or Bundi, and migrated to Kota shortly after the year it was established as an independent state (1631). In the following decades two great patrons—Rao Madho Singh (reigned 1631–48) and Rao Jagat Singh—and a small group of painters perfected a local style independent of Bundi, Kota's parent state. Because the Master of the Elephants was at the forefront of this activity, his influence can be traced in the work of later generations, including that of his greatest student, the so-called Kota Master (see cat. 66).

Numerous small details allow us to attribute this drawing to the master's existing *oeuvre*. His human figures are particularly distinctive, and variants of the same formulaic character—a stocky, mustached fellow with an aquiline nose, small chin, bulbous torso, and tapering feet—appear in all of his works. The master's elephants are equally distinctive. They wear disproportionately large ornaments and have thickened ankles and stubbed-toe feet. These features allow us to insert this drawing in a chronology of the master's work. It falls midway between a drawing of c. 1650 in the Harvard University Art Museums, Cambridge,[4] and a drawing of c. 1670 in the Howard Hodgkin Collection, London.[5] TM

PUBLISHED: Desai et al. 1985, pp. 52–53, no. 44

1. Quoted in Desai et al. 1985, p. 53, no. 4.
2. For other Kota drawings of this subject, now in the collections of Lisbet Holmes and the Harvard University Art Museums, Cambridge, see McInerney and Hodgkin 1983, nos. 27, 29, respectively.
3. For a discussion of the Master of the Elephants, see Stuart Cary Welch, "Kotah's Lively Patrons and Artists," in Welch 1997, pp. 19–23.
4. Ibid., p. 21, fig. 7.
5. Ibid., p. 20, fig. 6.

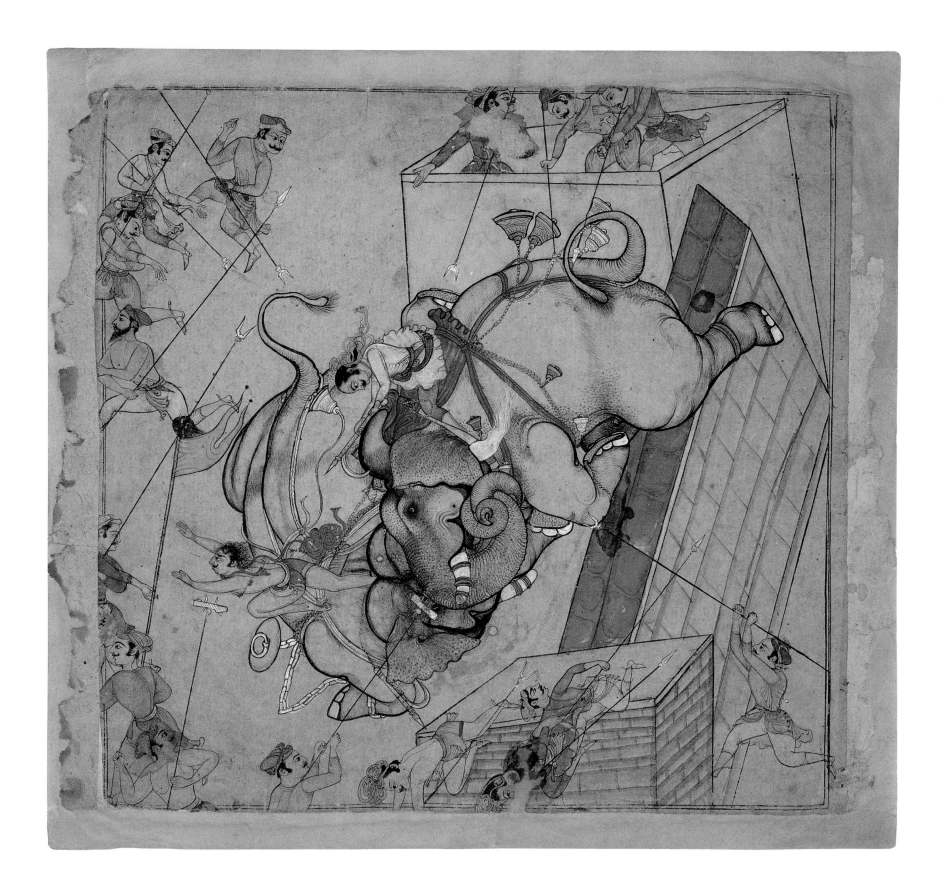

66. Rao Ratan of Bundi

Rajasthan, Kota, c. 1680
Opaque watercolor and gold on paper
11 x 13 3/4 inches (27.8 x 34.9 cm)

This magisterial, posthumous portrait of Rao Ratan (reigned 1608–31) of Bundi is one of the earliest Rajasthani equestrian portraits, and one of the finest. It can be attributed to the great artist that Stuart Cary Welch has dubbed the "Kota Master" (active 1675–1735), although it represents the master's surface-churning style in an unusually restrained guise.[1] This portrait would have been painted for Rao Jagat Singh (reigned 1658–83) of Kota, a direct descendant of Rao Ratan. It was during Rao Ratan's reign that Kota, formerly a part of Bundi state, became an independent territory. A Rajasthani inscription on the reverse of this painting reads, "Court of Rao Ratan."

The level-eyed Rao Ratan, mounted on a spirited charger, is accompanied by two attendants on foot. The friezelike arrangement of figures mimics the general outline of a Mughal equestrian portrait of this date. But the expected celadon green of a typical Mughal background has been warmed to the color of pea soup, and the attending figures have been given an off-kilter propulsion while still overlapping the border, which is equally Rajasthani. This blurring of distinctions reflects the social intermixture and artistic interchange that were transforming regional painting at this time.

Rao Ratan is preceded by a dark-skinned attendant wearing a colorful doublet and feathered turban. The dress and dark skin indicate that he is a native of the Deccan, the Islamicized region in southern India where Rao Ratan spent the greater part of his career (see cats. 40–43).[2] The rao is also accompanied by a second attendant who is waving a long scarf, the curious emblem of honor that is distinctive of a Deccani king. Although both the Deccani groom and scarf are unexpected features in a Kota or Bundi painting, they allude to the major achievement of Rao Ratan's career, one that took him far afield of the provincial backwater that was seventeenth-century Bundi.

As hereditary prince, Rao Ratan was free to rule Bundi without interference from the Mughals. But to contest a larger place in the world, he had only one real option: to enter imperial service subject to the pleasure of his Mughal liege lord. As traditional Rajput fighting skills were highly valued at the Mughal court, Rao Ratan, who was specially known for his skills in combat, found favor with the emperor Jahangir (reigned 1605–27) and was posted to the Deccan, some four hundred miles south of Bundi, where the Mughals had long been waging war with rival Muslim states. Rao Ratan eventually became the Mughal *chargé d'affaires* in the Deccan and was

awarded the title Ram Raj, "of which there is no higher."[3] It is this distinction, earned in the Deccan, that is alluded to here.

Yet the dark-skinned attendant and royal scarf are not the only features that link this painting to the Deccan. Welch believes the Kota Master was himself a Deccani-born artist, possibly owing his whiplash line and often sultry color to earlier training at one of the Deccani courts. He would most likely have joined the Kota atelier after meeting Rao Jagat Singh (reigned 1658–83) of Kota (see cat. 65), a direct descendant of Rao Ratan and another hardened veteran of the ongoing Mughal-Deccani wars. TM

PUBLISHED: Joachim K. Bautze, "Portraits of Rao Ratan and Madho Singh Hara," *Berliner Indologische Studien*, vol. 2 (1986), pp. 87–106, fig. 13; Kossak 1997, p. 58, no. 28

1. For a discussion of the Kota Master, see Welch 1997, pp. 17–30. For a closely related equestrian portrait of Rao Chattar Sal (reigned 1631–59) of Bundi, accompanied by a similarly dressed groom, see Sotheby's, London, October 10, 1977, lot 58. This painting can also be attributed to the Kota Master.
2. For a c. 1680 equestrian portrait of Maharaja Jaswant Singh (reigned 1638–78) of Marwar attended by a dark-skinned servant wearing a feathered Deccani turban, in the Kanoria Collection, Patna, see Crill 1999, pp. 48–49, fig. 27.
3. Bautze 1997, p. 41.

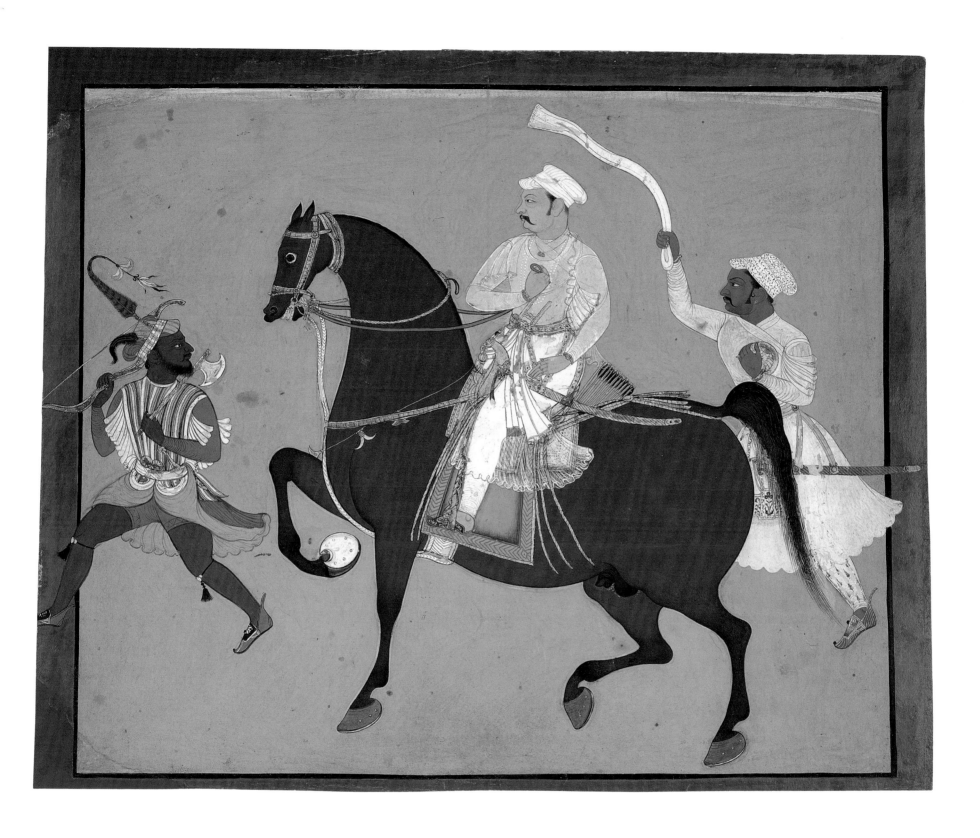

67. Rao Ram Singh I of Kota Plays Nanda

Possibly an illustration from a dispersed series of the *Bhagavata Purana*
Rajasthan, Kota, c. 1700 (mounted on a late eighteenth-century Jaipur album page)
Opaque watercolor and gold on paper
11 3/16 x 9 5/16 inches (28.3 x 23.7 cm)

The infant Krishna, his brother Balarama, and four of their toddler playmates are scampering beneath the watchful eye of Nanda, chief of the cowherding community to which they all belong. Krishna has clambered into Nanda's lap to claim the cache of sweets that his foster father has tried to conceal. Playing with the golden rattles and golden sticks that are symbols of the cowherds, the other toddlers are only dimly aware of the reward that Krishna has seized. Nanda supervises their general bewilderment from a vantage of padded comfort. Seated on a cushion and supported by a bolster, he is attended by a servant holding a *chauri* (fly whisk). This royal emblem is a clue to his actual identity, for within the scheme of this picture, he is not only Nanda, the foster father of Krishna, but also Rao Ram Singh I (reigned 1695–1707) of Kota, the ruler for whom this painting was made.[1] The artist has used Ram Singh's features as a stand-in for Nanda's, a flattering Kota convention that was also mined for gold in other periods.

With its richly colored tiles and picturesquely silhouetted balconies and domes, Nanda's house is the spitting image of the Kota palace. Yashoda, the foster mother of Krishna, is churning butter in the middle distance, framed by a room open to one side. Yashoda is accompanied by a maid who offers assistance, and by two other women who chatter uselessly on her opposite side. It has been suggested that these women are the aggrieved mothers of the infant *gopas* (cowherds),[2] who have come to complain of the impish pranks by which Krishna has pestered their entire community. These misdeeds—including pilferage, vandalism, intentional incontinence, and the eating of dirt—are catalogued in several well-loved passages from the *Bhagavata Purana*, the vast Hindu chronicle of the god Vishnu and his numerous incarnations, including Krishna, the eighth incarnation.

The specific passage Daniel J. Ehnbom believes this painting illustrates is found in Book 10, Chapter 8, Verses 27–31.[3] However, although it may indeed depict these lines, it bears no text to confirm this identification. And the folio has been pasted onto a later album page, leaving no clue as to its original purpose or format. Moreover, even if this painting does illustrate the *Bhagavata Purana* passage cited above, it does so in a remarkably vague and undramatic way. The two women, for example, have not stepped forward to confront Yashoda directly, as described in the text, but merely stand to one side, simpering to one another.

In any event, narrative pith and textual fidelity were not the artist's foremost concerns. His picture is really a painted valentine for Ram Singh I. In the guise of Nanda, the rao presides at the center of the picture; its arduously constructed lines and pretty surface patterns only underscore his primal importance. And there he sits, radiant and relaxed: Ram Singh I, the earthly support of his Infant Lord.

When this painting was mounted as an album page in Jaipur in the late eighteenth century, it was furnished with its present rather coarsely decorated borders in the late Mughal style. A late eighteenth-century Jaipur painting of only very ordinary quality, depicting the adult Krishna seated on a throne, is mounted on the reverse (see Appendix).[4] TM

PUBLISHED: Spink 1987, p. 42, no. 18

1. Daniel J. Ehnbom in Spink 1987, p. 42, no. 18. For a painting from a *Rukmini Mangala* series in which a portrait of Ram Singh I is used as a stand-in for Rukmini's father, now in the Municipal Museum, Allahabad, see Archer 1959, p. 53 n. 1, fig. 33. For other portraits of Ram Singh I, see Milo Cleveland Beach, *Rajput Painting at Bundi and Kota* (Ascona: Artibus Asiae Publishers, 1974), figs. 60, 67 (private collection); and Welch 1997, p. 45, fig. 7 (collection of Mr. and Mrs. Clark Blaise).
2. Ehnbom in Spink 1987, p. 42, no. 18.
3. Ibid. See also Krishna-Dwaipayana Vyasa, *The Srimad-Bhagvatam,* trans. J. M. Sanyal, 2nd ed. (New Delhi: Munshiram Manoharlal, 1973), vol. 2, pp. 34–35.
4. For other Kota paintings from the same Jaipur album, see Spink 1987, pp. 44–51, nos. 19–21.

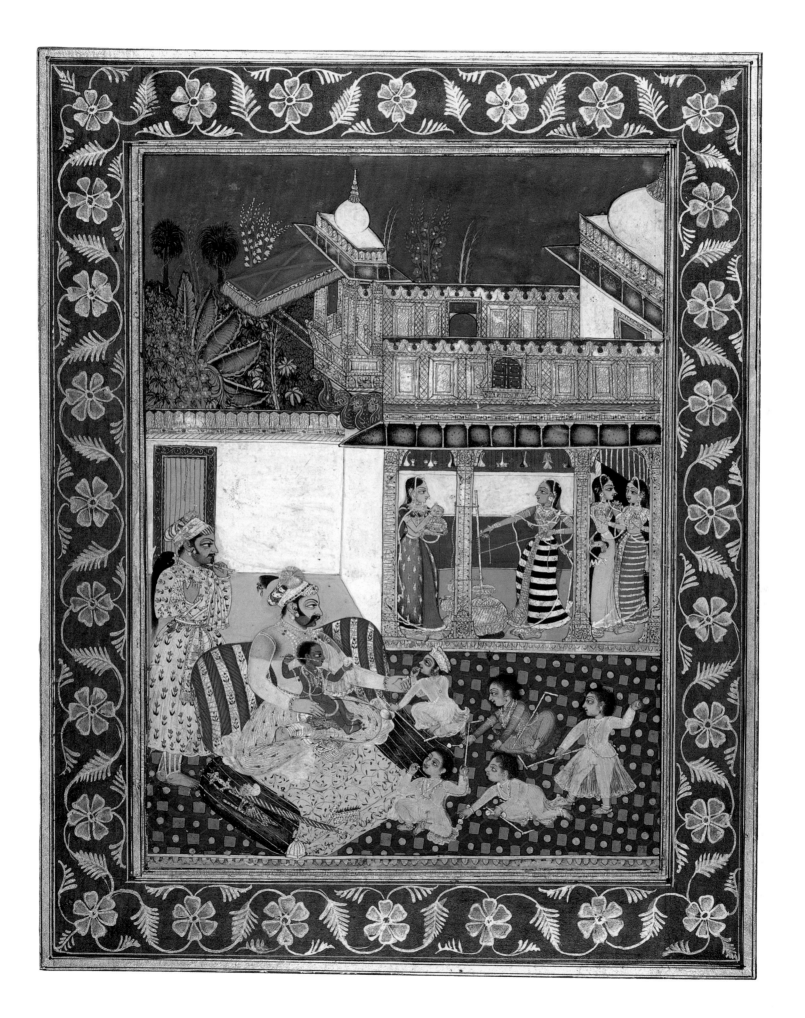

68. *Radha and Krishna Beside a Lake at Sunset*

Rajasthan, Kota, c. 1750
Opaque watercolor and gold on paper
11 3/8 x 8 1/8 inches (28.9 x 20.6 cm)

Radha and Krishna are seated on the ledge of the lakeside *ghat* (stepped platform), surrounded by the bolster, pillows, and broken flower garlands that denote an earlier interlude of lovemaking.[1] Seated in identical attitudes of royal ease *(lalitasana)*, the two figures are so tightly joined that their outlines overlap to suggest a common silhouette. This physical proximity expresses the perfect fusion of their bodies and souls, an ideal condition resulting from love in union *(samyoga)*. On a mundane level, love in union represents the goal of all romantic love. But on a higher level, it represents the reconciliation of the finite and the infinite, and the subsumation of the human in the divine. Both of these ideas are embodied in the love of Radha, a simple village girl, and Krishna, the eighth incarnation of Vishnu.

Seated in a landscape, the divine couple gaze into space, as if transfixed by the riot of nature their presence has provoked. The densely inhabited lotus pond and adjacent jungle teem with life. Paired birds occupy the storm-tossed surface of the lotus pond, or nestle among the trees that line its edge. Like

Radha and Krishna, these creatures are responding to the exuberant life force that has reemerged with the arrival of rain. Following a period of heat and drought, the monsoon, or rainy season, is an annual miracle that occurs between the months of July and mid-September. When water is abundant,

> life wakes and shines, and the forest seems to show its glee in flowering *kadambas* [trees] which are covered with yellow ball-like flowers Rain-clouds drench the earth and the thirsty brown earth suddenly gets covered with a carpet of green grass. Velvet mites, the scarlet *birbahuti* [flowers], and [the] brides of heroes, make the earth look like a pretty woman decked with sparkling gems.[2]

The monsoon is therefore a season of fertility and regeneration, but also a time of love.

A later and coarsened version of this same picture was painted at Bundi, Kota's neighboring state.[3] Its subject has been thought to illustrate the month of Shravana (July-August), one of the prescribed subjects in a *Barahmasa* (Twelve Months) series depicting the various activities and "conditions of love" that characterize each month of the Indian year (see cat. 84). But neither the present painting nor its Bundi copy represents the Teej festival—the standard signifier of Shravana in the Bundi-Kota *Barahmasa* tradition.[4] And neither shows an activity or background that is specific to one rainy month, yet exclusive to another. For these reason, these paintings are probably not *Barahmasa* illustrations, but fully independent, nonserial works. TM

1. There are two short Rajasthani inscriptions on the reverse. The first is illegible; the second appears to read, "Lord of the *Gopis* [Krishna]."
2. Randhawa 1962, pp. 138–39.
3. National Museum, New Delhi, 56108/4; see Jiwan Sodhi, *A Study of the Bundi School of Painting (from the Collection of the National Museum, New Delhi)* (New Delhi: Abhinav Publications, 1999), plate 53. For yet another version, see Sotheby's, London, April 10, 1989, lot 52, plate XXIII.
4. For a typical eighteenth-century Bundi-Kota depiction of Shravana, now in the Victoria and Albert Museum, London, I.S. 552-1952, see Dwivedi 1980, plate 72.

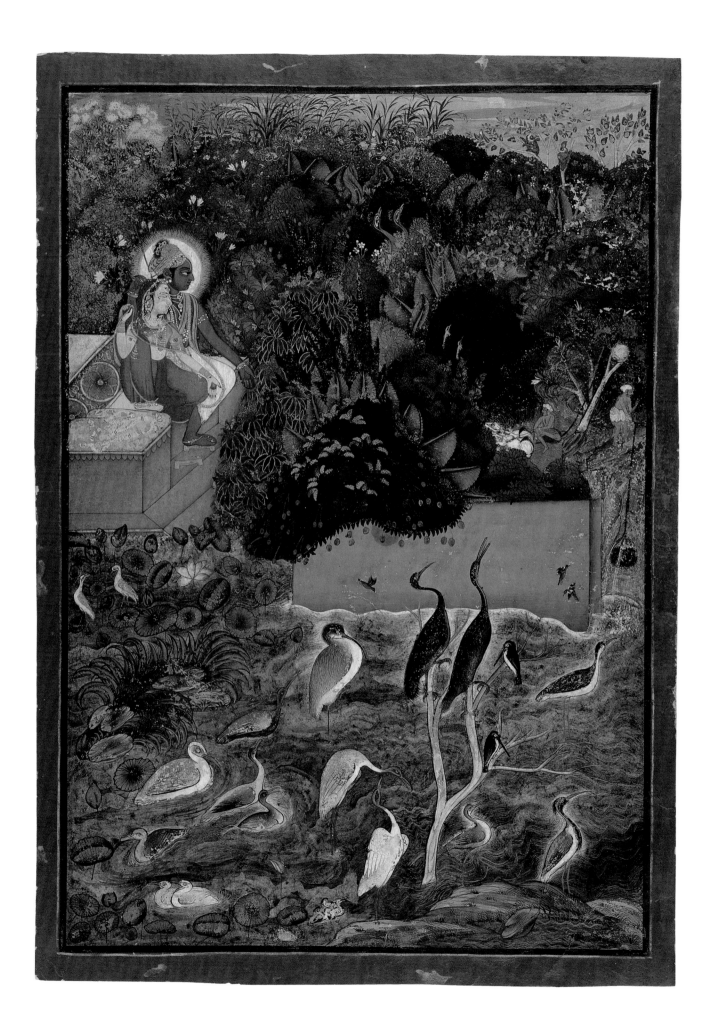

69. *Maharao Shatru Sal I of Kota and Courtiers Celebrate Krishna's Birthday*

Rajasthan, Kota, dated 1764
Opaque watercolor, gold, and silver-colored paint on paper
19 7/16 x 14 1/4 inches (49.3 x 36.1 cm)

According to an inscription on the reverse (see Appendix), this boisterous painting depicts the birthday festival of Krishna (Janmashtami) as celebrated in the principal courtyard of the Kota palace in the year A.D. 1764 (Samvat 1821).[1] As Krishna's birthday occurs in the month of Bhadra (August-September), we know the 1764 festival was the last that Maharao Shatru Sal I (reigned 1758–64) celebrated: he died about three months later, that is, on December 17 of the same year.

In this painting the nimbate and still healthy-looking maharao stands at the center of a riotously skewed composition, his figure a stable upright outlined by a tilted rectangle of brilliant white. Shatru Sal I is gazing with adoration at the tiny golden image of Krishna, and his equally small consort, that occupies the flower-bedecked swing that has been installed in the Raj Mahal section of the Kota palace. This small golden image is a representation of Brijnathji, a form of Lord Krishna associated with the Vallabha Sampraday community, to which the Kota royal house and a majority of Kota's Hindu population belong.[2] The image depicted here is a representation of the actual icon that was given to an earlier Kota ruler, Maharao Bhim Singh (reigned 1707–20), in the year he became a follower of the Vallabha Sampraday. Bhim Singh installed this small golden statue in a special shrine in the Kota palace. And from 1719 until the present day, it has been regarded as the tutelary divinity, and the most sacred possession, of Kota state.[3]

Traditionally the Janmashtami celebration begins around midnight with the sighting of the new moon. In this depiction, a white smear in one corner of the inky sky indicates that the 1764 celebration has already begun. Brijnathji has been bathed, and *arati* (the circling of oil lamps) and *puja* (the presentation of honor offerings) have been performed. Brijnathji has also been offered *prasad,* food that he has consecrated and returned. In the ceremony depicted here, this grace of the Divine Lord is being distributed to the courtiers who are standing in the lower right and at the center left. The principal devotee, Maharao Shatru Sal I, presides at the center, accompanied by his youthful commander in chief, Zalim Singh Jhala, who wears the Bundi-style turban that denotes his foreign birth.[4] The maharao is also accompanied by three attendants who mimic his attitude of adoration, but with their gaze directed not at Brijnathji, but at Shatru Sal himself. (According to certain Kota traditions, maharao and god are to some degree interchangeable.) Dressed in saffron-colored garments appropriate to the occasion, courtier-devotees line the walls of the enclosed courtyard, while female singers, standing at the rear, perform *bhajans* (devotional songs) as if prompted by a frenzy of uncontrollable emotion.

These festive and sacred rites unfold in the Raj Mahal section of the Kota palace, where the maharao normally received important visitors and conducted public affairs of state. This symmetrical, two-story structure contained an imposing throne room on its ground floor. This room was partially enclosed by a verandah, and fronted by a spacious courtyard and ornamental pool. (At present, the Raj Mahal and its courtyard still retain much of their original appearance, but the pool no longer exists.) As the marble pool evoked the mythical lake where Krishna once dallied with Radha (see cat. 68), the Raj Mahal made an appropriate backdrop for the celebration of Janmashtami. But the setting conveyed another idea as well. As Brijnathji is being honored not in the temple where he is normally housed, but in the throne room of the royal palace, his presence underscores a belief that had been current since the days of Maharao Bhim Singh: Brijnathji is the actual ruler of Kota state. TM

PUBLISHED: Bautze 1987, figs. 9–10

1. Sorting out the Rajasthani inscriptional material on the reverse is complicated, as the three principal inscriptions were written in two different places, at three different times. After the painting was finished, it was inscribed at Kota with the following notation: "A painting of Janmashtami as celebrated in the informal sitting place of the Raj Mahal [section of the Kota palace]." Shortly after, the painting was sent by Zalim Singh Jhala, the commander in chief at Kota, as a gift to Maharana Ari Singh of Mewar. After the painting had arrived there, it was inscribed again (in a different hand): "This painting was sent as a gift by Jhala Zalim Singh of Kota. [Received] on the first day of the month of Agrahan [November-December] Samvat 1821 [A.D. 1764]." Twenty days later, it was inscribed once again: "Entered in the records on the fourth day of Pausha [December-January], Samvat 1821 [A.D. 1764]."
 This painting has a known Mewar provenance. As it had remained in the Mewar royal collection until relatively recent times, it also bears a number of typically Mewar archival notations on its reverse. For discussion of the three inscriptions, see Bautze 1987, p. 268 n. 3.
2. Woodman Taylor, "Picture Practice: Painting Programs, Manuscript Production, and Liturgical Performances at the Kotah Royal Palace," in Welch 1997, p. 61.
3. For discussion of the Brijnathji cult at Kota, see ibid., pp. 61–72.
4. Zalim Singh Jhala would become the *éminence grise* at Kota during the late eighteenth and early nineteenth centuries. For discussion of his career, see Bautze 1997, pp. 50–54.

70. A Prince Restrains a Rampaging Elephant

Rajasthan, Kota, c. 1780
Opaque watercolor, gold, and silver-colored paint on paper
11 7/8 x 17 1/2 inches (30.2 x 44.5 cm)

A skittery elephant is bounding across an empty field, harried by a posse of human enforcers. Neither the pointed goad *(ankush)* of his master, nor the pikes and whirling firecrackers of his handlers *(sat'maris),* nor the whip of the approaching horseman has any power over him. With barely a nod, the elephant rushes onward.

Paintings of elephants were a staple of seventeenth-century Kota art, when the greatest works in this genre, unrivaled in their energy of line and sense of mass in motion, were first produced (see cat. 65). But the heroic age at Kota did not survive the middle years of the eighteenth century, and by the time this charming painting was made, court painting had entered a period of relative decline. Rather than invent new models, painters revised or adapted existing models. The results were quite attractive, as earlier product was usually repackaged in an elegant,

fin-de-siècle box. But as the obsession with style for style's sake gained strength, painting lost touch with actual experience.

This fine picture retains something of the power and immediacy of its now-lost seventeenth- or early eighteenth-century Kota model. But its intensity is only surface deep—an effect of line, shape, and decorative pattern. As in earlier Kota paintings, the elephant has been carefully modeled. But its body lacks believable structure, and its movement is not natural or convincing. The extended forward leg has the shape of an elegant object, not the outline of an elephant in flight. The human figures have virtues and deficiencies of the same kind. Their bodies compose a syncopated counterpoint at the edge of the picture, but their limbs are so rubbery and disjointed that the figures appear to swim rather than run in space. In the hands of a fine painter, willful distortions like

these can result in the delightful configurations of pattern and line that a more painstaking delineation of form will rarely achieve.

The figure wearing royal dress is perhaps Maharao Umed Singh I (reigned 1771–1819) of Kota,[1] as Kota paintings of his period have the same enamel-like intensity of color and the same spider's-web evenness of surface and line. Another Kota (or possibly Bundi) painting of this date makes use of a slightly different variant of the same composition.[2] TM

1. For other portraits of Umed Singh I at approximately the same age, see Welch 1997, pp. 164–70, nos. 45, 46; pp. 172–79, nos. 48–51; and Joachim K. Bautze, "A Second Set of Equestrian Portraits Painted During the Reign of Maharao Umed Singh of Kota," in *Indian Painting: Essays in Honour of Karl Khandalavala,* ed. B. N. Goswamy with Usha Bhatia (New Delhi: Lalit Kala Akademi, 1995), p. 40, figs. 4, 5; p. 44, fig. 9.
2. Now in a private collection; see Cimino 1985, p. 90, no. 89.

71. Krishna Holds Aloft Mount Govardhana

Page from a dispersed series of the *Satasai* of Bihari
Central India, Bundelkhand, Datia, c. 1770
Opaque watercolor, gold, and silver-colored paint on paper
8 7/8 x 9 1/4 inches (22.6 x 23.5 cm)

The poetry in white in the upper border of the painting reveals that the page was originally part of an illustrated series of the *Satasai*, the monumental poem of the poet Bihari (1595–1664). Bihari spent his life moving among several cities in or near Braj, the area around Mathura and Agra, called by various rajas and Shah Jahan to employment as court poet in much the same way that painters moved among Indian courts when work was available. When Bihari was still a child, he and his father left their natal place Gwalior to join the circle of the great poet Keshavadasa (see cats. 20–22, 84) at Orchha. Father and son moved with the poet to Vrindavan, Krishna's childhood home, near Mathura, and the center of the *bhakti* movement (the religion of devotion especially directed toward Krishna). Eventually, after several years at the Mughal court at Agra, Bihari returned to Vrindavan before moving to Amber, where he was the court poet for Mirza Raja Jai Singh. At Amber in 1647 he completed the 713-verse poem, the *Satasai* (literally the "Seven Hundred").[1] Written in Brajbhasha, the Hindi dialect of Braj, the *Satasai* addresses every aspect of love in its many forms, both carnal and divine.

The poem here illustrated can be translated:

*When the assemblage of clouds
began to pour at Indra's command
as though they would cause
the world's dissolution,
Kṛṣṇa lifted the Goverdhana [sic] mount
on his hands
And destroyed
Indra's arrogance.*[2]

The story referred to and illustrated in the painting is as follows (see also cat. 32). Krishna found his friends the cowherds (*gopas*) preparing to worship Indra, the Lord of the Heavens and God of Rain. When he asked why Indra was to be the object of veneration, they replied that Indra was the all-powerful Lord of the Rain, who granted water, which is the life of living beings. Krishna asked them instead to worship the mountain Govardhana, and said that if they did, the spirit of the mountain would be revealed. The *gopas* agreed to do so. Krishna himself became the spirit of the mountain and received their offerings.

Furious at being replaced, Indra sent a dreadful storm of the worst kind of destructive clouds to punish the *gopas* and *gopis* and their cattle. But Krishna lifted the mountain like an umbrella over his friends and the cattle, and held it up on one finger for seven days. Indra then understood Krishna's power, relented, asked Krishna's forgiveness, and was pardoned. As with other of the fantastic tales in the *Bhagavata Purana*, from which this episode is adapted, the story contains an underlying moral message: pride dispels knowledge, allowing evil to become manifest.

In the painting, the *gopas*, *gopis*, and their cows adore Krishna, who easily stands on one foot while holding Govardhana aloft with his left hand. The rain comes down in torrents from a black sky filled with lightning and is deflected away from them all by the massive mountain. The somewhat stiff composition, with groups of adoring figures on either side of the Krishna figure above two groups of cattle along the lower margin, is often seen in *picchawais*, the backdrops of painted cotton that hang behind the images in temples to Krishna.[3] The nearly square shape and the blue-black borders with the couplet written in white across the top make the set of paintings from which this comes unusual and easy to identify. The group is associated with Datia not only because of the chunky, long-limbed, small-headed human figures, but also because the pages are stamped on the versos with a Datia state seal (see Appendix). The number 25 in the left margin indicates the place of the verse in the arrangement in this particular Datia set of Bihari's 713 couplets. The couplets are arranged in various orders in different editions of the *Satasai*.

There is at present no way to know if the complete late eighteenth-century Datia *Satasai* included the entire 713 stanzas of Bihari's work. However, there are pages from it scattered throughout the world in collections of South Asian painting.[4] The set, or perhaps one volume of it, was apparently broken up at the beginning of the last great period of selling and buying Indian painting; the earliest sale in London of paintings from the Datia *Satasai* seems to have been at Christie's in 1968.[5] ES

1. Krishna P. Bahadur, "Introduction," in Bihari, *The Satasaī*, trans. Krishna P. Bahadur (Harmondsworth, Middlesex, England: Penguin Books/UNESCO, 1990), pp. 15–16.

2. Ibid., p. 300, no. 686.

3. See Robert Skelton, *Rajasthani Temple Hangings of the Krishna Cult from the Collection of Karl Mann, New York* (New York: American Federation of Arts, 1973), nos. 3, 9.

4. Other paintings from this set are in the San Diego Museum of Art (1990:988, 1990:989, 1990:990 [Portland 1968, p. 65, no. 50]); and the John Kenneth Galbraith Collection (Welch and Beach 1965, p. 87, no. 43). Edwin Binney (in Portland 1968, p. 65, no. 50) mentions that some pages are also reproduced in Maggs Brothers' *Oriental Miniatures and Illumination*, Bulletin No. 5, but neglects to say how many or to give the complete reference. In three issues of their bulletin, Maggs Brothers published several of these pages, and there are no doubt more in other numbers from their series not at present available to this writer. See Maggs Brothers, London, *Oriental Miniatures and Illumination*, Bulletin No. 23 (March 1975), p. 119, nos. 148–50; Bulletin No. 24 (December 1975), p. 179, nos. 220–22; Bulletin No. 29 (September 1978), pp. 4–5, nos. 18–20.

5. Christie's, London, December 18, 1968, lots 175–80. Another page was sold at Christie's on June 25, 1969, lot 78.

72. *The Lover Rides His Horse Far into the Pond to Let Him Drink*

Central India, Bundelkhand, c. 1800–1825
Opaque watercolor on paper
13 1/8 x 17 3/4 inches (33.4 x 45.2 cm)

An unknown artist has followed the couplet of poetry on the reverse of this painting— "Riding far into the pond, he lets his horse drink./ In their hearts, the maidens were greatly astonished to see him do this."—to produce an image that faithfully illustrates the words (see Appendix). As yet, the painter, the poet, and the poem remain obscure.

The man has, indeed, ridden his horse into the middle of a shallow pond to let him drink. Across the pond a group of village women see him in the water. Full of lotus leaves and upright flowers, the pond is populated with saras cranes, ducks, and other waterfowl. A host of animals, from wild boar to big cats, inhabit the surrounding jungle. Many of the different types of trees that make up the forest around the lake are in flower, perhaps an indication that the event takes place in the spring, when trees bloom, sending fragrance through the air, bees buzz, and separated lovers are particularly miserable. Tension is created by the fierce acid green of the ground and by the sharp zigzags of the shore that separate the rider from the group of women and point to him from both sides of the pond. The busy concentric ripples stirred up by the thirsty steed provide a jolt of energy.

Very often written in rhyming couplets, the classic Hindi love story, or for that matter any love story written in a South Asian language, includes, among other events: lovers being separated for lengths of time, great longing of each for the other, *sakhis* (girl-friends of the young woman) playing crucial roles in reuniting the pair, chance meetings, and a definite awareness of months and seasons of the year. For instance, the *Barahmasa*, or "Twelve Month," form of poetry, which appears in both the vernacular and literary traditions in North India, describes each of the twelve months of the year, with a couplet or stanza devoted to each month (see also cat. 84).[1] It is not difficult to fit the painting into such a story, but until the text is positively identified, the following explanation of the painting must remain conjecture. As one of the women in the painting carries water vessels, she has come with her friends to the lake to take water back to the village. They are astonished to see their friend's lover ride his horse all the way into the pond to let him drink (because people usually stop at the shore? because they recognize him and know he was not expected to be in the vicinity?), and will take the news that he is back to their friend.

What one cannot see, of course, is the painting meant to precede this one, nor the one that comes next. Two sets of numbers, 15 on the front and 13 on the reverse, reveal that the painting is one of a series. The discrepancy may be due to there having been two pages without paintings, perhaps with title and text, at the beginning. Sets of illustrations more often than not were left unbound, but usually were numbered. A third number, 105, may refer to the place of the painting in a larger series, if the 13 and 15 refer to its place in a chapter or other section of a larger work. Were the unknown paintings available, the meaning of the couplet and of the Bellak picture would become clear. Sets of paintings illustrating stories were meant to be viewed in sequence. Other paintings from this group have not yet been identified.

The particular court at which the painting was produced also remains unknown, but the language of the couplet and the amorphous characteristic style of the painting suggest an origin somewhere in the north-central region known as Bundelkhand. The use of gold reveals that the patron was prosperous. Whereas the crude drawing of the women, mountains, wildlife, and trees indicates a provincial, untrained hand, the psychedelic colors, shorelines, and water swirls are the work of a wild imagination. ES

1. Charlotte Vaudeville, *Barahmasa in Indian Literatures: Songs of the Twelve Months in Indo-Aryan Literatures* (Delhi: Motilal Banarsidass, 1986), p. 3.

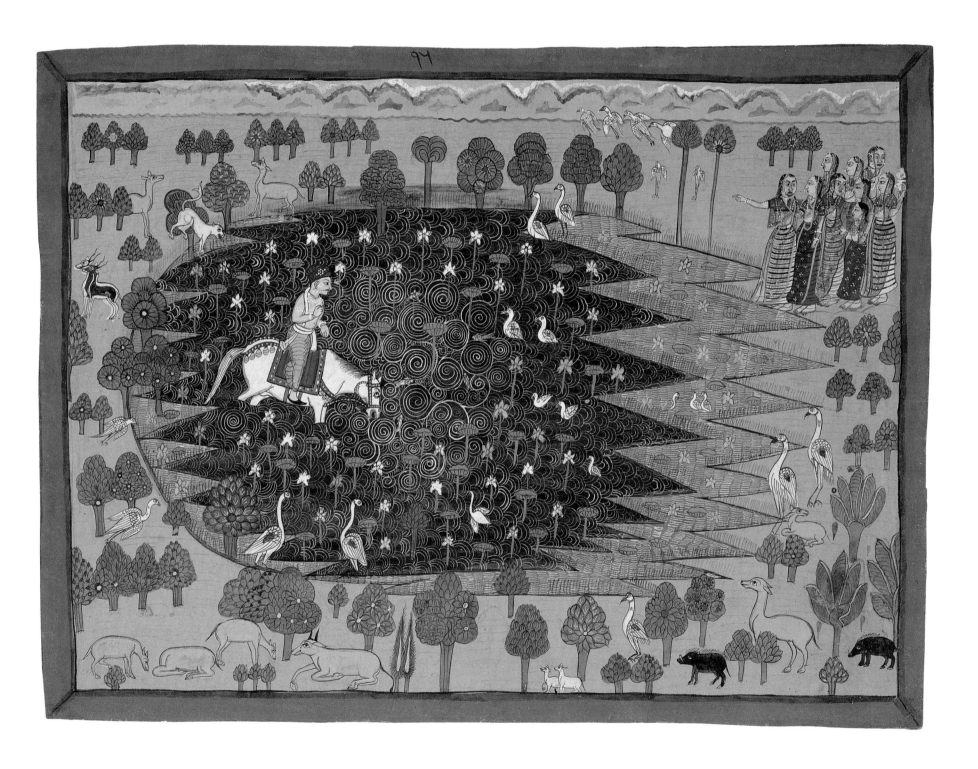

73. *Maharao Ram Singh II of Kota Spearing a Buffalo*

Rajasthan, Kota, dated 1854
Transparent and opaque watercolor, ink, and silver-colored paint on paper
14⅝ x 18⅞ inches (37.1 x 47.9 cm)

Ram Singh II (reigned 1827–66) of Kota was the last great patron of Indian court painting (see cats. 74, 75). In the years following his death, with the downfall of the Mughal emperor in 1858 and the ascendancy of the British raj, traditions that had inspired earlier generations of court patronage fell into disrepute. Native princes adopted the Eurocentric taste of their viceregal rulers, and inherited court painters were gradually discharged (see cat. 90). Patronage continued at Kota until about 1890, and at the smaller or more conservative states until about 1910 or even later.[1] But this later court painting survived in a kind of twilight world, its purpose lost along with the understanding of earlier patrons like Ram Singh II.

This painted sketch of 1854, which was a preparatory drawing for a finished work, reflects the foundation in craft that had sustained Kota's workshop tradition during its glory days.[2] Mounted on a horse, Ram Singh II is pursuing the fleeing water buffalo he has speared. Wearing body armor and a visored helmet, the maharao is followed by three attendants who carry his royal regalia (parasol, fly whisk, and peacock-feather fan) and an unsheathed sword. Once the maharao has weakened the water buffalo with repeated thrusts of his spear, the sword bearer will draw near, and Ram Singh will finish the beast with a *coup de grâce*.

This drawing illustrates an event that took place every year.[3] To celebrate his birthday, Ram Singh II would hunt a water buffalo—a very dangerous animal when challenged—on the field of the Kota polo grounds. This drawing depicts that grass and scrub polo field, but not the invited guests or excited hoi polloi who would have applauded from the sidelines.

Another preparatory study, drawn by the same artist for the same painting, is in the collection of the Victoria and Albert Museum, London,[4] and represents an earlier stage in the long process that resulted in a finished work. In the London study the outlines of Ram Singh II and his horse have been finalized, but the drawing lacks the attending figures, landscape elements, and body color that are visible in the present work. Many other preparatory studies for this painting—running the gamut from initial sketches to more fully detailed studies—would have been produced but have not survived. However, the finished painting itself, or a related version completed the following year, has survived, and is in the Chester Beatty Library in Dublin. Dated 1855, this brilliantly colored picture is masterfully put together, rather like a couture dress, its surface an interlocking structure of line, pattern, and silhouette.[5] All of Ram Singh's greatest paintings would have had a similar evolution, and foundation, in drawing (see also cat. 74). TM

1. For a discussion of later court painting at Udaipur, which survived until about 1945, see Topsfield 1990.
2. A lengthy Rajasthani inscription in the upper right incorporates the date and a description of the event.
3. Joachim K. Bautze, personal communication with the owner, September 15, 1987.
4. I.S. 311-1952; see Archer 1959, fig. 49.
5. Leach 1995, vol. 2, p. 1006, no. 10.45; p. 1016, plate 146. For a related painting of Ram Singh II hunting a water buffalo in a jungle, see Colnaghi 1978, pp. 64–65, no. 72. For a related painting of him hunting a water buffalo on the occasion of the Dasahra festival, see Joachim Bautze, "Scenes of Devotion and Court Life: Painting Under Maharao Ram Singh of Kota," in Topsfield 2000, p. 137, fig. 15.

74. *Maharao Ram Singh II of Kota*

Rajasthan, Kota, c. 1840–50
Transparent and opaque watercolor and ink on paper
15 x 10 1/4 inches (38.1 x 26 cm)

This drawing displays the idealized physiognomy that was partially invented by Maharao Ram Singh II himself. An earlier portrait of c. 1833 is less idealized, revealing the pockmarked skin, flabby lip, and fishbowl eyes that were integral to Ram Singh's natural appearance.[1] But such verisimilitude was obviously not to the young maharao's liking, and from about 1836, his portraits acquire the softened and relatively harmonized features that are visible here. A rare portrait photograph of c. 1865, taken when Ram Singh II was about fifty-seven years old, captures the aging and rumpled aspects of his appearance that court painters had been trained to ignore.[2]

No Kota ruler was painted more often than Ram Singh II (see also cats. 73, 75), but head-and-shoulder portraits are reasonably rare.[3] In this example the maharao is wearing the trademark headdress that he designed for himself—"a coneless, flat turban with a peak above the forehead, resembling the cap of a contemporary Britisher."[4] His facial expression is remarkably vivid, and there is no softening architectural frame to lessen the impact of his physical presence.

Drawn from memory rather than life, this sheet displays a mastery of outline that sets it apart. The artist has drawn these features so many times before he has purged their contours of any hesitancy of doubt. One curve engenders an answering curve. One organic shape mimics another. This controlled yet buoyant line is characteristic of Ram Singh's finest artist, an anonymous painter who also created a remarkable series of devotional pictures (c. 1831)[5] and two great paintings on cloth (c. 1842[6] and c. 1851[7]). "He perpetuated," writes Stuart Cary Welch, "Kotah's draftsmanly tradition by sketching everything that crossed his path, animals included."[8] This foundation in drawing gives the figures and objects in his painted works a characteristically precise and solid structure.

This example of the master's skill in drawing is actually the study for a miniature or mural painting of the same size. It incorporates two separate stages of work: an initial underdrawing in diluted tones of ink, and a final overdrawing in black. The overdrawing is heightened with a network of parallel lines to indicate shading and touches of transparent gouache to indicate color. These *aides-mémoires* would guide a later stage of work, that is, the completion of a fully colored version. TM

PUBLISHED: McInerney and Hodgkin 1983, no. 6

1. San Diego Museum of Art; see Bautze 1997, p. 53, fig. 14.
2. Sven Gahlin Collection, London; see ibid., p. 55, fig. 15.
3. For other portraits of Ram Singh II, see Joachim Bautze, "Portraitmalerei unter Maharao Ram Singh von Kota," *Artibus Asiae,* vol. 49, nos. 3–4 (1988–89), pp. 316–50.
4. Bautze 1997, p. 56.
5. Rao Madho Singh Trust Museum, Fort Kota; see Welch 1997, pp. 186–201, nos. 55–62.
6. Rao Madho Singh Trust Museum, Fort Kota; see Welch 1985, pp. 429–33, no. 285.
7. Topsfield and Beach 1991, pp. 108–9, no. 42.
8. Stuart Cary Welch, "Kotah's Lively Patrons and Artists," in Welch 1997, p. 35.

75. Maharao Ram Singh II of Kota Riding His Horse on the Palace Roof

Ascribed to Namaram
Rajasthan, Kota, dated 1851
Opaque watercolor and gold on paper
20 3/4 x 27 15/16 inches (52.6 x 70.9 cm)

A frontal elevation of the Kota palace occupies the greater portion of this large picture, squeezing its foreground and background into a single plane.[1] The building is eerily empty except for an assembly of figures on its highest roof. In this incongruous setting, the invited courtiers and other guests (including Mr. Morrison, the local British political agent, who is dressed in black) have gathered to watch Ram Singh II (see also cats. 73, 74) ride a horse on the top of his palace. Only the vast height of the supporting building suggests the type of challenge that made the event worth staging.

The episode depicted here is not an escapist fantasy: it actually took place, as a commemorative tablet in the Kota palace proves beyond doubt.[2] The year was 1850, when Ram Singh II rode a horse that had been guided to the roof by means of a specially constructed wooden scaffolding.[3] Mr. Morrison and a number of the most important nobles and courtiers were in attendance. Later in the evening the maharao hosted a special *darbar* (court assembly). All of the decorations were pink, and the guests were asked to wear clothing and turbans of the same color.[4] The *darbar* "was followed by rounds of jolly festivities enlivened with drinks and a sumptuous feast."[5]

Ram Singh II had a practical joker's sense of humor, which he exercised at will. Other paintings of the period depict him riding an elephant on the roof of the palace, or shooting a tiger while making love. One might easily assign these pictures to a realm of fantasy or myth, but the present, equally outlandish painting depicts a historically verifiable ocurrence. This basis in fact suggests that daily life in the Kota palace was far more interesting than anyone might have guessed.

As Ram Singh II was an obsessive memorialist, court artists accompanied him everywhere to record the public and private events that filled his day. The results are extremely wide-ranging, including paintings of weddings, *darbars*, and distant travel; religious and secular celebrations; polo matches and boating parties; hunting expeditions and sex. But the focus and attention never vary much: there are very few paintings in which Ram Singh II does not appear as the central character and *raison d'être*.

The maharao was wildly eccentric, and perhaps monstrously self-absorbed. But his interest in the everyday world—in the reflected backdrop of his personal glory—encouraged court painters to record landscape, architecture, and genre details with uncommon fidelity. These elements fill the highly detailed backgrounds of paintings of his period, giving them a physical immediacy and a moody intensity that the foreground figures often lack.

There are at least two other versions of this same painting: one is still mounted on a wall in the Bada Mahal section of the Kota palace;[6] the other was sold at auction in 1980.[7] TM

1. A related architectural format was used to notable effect by the painter Nainsukh; see cat. 79 and Goswamy 1997, pp. 138–45, nos. 45–48.
2. Singh 1985, p. 20 n. 90.
3. A Rajasthani inscription includes the date and the name of the artist: "Shri Hari/folio showing His Highness . . . Samvat 1908 [A.D. 1851], seventh day of the bright half of Asardh [June-July]. Picture by the painter Namaram./Rs. 50."
4. For a painting depicting this all-pink *darbar*, now in the Jagdish and Kamla Mittal Museum, Hyderabad (76.157), see Desai et al. 1985, p. 121, no. 99.
5. Singh 1985, p. 20 n. 90.
6. Ibid., fig. 44.
7. Christie's, London, October 16, 1980, lot 167.

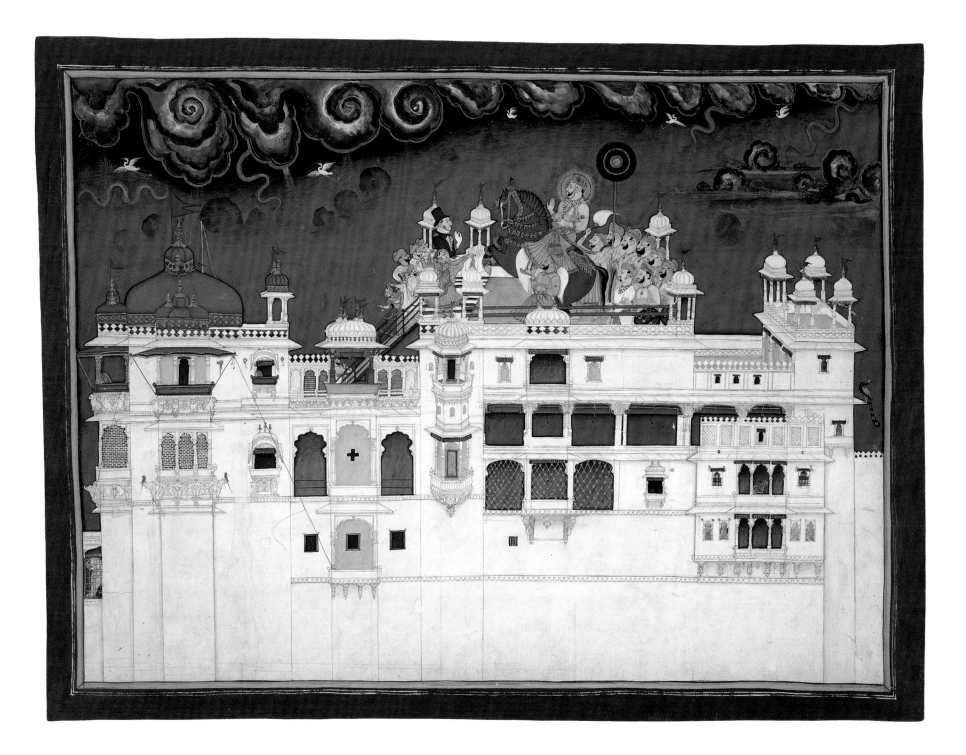

76. Maharaja Surat Singh of Bikaner Confers with Guru Narayanaji

Rajasthan, Bikaner, c. 1810–20
Opaque watercolor, gold, and silver-colored paint on paper
11 1/2 x 16 inches (29.3 x 40.7 cm)

This painting takes up the now-familiar theme of a king and his spiritual counselor, but presents it in a vastly different light. In this case, the ruler of Bikaner, Maharaja Surat Singh (reigned 1787–1828), and a holy man, Narayanaji, meet privately in an intimate palace chamber whose lateral doors and windows remain shuttered. Surat Singh, forgoing a halo but sporting an extravagantly sculpted beard and a high, jeweled turban, joins his hands in veneration of his visitor. Narayanaji, a physically imposing figure even when dressed in the simple robes of a religious teacher, reciprocates with a gesture of discourse. Standing respectfully at a discreet remove are two of Surat Singh's most important courtiers: a minister (on the right) and the treasurer, Multanmal Khajanchi (on the left), both striking gestures that echo those of the maharaja and the sage.[1]

Surat Singh apparently had ample reason to seek spiritual guidance, for he purportedly gained the throne through a series of reprehensible machinations. These began when Surat Singh had his mother fatally poison his sickly brother, Raj Singh, after a reign of less than a fortnight, and culminated eighteen months later when he brought his own regency to an end

by strangling Raj Singh's infant son, the presumptive heir, a murder he carried out personally when he could find no other noble willing to stain his hands with royal blood.[2] Surat Singh could not resist the internecine struggles of the region either. For a while, these campaigns went well, and Bikaner extended its local control. Eventually, however, Surat Singh became embroiled in a ruinous alliance against Marwar, a course of action that seriously depleted the state treasury and brought Surat Singh himself to the edge of death for a time. Colonel James Tod, the British agent in Rajasthan between 1818 and 1822, caustically remarked of Surat Singh, that "having cherished the idea that he might compound his past sins by rites and gifts to the priests, he is surrounded by a group of avaricious Brahmans *[sic]*, who are maintained in luxury at the expense of his subjects."[3] Although there is no evidence that Narayanaji was the beneficiary of such calculated favors, other gurus certainly did serve as political brokers. Guru Devnath, who is shown in another Bellak painting (cat. 77) with Maharaja Man Singh of Jodhpur, was instrumental in reconciling the two foes, and is depicted in conference with Surat Singh in a painting of 1813.[4]

The painting itself is a study in formal restraint. The anonymous artist has no interest in the colored frenzy of the corresponding Marwar scene (cat. 77), or the busy patterns of Bikaneri painting of a century earlier (cat. 52). Instead, he imparts a sense of solemnity to the scene by installing the four white-robed figures in a rigorously symmetrical arrangement, and by restricting the palette to a series of somber browns. With the palace virtually uniform in color, the crisp architectural drawing assumes a dominant role. Such aesthetic refinement dates the work in the latter half of Surat Singh's reign, a time of high artistic achievement despite the roiling political climate.[5] JS

PUBLISHED: Kramrisch 1986, pp. 94, 176, no. 87

1. These identifications are written below the figures, and repeated on the reverse. The minister on the right is designated simply as *hazuri* (minister). The caption in the lower center, "*Ḍhuṇḍhakīsāj,*" may be a place name.
2. Tod 1971a; vol. 2, pp. 1138–39.
3. Ibid., p. 1142.
4. Goetz 1950, pp. 50, 117.
5. See, for example, ibid., p. 176, fig. 87. For an image of Surat Singh dated 1809, see ibid., p. 173, fig. 82.

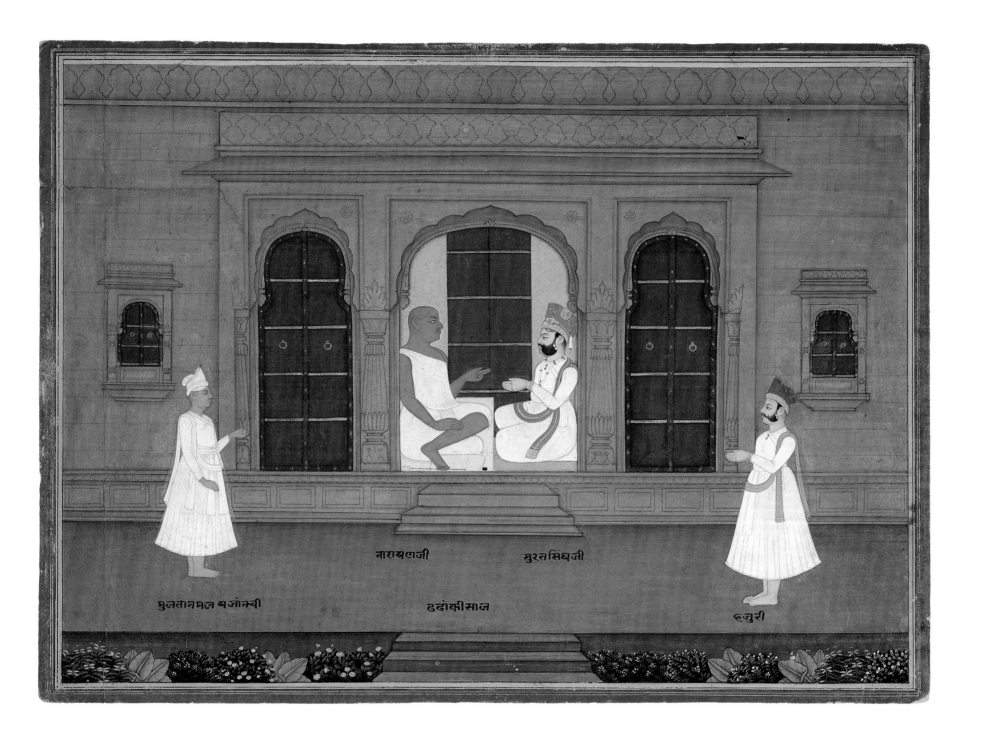

नारायलजी सुरतसिंघजी

घुलतानमल्ल बजोन्ची ह्योकीसाज हुजुरी

77. *Maharaja Man Singh of Jodhpur Visits the Mahamandir (Great Temple)*

Ascribed to Bulaki
Rajasthan, Marwar, Jodhpur, dated 1815
Opaque watercolor and gold on paper
20 5/8 x 30 inches (52.2 x 76.3 cm)

This uncommonly large painting depicts a bird's-eye overview of the Mahamandir (Great Temple) near Jodhpur, the royal capital of Marwar state.[1] The temple's residential dependencies, marketplaces, and adjoining palace and garden fill the wide green expanse that borders three of its sides. The temple and its neighborhood, comprising 1,000 houses and 112 shops, were enclosed within a stone wall a mile and a quarter in circumference, and located about a mile northeast of Jodhpur on the road to Mandor.[2] Today, the temple and its palace still exist, but the surrounding area, a former garden suburb, has become an overbuilt extension of Jodhpur itself.

In this sylvan overview dated A.D. 1815, Maharaja Man Singh (reigned 1803–43) stands in the Mahamandir courtyard, flanked by three officers of his court (identified in the inscription as Dhandhal Govardhandas, Khichi Umo, and Gehlot Jivandas).[3] With hands clasped in reverence, Man Singh is paying homage to the surprisingly lifelike image of the yogic saint Jalandhar Nath (c. A.D. 1050), which is enshrined in the temple's inner sanctum. The maharaja is attended by four hereditary officers of the Mahamandir trust: the head priest *(mahant)*, Devnath, holding a peacock-feather fan *(morchal)*; Bhimnath, his brother; and Likhminath (or Laxminath) and Ladunath, the sons of Bhimnath and Devnath, respectively. This family resided in the courtyard palace that is depicted in smaller scale in the upper left of the picture. The maharaja's enormous cavalcade—169 retainers on elephant, camel, horse, and foot—stands at attention in empty spaces on three sides of the temple's perimeter wall. Their orderly configurations mimic, yet in mirror reverse, the staggered interplay of buildings depicted in topographical format on the remaining sides. This grandly structured composition converges on the figure of Jalandhar Nath: his face marks its exact center. Intensified by a background of soft color, a vibrant rectangle of red and gold focuses attention on the room where Jalandhar Nath is enthroned.

Veneration of Jalandhar Nath and loyalty to Devnath, his priest, were the primary passions of Man Singh's reign. He had acquired his devotion in Jalor, a town eighty miles south of Jodhpur, where he lived from the age of nine to twenty. Jalor was at once a stronghold of noblemen allied against Man Singh's murderous uncle, Maharaja Bhim Singh (reigned 1793–1803), and the chief site of the Natha cult in Marwar.[4] The local Jalandhar Nath temple was under the care of Devnath, a shrewd dispenser of advice and prophecy, who became Man Singh's trusted friend. When Man Singh inherited the throne in 1803, he made Devnath his spiritual guru and principal advisor, and built the Mahamandir to honor Jalandhar Nath. Devnath and his family were installed in the adjoining palace, and the complex was furnished with houses and shops to provide income for their upkeep.[5]

In the year this painting was completed, the temple and its surrounding neighborhood were only ten years old. In preparing this freshly minted overview, the artist Bulaki may have consulted topographical plans that were still available in the Jodhpur palace. The buildings outside the temple's perimeter walls are depicted from a great height and are viewed in elevation as well as in plan, features that recall the topographical conventions that are distinctive to an Indian map.[6] According to this visual system, a building can be viewed from any angle, for what matters is not the building itself, but its relative size and position in the overall plan. A similar topographical overview appears in only one other Marwar painting of this period: another image of the Mahamandir complex, dating from c. 1813.[7] TM

1. For a good photograph of the Mahamandir, see R. A. Agarawala, *Marwar Murals* (Delhi: Agam Prakashan, 1977), plate XIII.
2. A.H.E. Boileau, *Personal Narrative of a Tour Through the Western States of Rajwara, in 1835 . . .* (Calcutta: N. Grant Tank Square, 1837), p. 135. I am grateful to Deborah Diamond for this reference.
3. The Rajasthani inscription along the top and bottom reads in full: "The Jalandhar Nath Temple/Ayasji [an honorific title] Devnath Maharaja, Bhimnath, Ladunath, Likhminath. Placed in the royal storeroom. His Royal Highness, Dhandhal Govardhandas, Khichi Umo, Gehlot Jivandas. Painted by Bulaki, Samvat 1872 [A.D. 1815]." I am grateful to Deborah Diamond for this translation.
4. The Natha yogic cult embraces many occult Hindu beliefs and practices. Their saints bear the title "Nath." There are traditionally nine Naths, including Jalandhar Nath, the historical son of a queen of Comilla in East Bengal. Popular tradition holds that the Naths never die, but live on in timeless suspension in Himalayan fastnesses. See Benjamin Walker, *Hindu World: An Encyclopedic Survey of Hinduism,* vol. 2 (New Delhi: Manoharlal Publishers, 1983), p. 128. The yogi members of the cult (Kanphata yogis) wear distinctively huge earrings.
5. Devnath was assassinated by Man Singh's enemies in 1815, that is, in the year this painting was finished. To avoid conflict in the family, Ladunath was put in charge of a newly built temple in Jodhpur city, and Bhimnath was put in charge of the Mahamandir. Bhimnath held this position until his death in 1828. His son Likhminath was chief priest of the Mahamandir from 1828 until 1842.
6. See Susan Gole, *Indian Maps and Plans: From Earliest Times to the Advent of European Surveys* (New Delhi: Manohar, 1989).
7. Mehrangarh Museum Trust, Jodhpur, 14(2); see Crill 1999, p. 118, fig. 92. While this painting is not inscribed, its style is different from that of Bulaki. For other paintings by Bulaki, also owned by the Mehrangarh Museum Trust, see ibid., p. 149, fig. 123; p. 171, fig. 142.

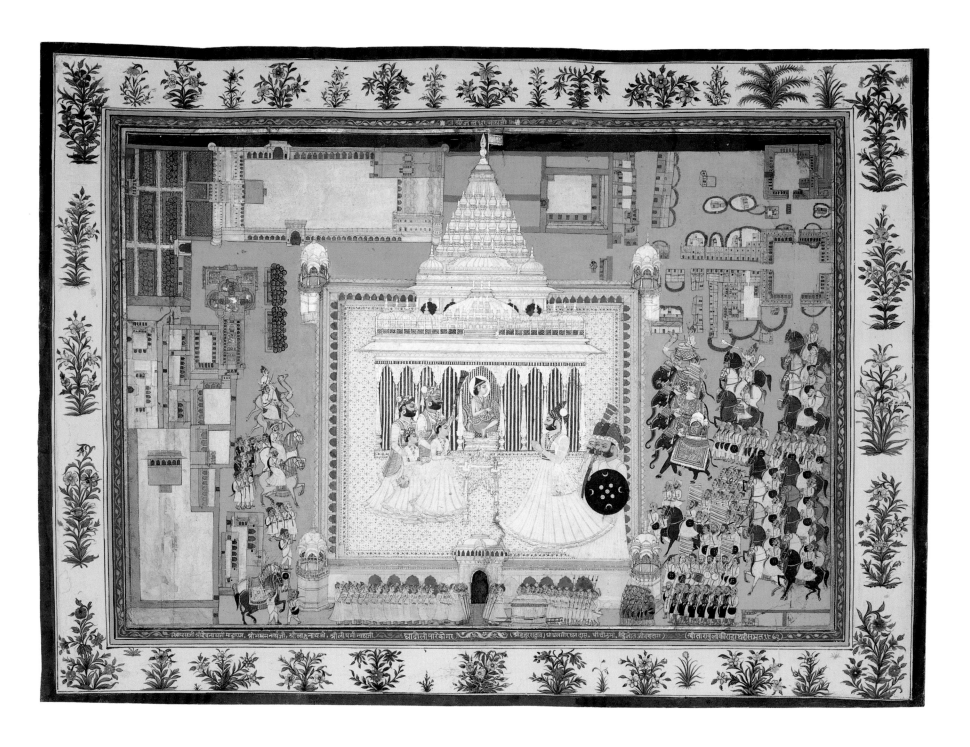

78. *Nawab Muhammad Riza Khan Smoking a* Huqqa

Eastern India, Mughal style at Murshidabad, c. 1780–90
Opaque watercolor and gold on paper
12 1/16 x 9 11/16 inches (30.6 x 24.7 cm)

By the early eighteenth century, the heyday of the Mughal empire had passed. As centralized authority waned, strong men seized the opportunity to transform their governorships into independent fiefdoms with only a nominal attachment to the Mughal court. The emergence of regional courts was particularly pronounced in the remote eastern part of the empire, where Delhi's grasp on power had traditionally been subject to challenge. One important regional court was based in the wealthy state of Bengal, where the first of these ambitious nawabs, Murshid Quli Khan, renamed the new capital Murshidabad in his own honor. When Murshidabad reached the height of its prosperity and power about mid-century, English visitors placed it on a par with London. By the late eighteenth century, however, catastrophic political miscalculations and relentless British expansion caused Murshidabad to be eclipsed by Calcutta, a new economic and political powerhouse 120 miles to the south.

This precipitous political decline naturally had artistic repercussions. Murshidabad was home to an interesting variant of the late Mughal style, distinguished primarily by its spare compositions, deep vistas, cool grayish palette, and dark-featured figures. But as the court patronage that had attracted artists to Murshidabad began to atrophy, many artists left to seek employment elsewhere in the region or adopted a heavily Europeanized style favored by a new class of British patrons. However, some of the anonymous artists who lingered on at Murshidabad must have been among the very best talent available, for this relatively late portrait is among the most compelling paintings ever produced at this court.

An inscription written on the reverse of the painting in an eighteenth-century English hand identifies the subject as a "Portrait Nawab Mahomed Reza Kaun of Cossimbazaar."[1] The portrait depicts Muhammad Riza Khan at one of the high points of an unusually checkered career. Once governor of a region in eastern Bengal, Muhammad Riza was arrested and brought in ignominy to Murshidabad;

once there, he rebounded in equally dramatic fashion, gaining first the favor of Lord Clive and then that of Nawab Najm al-Dawla of Murshidabad. He was appointed minister by the latter, and enjoyed complete control of revenue collection. The temptations of such a position plunged him inevitably into court intrigues, which led not once but twice to disgrace and financial ruin. Muhammad Riza Khan apparently needed little encouragement to stray down this path. A contemporary account describes him as an incorrigible spendthrift, squandering time and money on games of chance and extravagant houses. Such financial irresponsibility made Muhammad Riza Khan a target of scathing social reproach, a state he exacerbated by the pretentious airs he assumed personally and encouraged in his sons. He and his family were roundly condemned by a contemporary observer:

It is in the middle of such a court of famished wretches, that those hopeful noblemen firmly believe themselves equal to Assef-dja [Asaf Jah], and have such high notions of themselves, that they think it a sin to bow the head of modesty and civility to any man, or to go to visit any one; and although he should be of an illustrious family, they think it a reflection upon themselves, whilst at the same time, the smallness of their means and income is such, that they have not one gentleman to attend them, and to keep them company. Hence they are desirous of seeing their houses frequented; and this is so far true, that whenever any one chances to fall into their hands, they lay hold of him, and detain him so long by prolonging the conversation, that he is ready to lose his temper. With all this, they will not suffer any one to smoke his Hocca [*huqqa*] in their presence, nor to ease his legs by altering his respectful posture. On all these accounts the few that frequent their houses are discontented; but no man of rank chooses to go there.[2]

Perceiving his subject's innate haughtiness, the painter sets Muhammad Riza Khan alone at one end of a lacquered seat broad enough to accommodate two, his only companion the *huqqa* whose mouthpiece he raises broodingly to his lips. Man and waterpipe rest lightly on a grass mat, its busy rhythmic weave contrasting deftly with the starkness of the chilly blue wall. Against this backdrop of geometric and textural equilibrium, Muhammad Riza Khan strikes a remarkable pose—aquiline head and massive arms angled one way, powerful rump and legs turned the other—conveying, perhaps inadvertently, not a sense of a mind and body at ease, but one of a vain man beset by contradictory and disquieting impulses.

Although many painters follow the contours of the primary forms when they apply paint to the background, this artist does so in a manner that goes well beyond mere expeditiousness. He deliberately darkens the strokes immediately adjacent to his sitter's face and white robes, as well as those around the very perimeter of the blue-gray wall. The result is a kind of solarized effect that imparts a slightly sinister cast to both Muhammad Riza Khan and his domain. The painter displays his virtuosity with paint elsewhere as well, using concentrations of tiny dots of paint to render a discreet embroidered pattern on the white *jama*, and long rivulets of paint to suggest the clinging folds of the gauzy garment. JS

PUBLISHED: Victoria and Albert Museum, London, *The Indian Heritage: Court Life and Arts Under Mughal Rule* (April 21–August 22, 1982), p. 51, no. 92; Ehnbom 1985, pp. 80–81, no. 32; Oppi Untracht, *Traditional Jewelry of India* (London: Thames and Hudson, 1997), p. 368, fig. 804

1. Cossimbazar, a town located five miles south of Murshidabad along the Hooghly River, was an important center for the production and trade of cotton and raw silk.
2. Seid-Gholam-Hossein-Khan, *The Sëir Mutaqherin; or, Review of Modern Times: Being an History of India . . . as Far Down as the Year 1783* (1789; reprint, Lahore: Sheik Mubarak Ali, 1975), vol. 3, pp. 149–50.

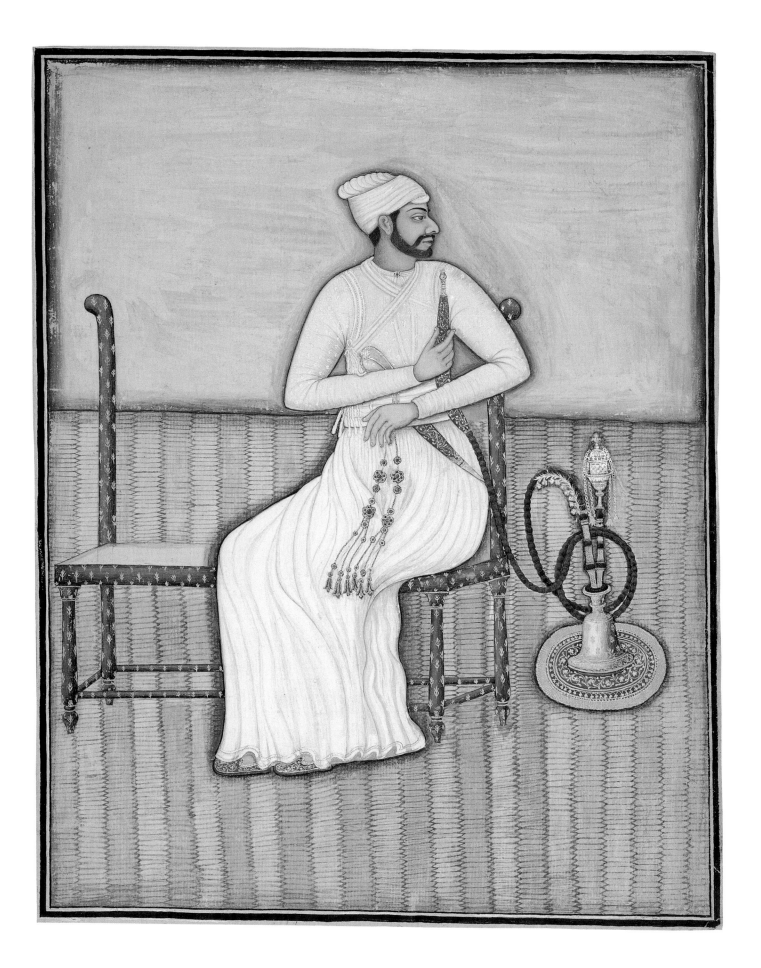

79. The Poet Bihari Offers Homage to Radha and Krishna

Attributed to Nainsukh
Opening page of the *Satasai* of Bihari
Panjab Hills, Basohli or Guler, c. 1760–65
Opaque watercolor, gold, and silver-colored paint on paper
9⁷/8 x 13 inches (25.1 x 33 cm)

Subtle of drawing, color, emotion, and meaning, this masterpiece of Pahari painting constituted the opening page of the *Satasai* of the poet Bihari, a Hindi poem of some seven hundred two-line verses describing the nuances of love and lovers.[1] The poem, completed by the ardently Vaishnava Bihari (see cat. 71) for Raja Jai Singh of Amber, was supposedly instigated by his queen as a way to get the king's mind off a recent infatuation.[2] The verse written in gold at the top of the page is the invocation that begins the *Satasai*: "Take away the pain of existence, this cycle of the world, from me, Radha, you, whose [golden] reflection turns Krishna's [blue complexion] into a glowing green [i.e., makes him come to life]."[3]

The setting of the painting is a palace terrace with gleaming white railings and bold red-striped dhurrie. Behind is a golden sunrise sky tinged with color. On a gilded, jewel-encrusted throne beneath a silver canopy rest Krishna and Radha. Krishna, regally composed but youthfully handsome, wears a peacock-feather crown and grasps a blooming lotus. Radha, with glowing light complexion, holds out a floral garland as if about to present it. Their enthronement and postures, the sheltering umbrella, and the peacock-feather fly whisk held by a maid behind them are ancient designators of both royalty and divinity, and, indeed, their portrayal in this painting is intimately linked with royal portraiture. To further the courtly ambience, a second maid holds a jeweled tray and box, probably containing betel leaves. All four of the figures—Krishna, Radha, and the maids—bear the exquisitely idealized features that become, from about this time forward, the image types used for male gods and most women painted in the Kangra Valley region.

The man approaching the divine couple, however, is quite individualized and not at all ideal. Dressed in a simple white diaphanous *jama*, a restrained court sash (*patka*) around his waist, he is neither prince nor heavenly attendant. Tucked under one arm is a pink-and-red-striped cloth satchel (*basta*), a type

of bag that contains the writing tools of a poet or scribe—or the brushes and pigments of a painter. The man folds his hands in the reverent gesture of *anjalimudra* to Radha and Krishna; he is humble but rapt, his left leg slightly bent as he bows forward, his eyes meeting those of the gods in an understated but moving rendition of the rite of *darshan*—the powerful interactive gaze of man and god.

Given the fact that the invocation inscribed on the page is addressed not to Krishna but to Radha as intercessor, it is instructive to compare her depiction with that in a closely related image attributed to the same artist, *Raja Balwant Singh of Jasrota Does Homage to Krishna and Radha*, in the collection of the Metropolitan Museum of Art, New York.[4] In this latter work, it is the king who honors Krishna and Radha, likewise enthroned. There, however, Radha's eyes are downcast modestly, and the interaction is strictly between the king and Krishna.[5]

B. N. Goswamy first identified the supplicant in this *Satasai* page as most likely the poet Bihari,[6] on the strength of his dress, *basta,* and pose combined with the invocatory verse at the top of the page. The practice of depicting the writer in such a position on the opening illustration of a text he had composed was not uncommon,[7] although the painter of this page could not have been aware of the long-dead Bihari's physical features.

In 1992 Goswamy and Eberhard Fischer attributed the painting to the hand of the Pahari master Nainsukh of Guler (c. 1710–1778), and Goswamy subsequently amplified both this attribution and the painter's life and *oeuvre* in his 1997 monograph on the artist.[8] They also noted that the facial features of the supplicant they identify as Bihari match rather well with what is arguably a self-portrait of Nainsukh.[9] Although the face in this supposed self-portrait does differ slightly from that in the Bellak page—the mustache is smaller, the expression more somber, and the gaze more downcast—the finely chiseled profile, prominent teeth, long, thin neck, and well-defined

jaw make the identification very convincing.[10] Thus, in this reading, the painting has multiple layers of identity. Krishna and Radha are both deities and royal patrons; the man with the satchel is both devotee and supplicant artisan, century-dead poet and living painter. DM

PUBLISHED: Kramrisch 1986, pp. 126, 184, no. 116; Goswamy and Fischer 1992, pp. 302–3, no. 128; Goswamy 1997, pp. 230–31, no. 90; Garimella 1998, p. 83, fig. 8

1. This page may be from a dispersed set, but no other leaves are known.
2. Krishna P. Bahadur, "Introduction," in Bihari, *The Satasaï,* trans. Krishna P. Bahadur (Harmondsworth, Middlesex, England: Penguin Books/UNESCO, 1990), pp. 15–16.
3. Translated in Goswamy and Fischer 1992, p. 302, no. 128.
4. 1994.377; see Kossak 1997, p. 98, no. 58.
5. In addition, although Balwant Singh stands with his hands together in *anjali* and bows slightly, there is decidedly less subservience in his posture and gaze than in those of the man depicted here, yet there is also less response on the part of both gods.
6. In a 1985 letter to Stella Kramrisch.
7. The *Gita Govinda* of 1730, which Goswamy attributes to Nainsukh's brother Manaku, likewise begins with an image of its author, the twelfth-century poet Jayadeva, honoring Vishnu (Goswamy and Fischer 1992, pp. 252–53, no. 100).
8. Ibid., p. 303, no. 128; Goswamy 1997, pp. 230–31, no. 90. This latter book and the accompanying exhibition were the first dedicated to a single premodern Indian artist.
9. This is the man genuflecting behind the throne of Raja Balwant Singh of Jasrota in a work in the Museum Rietberg, Zurich (see fig. 26). The English inscription on the reverse states that "the painter of pictures is sitting in opposite side" (Goswamy and Fischer 1992, pp. 286–87, no. 117). If both Goswamy's attribution of this painting to Nainsukh and the English inscription are to be believed, then this is the face of the artist. The Bellak page certainly adds weight to this supposition.
10. Goswamy also dates the Rietberg page (see n. 9 above) slightly earlier than the Bellak (most recently to c. 1745–50; see Goswamy 1997, p. 126, no. 39), which would certainly account for the smaller mustache. The difference in expression is easily explained by the context: in the Rietberg work the artist is approaching his patron during a critique; in the Bellak page he approaches the god.

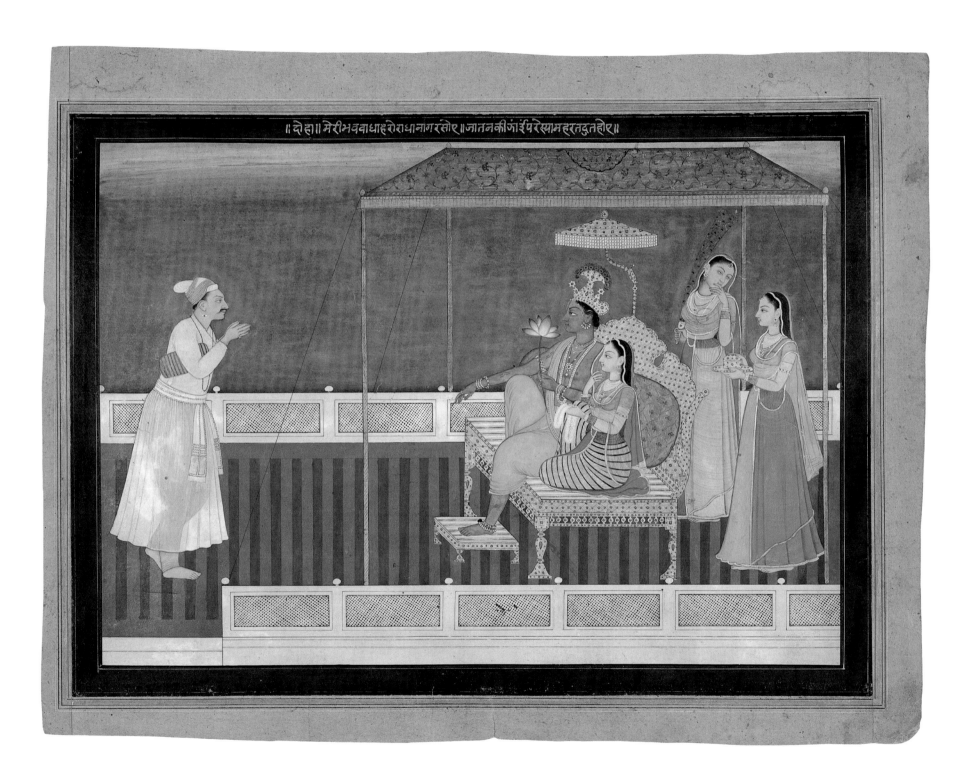

80. The Demon Samvara Kidnaps Krishna's Infant Son, Pradyumna

Page from a dispersed series of the *Bhagavata Purana*
Panjab Hills, Basohli, c. 1760–65
Opaque watercolor, gold, and silver-colored paint on paper
12 x 16 inches (30.5 x 40.6 cm)

The dramatic yet satisfying story of Pradyumna and Samvara is told as part of the tenth book of the *Bhagavata Purana*, which recounts the life and deeds of Krishna.[1] The tale begins aeons before the actual incident, at the time when Kama, god of love, annoyed Shiva and was incinerated in his furious glare. To regain a physical form, Kama appealed to Krishna and was reborn as Pradyumna, the son of Krishna and his wife, Rukmini. There was a prophecy, however, that such a son was destined to kill the *asura* (demon) Samvara. To protect himself, Samvara kidnapped the week-old infant and threw him in the ocean, where he was immediately swallowed by a huge fish. Soon a fisherman caught the fish and, little guessing its contents, presented it to Samvara. When the kitchen staff cut open the fish and discovered the baby, they called their supervisor, Mayavati, who was actually the incarnation of Kama's wife, Rati. Knowing his true identity, Mayavati reared her reborn husband as her own child. Eventually he fulfilled the prophecy by killing the demon, and the couple were (re)married.

The painting shows the abduction of the infant as a moment of anguish and action that is caught, suspended, in a crystal-clear vision. In a high room of a golden palace, Rukmini huddles on a bed, her head bowed, one hand touching her chin, the instant after the demon has seized her son. A thin cloth band is tightly tied around her head, a Pahari practice at the time of delivery used here to signal that the abduction has occurred only a short time after the birth. Around Rukmini, her women attendants are caught in various poses of explication and surprise. An old woman at the corner looks concerned and holds out a hand; one of the younger ones hold up her index finger, either warning or pointing behind to the demon.

The trees below are in shadow, the sky dark. Against it, the great white leaping demon Samvara stands in sharp contrast. He is depicted flying, as if running through the air, and in great detail—with mottled white body, parrot feet, monkey-like tail ending in a tuft of black hair, gold-tipped horns, pointed ears, and a long, wrinkled snout with fierce teeth and tusks. His eyes bulge, his jaws gape, and his pink tongue lolls outward in his exertion. Yet Samvara cradles the baby gently in both arms, and the infant seems unfazed by his abduction, his only sign of agitation the one hand he lifts toward his mouth.

This painting comes from a dispersed series that has been called the "larger" Basohli-Guler *Bhagavata Purana*. Over thirty pages have been published, although it originally contained many, many more. In addition to the Bellak painting, three other illustrations of the Samvara episode from this manuscript are in Western collections: one showing Samvara being given the fish,[2] and two representing events toward the end of the story.[3] The folio numbers on two of these pages indicate that the story was very condensed and likely told in no more than seven images.

One other page of this series, in the Binney Collection of the San Diego Museum of Art, bears a date equivalent to 1769. However, because this date appears not as part of a colophon but rather in the middle of the narrative sequence, some scholars choose to date the series slightly earlier (c. 1760–65), others slightly later (c. 1770–80). Stylistically the earlier dating is more convincing, although the precise relationship of the inscribed date to the whole remains unclear.

The compositions, choices of narrative moments, and style of this *Bhagavata Purana* are undoubtedly based on the extensive set of paintings and drawings of about 1740 attributed to the master artist Manaku of Guler, son of Pandit Seu and brother of Nainsukh (see cat. 79). While skillfully rendered, Manaku's work partakes of the aesthetic of earlier paintings such as Devidasa's *Rasamanjari* of 1694–95 (see cat. 26), with its pure, bright color and clear, bold narratives. Compositions favor a few large figures set in the foreground and simple juxtapositions of an architectural interior with a solid color field as the exterior. Although most pages of the "larger" *Bhagavata Purana*, like the one shown here, continue this conservative but nevertheless highly effective style, its compositions generally display somewhat greater complexity and a perfection of draftsmanship that at times borders on hardness.

In his recent writings, B. N. Goswamy attributes the bulk of the images in this series to Fattu (c. 1725–c. 1790), eldest son of Manaku. He speculates that the set may have been begun even before Manaku's death and completed afterward. During its production, however, Fattu came more and more under the influence of Nainsukh.[4] Undoubtedly this series is pivotal in showing the stylistic transition from vivid clarity to delicate idealism undergone by this work-shop of painters. Not only do some pages, such as the Bellak painting, hearken more toward Manaku's bold drawing and color and clear narrative, while others favor Nainsukh's tonal delicacy and subtle expression, but the two approaches frequently blend in the details of single paintings. Yet whereas Goswamy sees this as a gradual stylistic shift on the part of Fattu, Jutta Jain-Neubauer attempts to limit Fattu's hand to only a few of the images—those most closely resembling the work of Nainsukh (she does not speculate on the authorship of the remainder of the paintings).[5] Whatever the truth was about Fattu's involvement, there is no doubt that the merging of these two modes of depiction formed the basis for the distinctive Pahari style that developed from the late eighteenth to the early twentieth centuries. DM

PUBLISHED: Basil Gray, ed., *The Arts of India* (Ithaca: Cornell University Press, 1981), p. 174, fig. 188

1. The reverse of this painting is inscribed in Sanskrit in black script: "He [Kama] was born as Krishna's son in the princess of Vidarbha [Rukmini]. He was called Pradyumna, and was in no way inferior to his father. Samvara, who could take any form, took the newborn infant" (see Appendix). The writing then changes to alternating red and black letters, indicating the end of the chapter: "This is Pradyumna's birth and abduction from the last part of the tenth chapter of the great *Bhagavata Purana*" (translation by Signe Cohen). Another inscription, written in Gurmukhi on the top of the reverse, reads: "no. 203. Samvar was told by [the sage] Narad that his death was foretold at the hands of a son of Krishna. Therefore as soon as the child was born, Samvara abducted Pradyumna" (translation by B. N. Goswamy). This inscription is in precisely the same format and hand as one on a page from a *Bhagavata Purana* that dates to c. 1870–80 (see cat. 88).
2. *Samvara Receives the Fish*, folio 214 (Victoria and Albert Museum, London, I.S. 4-1960; Archer 1973, vol. 2, p. 38, Basohli no. 22[xi]).
3. *Pradyumna and Samvara Fight with Maces*, folio 216; and *Pradyumna and Maya Fly to Dvarka*, no folio number; both in the Cleveland Museum of Art, 60.184 and 71.93, respectively.
4. W. G. Archer (1973, vol. 1, pp. 50–51) speculated that Nainsukh himself may have actually produced at least one page from this series. Goswamy disagrees and instead thinks that the "larger" *Bhagavata Purana* was produced to complete the earlier Manaku series, with which it links to finish the story of Krishna's life. Thus Fattu, if he was indeed the artist, was continuing his father's series in an enlarged format.
5. Jutta Jain-Neubauer, "Fattu: A Rediscovery," in Ohri and Craven 1998, pp. 81–97. She identifies Fattu's hand by a set of drawings in the National Museum, New Delhi, bearing a late inscription at midpoint attributing one drawing to Fattu.

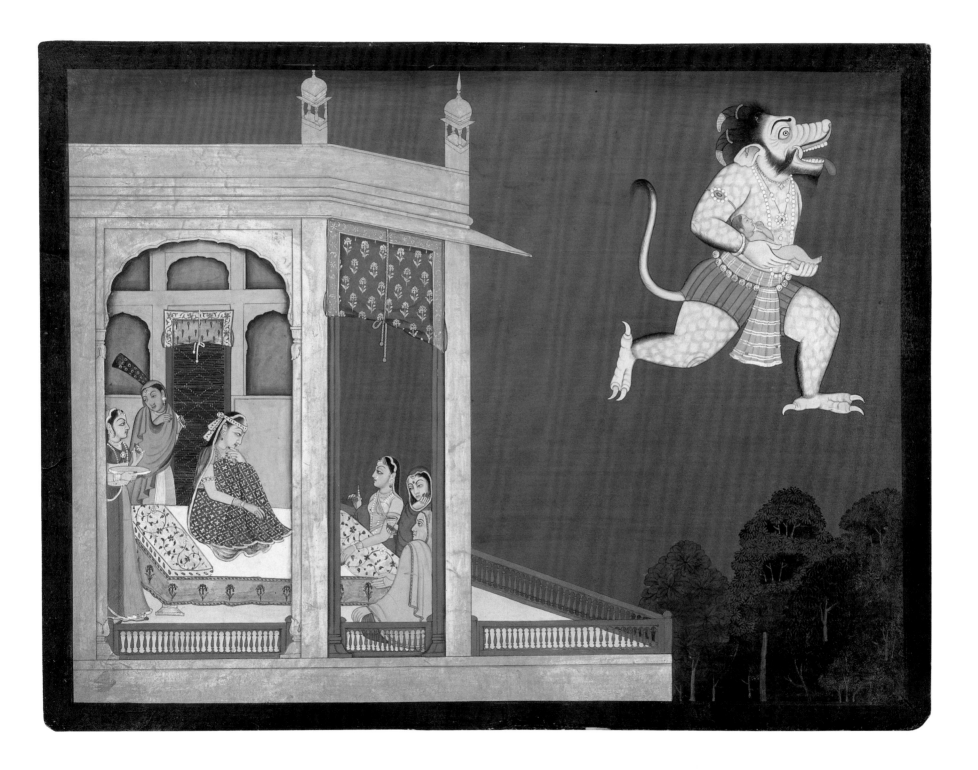

81. *Rama Pines in the Wilderness*

Page from a dispersed series of the *Ramayana*
Panjab Hills, Guler or Kangra, c. 1775–80
Opaque watercolor and gold on paper
10¼ x 14¹⁵/₁₆ inches (26 x 36.4 cm)

In this scene from the *Aranyakanda*, the third section of the epic *Ramayana,* depicting Rama's forest exile, the figures are small and set at a distance. While typical of many of the illustrations from this series, this stylistic trait is particularly appropriate to this episode. Set in a deep landscape of rolling hills, the scene takes place after the abduction of Rama's wife, Sita, who has been captured by the demon king Ravana and spirited away to his island stronghold of Lanka. Rama and his brother Lakshmana know only that Sita has disappeared; they have not yet discovered how or to where. White-skinned Lakshmana, dressed in an antelope-pelt skirt and leaf hat, charges energetically across the hill, bow half-drawn. He is searching for Sita. Meanwhile, Rama's grief at his loss has enervated him. He sits slumped on the ground. His leaf hat, bow, and sheaf of arrows are forgotten by his side; his antelope-skin garment and floral garland hang awry; the drooping vines above amplify his mood. Although there is no inscription on the painting, it most likely illustrates the end of Sarga 59 and beginning of Sarga 60. Rama, after becoming "unconscious in the misery of his anguish, and heaving deep and burning sighs," asks his brother to go down to the Godavari River and look for Sita, to see if she is by its banks gathering lotus flowers.[1]

The landscape is truly idyllic, its distant viewpoint and cool colors deepening the dreamy detachment. Rolling grassy hills dotted with a few lone pines occupy the center of the painting, shading from dark green to rosy tan, the farthest nearly covered with darker green puffs indicating deciduous trees. A cottony cumulus cloud fills the left half of the gray-blue sky. In the foreground is a forest river spotted with peach-colored boulders. The dark blue inner border securely frames the distant scene, while the outer border of pink speckled with red picks up and accentuates the warmer tones in the composition. As in the pages of the closely related *Gita Govinda* (see cats. 82, 83), the grass and the shading of the rocks are produced primarily by washes of varied greens, with the delicately rendered thin, parallel lines used ubiquitously by later painters of the region (see cats. 85, 86) appearing only occasionally on the hills.

This page comes from what was originally a large series of the *Aranyakanda* chapter known as the "Bharany" *Ramayana* for its former owner, the dealer-collector C. L. Bharany of Amritsar.[2] Various scholars have assigned leaves from it to either Kangra[3] or Guler.[4] Goswamy and Fischer link the set with the family of Pandit Seu and Nainsukh, attributing it to "a master of the first generation after Nainsukh,"[5] when the family had moved its base to Guler. Recently, Vishwa Chander Ohri has argued for a specific attribution to Gaudhu (or Godhu), Nainsukh's second son, but this seems difficult to justify for a variety of reasons.[6] However, it does appear likely that at least two distinct, though closely related, masters were responsible for this set of paintings: the one seen here emphasizing tiny, remote figures and a looser though more delicate style; the other favoring a slightly closer, harder, and more dramatic approach. DM

PUBLISHED: Andrew Topsfield, *Paintings from the Rajput Courts* (London: Indar Pasricha Fine Arts, 1986), pp. 46–47, plate 27

1. *Rāmāyana* 1984–94, vol. 3, pp. 217–18.
2. According to B. N. Goswamy and Eberhard Fischer (1992, p. 313), more than one hundred pages of this series may have survived and are scattered in collections across India, the United States, and Europe. At least twenty pages have been published. There has been some confusion between this series and a second, closely related *Ramayana,* probably painted in the same workshop at a slightly later date. Georgina Fantoni (in Fogg 1999, pp. 112–13, nos. 73i–ii) gives a clear discussion of the differences between the two series.
3. Archer 1973, vol. 1, p. 292; Archer 1976, pp. 72–73, no. 40; Ehnbom 1985, p. 234, nos. 116–18; Kramrisch 1986, pp. 130, 185, no. 20; Poster et al. 1994, pp. 262–64, no. 215; Kossak 1997, p. 103, no. 62.
4. Pal 1978, no. 67.
5. Goswamy and Fischer 1992, pp. 313, 340–43.
6. Ohri's (1998, pp. 98–114) attribution rests on this set's similarity to a *Ramayana* in the Bhuri Singh Museum, Chamba, which he assigns in part to Gaudhu. Of the "Bharany" *Ramayana* he writes that "it is probable that Godhu later painted and also guided his juniors through the completion of [this] series for Raja Sansar Chand of Kangra around 1785." (Ohri publishes the Chamba *Ramayana* in *The Exile in the Forest* [New Delhi: Lalit Kala Akademi, 1982].) However, Ohri's speculation that the "Bharany" *Ramayana* was created for the great patron Sansar Chand of Kangra was first made by W. G. Archer, who linked this work with the *Bhagavata Purana* of c. 1780 and the contemporaneous *Gita Govinda* (cats. 82, 83), which "could have been commissioned in anticipation of Sansar Chand's marriage in 1781" (Archer 1976, p. 72; see also Archer 1973, vol. 1, pp. 292–94). Unfortunately, no concrete evidence seems to exist for this romantic claim.

82. Radha, Enter Madhava's Intimate World

Page from a dispersed series of the *Gita Govinda* of Jayadeva
Panjab Hills, Guler or Kangra, c. 1775–80
Opaque watercolor and gold on paper
6 11/16 x 10 3/4 inches (17 x 27.3 cm)

The *Gita Govinda* (Song of the Dark Lord) is an evocative rendition of the love play of Krishna and his inamorata, Radha, by the twelfth-century poet Jayadeva (see also cats. 83, 87). Devotional in intention, it begins with an homage to Lord Krishna, incarnation of Vishnu, the supreme deity. It then conjures images of obsessive passion—the anguish of separation from the object of desire, the bliss of climactic union—as a way to understand the soul's craving to merge with God. Yet the writing is also clearly intended to stimulate the senses not only by its tactile eroticism but by its delicious poetry.

Other texts on love, such as the *Rasikapriya* (see cats. 20–22) and *Rasamanjari* (see cat. 26), use the Krishna-Radha theme occasionally to help classify types of lovers and the moods and variations of relationships. Like them, the *Gita Govinda* elucidates the nuances of the love, but it treats these nuances as parts of a continuous devotional narrative that takes the reader through the tempestuous process of emotional—and spiritual—struggle for grace. Not surprisingly, it became a cornerstone for the religious movement advocating passionate and direct devotion to Krishna *(bhakti)*. *Bhakti* spread across northern India from the thirteenth century onward, reaching the Panjab Hills in force in about the sixteenth, when many of the local rulers became ardent devotees.

The Krishna of the poem is the youthful resident of the village of Vrindavan, where he is being raised by his foster parents, Nanda and Yashoda. Radha is a young village woman, and the days of the two are spent herding cows in the gentle hills and forests of the region. The plot is set off when Nanda requests that Radha walk the timid, slightly younger Krishna home through the forest. Krishna's timidity, however, lasts only until they are alone in the woods, where he begins to seduce her. The remainder of the poem treats of their relationship—the anxiety and distrust that separate them, their longing for one another, the attempts of Radha's female friend *(sakhi)* to reunite them, and their passionate union.

The scene depicted here comes from close to the end of the poem, in the eleventh and penultimate chapter. Krishna has been careless with Radha's affections; he has allowed the other *gopis* (cowherdesses) to tempt him into joining their springtime love-play (see cat. 87). Radha withdraws in jealousy and refuses to rejoin Krishna, even when her *sakhi* brings her Krishna's impassioned plea. Yet Radha, in her forest retreat, suffers agonizingly with her unfulfilled longing for Krishna. Finally, at the urging of her *sakhi*, she overcomes her jealousy and pride to join Krishna, who is here called by his epithet Madhava, or the Honey-Sweet One.[1] The two verses inscribed on the back of this painting (see Appendix) are rendered in full in Barbara Stoler Miller's exquisite translation:

> *Seeing Hari [Krishna] light the deep thicket*
> *With brilliant jewel necklaces, a pendant,*
> *A golden rope belt, armlets, and wrist bands,*
> *Rādhā modestly stopped at the entrance,*
> *But her friend urged her on.*
>
> *Revel in wild luxury on the sweet thicket floor!*
> *Your laughing face begs ardently for his love.*
> *Rādhā, enter Mādhava's intimate world!*[2]

Although the first of these verses comes as the end of the previous song and the second begins the next song, the artist has chosen not only to depict them together in a single image, but to invert the literary sequence in the visual. The first verse is illustrated at the right third of the painting. The intertwined trunks of a grove of trees form a bower for Krishna, who sits cross-legged on a bed of leaves. A thick, dark vine entwines the lower part of the nearest tree. Krishna's body is brightly lit, and the leaves around him—both of the bed and the undersides of the tree boughs—glow chartreuse, as if lit by his body to give reality to the poetic conception that he "lights the deep thicket."

Krishna wears his usual saffron garment and crown plus all the jewelry specified in the text:

jeweled necklaces and pendant, a golden rope belt, armlets, and wristbands (they also appear in almost every other depiction of him in this series, even when not described in the verse). He is also adorned with the long white garland that appears only occasionally in other scenes. He holds his left hand up to his right shoulder and turns his head to the right, tilting it upward as if listening intently for some sound of Radha's approach. The pose combines with his slight smile to express both eagerness and anticipation.

The remainder of the page, on the left, illustrates the second verse, where Radha's friend urges her to "enter Madhava's intimate world." Orange-clad Radha stands huddled in her golden shawl, face lowered, shoulder tense. Her friend, in a green shawl over her pink-striped skirt, holds Radha with one arm and inclines her head sympathetically. Her other hand is held with fingers together to indicate that she is speaking the gently coaxing words of the poem. The night is moonless. Barren hills flank one side of the winding River Yamuna, the forest appears on the other side. The river is a primary player in this painting series, depicted in its varying moods on every page. Here it meanders quietly and darkly around the disparate protagonists, soon to be united in their luminous, intimate world. DM

PUBLISHED: M. S. Randhawa, *Kangra Paintings of the Gīta Govinda* (New Delhi: National Museum, 1963), pp. 96–97, plate XII; *Gita Govinda*, Lalit Kala Series, Portfolio Nos. 2–3 (New Delhi: Lalit Kala Akademi, 1965), plate 10; *Gita Govinda*, Lalit Kala Series, Portfolio No. 15 (1976; reprint, New Delhi: Lalit Kala Akademi, 1978–79), plate 10; Kramrisch 1986, pp. 131, 185, no. 121; M. S. Randhawa, *Indian Paintings: Exploration, Research, and Publications* (Chandigarh: Government Museum and Art Gallery, 1986), p. 192, plate 33; Goswamy and Fischer 1992, p. 326, no. 133; Garimella 1998, p. 72, fig. 1

1. Barbara Stoler Miller (1977, p. 19) gives a fuller etymology for this word, which may also mean "springtime," as well as referring to Madhu, the forefather of Krishna's clan, and to Krishna as killer of the demon Madhu (Madhusudana).
2. Ibid., p. 118 (Sarga 11, Verses 13–14).

83. As Passion Took Over

Page from a dispersed series of the *Gita Govinda* of Jayadeva
Panjab Hills, Guler or Kangra, c. 1775–80
Opaque watercolor and gold on paper
6 3/4 x 6 1/16 inches (17.1 x 15.4 cm)

From the final chapter of the same *Gita Govinda* series as *Radha, Enter Madhava's Intimate World* (see cat. 82), this page illustrates the first stage in the culmination of Radha and Krishna's springtime encounter in the Vrindavan woods. After he has wooed and abandoned her, after she has withdrawn in jealousy and been tormented with longing, after her friend has convinced her to overcome her anger and fear, Radha goes to Krishna, and their lovemaking is ecstatic.

The verse that is partially preserved on the back of this painting (oddly upside down; see Appendix) describes the lovers at the threshold between foreplay and intercourse: their bristling hair impedes a close embrace, their blinking impedes their loving gaze, their playful talk impedes their kisses, the battle that is courtship impedes the attainment of bliss.[1]

In the painting the couple are entirely nude but for their jewelry; Krishna has even taken off his necklaces. Radha's legs wrap up and around him, yet she pulls back slightly and braces herself on the ground behind with one hand. Her unbound hair cascades down her back, and her young nipples, pink and erect, are stimulated with desire. Krishna crouches between her legs, leaning forward. With one hand he holds her foot, with the other he reaches beneath her knee to fondle her breast. Radha places her hand over his, both playfully delaying and fervidly encouraging. Her head is bent, but she glances upward to meet eyes that are intent and tender. Charged with a visual ambiguity that mirrors the words of the verse,[2] the scene crackles with passionate anticipation, and is infinitely gentle.

The landscape is in deep night; stars peek out above the shadowy treetops at the top right. Radha and Krishna embrace on a bed of leaves within a bower of trees. It is the same setting in which Krishna earlier sat alone (see cat. 82), but here the topography is seen from a lower and closer angle. The River Yamuna winds behind the trees, so that the lovers appear as if alone on an island. Unfortunately at some point in its history this page and others from this series depicting explicit sex were rebordered and the "excess" landscape cropped.[3] In this painting, a large section of landscape seems to have been cut from the left half. The original composition would most likely have shown the river continuing toward the lower left, winding between barren hills to create a stark, dark expanse that would have emphasized Radha and Krishna's isolation.

Over 35 paintings from this *Gita Govinda* series have been published,[4] but, according to W. G. Archer,[5] who linked it with a numbered set of drawings in the National Museum, New Delhi, the original likely contained over 150 images. Archer himself speculated that the set may have been the work of Khushala (Manaku's younger son; see cat. 85) and Gaudhu (Nainsukh's second son). While this is difficult to substantiate, the paintings do clearly relate to the workshop-lineage of Pandit Seu, Nainsukh, and Manaku.[6] Goswamy believes that the planning and preliminary sketches for this set, or at least many of them, were actually done by the master Nainsukh himself in the last decade of his life (see cat. 79).[7] He does not, however, attempt to designate an individual hand for the completed paintings, attributing them generally to the workshop and a "master of the first generation after Nainsukh," active about 1775–80.[8] Vishwa Chander Ohri also attributes the set to painters working in Guler but dates it slightly earlier, to c. 1760–65.[9]

Whichever hand was responsible, however, the combination of style and subject in this *Gita Govinda* makes it arguably the apotheosis of the idealized vision for which Pahari painting is known, an unblemished world of exquisite people and delightful landscape. While retaining the delicate detailing of Nainsukh himself, it is no longer anchored in a love of individualization, but creates and depicts a self-contained dream of earthly perfection. DM

1. According to Barbara Stoler Miller (1977, p. 203), this is a variant verse of the longer recension of the *Gita Govinda*; it follows Verse 10 of Sarga 12. For a translation see ibid.
2. Although W. G. Archer (1973, vol. 1, p. 291, Kangra nos. 33 [i–viii]) says that the verses on the back of each painting refer to the next painting in the set, not to the one on which they are inscribed, the verses on this and cat. 82 certainly correspond with the scenes depicted, as is the case in other instances.
3. A similarly cut and rebordered page is in the Museum Rietberg, Zurich (RVI 952; see Goswamy and Fischer 1992, p. 330, no. 137), while another page, in the Robbins Collection of the Indian Princely States (Garimella 1998, p. 74, fig. 3), has been cut down to different dimensions and not rebordered, indicating more than one campaign of desecration.
4. Pages are widely scattered in numerous public and private collections in the United States, Europe, and India. Many are known to have come from the collection of Maharaja Manvindra Shah of Tehri-Garhwal (Archer 1973, vol. 1, p. 291).
5. Ibid., p. 292.
6. The colophon page of this *Gita Govinda* (National Museum, New Delhi) is almost an exact copy of the colophon page of an important earlier version of the text bearing a date (1730), a place (Basohli), and an artist's name (Manaku). B. N. Goswamy and Eberhard Fischer (1992, pp. 240–49) believe this work was indeed done by Manaku of Guler, son of Pandit Seu. Roy Craven, Jr. ("Manaku: A Guler Painter," in Ohri and Craven 1998, pp. 46–67), on the other hand, argues that it should be attributed to another artist of the same name, living in Basohli at the same time, whereas F. S. Aijazuddin ("The Basohli *Gita Govinda* Set of 1730 A.D.— A Reconstruction," *Roopa-Lekhā*, vol. 41, nos. 1–2 [1973], pp. 7–34) sees four different painters at work on this series, one of whom was patronized by a Mankot ruler. However, the fact that the colophon pages are near duplicates indicates at least a consciousness of the first by the painter of the second, and certain similarities of composition and conception between the two versions have led Goswamy and Fischer (1992, pp. 247, 312) to speculate that those responsible for the later *Gita Govinda* worked in part from drawings made for the older version.
7. Goswamy 1997, pp. 244–47, no. 97, pp. 250–51, no. 99; Fischer and Goswamy 1999, pp. 34–43, nos. 12–17.
8. Fischer and Goswamy 1999, p. 41, nos. 16–17.
9. Vishwa Chander Ohri, "Introduction," in Ohri and Craven 1998, pp. 7–9.

84. A Winter Evening

Page from a dispersed series of the *Barahmasa*
Panjab Hills, probably Guler or Kangra, c. 1775–85
Opaque watercolor, gold, and silver-colored paint on paper
11 1/16 x 8 1/8 inches (28 x 20.6 cm)

Gold stars pepper the black sky above a high palace terrace. On it stands a shadowy white pavilion with a pink curtain rolled up in front, as though it were a stage set. We gaze into an intimate scene of bundled lovers, evenly illuminated by two candles that stand at the far corners of the room, to either side of the bed. The candles are covered with translucent shades, each punctuated by a round hole that allows a golden stream of light to pour forth. This interior set is delicately delineated, including the vivid navy blue carpet with yellow floral scrollwork and garden-green border. Outside of the lighted bower, however, the night yields minimal detail. Behind the pavilion appear the geometrically abstracted upper segments of four brick buildings,[1] their roofs lit by the spill from the interior. Between them is the suggestion of shadowy trees.

The hero rests with crossed legs on the yellow bedcover. In a conflation of the god and the poetic princely hero, he is depicted with the blue skin of Krishna but the dress of a prince or wealthy man of the Panjab Hills. He wears a green turban and a heavy green *jama* ornamented in yellow, probably meant to represent a woven woolen garment. The heroine, too, is warmly clad, swathed in a thick red shawl with pink inner lining and zigzagging lines to indicate quilting.

The heroine reclines in Krishna's lap, as if against a bolster, and reaches with her left arm to encircle his neck. With his right hand, Krishna feeds her *pan*, a slightly narcotic digestive wrapped in betel leaf, here folded into a triangle, while holding out a second piece in his other palm. She gazes upward, but he is behind her—their eyes cannot meet.

This painting comes from a series illustrating a well-known poem, the *Barahmasa* (Twelve Months),

each verse of which romantically evokes the atmosphere of its particular month of the year; the most popular version of the text was composed by the poet Keshavadasa. On the reverse of this painting is written the word *magher* in Takri script. This is the Pahari form of the month of Margashirsha, mid-November to mid-December, which is the onset of winter and usually considered the first month of the year. Although the weather does become much colder during this period, particularly in the northerly Pahari region, this image does not entirely match Keshavadasa's verse for the month, which runs, in part:

> *The river banks are covered with flowers*
> *And joyous notes of swans fill the air.*
> *The days are neither cold nor hot,*
> *How lucky to be together my love!*
> *Do not therefore leave me alone.*[2]

In fact, the painting much more closely illustrates the verse for the following month, Pausha (mid-December to mid-January):

> *Anything cold in the month of Pausha,*
> *food, water, house, or dress,*
> *Is liked by none anywhere.*
> *Cold are the earth and the sky,*
> *and the rich and the poor all alike*
> *Want sunshine, massage, betel, fire,*
> *company of women, and warm clothes.*
> *The days are short and nights are dark*
> *and long, and this is the month for love.*
> *Do not quarrel and turn away from me,*
> *and leave me not in this month of*
> *Pausha.*[3]

Without the inscription on the reverse, this painting of snugly clad lovers, warmed by betel and by each other, with flaming candles creating an intimate sanctuary against the dim, frigid world, would have been taken for an illustration of Pausha. It is possible, therefore, that the notation is a mistake, perhaps caused as a later cataloguer accidently flipped two pages rather than one when this *Barahmasa* series was still intact.

When previously published, the Bellak painting was dated to c. 1800. However, close examination of details, including the delicate faces and intricate patterning, links it instead with an earlier period of the major workshop of the Guler region, which B. N. Goswamy describes as the "first generation after Nainsukh."[4] DM

PUBLISHED: Spink 1982, no. 115

1. The architecture is very close to that found in pages of the dispersed *Bhagavata Purana* of c. 1760–65 (see cat. 80).
2. Randhawa 1962, p. 144. An approximately contemporaneous painting, *Bhup Singh and His Rani Under a Quilt,* is in the Victoria and Albert Museum, London (I.S. 202-1949; see Desai et al. 1985, cover, pp. 92, 94, no. 75). It, too, may be a *Barahmasa* page, depicting a similar scene. Here the two huddle together under a huge quilt, but the hero is shown as the specific human prince rather than as Krishna.
3. Ibid.; see also Dwivedi 1980, pp. 136–37.
4. See especially cats. 81–83. In terms of the specific handling of faces (relatively small heads, with large eyes showing the skin below), and such details as the unsagging rolled curtain, the hand matches that which Vishwa Chander Ohri (1998, pp. 98–114) has recently attributed to Nainsukh's third son, Nikka (c. 1745–1833), possibly from the period when he was working for the Chamba patron Raja Raj Singh (reigned 1764–97). While the stylistic affiliation is probable, whether Nikka's name and the Chamba patronage may be attached to this painting awaits further evidence.

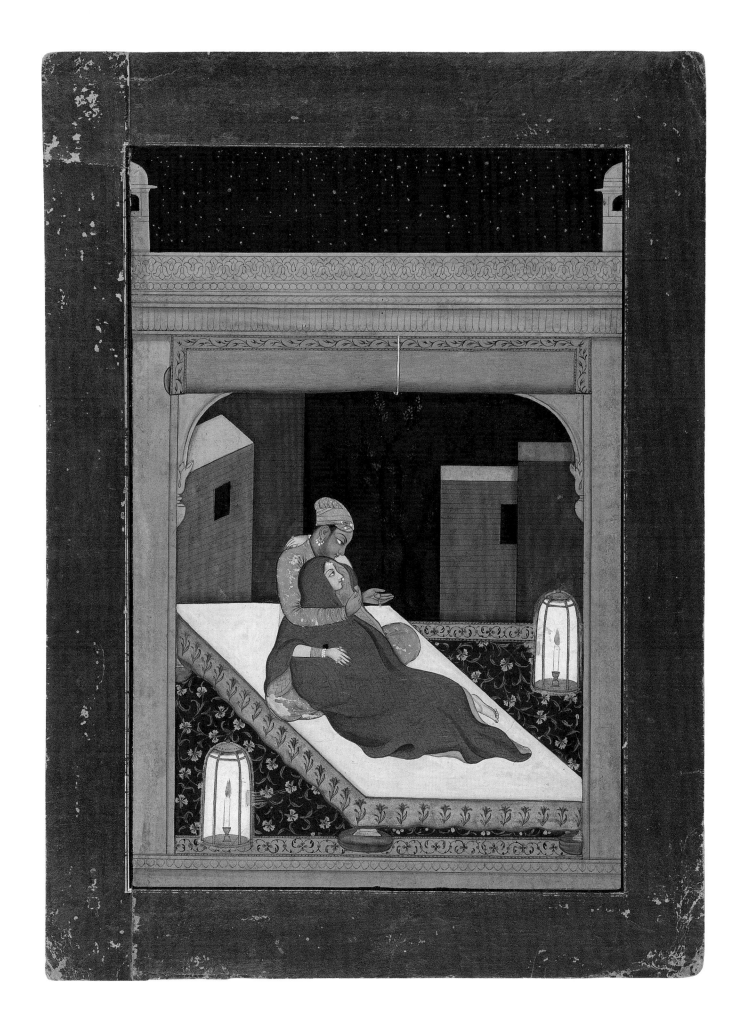

85. The Gods Sing and Dance for Shiva and Parvati

Ascribed to Khushala
Page from an unidentified dispersed series
Panjab Hills, probably Guler or Kangra, c. 1780–90
Opaque watercolor and gold on paper
9 x 12 15/16 inches (22.9 x 32.9 cm)

This composition of divinity at its most bucolically regal balances perfectly, like the elegant counterpoint of the central dancers. It represents the zenith of Pahari idealization, just at the watershed where softness and naturalism concretize into the more cartoon-like repetition that is very different in feeling, though charming in its own right (see cat. 87). Yet this painting's importance lies beyond its beauty, for it bears on its reverse a rare inscription (see Appendix) giving the names of two known painters—one as maker and one as owner—that link it with the painter-family of Pandit Seu and his sons Nainsukh (see cat. 79) and Manaku.

The inscription is in part ambiguous. In one hand it states: "Pictures twenty [a group of twenty pictures] first refined [or 'fine'] painted [or 'drawn' or 'written'] by Khushala." Following this, in another hand, is the word "Kamedi," meaning "belonging to or owned by Kama."[1] Given the style and the pairing of the two names, it is indisputable that the first refers to Khushala (c. 1730–c. 1790), the younger son of Manaku, and highly probable that the second refers to Kama (c. 1735–c. 1810), the eldest son of Nainsukh.[2] As the only known work actually ascribed to Khushala, this painting adds a crucial piece of evidence for sorting out the individual hands of the first generation of descendants of Nainsukh and Manaku. There was an oral tradition that Khushala was the favorite painter of Sansar Chand of Kangra.[3] Archer speculates that he worked together with his elder brother Fattu on the *Gita Govinda* of c. 1775–80 (cats. 82, 83), among other collaborations.[4]

Gentle hills with occasional trees slope down to the bank of a lake filled with pink lotuses in all stages of their life cycle. It is the holy Lake Mansarovar in Jammu region, part-time home to the god Shiva and his wife, Parvati, when they leave the barren ice of Mount Kailasa. The gently rolling hills, grazing deer, and flowering trees are an ideal setting for a divine (or royal) outing. On the left in the middle ground, Shiva and Parvati sit together on a tiger skin. She wears a sumptuous skirt of gold cloth worked with pink flowers and an orange scarf. Shiva, turned three-quarter

view in a typical depiction that makes visible the open third eye on his forehead, has skin white with ash. A live snake wriggles around his neck, from which hang his ritual *rudraksha* beads. He wears a leopard skin as his lower garment, and his long ascetic's hair, lightened by ash and neglect, falls unbound to his shoulders. However, this Shiva is far from the fierce ascetic god that is usual with these attributes. Instead, he is a beautiful, sweet-faced young man (very similar to the grief-stricken Rama of cat. 81). He accompanies the musicians before him on another typical attribute of the mendicant sage, the *damaru* (double drum).

In front of the divine couple, two women dance in a rhythmic symmetry that is as expressive as it is lyrical; their delicacy and shyness echo those of the antelope behind them. To the right, a large group of male musicians play strings and percussions—vinas, cymbals, sitars, and mridangams. All are beautiful young men, wearing crowns, jewels, and gold-bordered garments, making it likely that they are gods and other heavenly denizens, all performing for the supreme couple. The one with the prominent orange vina may be the sage Narada. In the middle of the group, musicians assist a third woman as she dons her golden scarf, exquisitely textured with thin lines incised in the gold,[5] in preparation for her performance. The crowd of divine musicians, though, is so vast that it continues out of the picture at the right, winds around the hill, and reappears behind the trees as a sea of indistinct faces, those in the distance fading into multicolored dabs to imply a multitude beyond measure.

The landscape is as carefully composed as it is idyllic, picturesque in all senses. As the hills recede they appear to be closer together, while trees, animals, and people shrink in size the farther back they are placed in the picture plane. Yet it is not Western linear perspective that is in use here, but only a semblance of it, modified to best suit the narrative and design.

A second painting, in the collection of Paul Walter,[6] is undoubtedly from the same series. It represents Shiva and Parvati bathing in a lotus-strewn

lake. Not only does it match the Bellak image in size and subject, but its details are handled in precisely the same manner—for example, the idiosyncrasy of the distinctively folded mouth of the tiger skin appears in both images, and the clothing that Parvati wears in this painting is that which she has discarded on the tiger skin in the bathing scene. Just what story these pages illustrate, however, is more difficult to determine, as no text accompanies them.[7] It may have been part of a group of paintings relating to the birth of Shiva's son Kumara (who is also called Karttikeya and Skanda), showing the assembly of the gods the moment after Shiva accepts Parvati as his bride. DM

PUBLISHED: Kramrisch 1986, pp. 132, 186, no. 122; Goswamy and Fischer 1992, pp. 332–33, no. 138

1. Translated by B. N. Goswamy. It had previously been mistranslated as: "Twenty paintings. Design by Kushala [*sic*]. Painted by Kāma" (Kramrisch 1986, p. 186, no. 122).
2. For a reconstruction of the lineage of this family of artists, see Goswamy and Fischer 1992, p. 307. They date this painting to c. 1800 and do not mention the inscription.
3. J. C. French (1931, p. 69) talks about the painter Kushan Lal and his relationship to Sansar Chand. He later told W. G. Archer that this information came from the maharaja of Lambagraon (see Archer 1973, vol. 1, p. 268).
4. Archer 1973, vol. 1, p. 292.
5. This treatment is seen frequently in paintings from this workshop at this time.
6. Pratapaditya Pal (1997, frontispiece; p. 58, no. 14 [detail]) identifies the Bellak page as the mate of this page, saying that there is "no doubt of the stylistic kinship." He then discusses the inscription on the Bellak page, using it to attribute the bathing scene to Khushala and Kama.
7. M. S. Randhawa (1967, plate X) believed that a page showing the same composition as the Walter page was from a set illustrating the love story of Aniruddha and Usha. In an advertisement for Kapoor Galleries (*Apollo*, n.s., vol. 121, no. 276 [February 1985], p. 15), the Walter image was captioned, "'Shiva and Parvati Bathing' in a pond, a folio from the Shiva Purana," and Stella Kramrisch (1986, p. 186, no. 122) likewise speculated that the Bellak page might illustrate the *Shiva Purana*. Pal (1997, p. 58, no. 14), however, wrote that it has an "unusual subject matter . . . intriguing for its literary source," but chose to leave it unidentified, as Goswamy and Fischer (1992, pp. 332–33, no. 138) did with the Bellak page.

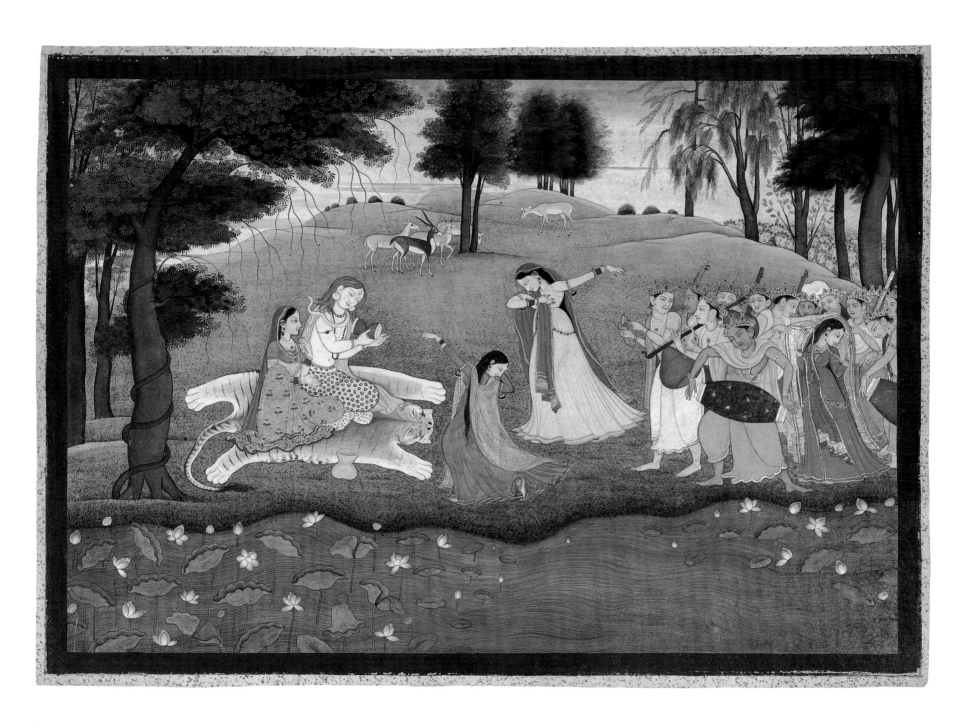

86. *Shiva Describes the Benefits of Pilgrimage*

Page from a dispersed series of the *Kedara Kalpa*
Panjab Hills, Kangra, c. 1800–1825
Opaque watercolor, gold, and silver-colored paint on paper
14 1/4 x 19 1/8 inches (36.2 x 48.6 cm)

The scene is dominated by the icy crags of the high mountain setting, depicted by a wall of pointed rocks placed at contrasting diagonals: white, surrounded by a single brush stroke of light black-gray paint with shading added by a faint green wash overlaid with thin, light gray parallel lines, indicates their frozen state. The sky is pale blue with gentle clouds, and, at right, two sweeps of sunset above hint of the vast mountain valley. Across the bottom of the page flows a silver river regularly punctuated by crossed black rocks alternating with single white boulders to echo, one in shape, the other in color, the mountainscape behind.

In contrast to the barren ice, a single large, lush tree rises behind the seated deities. It is encircled by creepers that end in the branches with triple strands of hanging pink flowers, and the tree itself bears a smattering of light orange-brown leaves or flowers. Below the tree is laid a tiger skin with prominent mustache. On it rests a gold-tooled and jewel-studded throne covered in an intricate and delicate white floral spread, with an equally ornate gold umbrella with pearl fringe attached to one corner.

On the throne sits Shiva, dressed as a Pahari prince with only subtle indications of his usually horrific iconography. He wears an orange *jama*, courtly jewelry, and an elaborate peaked crown with pearl fringe like that on the royal umbrella above. It is only by the live snake at his waist, the faint forms of a third eye and crescent moon at his brow, and the long, thin staff of the trident he holds tucked under one arm that he can be identified. He reaches out one hand as if conversing; the other touches thumb and forefinger as if holding an absent flower, another gesture of discourse. To his left his wife, Parvati, perches sideways with a foot on the throne rail. She wears layers of diaphanous fabric.

Neither she nor Shiva seems relaxed, however. They both sit erect, deep in conversation with their six-headed, six-armed son Karttikeya, who kneels on the ground in front of them. It is Shiva who does the talking, however,[1] as indicated by the gestures of his raised hands. Parvati's hand reaches toward her lips as she listens in wonder; the other hand rests in her lap. Two of Karttikeya's hands are folded in quiet reverence toward his parents (a third hand holds his spear, while the other three rest on his lap).

Karttikeya is conceived more like a sculpted icon than a moveable human being—equal-size heads project to either side (only three look at his parents), and arms reach both fore and back. Behind him stands his *vahana* (vehicle), the peacock. At the opposite side of the painting, behind the throne, rests Shiva's *vahana*, the white zebu bull Nandi, shown with gold ornaments and an elaborate orange cloth covering rimmed in silver. The animals give a human-scale frame to the divine scene that would otherwise appear overshadowed by the imposing landscape.

Although nine other pages from this series had been published,[2] the text that they illustrated remained a mystery until very recently. Apart from the Bellak page, all the other known paintings depict five sages at various stages of a Himalayan pilgrimage: at times emaciated from their wilderness wanderings, at times rested and fed in a variety of sumptuous, possibly celestial, palaces.[3] B. N. Goswamy, while publishing yet another page,[4] has finally identified the story as part of a little-known Shaiva text, the *Kedara Kalpa*, that extols the virtues of pilgrimage to the holy mountain region of Kedara-Kailasa, evidently referring to Kedarnath in modern Uttar Pradesh, which remains of utmost significance today. According to Goswamy, the text utilizes the narrative device of Shiva telling Parvati and Karttikeya a variety of stories that illustrate the benefits of such pilgrimage. The longest of these tales describes five sages traveling through mountains covered in ice and snow, experiencing both rigors and marvels, including great golden palace-cities, through devotion to Shiva. The location of this painting is ostensibly Shiva's abode on Mount Kailasa, from where he narrates the story. However, the dramatic landscape depicted closely resembles the setting of the Kedarnath temple, which stands in a verdant valley surrounded by walls of perpetually snow-covered mountains, the great Kedardome peak rising up ridge-like behind the temple itself.

This painting is framed with an inner blue border and an outer red one on which the number 3 is inscribed in white at the top. Five of the other known pages are also numbered, running from 5 to 28. With the exception of this page, all show the story of the five sages. It can thus reasonably be concluded that the set did not illustrate the complete manuscript, but only the episode of the sages, and that this page, early in

the series, shows the narrative device at the beginning, when Shiva is seen telling the tale to Karttikeya.

Although not as evident in this image, most of the compositions are highly complex with multiple events envisioned within the same painting. These factors, together with the fairly squat figures, distinctive blunt physiognomy, and overburdened vegetation, link this set with the workshop Goswamy identifies as that of Purkhu of Kangra (see cat. 87). However, unlike the flattened picture plane and often unreadable spatial relationships seen in the works attributed to Purkhu himself, the artist responsible for this painting has produced a clear fore-, middle-, and background, and this sense of ordered space also appears in the companion pages, even when the composition is crowded with figures and architecture. In addition, much more than other works connected with this atelier, this set of paintings integrates the individual scenes and utilizes visual correspondences in a sophisticated, almost literary, style. DM

PUBLISHED: Kramrisch 1986, pp. 128, 184–85, no. 118

1. Stella Kramrisch (1986, pp. 184–85, no. 118) misunderstood Karttikeya's gesture and thus titled the work *Kārttikeya Addresses Śiva and Pārvatī in the Icy Himalayas.*
2. The five pages with numbers are: no. 5, John Gilmore Ford Collection (Pal 1971, p. 42, no. 50); no. 6, Ehrenfeld Collection (Ehnbom 1985, pp. 252–53, no. 127); no. 8, Virginia Museum of Fine Arts, Richmond (Kramrisch 1981, pp. 222–23, no. P-52C); no. 16, Sam Fogg Collection, London (Fogg 1999, pp. 104–5, no. 68); and no. 28, Dr. Michael Hudson Collection, New York (Kramrisch 1981, pp. 222–23, no. P-52A). Three other pages bear no numbers, and are in the Walter Collection (Pal 1978, pp. 194–95, no. 72a); the Los Angeles County Museum of Art; and the Goenka Collection. The ninth page, possibly from a later series, is National Museum, New Delhi, 63.1155 (Archer 1973, vol. 2, p. 126, Hindur no. 5); I do not know if it has a number.
3. Scholars have speculated on their identification. Archer (1973, vol. 1, p. 173, Hindur no. 5) thought they were "the five *rishis* dispatched by Indra to please Shiva" in the *Shiva Purana*; Pal (1978, p. 194, no. 72) speculated they might be "the five Pāndava brothers . . . on their way to heaven"; Kramrisch (1981, p. 222, no. P-52) suggested they were the five celestial sages (*devarishis*); while Georgina Fantoni (in Fogg 1999, pp. 104–5, no. 68) gives a final alternative, suggested to her by Robert Skelton, that the pages are from a *Ramayana,* and that the five sages are the *rishis* led by Vishvamitra to celebrate Rama's return from exile.
4. Goswamy with Bhatia 1999, pp. 280–81, no. 216. In his forthcoming publication of the text, Goswamy intends to argue this identification more completely.

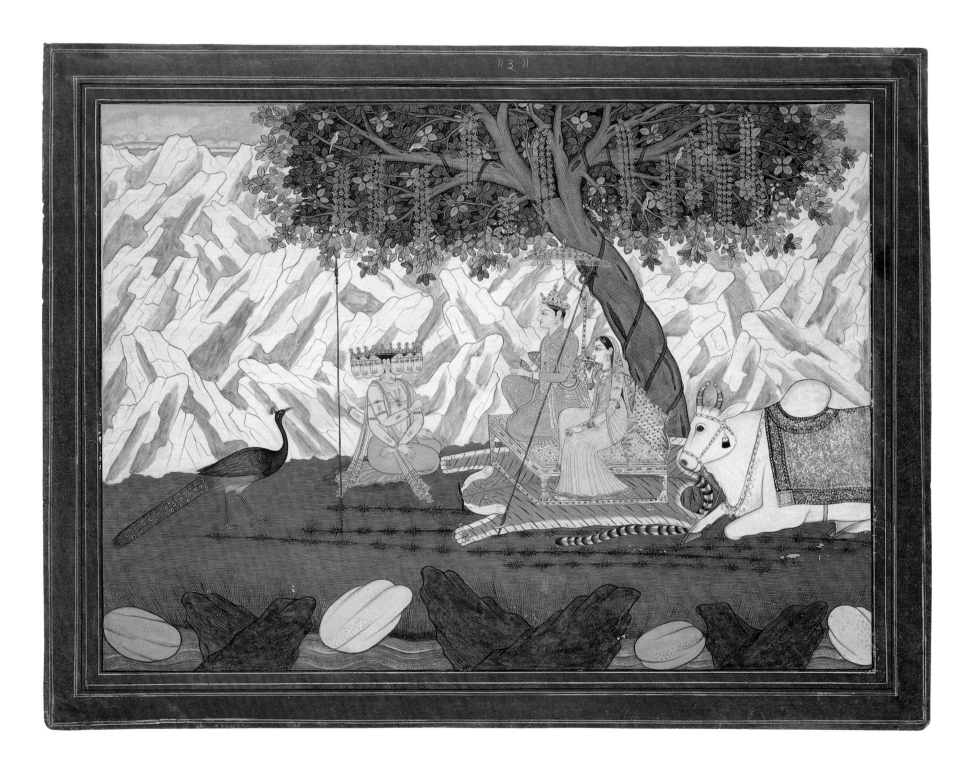

87. *When He Quickens All Things*

Page from a dispersed series of the *Gita Govinda* of Jayadeva
Panjab Hills, Kangra, c. 1800–1810
Opaque watercolor and gold on paper
11 1/16 x 14 3/16 inches (28.1 x 36 cm)
Collection of Jennifer Bellak Barlow

A musically rhythmic pattern of people and landscape is created in this painting, making it perhaps the most aesthetically satisfying page of this late but spectacular series, known as the "Lambagraon" *Gita Govinda*.[1] The group of Krishna and twelve *gopis* forms a partial circle around the upper left. Colors are richly saturated but limited—pink, orange, yellow, shades of green, blue, and gray. The sky is the deep blue-gray that follows a spring rainstorm, bushes flower profusely, and trees show the bright green of first growth. Equally vernal is the scene of high-spirited, hormone-driven horseplay. The word "Vasant"—the spring season—appears in white letters at the center of the painting. On the back is inscribed part of Verse 46 from the first section of the *Gita Govinda* (see also cats. 82, 83), which reads in full:

> *When he quickens all things*
> *To create bliss in the world,*
> *His soft black sinuous lotus limbs*
> *Begin the festival of love*
> *And beautiful cowherd girls wildly*
> *Wind him in their bodies.*
> *Friend, in spring young Hari [Krishna] plays*
> *Like erotic mood incarnate.*[2]

The composition is a gentle diagonal, emphasized by the river across the lower margin. Near the river stands Radha (identified above her head as "Radhika," as she is throughout the series). The *sakhi*, her female confidante, is with her; she is smaller in scale than Radha, and she talks animatedly, one hand raised in explication, the other pointing at Krishna. Radha's body language—head lowered, arms pulled inward—speaks eloquently of the growing jealousy and anger she feels as she realizes Krishna's abandonment. The surrounding foliage isolates and reflects this vignette—vines droop above their heads; the trunk of a tree curves to echo Radha's bent back.

The balance of the painting is filled with Krishna's amorous frolics amid luxuriant vegetation. Four women playfully struggle with the god, his dark limbs entwining them to lucidly illustrate the verse. The tussle is not subtle. Krishna holds one *gopi* in a headlock under his right arm, grabs another by the wrist, catches the waist of a third, and entraps a fourth with his leg. Around the tree to the left of Krishna, three *gopis* wonder and exclaim. On his other side, one *gopi* tugs another from Krishna's embrace as a third stretches out to link with the tree on the right, behind which cluster the final three. Of these, two point and expostulate while the third girl wraps her body languorously around the trunk, as if "drunk from dancing in the rite of love."[3]

The line of *gopis* curves across the page, anchored between two prominent trees. It echoes the form of the swing that plays a key role in the celebration of spring, and, not incidentally, usually personifies the *raga* (musical mode) of Vasant. Indeed, it is likely that the inscription and the image are intended as more than generic references to the season, giving a specific instruction as to the *raga* in which these verses are to be sung.[4]

The figures themselves are relatively squat, with highly mannered postures and gestures, including acutely inclined heads and hands bent sharply backward at the wrist. Other details of physiognomy, garments, and foliage, as well as the crowded compositions tilted toward the front of the picture plane and individual labeling, relate this painting and others from the series to the workshop of Purkhu (see cat. 86), an artist known to have been patronized by the powerful Maharaja Sansar Chand (reigned 1777–1823) of Kangra and likely responsible for numerous portraits of that ruler and his court.[5]

For this *Gita Govinda* series, the connection to Kangra is strengthened by the fact that it was inherited in the 1930s and subsequently dispersed by a descendant of Sansar Chand, Raja Dhrub Dev Chand[6] of Lambagraon, a town along the Beas River and late family seat of the Katoch Rajputs, the Kangra ruling family. B. N. Goswamy, however, attributes the series to the "family workshop of Purkhu of Kangra,"[7] rather than to the master's own hand. Compared to the works Goswamy believes are by Purkhu himself, the *Gita Govinda* pages do show slightly more elongated figures, compositions more removed from the front of the picture plane, a greater attention to the overall flow of composition, and significantly more varied postures. These differences may be due to another hand at work, although they may also be dictated by the subject, reflecting the more lyrical nature of the text. DM

PUBLISHED: Kramrisch 1986, pp. 138, 187–88, no. 128

1. A number of pages from this series are in India, particularly in the National Museum, New Delhi; one is in the Goenka Collection (Goswamy with Bhatia 1999, p. 276, no. 213). Others are scattered in collections in the West, including the Binney Collection of the San Diego Museum of Art; the Los Angeles County Museum of Art (Pal 1997, pp. 90, 93, no. 41d); the Brooklyn Museum (72.43; Poster et al. 1994, pp. 274–75, no. 226); and the Museum of Fine Arts, Boston (17.2389, 17.2391). W. G. Archer (1973, vol. 1, p. 307, Kangra nos. 67[i–iii]) called this the "second Kangra" *Gita Govinda* series.
2. Miller 1977, p. 77.
3. Ibid., p. 76.
4. Added evidence that the inscription and the swing-like composition are indicators of the *raga* is provided by another page from this same *Gita Govinda* series, in the National Museum, New Delhi. Labeled "Desakh," it includes an image of a wrestler who stands out of context in the Vrindavan woods, his presence comprehensible only as a personification of the *raga* of that name (B. N. Goswamy, personal communication, 2000). Barbara Stoler Miller (1977, pp. 48 n. 30, 77) writes that the verse found on the Bellak page is to be sung with *raga* Ramakari, but that the coordination of *ragas* to verses is not consistent in different versions of the text.
5. Purkhu seems to have been first mentioned in relation to Sansar Chand in B. H. Baden Powell's *Hand-Book of the Manufactures and Arts of the Punjab* (Lahore: Punjab Printing Company, 1872), p. 355. Goswamy and Fischer (1992, pp. 368–87) identify a number of narrative series as probably produced by his workshop, although they do not attempt to distinguish the hands of individual painters.
6. He was the great-great-grandson of Sansar Chand's brother Fateh Chand. J. C. French published one page from the series as "Collection of Colonel the Maharaja Sir Jai Chand of Lambagaon [*sic*]" (1931, plate XXII). Ananda Coomaraswamy acquired two pages in c. 1910 (now Museum of Fine Arts, Boston, 17.2389, 17.2391). Dhrub Dev Chand also owned the "vertical" Mankot *Bhagavata Purana* (see cat. 32) and the *Dashavatara* series (see cat. 33).
7. Goswamy with Bhatia 1999, p. 276, no. 213. Karl Khandalavala (1959, pp. 150–51) early speculated that this set was patronized by Sansar Chand himself, while Archer (1973, vol. 1, p. 307, Kangra nos. 67[i–iii]) made the same connection, but saw it as painted a bit later, possibly for Sansar Chand's brother Fateh Chand, between 1820 and 1825.

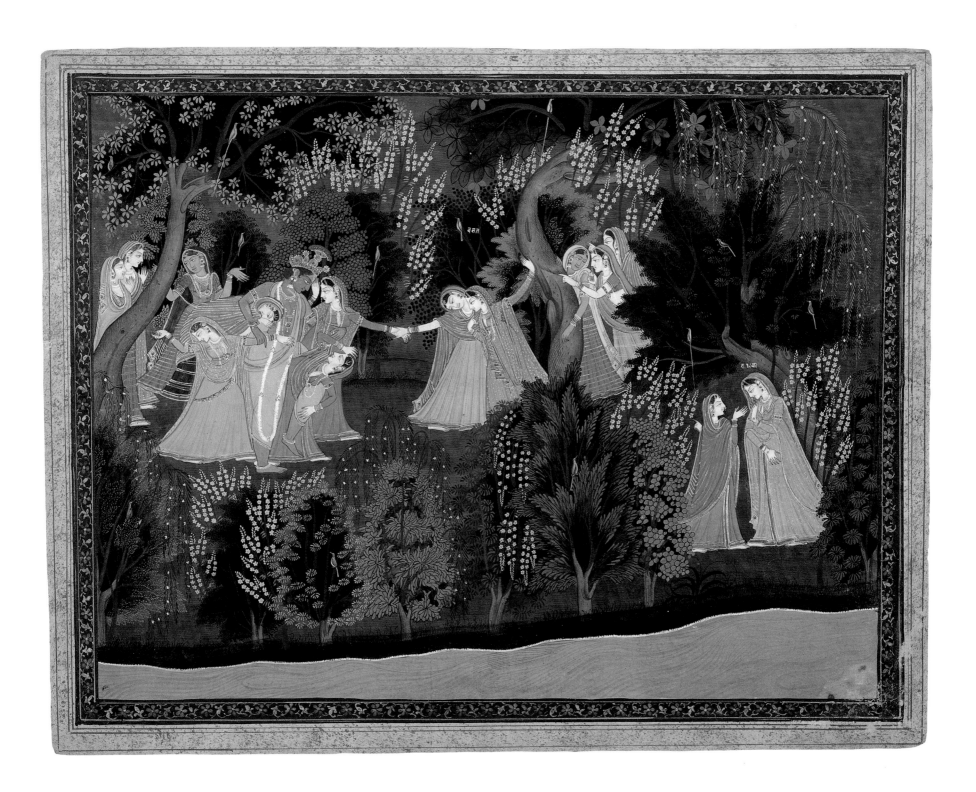

88. *Krishna and Balarama Hear About the Demon in the Palm Grove*

Probably an additional page for a composite series of the *Bhagavata Purana*
Probably Panjab Plains, c. 1870–80
Opaque watercolor on paper
12 x 16 3/16 inches (30.5 x 41.1 cm)

Many of the tales of Krishna's early life told in the *Bhagavata Purana* juxtapose his outward identity as a rambunctious young cowherd with his reality as the ultimate deity, Vishnu, through his destruction of an array of colorful demons. Often in these stories it is also shown how Krishna's brother Balarama also partakes of the godhead.

The three lines of Sanskrit verse on the back of this painting tell the beginning of the story, when the cowherd *(gopa)* Shridama, together with Subala and Stoka-Krishna, comes to Krishna and Balarama with a problem (see Appendix).[1] Nearby there is a grove of palm trees filled with delicious fruit, ripe and falling to the ground. The fruit tempts the *gopa* boys, but is well guarded by Dhenuka, a cannibal *asura* (demon) in the form of a donkey. Dhenuka and his retinue viciously devour anyone—bird, cow, or man—daring to approach. Shridama begs the divine brothers to help retrieve the fruit. They and the *gopas* enter the grove, where Balarama kills Dhenuka by grabbing his legs, whirling him overhead, and skewering him atop a tall tree; together, Balarama and Krishna then use the same technique to destroy the demon's party.

Here Krishna, Balarama, and the *gopas* first approach the palm grove. At the far right of the group, the mustached Shridama (identified by an inscription over his head) and, presumably, Subala and Stoka-Krishna, excitedly point to the grove and describe the lurking *asura* to Krishna and Balarama. The remainder of the *gopas* talk among themselves, their agitation contrasting with the poised listening of Krishna and Balarama.

The grove itself occupies the right half of the central ground of the painting, a major element in the composition. Along the bottom third runs a river; small pink and blue stones border its banks, and huge gray fish, shown in full side view as if lying on the surface, swim within it. The left half of the central distance is taken up with the group of *gopas,* clutching their herder's staffs, gathered in an arch around the crowned figures of white-skinned Balarama and blue-skinned Krishna.

The cowherds are distinguished from one another by clothing and skin color (some light, some dark), by full face or profile depiction, by hairstyle, and by body pose, yet they are essentially the same figure with the same face—slightly blunter and fuller than those of the brothers—repeated eleven times. There is a distinct lack of ornament and sartorial detail in the painting of the figures that, taken together with the unpainted border, may indicate the artist left unfinished some final touches. However, in other images from this group, where cowherds appear in conjunction with more elaborately clad figures, the *gopas* likewise lack ornamentation.

The landscape here, although depicting a far horizon, does not have the sense of deep space nor of delicate detail seen in earlier Pahari works (see cats. 81, 85). Instead, its distance is created by schematically layered hills with tops outlined in regular lines of lighter green, dotted with varying sized cannonballbushes perched on the rises in sets of two or three. Stands of deciduous trees peek from the valleys in the middle distance, and wet daubs of white, orange, and gold form the clouds stretching across the narrow section of sky. The palm grove itself appears as a pattern of perfect circles of triangular fronds and spindly trunks with patchwork shading.

Although there is an oral tradition[2] that W. G. Archer attributed this painting to the small Pahari kingdom of Sirmur, he published a page probably from the same series and attributed it by formal comparison to the kingdom of Hindur (Nalagarh).[3] More recently, another related *Bhagavata Purana* page has been published as "probably Garhwal."[4] Even more than works of the late eighteenth and early nineteenth centuries, which display a distinctiveness of workshop traditions, such paintings that date after the mid-nineteenth century show an almost cartoonlike generic style that current scholarship has not begun to disentangle.

On the reverse of this painting, however, there is an additional clue about its origins that leads to a conclusion of major significance for the later use and appreciation of these works in the Indian milieu: above the standard inscription of the Sanskrit text from the *Bhagavata Purana* are four lines written in Gurmukhi, the language of the Panjab Plains, that give the chapter and verse of the passage as well as a brief identification of the subject. What imparts it importance, however, is that Gurmukhi inscriptions that precisely match this one in format and hand are found on the pages of two other dispersed Pahari *Bhagavata Purana* sets that were probably painted by successive generations of the same family, which B. N. Goswamy calls that of Pandit Seu, Nainsukh, and Manaku. The earlier is the so-called larger Basohli *Bhagavata Purana* (see Appendix, cat. 80) of about 1760–65 and the later the well-known "Kangra" *Bhagavata Purana* of c. 1780, which was probably painted in Guler (for paintings closely related in style, see cats. 81–83).[5] The most likely scenario to be derived from this evidence is that both series, at some time during the second half of the nineteenth century, were in the possession of an individual in the Panjab Plains region who attempted to amalgamate them into a single narrative set; commissioned a painter trained in the Pahari tradition to create additional pages as fillers for missing scenes (for the practice of creating replacement pages, see also cat. 34); and added the Gurmukhi inscriptions onto all the pages, perhaps because he could not comfortably read the Sanskrit verses.

Although extremely popular with Western collectors in the first half of the twentieth century for their idealized charm, such "late" paintings, produced in great numbers, have now fallen into disfavor. However, the best of these works not only show a combination of lively narrative and clever composition, but emphasize the continuity of patronage and the popularity of the texts interpreted—or, in this case, "completed"—by a new generation of artists. DM

1. Book 10, Chapter 15, verses 20–21.
2. On an invoice for the painting is recorded: "According to a former owner, W. G. Archer suggested the painting was made in Sirmur."
3. Archer 1973, vol. 1, p. 173, Hindur no. 8; vol. 2, p. 127, Hindur no. 8.
4. The Cleveland Museum of Art, 71.301; see Leach 1986, pp. 272–73, no. 110.
5. It was B. N. Goswamy who noticed the relation of the inscription on this page with that on cat. 80, and then made the further connection with the c. 1780 manuscript. From these factors we deduced the above scenario.

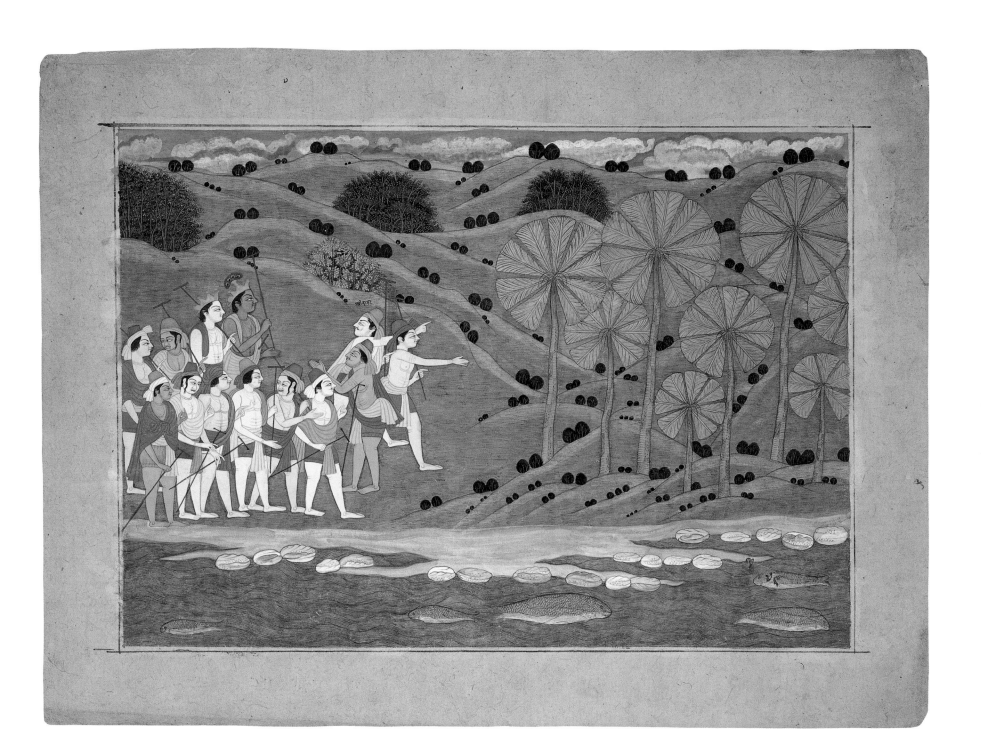

89. *The Stallion Tota and His Groom*

Ascribed to Lal Singh
Panjab Plains, dated 1893
Opaque watercolor, gold, and silver-colored paint on paper
10 x 13 15/16 inches (25.4 x 35.4 cm)

Standing in a circular driveway within a leafy garden by a great walled house, the groom Mahfooz firmly holds the bridle of the very beautiful white stallion Tota, whose name means "Parrot." His red velvet saddle is decorated with gold bands and long streamers attached to a gold back strap that stretches from the rear of the saddle to the base of his tail. Around his fetlocks, along his shoulder to his withers, and around his neck at his throat latch are supple black bands with a granular texture, as if either a finely braided material or beaded work. The gold trappings, red velvet saddle, and unusual black decorations[1] suggest that Tota belonged to a member of the aristocracy; the Gurmukhi alphabet and Panjabi language of the inscription indicate that the patron was a Sikh, or perhaps a Panjabi Hindu.[2] This painting was probably one of a series documenting the household of the patron. Sometimes such series were bound into albums, but more often were kept as individual paintings.

Lal Singh's painting of the white stallion Tota owes much to photography, to the extent that it is difficult to determine whether it is, in fact, a painted photograph. The painted surface is the same size as, or slightly smaller than, the photographs produced in the Panjab at the end of the nineteenth century.[3] In the more "traditional" South Asian equine portrait (such as cats. 44, 45, or 49), the figures seem to levitate in nonexistent space, devoid of any indication of surroundings. Lal Singh, however, creates a garden in believable space, with a curving pathway and realistic shadows. His proportions of man and animal are closer to what we understand to be lifelike than are those in the earlier paintings. The proportion of figures to the area of the whole mimics that of late nineteenth-century photographs of men and horses.[4] If Lal Singh's portrait of Tota is not a painted photograph, the artist must have had access to a photograph of similar composition.[5]

The art of photography was introduced into India in the 1840s, and by 1849 the first professional photographic studio opened in Calcutta.[6] Over the following years, this new medium became enormously popular with the indigenous population as well as with the foreigners. The resident Europeans made or commissioned not only albums of photographs that recorded the usual tourist attractions but also series of photographs that recorded their everyday life in India.[7] The tradition in India of making albums of paintings of one's colleagues, servants, favorite animals, and, for that matter, one's self (see cats. 44–46, 51) predated photography by several hundred years. While the craze for photographs forced many professional portrait painters out of business,[8] photographs themselves had a tremendous influence on painting in South Asia in the late nineteenth and early twentieth centuries (see cat. 90). By the same token, nineteenth-century Indian photography is indebted to the tradition of Indian court painting for its well-established canon of subjects. ES

1. For one other representation of such horse trappings, see R. P. Srivastava, *Punjab Painting: Study in Art and Culture* (New Delhi: Abhinav Publications, 1983), fig. 116. The artist may or may not be the same Lal Singh.
2. The inscription at the top reads: "A painting of the stallion Tota and his groom Mahfooz, the work of Lal Singh the painter, 28 Baisakh, Samvat 1940 [May 1893]."
3. Arthur Ollman, personal communication, June 2000.
4. See *Englishman with His Dog and Horse*, in Worswick and Embree 1976, plate 56.
5. For a photograph and a painting copied from it, see Judith Mara Gutman, *Through Indian Eyes* (New York: Oxford University Press, 1982), repro. p. 108.
6. Worswick and Embree 1976, pp. 3–4.
7. For examples, see ibid., plates 53–58.
8. Ibid., pp. 3–4.

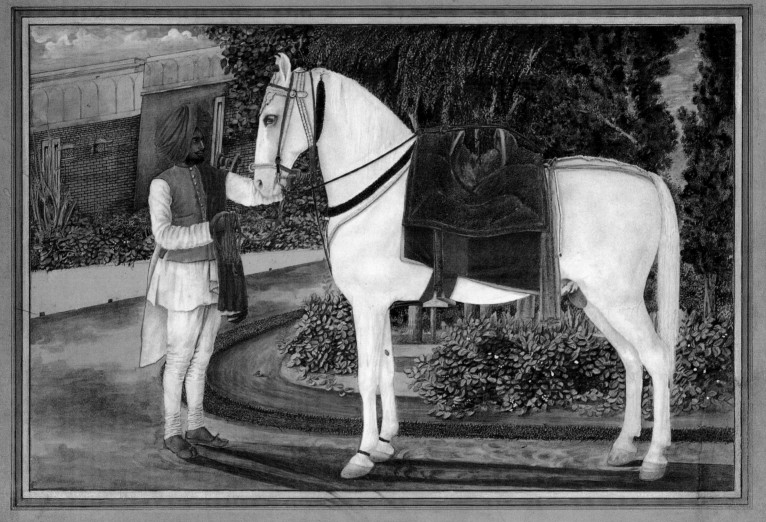

90. *Thakur Balwant Singh Presides at a Dance Performance*

Ascribed to Mohan Lal
Rajasthan, Jaipur, c. 1890
Opaque watercolor, gold, and silver-colored paint on paper
29 13/16 x 35 13/16 inches (75.5 x 90.9 cm)

Maharaja Balwant Singh was the son of the *thakur* (baron) of Khandela, one of the *thikanas* (fiefs) of Jaipur state in Shekhawati, the arid region north of the royal capital.[1] By the late nineteenth century, most of the *thakurs* had large houses in Jaipur city, where they resided for the better part of the year. The imposing assembly hall depicted here is furnished to impress: the billowing curtains, Axminster carpet, crystal chandeliers, and askew wall clocks proclaim the occupant's wealth and fashionable, European taste. But Balwant Singh's guests are oblivious to their surroundings. Sitting in stiffly parallel rows, they have the lifeless detachment of people invited to an inquisition, not to a *nautch* (dance performance). All of their missing excitement has concentrated in the foreground carpet, where it erupts in a delirious torrent of pattern and color.

By 1890, Jaipur was the largest and most modern city in Rajasthan. The city had been transformed during the reign of Maharaja Ram Singh II (1835–80), who wanted to make Jaipur a second Calcutta.[2] Guided by the British political agent and a staff of imported advisors, the maharaja initiated a program of modernization (and Westernization) that was unprecedented in Rajasthan. Slavery, infanticide, and *sati* (the self-immolation of widows) were abolished, and the urban fabric of Jaipur was updated and enlarged. The walled city was provided with waterworks and gas lighting, and a new district was constructed beyond the old city walls. Laid out with broad streets in the style of a European cantonment, this new area centered on the Ram Niwas Gardens (1868), which copied the design of a celebrated Calcutta park.

Ram Singh's plans for the visual arts resulted in the creation of two powerfully Westernizing institutions: the maharaja's School of Arts (1867) and the Albert Hall Museum (1876). The School of Arts was supervised by F.W.F. DeFabeck, an amateur photographer. Its curriculum focused on the teaching of craft: plain and ornamental carpentry; carving in wood, bone, and ivory; pottery; and the like. Instruction in Indian miniature painting was not part of the program. Indeed, this centuries-old tradition was regarded with withering contempt: its practitioners were encouraged to learn carving and pottery like everyone else. The Albert Hall Museum was designed by Samuel Swinton Jacobs, a "walking dictionary of Indo-Saracenic architecture," and led by curator Thomas Holbein Hendley, another walking dictionary, but one who specialized in the arts and crafts. Hendley's museum exhibited the carefully crafted yet lifeless articles that DeFabeck's students fabricated. Their creations still fill the galleries that one can visit today.

Ram Singh's innovations had a devastating impact on traditional court painters. Mohan Lal, the creator of the present picture, was probably dismissed from the maharaja's service around the time the Jaipur art school and museum were established. In trawling for new customers (the inscription tells us where to find him), Mohan Lal would have faced powerful competition from the growing number of professional photographers who dominated the market for portraiture from the 1870s onward (see cat. 89). Mohan Lal's paintings offered the same objective format. (Note the way his figures are all depicted in "face-the-camera" pose.) But when compared to a photograph, his paintings were much larger, brilliantly colored, and less appallingly frank. These competitive advantages would have kept him busy in the years 1880–1910.[3] But after 1910, when the demand for paintings in the photographic style collapsed, later artists at Jaipur descended to a DeFabeck level of craft. Yet it was at this very time that artists like Abanindranath Tagore in Calcutta were "rediscovering" the court painting traditions and using them as inspiration to create a national contemporary art in India. TM

1. I am grateful to Mr. Kripal Singh Shekhawat of Jaipur for this information. The Rajasthani inscription along the top and bottom offers the following identifications: "Painted by Mohan Lal of Jaipur [who resides] in the neighborhood beneath the Tiger Fort [Nargad, or Nahar Garh]. / Maharaja Thakur Balwant Singh Shekhawat, Thikana Fort Kinlanpura [or Kalyanpura]." Mr. Singh also tells me that the title "*thakur* of Kinlanpura" was a courtesy title given to the second son of the Khandela noble house. Kinlanpura is a fort on the outskirts of Khandela.
2. Jadunath Sarkar, *A History of Jaipur, c. 1530–1938*, ed. Raghubir Sinh (Hyderbad: Orient Longman, 1984), p. 363.
3. For two other photographic-style portraits by Mohan Lal, see Topsfield 2000, p. 11, fig. 12; and Jaipur Adhai Sati Samaroh Samiti, *Exhibition of Dhundhar Painting from Raja Man Singh to Sawai Man Singh* (1977), no. 69. The first painting is in the Ashmolean Museum, Oxford (1995.34). The second, dated 1899, is in the collection of Kumar Sangram Singh of Nawalgarh, Jaipur.

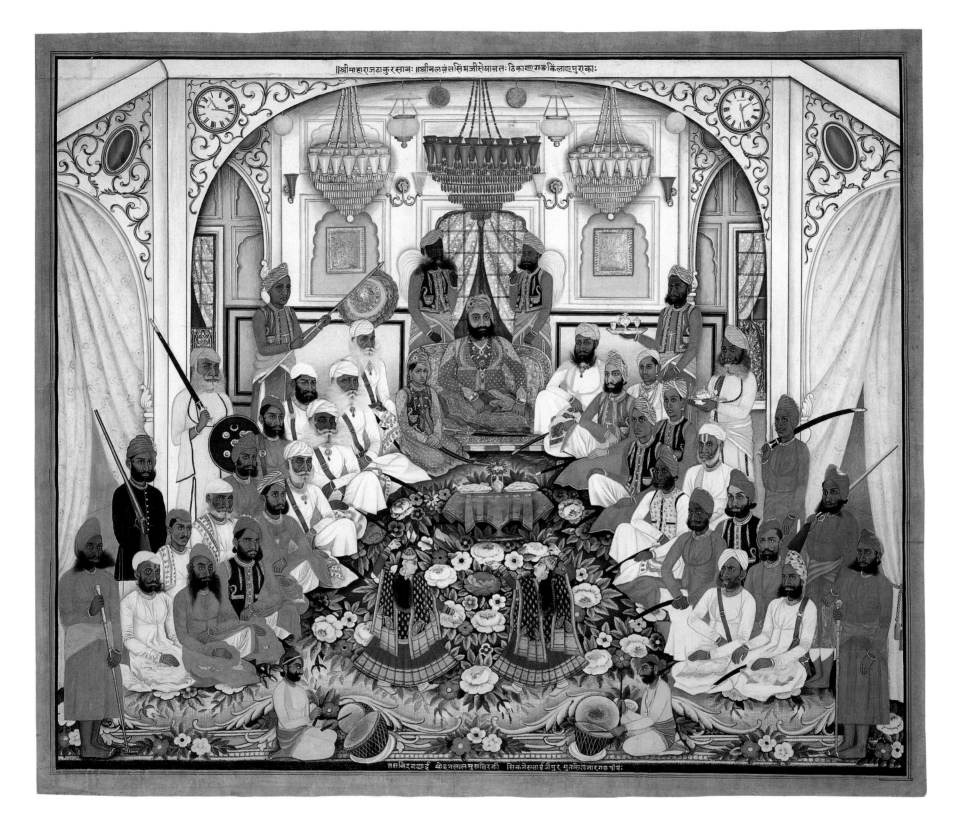

श्रीमाहाराजठाकुरसानः ॥श्रीनलब्रतसिंघजीसेखावतः ठिकाणागड किलाणपुराका:

तस्बिरबणाई मोहनलालमुखबिरजी सिब.नेसबाई जैपुर मुतबिलनारागडजीव:

Appendix

The reverse sides of a select number of paintings in the Bellak Collection are reproduced here.

CAT. 13

CAT. 19

CAT. 14

CAT. 26

CAT. 35

CAT. 42

CAT. 44

CAT. 46

CAT. 58

CAT. 43

CAT. 61

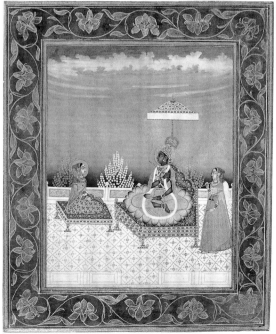

CAT. 67

CAT. 69

CAT. 80

CAT. 71

CAT. 82

CAT. 72

CAT. 83

CAT. 85

CAT. 88

Bibliographic Abbreviations

Archer 1959
W. G. Archer. *Indian Painting in Bundi and Kotah.* London: Her Majesty's Stationery Office, 1959.

Archer 1973
W. G. Archer. *Indian Paintings from the Punjab Hills: A Survey and History of Pahari Miniature Painting.* 2 vols. London: Sotheby Parke Bernet; Delhi: Oxford University Press, 1973.

Archer 1976
W. G. Archer. *Visions of Courtly India: The Archer Collection of Pahari Miniatures.* Exh. cat. Washington, D.C.: International Exhibitions Foundation, 1976.

Bautze 1987
Joachim K. Bautze. "Zur Darstellung der Hauptgottheiten Kotas in der Malerei der zweiten Hälfte des 18. und der ersten Hälfte des 19. Jahrhunderts." *Berliner Indologische Studien,* vol. 3 (1987), pp. 253–78.

Bautze 1997
Joachim K. Bautze. "The History of Kotah in an Art-Historical Context." In Welch 1997, pp. 39–60.

Beach 1987
Milo Cleveland Beach. *Early Mughal Painting.* Cambridge: Harvard University Press for the Asia Society, 1987.

Beach 1992
Milo Cleveland Beach. *The New Cambridge History of India.* Vol. 1, pt. 3, *Mughal and Rajput Painting.* Cambridge: Cambridge University Press, 1992.

Canby 1994
Sheila Canby, ed. *Humayun's Garden Party: Princes of the House of Timur and Early Mughal Painting.* Mumbai: Marg Publications, 1994.

Chandra 1957–59
Pramod Chandra. "A Series of Ramayana Paintings of the Popular Mughal School." *Prince of Wales Museum Bulletin,* no. 6 (1957–59), pp. 64–70.

Chandra and Shah 1975
Moti Chandra and Umakant P. Shah. *New Documents of Jaina Painting.* Mumbai: Shri Mahavira Jaina Vidyalaya, 1975.

Cimino 1985
Rosa Maria Cimino. *Life at Court in Rajasthan: Indian Miniatures from the Seventeenth to the Nineteenth Century.* Exh. cat. Florence: Mario Luca Giusti, 1985.

Colnaghi 1978
P & D Colnaghi & Co. Ltd., London. *Indian Painting: Mughal and Rajput and a Sultanate Manuscript.* April 5–May 3, 1978.

Crill 1999
Rosemary Crill. *Marwar Painting: A History of the Jodhpur Style.* Mumbai: India Book House Limited, 1999.

Crill 2000
Rosemary Crill. "The Thakurs of Ghanerao as Patrons of Painting." In Topsfield 2000, pp. 92–122.

Czuma 1975
Stanislaw Czuma. *Indian Art from the George P. Bickford Collection.* With an introduction by W. G. Archer. Exh. cat. Cleveland: The Cleveland Museum of Art, 1975.

Das 1995
Asok Kumar Das. "Activities of the Jaipur Suratkhana, 1750–1768." In Guy 1995, pp. 200–211.

Das 1998
Asok Kumar Das, ed. *Mughal Masters: Further Studies.* Mumbai: Marg Publications, 1998.

Das 1998a
Asok Kumar Das. "Devidasa at the Basohli Court." In Ohri and Craven 1998, pp. 1–16.

Das 1999
Asok Kumar Das. "The Elephant in Mughal Painting." In *Flora and Fauna in Mughal Art,* edited by Som Prakash Verma (Mumbai: Marg Publications, 1999), pp. 36–54.

Dehejia et al. 1999
Vidya Dehejia et al. *Devi, the Great Goddess: Female Divinity in South Asian Art.* Exh. cat. Washington, D.C.: Arthur M. Sackler Gallery, Smithsonian Institution, in association with Mapin Publishing and Prestel Verlag, 1999.

Desai et al. 1985
Vishakha N. Desai et al. *Life at Court: Art for India's Rulers, Sixteenth–Nineteenth Centuries.* Exh. cat. Boston: Museum of Fine Arts, 1985.

Dwivedi 1980
V. P. Dwivedi. *Bārahmāsā: The Song of Seasons in Literature and Art.* Delhi: Agam Kala Prakashan, 1980.

Ebeling 1973
Klaus Ebeling. *Ragamala Painting.* Basel: Ravi Kumar, 1973.

Ehnbom 1984
Daniel J. Ehnbom. "An Analysis and Reconstruction of the Dispersed *Bhāgavata Purāna* from the *Caurapañcāśikā* Group." Ph.D. diss., The University of Chicago, 1984.

Ehnbom 1985
Daniel J. Ehnbom, with Robert Skelton and Pramod Chandra. *Indian Miniatures: The Ehrenfeld Collection.* Exh. cat. New York: Hudson Hills Press in association with the American Federation of Arts, 1985.

Falk 1976
Toby Falk. "Rothschild Collection of Mughal Miniatures." In P & D Colnaghi & Co. Ltd., London, *Persian and Mughal Art* (April 7–May 20, 1976), pp. 167–70.

Falk 1992
Toby Falk. "The Kishangarh Artist Bhavani Das." *Artibus Asiae,* vol. 52, nos. 1–2 (1992), Notice 1 (n.p.).

Falk and Archer 1981
Toby Falk and Mildred Archer. *Indian Miniatures in the India Office Library.* London: Sotheby Parke Bernet; Delhi: Oxford University Press, 1981.

Falk and Lynch 1989
Toby Falk and Brendan Lynch. *Images of India.* London: Indar Pasricha Fine Arts, 1989.

Filippi 1997
Gian Giuseppe Filippi, ed. *Indian Miniatures and Paintings from the Sixteenth to the Nineteenth Century: The Collection of Howard Hodgkin.* Exh. cat. Milan: Electa, 1997.

Fischer and Goswamy 1999
Eberhard Fischer and B. N. Goswamy. *Paintings by Nainsukh of Guler: Indian Miniatures—Works from the Pahari Region of the Eighteenth Century in the Collection of the Museum Rietberg Zürich Ascribed to the Master, His Workshop, and His Successors.* Zurich: Museum Rietberg, 1999.

Fogg 1999
Sam Fogg, London. *Indian Paintings and Manuscripts.* London: Sam Fogg, 1999.

French 1931
J. C. French. *Himalayan Art.* With an introduction by Laurence Binyon. Delhi: Neeraj Publishing House, 1931.

Garimella 1998
Annapurna Garimella. "A Handmaids' Tale: *Sakhis,* Love, Devotion, and Poetry in Rajput Painting." In Arthur M. Sackler Gallery, Smithsonian Institution, Washington, D.C., *Love in Asian Art and Culture* (Washington, D.C.: Arthur M. Sackler Gallery, 1998), pp. 71–96.

Glynn and Smart 1997
Catherine Glynn and Ellen Smart. "A Mughal Icon Re-Examined." *Artibus Asiae,* vol. 57, nos. 1–2 (1997), pp. 5–15.

Goetz 1950
Hermann Goetz. *The Art and Architecture of Bikaner State.* Oxford: Bruno Cassirer for the Government of Bikaner State and the Royal India and Pakistan Society, 1950.

Goswamy 1997
B. N. Goswamy. *Nainsukh of Guler: A Great Indian Painter from a Small Hill-State.* Supplement 41 of *Artibus Asiae.* Zurich: Museum Rietberg, 1997.

Goswamy with Bhatia
B. N. Goswamy with Usha Bhatia. *Painted Visions: The Goenka Collection of Indian Paintings.* New Delhi: Lalit Kala Akademi and Rabindra Bhavan, 1999.

Goswamy and Fischer 1992
B. N. Goswamy and Eberhard Fischer. *Pahari Masters: Court Painters of Northern India.* Supplement 38 of *Artibus Asiae.* Exh. cat. Zurich: Museum Rietberg, 1992.

Guy 1995
John Guy, ed. *Indian Art and Connoisseurship: Essays in Honour of Douglas Barrett.* New Delhi: Indira Gandhi National Centre for the Arts in association with Mapin Publishing, 1995.

Guy and Swallow 1990
John Guy and Deborah Swallow, eds. *Arts of India: 1550–1900.* London: Victoria and Albert Museum, 1990.

Haidar 2000
Navina Najat Haidar. "Satire and Humour in Kishangarh Painting." In Topsfield 2000, pp. 78–91.

Havell 1908
E. B. Havell. *Indian Sculpture and Painting: Illustrated by Typical Masterpieces with an Explanation of Their Motives and Ideals.* London: John Murray, 1908.

Hayward Gallery 1982
Hayward Gallery, London. *In the Image of Man: The Indian*

Perception of the Universe Through 2000 Years of Painting and Sculpture. March 25–June 13, 1982.

Hodgkin 1991
Howard Hodgkin. "About My Collection." *Asian Art*, vol. 4, no. 4 (Fall 1991), pp. 9–28.

Hutchison and Vogel 1933
J. Hutchison and J. Ph. Vogel. *History of the Panjab Hill States.* 2 vols. Lahore: Superintendent, Government Printing, 1933.

Jahangirnama 1999
The Jahangirnama: Memoirs of Jahangir, Emperor of India. Translated, edited, and annotated by Wheeler M. Thackston. Washington, D.C.: Freer Gallery of Art and the Arthur M. Sackler Gallery, Smithsonian Institution, in association with Oxford University Press, 1999.

Khandalavala 1958
Karl Khandalavala. *Pahārī Miniature Painting.* Mumbai: The New Book Company Private Limited, 1958.

Khandalavala 1985
Karl Khandalavala. "Three *Laur Chandā* Paintings in the Asian Art Museum of San Francisco." *Lalit Kala*, no. 22 (1985), pp. 19–27.

Khandalavala and Chandra 1959–62
Karl Khandalavala and Moti Chandra. "New Documents of Indian Painting." *Prince of Wales Museum Bulletin*, no. 7 (1959–62), pp. 23–34.

Khandalavala and Chandra 1969
Karl Khandalavala and Moti Chandra. *New Documents of Indian Painting: A Reappraisal.* Mumbai: The Board of Trustees of the Prince of Wales Museum of Western India, 1969.

Khandalavala and Mittal 1974
Karl Khandalavala and Jagdish Mittal. "The *Bhāgavata* MSS from Palam and Isarda: A Consideration in Style." *Lalit Kala*, no. 16 (1974), pp. 28–32.

Khandalavala et al. 1960
Karl Khandalavala, Moti Chandra, and Pramod Chandra. *Miniature Paintings from the Sri Motichand Khajanchi Collection.* New Delhi: Lalit Kala Akademi, 1960.

Khandalavala et al. 1961
Karl Khandalavala, Moti Chandra, Pramod Chandra, and Parmeshwari Lal Gupta. "A New Document of Indian Painting." *Lalit Kala*, no. 10 (October 1961), pp. 45–54.

Kossak 1997
Steven Kossak. *Indian Court Painting: Sixteenth–Nineteenth Century.* Exh. cat. New York: The Metropolitan Museum of Art, 1997.

Kramrisch 1981
Stella Kramrisch. *Manifestations of Shiva.* Exh. cat. Philadelphia: Philadelphia Museum of Art, 1981.

Kramrisch 1986
Stella Kramrisch. *Painted Delight: Indian Paintings from Philadelphia Collections.* Exh. cat. Philadelphia: Philadelphia Museum of Art, 1986.

Krishna 1995
Naval Krishna. "Painting and Painters in Bikaner: Notes on an Inventory Register of the Seventeenth Century." In *Indian Painting: Essays in Honour of Karl J. Khandalavala*, edited

by B. N. Goswamy with Usha Bhatia (New Delhi: Lalit Kala Akademi, 1995), pp. 254–80.

Leach 1986
Linda York Leach. *Indian Miniature Paintings and Drawings: The Cleveland Museum of Art Catalogue of Oriental Art.* Part 1. Cleveland: The Cleveland Museum of Art in association with Indiana University Press, 1986.

Leach 1995
Linda York Leach. *Mughal and Other Indian Paintings from the Chester Beatty Library.* 2 vols. London: Scorpion Cavendish, 1995.

Leach 1998
Linda York Leach. *The Nasser D. Khalili Collection of Islamic Art.* Vol. 8, *Paintings from India.* London: The Nour Foundation in association with Azimuth Editions and Oxford University Press, 1998.

Lee 1960
Sherman Lee. *Rajput Painting.* Exh. cat. New York: Asia Society, 1960.

Lerner 1984
Martin Lerner. *The Flame and the Lotus: Indian and Southeast Asian Art from the Kronos Collections.* Exh. cat. New York: The Metropolitan Museum of Art, 1984.

Lipsey 1977
Roger Lipsey. *Coomaraswamy.* Vol. 3, *His Life and Work.* Bollingen series, 89. Princeton: Princeton University Press, 1977.

Losty 1982
Jeremiah P. Losty. *The Art of the Book in India.* Exh. cat. London: The British Library, 1982.

Lowry 1988
Glenn D. Lowry with Susan Nemazee. *A Jeweler's Eye: Islamic Arts of the Book from the Vever Collection.* Washington, D.C.: Arthur M. Sackler Gallery, Smithsonian Institution, in association with the University of Washington Press, 1988.

McInerney 1982
Terence McInerney. *Indian Painting, 1525–1825.* Exh. cat. London: David Carritt Limited, 1982.

McInerney and Hodgkin 1983
Terence McInerney and Howard Hodgkin. *Indian Drawing.* Exh. cat. London: Arts Council of Great Britain, 1983.

Miller 1977
Barbara Stoler Miller, ed. and trans. *Love Song of the Dark Lord: Jayadeva's "Gītagovinda."* New York: Columbia University Press, 1977.

Minorsky 1959
V. Minorsky, trans. *Calligraphers and Painters: A Treatise by Qādī Ahmad, Son of Mīr-Munshī (circa A.H. 1015–A.D. 1606).* With an introduction by B. N. Zakhoder. Freer Gallery of Art Occasional Papers, vol. 3, no. 2. Washington, D.C.: Freer Gallery of Art, Smithsonian Institution, 1959.

Mitter 1994
Partha Mitter. *Art and Nationalism in Colonial India, 1850–1922: Occidental Orientations.* Cambridge: Cambridge University Press, 1994.

Morley 1981
Grace Morley. "The Rāma Epic and Bharat Kala Bhavan's

Collection." In *Chhavi*, no. 1, *Rai Krishnadasa Felicitation Volume* (Varanasi: Bharat Kala Bhavan, 1981), pp. 241–51.

Ohri 1991
Vishwa Chander Ohri. *On the Origins of Pahari Painting: Some Notes and a Discussion.* Shimla: Indian Institute of Advanced Study in association with Indus Publishing Company, 1991.

Ohri 1998
Vishwa Chander Ohri. "Nikka and Ranjha at the Court of Raj Singh of Chamba." In Ohri and Craven 1998, pp. 98–114.

Ohri and Craven 1998
Vishwa Chander Ohri and Roy C. Craven, Jr., eds. *Painters of the Pahari Schools.* Mumbai: Marg Publications, 1998.

Okada 1998
Amina Okada. "Kesu Das: The Impact of Western Art on Mughal Painting." In Das 1998, pp. 84–95.

Pal 1971
Pratapaditya Pal. *Indo-Asian Art from the John Gilmore Ford Collection.* Baltimore: Walters Art Gallery, 1971.

Pal 1972
Pratapaditya Pal, ed. *Aspects of Indian Art: Papers Presented in a Symposium at the Los Angeles County Museum of Art, October, 1970.* Leiden: E. J. Brill, 1972.

Pal 1978
Pratapaditya Pal. *The Classical Tradition in Rajput Painting from the Paul F. Walter Collection.* Exh. cat. New York: The Pierpont Morgan Library and the Gallery Association of New York State, 1978.

Pal 1997
Pratapaditya Pal, ed. *Dancing to the Flute: Music and Dance in Indian Art.* Exh. cat. Sydney: The Art Gallery of New South Wales, 1997.

Pal et al. 1994
Pratapaditya Pal et al. *The Peaceful Liberators: Jain Art from India.* Exh. cat. Los Angeles: Los Angeles County Museum of Art, 1994.

Pasricha 1982
Indar Pasricha. "Painting at Sawar and at Isarda in the Seventeenth Century." *Oriental Art*, n.s., vol. 28, no. 3 (Autumn 1982), pp. 257–69.

Portland 1968
Portland (Oregon) Art Museum. *Rajput Miniatures from the Collection of Edwin Binney, 3rd.* September 24–October 20, 1968.

Poster et al. 1994
Amy G. Poster et al. *Realms of Heroism: Indian Paintings at the Brooklyn Museum.* Exh. cat. Brooklyn: The Brooklyn Museum in association with Hudson Hills Press, 1994.

Rāmāyana 1984–94
The Rāmāyana of Vālmīki: An Epic of Ancient India. Princeton: Princeton University Press. Vol. 1, *Bālakānda*, introduction and translation by Robert P. Goldman; annotation by Robert P. Goldman and Sally J. Sutherland (1984). Vol. 2, *Ayodhyākānda*, introduction, translation, and annotation by Sheldon I. Pollock; edited by Robert P. Goldman (1986). Vol. 3, *Aranyakānda*, introduction, translation, and annota-

tion by Sheldon I. Pollock; edited by Robert P. Goldman (1991). Vol. 4, *Kiskindhākānda,* introduction, translation, and annotation by Rosalind Lefeber; edited by Robert P. Goldman (1994).

Randhawa 1959

M. S. Randhawa. *Basohli Painting.* New Delhi: Ministry of Information and Broadcasting, Government of India, 1959.

Randhawa 1962

M. S. Randhawa. *Kangra Paintings on Love.* New Delhi: National Museum, 1962.

Randhawa 1967

M. S. Randhawa. *Chamba Painting.* New Delhi: Lalit Kala Akademi, 1967.

Randhawa and Randhawa 1980

M. S. Randhawa and Doris Schreier Randhawa. *Kishangarh Painting.* Mumbai: Vakils, Feffer, & Simons, 1980.

Robinson et al. 1976

B. W. Robinson et al. *Islamic Painting and the Arts of the Book: The Keir Collection.* Edited by B. W. Robinson. London: Faber and Faber, 1976.

Schmitz et al. 1997

Barbara Schmitz et al. *Islamic and Indian Manuscripts and Paintings in the Pierpont Morgan Library.* New York: Pierpont Morgan Library, 1997.

Seyller 1985

John Seyller. "Model and Copy: The Illustrations of Three *Razmnāma* Manuscripts." *Archives of Asian Art,* vol. 38 (1985), pp. 37–66.

Seyller 1997

John Seyller. "The Inspection and Valuation of Manuscripts in the Imperial Mughal Library." *Artibus Asiae,* vol. 57, nos. 3–4 (1997), pp. 243–349.

Seyller 1999

John Seyller. *Workshop and Patron in Mughal India: The Freer Rāmāyana and Other Illustrated Manuscripts of 'Abd al-Rahīm.* Supplement 42 of *Artibus Asiae.* Zurich: Museum Rietberg in association with the Freer Gallery of Art, Smithsonian Institution, 1999.

Singh 1985

M. K. Brijraj Singh. *The Kingdom That Was Kotah: Paintings from Kotah.* New Delhi: Lalit Kala Akademi, 1985.

Skelton 1958

Robert Skelton. "Documents for the Study of Painting at Bijapur in the Late Sixteenth and Early Seventeenth Centuries." *Arts Asiatiques,* vol. 5, no. 2 (1958), pp. 97–125.

Spink 1982

Spink & Son Ltd., London. *Two Thousand Years of Indian Art.* April 6–23, 1982.

Spink 1987

Spink & Son Ltd., London. *Indian Miniature Painting.* November 25–December 18, 1987.

Tod 1971

James Tod. *Annals and Antiquities of Rajast'han or, the Central and Western Rajpoot States of India.* 2 vols. 1914; reprint, New Delhi: K.M.N. Publishers, 1971.

Tod 1971a

James Tod. *Annals and Antiquities of Rajasthan, or the Central and Western Rajput States of India.* Edited by William Crooke. 3 vols. 1920; reprint, Delhi: Motilal Banarsidass, 1971.

Topsfield 1980

Andrew Topsfield. *Paintings from Rajasthan in the National Gallery of Victoria: A Collection Acquired through the Felton Bequests' Committee.* Exh. cat. Melbourne: National Gallery of Victoria, 1980.

Topsfield 1990

Andrew Topsfield. *The City Palace Museum, Udaipur: Paintings of Mewar Court Life.* Ahmedabad: Mapin Publishing, 1990.

Topsfield 2000

Andrew Topsfield, ed. *Court Painting in Rajasthan.* Mumbai: Marg Publications, 2000.

Topsfield and Beach 1991

Andrew Topsfield and Milo Cleveland Beach. *Indian Paintings and Drawings from the Collection of Howard Hodgkin.* Exh. cat. London: Thames and Hudson, 1991.

Welch 1973

Stuart Cary Welch with Mark Zebrowski. *A Flower from Every Meadow: Indian Paintings from American Collections.* Exh. cat. New York: Asia Society, 1973.

Welch 1985

Stuart Cary Welch. *India: Art and Culture, 1300–1900.* Exh. cat. New York: The Metropolitan Museum of Art, 1985.

Welch 1994

Stuart Cary Welch. "A Matter of Empathy: Comical Indian Pictures." *Asian Art and Culture,* vol. 7, no. 3 (Fall 1994), pp. 77–103.

Welch 1997

Stuart Cary Welch, ed. *Gods, Kings, and Tigers: The Art of Kotah.* Exh. cat. Munich: Prestel, 1997.

Welch and Beach 1965

Stuart Cary Welch and Milo Cleveland Beach. *Gods, Thrones, and Peacocks: Northern Indian Painting from Two Traditions, Fifteenth to Nineteenth Centuries.* Exh. cat. New York: Asia Society, 1965.

Worswick and Embree 1976

Clark Worswick and Ainslie Embree. *The Last Empire: Photography in British India, 1855–1911.* Exh. cat. Millerton, N.Y.: Aperture, 1976.

Zebrowski 1983

Mark Zebrowski. *Deccani Painting.* London: Sotheby Publications; Berkeley and Los Angeles: University of California Press, 1983.